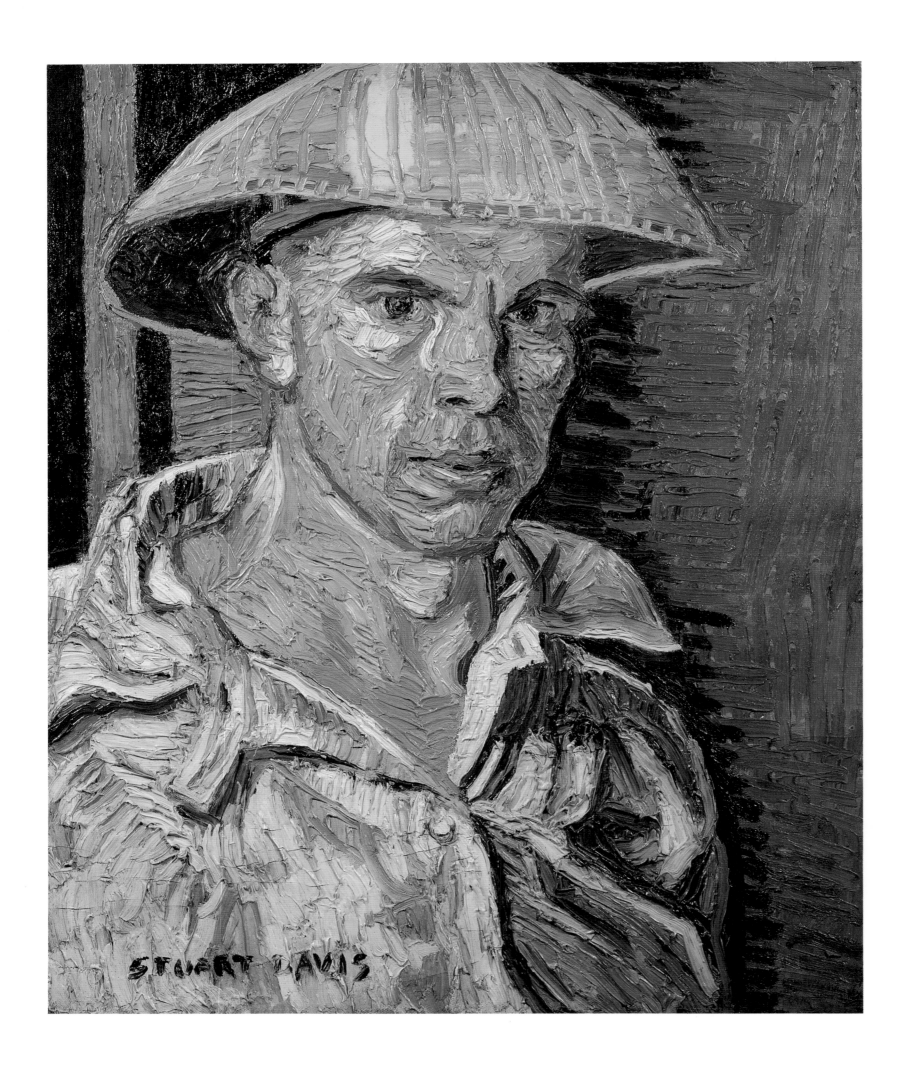

Karen Wilkin

STUART DAVIS

Abbeville Press
Publishers · New York

COVER: *Municipal*, 1961. See plate 30

FRONTISPIECE: *Self-Portrait* (*Chinese Hat*), 1919
Oil on canvas, 23¼ x 19¼ in.
Earl Davis; Courtesy Washburn Gallery,
New York

To My Father

EDITOR: **Nancy Grubb**
DESIGNER: **Nai Chang**
PRODUCTION SUPERVISOR: **Hope Koturo**
PICTURE RESEARCHER: **Serena Wilkie**

Chronology, Exhibitions, Public Collections, and Bibliography compiled by **Rebecca Wan**

Acknowledgments
During the preparation of this book I have benefited greatly from the generosity and cooperation of many people. I would like to thank, in particular, William C. Agee for his largeness of spirit and his insightful comments. Lawrence Salander and William Edward O'Reilly helped to launch the project and provided unflagging encouragement and practical help. Robert Hunter and Bruce Weber generously shared information; Rebecca Wan prepared the chronology, lists of exhibitions and collections, and bibliography. Finally, I would like to thank three individuals who profoundly influenced this book: Earl Davis, for his enthusiastic support and great kindness; Nancy Grubb, who made this a much better book; and Donald Clinton, for innumerable reasons.

FIRST EDITION

Library of Congress Cataloging-in-Publication Data
Wilkin, Karen.
 Stuart Davis.

 Bibliography: p.
 Includes index.
 1. Davis, Stuart, 1894–1964—Criticism and interpretation. 2. Painting, American. 3. Painting, Modern—20th century—United States. I. Davis, Stuart, 1894–1964.
II. Title.
ND237.D333W54 1987 759.13 87-1186
ISBN 0-89659-755-5

CONTENTS

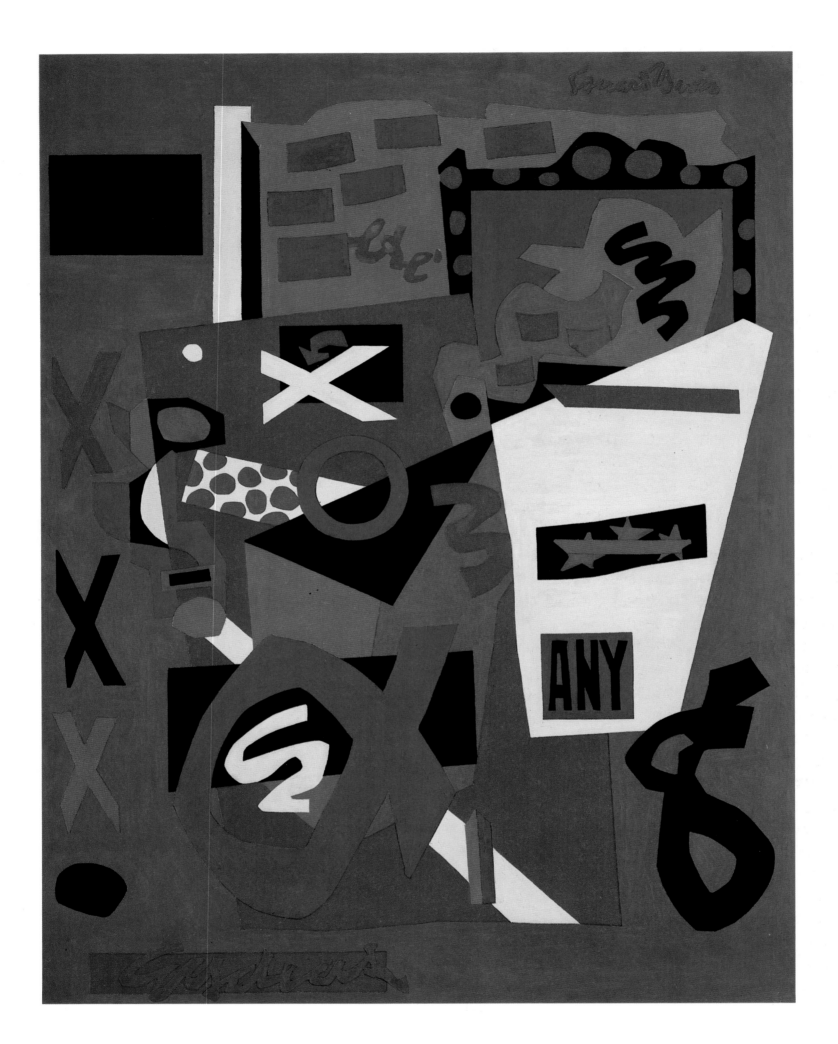

INTRODUCTION

In 1948 *Look* magazine published a list of the "ten best painters in America today," based on a poll of museum directors and critics across the country. The pioneer modernist landscape painter, John Marin, took first place, ahead of such traditionalists as Yasuo Kuniyoshi, Edward Hopper, and Charles Burchfield, and such engagé commentators as Ben Shahn and George Grosz. Max Weber placed second, presumably for his expressionist images of Hasidic Jews, since he had abandoned his early Cubist style years before. Lyonel Feininger's elegant, brittle cityscapes and Jack Levine's ham-fisted social satires tied for tenth place.

Marin's first-place position notwithstanding, *Look* magazine's list reflects the conservative, if not downright reactionary, taste of the American postwar art establishment, and it gives no accurate idea of the state of American painting at the time. By 1948, after all, Jackson Pollock had poured his first masterly pictures; Adolph Gottlieb was well into his splendid early series, the Pictographs; Arshile Gorky had found his distinctive voice; and Willem de Kooning had painted many of the black-and-white paintings that are arguably his best works. Abstraction was flourishing in America, but to judge from the results of *Look's* survey, establishment taste not only ignored nonfigurative art, it ignored modernism in general. (Marin's preeminence is misleading because his Yankee subject matter outweighed his formal adventurousness, and he had been well accepted since the 1920s.) For the most part, the critics and museum directors declared themselves in favor of the representational, the provincial, and often the second rate. Yet there is one exception among *Look's* top ten, one first-rate modernist wholly committed to an individual kind of abstraction: Stuart Davis, who placed fourth. His quirky canvases with their Cubist-derived, sharp-edged shapes, their razzle-dazzle color, and their rambunctious vernacular spirit seem completely at odds with the jurors' other choices.

1. *Seme,* 1953
Oil on canvas, 52 x 40 in.
The Metropolitan Museum of Art, New York; George A. Hearn Fund, 1953

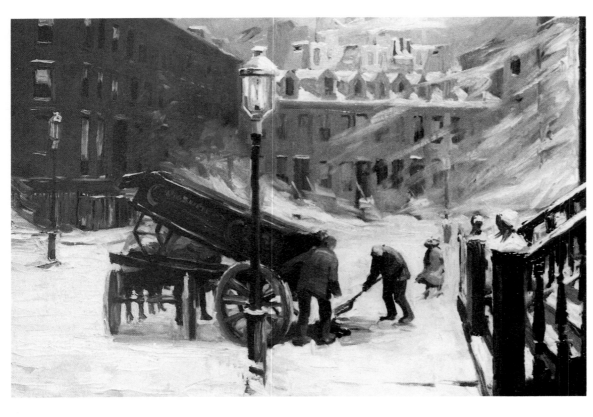

2. *Consumer's Coal,* 1912
Oil on linen, 29½ x 37½ in.
Sunrise Museums, Charleston,
West Virginia; Gift of
Amherst Coal Co.

3. *Woman Washing Hair,* 1912
Watercolor on paper,
14½ x 10½ in.
Earl Davis

4. *Backyards,* 1913
Watercolor on paper,
14½ x 10¾ in.
Earl Davis

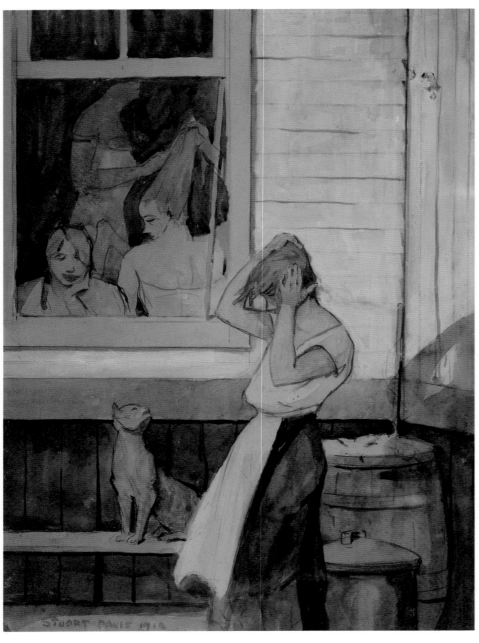

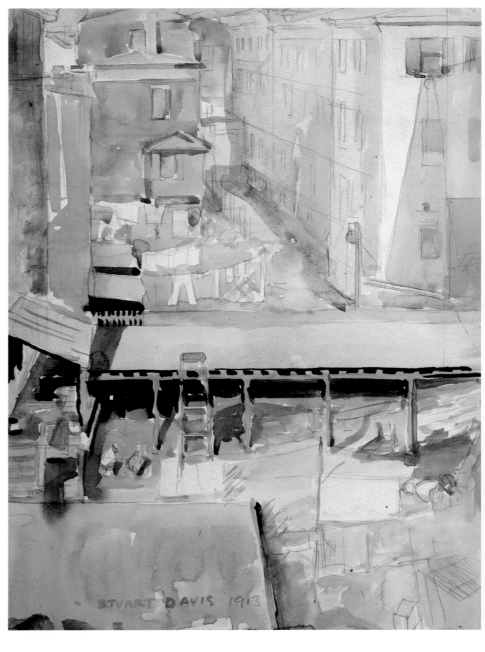

That Davis figured at all in the survey, much less as respectably as fourth, seems extraordinary. Not only were his paintings very different from any of the others', but throughout his career he had demonstrated convictions that set him apart from most of the artists chosen by the jury. Davis fervently believed that a painting was an independent, potent object and not an imitation of or a commentary on the existing world. His notebooks are filled with assertions such as "a work of art is never a picture *of* something. It always *is* something," and "No work of art was ever a replica of optical appearance."[1] For some reason, this uncompromising modernist was acceptable to "official" taste.

Seniority had something to do with it. In 1948 Davis was fifty-five. He had been exhibiting for more than thirty-five years; for more than a decade he had enjoyed the support of a small group of collectors; his works had entered an impressive number of private and public collections. He had received major commissions for murals, and in 1945 the Museum of Modern Art had mounted a full-scale retrospective exhibition. Most of the conservative painters on *Look*'s list were similarly recognized and most were about Davis's age (Marin, Feininger, and Weber were older; only Levine had been born in the twentieth century).

Davis's relationship to his own generation was, like so much of his career, anomalous: his aesthetic beliefs and his formation as an artist were closer to that of the first wave of American modernists than to those of his real contemporaries. Davis was nearly a generation younger than Marin or Marsden Hartley or Alfred Maurer, artists who had been among the first to respond to the lessons of the European avant-garde, but like them, he was profoundly attracted to these new ideas and used them as the basis for his mature art. Members of the first generation were often expatriates who had gained their knowledge of European modernism firsthand, in France and Germany; Davis first saw what he called Modern Art—with respectful capitals—in New York, at the 1913 Armory Show. The first generation had gone to Europe to seek out the new art; Davis had it thrust at him. He became an instant convert to the cause of modernism and remained its passionate advocate. In a kind of epiphany, he realized the old-fashionedness of his own art after seeing the radical works in the Armory Show. He spent the next ten years trying to become a modern artist, looking hard and assimilating the inventions of the artists he had come to admire: Paul Cézanne, Fernand Léger, Henri Matisse, Pablo Picasso, Georges Seurat, Vincent van Gogh. By the time Davis arrived in Paris, in 1928, he was completely at home in a modernist idiom. The task of being a modern artist occupied him for the rest of his life.

The single-mindedness of Davis's response is unusual. Most of his

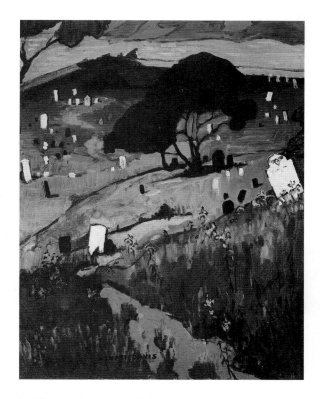

5. *Graveyard on the Dunes—Provincetown*, 1913
Oil on canvas, 38 x 30½ in.
Earl Davis

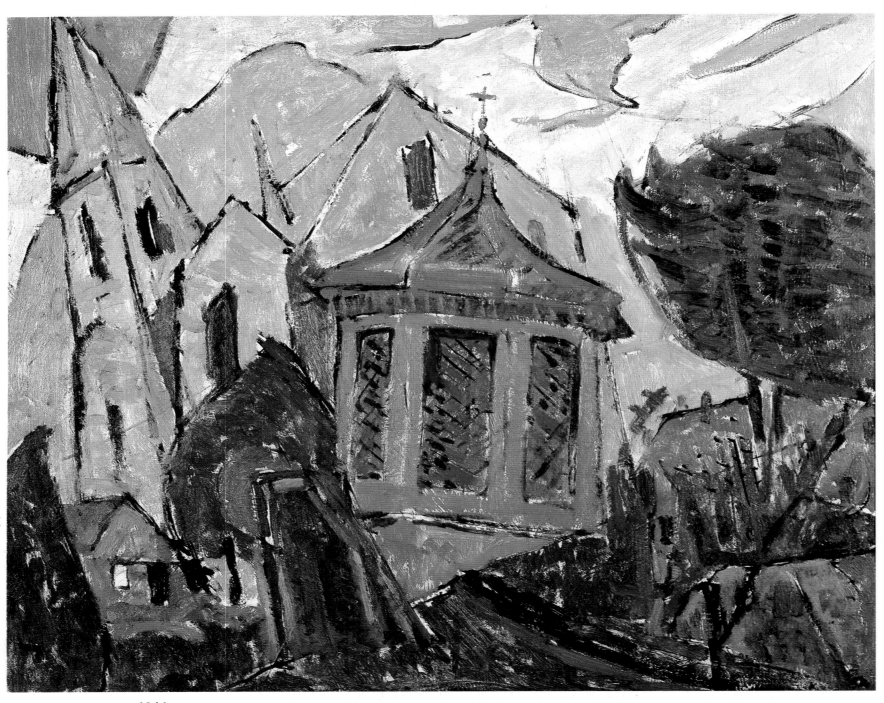

6. *Church Forms*, c. 1916
Oil on canvas, 19 x 23 in.
Earl Davis

contemporaries seem to have been less affected by their first encounter with radical European art: witness the painters on *Look's* list. Even some initially attracted to modernist ideas later rejected what they saw as foreign novelty and took refuge in tradition and nationalism. American art, they claimed, could grow only if it drew upon the particulars of the American experience and rejected European abstractness.

Paradoxically, no one was more tuned in to his surroundings than Davis. Born in 1892 into a family of artists, he was raised on the Ashcan School's brand of vernacular realism; as a precocious teenager, he studied with the movement's leader, Robert Henri, and knew many of its members, gaining direct experience of their declaration that even

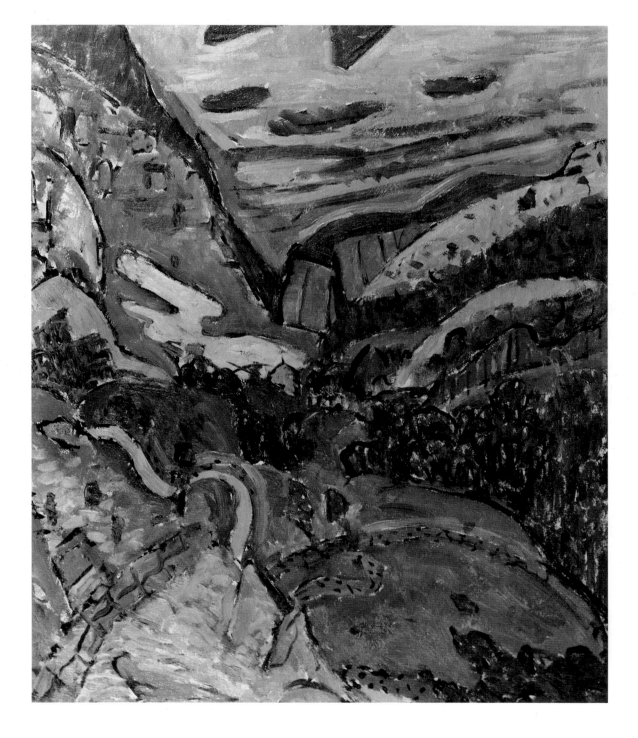

7. *Hillside with Stone Walls,*
c. 1916
Oil on canvas, 29¼ x 23½ in.
Earl Davis

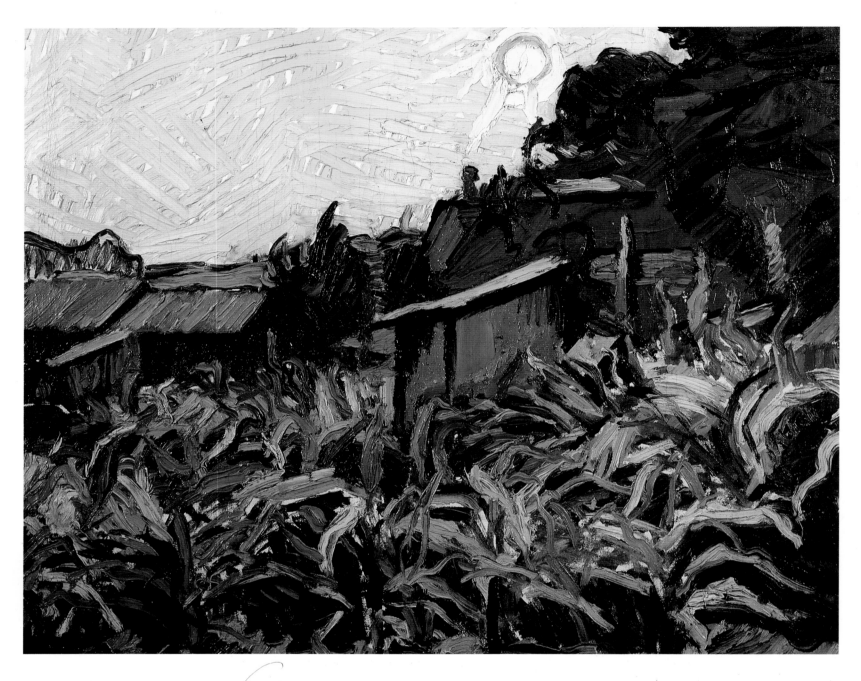

8. *Cornfield—Tioga,*
Pennsylvania, 1919
Oil on canvas, 24 x 30 in.
Earl Davis

the most unprepossessing aspects of daily city life could be good subject matter for painting. Everyday experience was the generating force for his paintings, and we can easily chart his delight in the urban accretions of New York, the unmistakable rooftops and railings of Paris, the picturesque muddle of the Gloucester waterfront. His much-quoted statement of "things which have made me want to paint, outside of other paintings," puts it clearly:

American wood and iron work of the past; Civil War and sky-scraper architecture; the brilliant colors on gasoline stations, chainstore fronts, and taxi-cabs; the music of Bach; synthetic chemistry; the poetry of Rimbaud; fast travel by train, auto, and aeroplane which brought new and multiple perspectives;

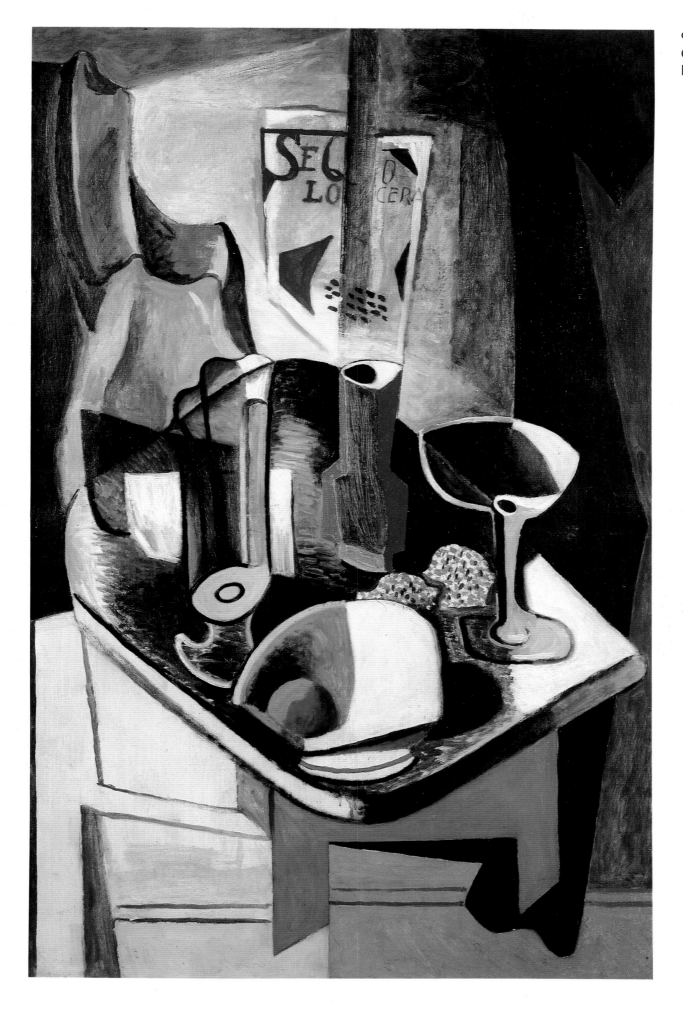

9. *Red Still Life,* 1922
Oil on canvas, 50 x 32 in.
Earl Davis

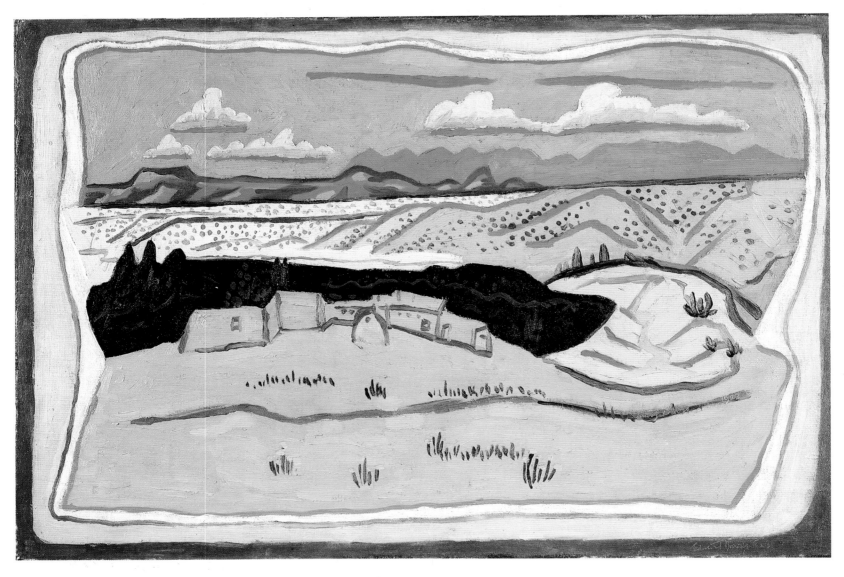

10. *New Mexico Landscape,*
1923
Oil on canvas, 22 x 32 in.
Whitney Museum of American
Art, New York

electric signs; the landscape and boats of Gloucester, Mass.; 5 & 10 cent store kitchen utensils; movies and radio; Earl Hines hot piano and Negro jazz music in general, etc.[2]

But while Davis stressed the importance of his day-to-day environment to his art, he was adamant that his paintings were autonomous, universal, *made* objects. "Real Art is a part of Real Situations not a report or a simulation of them."[3]

It is possible that, as with Marin, Davis's incorporation of fragments of his surroundings into his pictures consoled critics for the freedom with which he used them. He could be seen as a kind of modernist American Scene painter, which may help account for his fourth-place standing in the survey. Davis would have hated this association with artists such as Thomas Hart Benton, Grant Wood, and John Steuart Curry, whose work he disliked intensely and criticized vociferously. He was equally scornful of his contemporaries who responded to the upheavals of the period between the two world wars by turning their art

into explicit social commentary. Davis's deep sense of political and social responsibility is well documented: he helped to run the American Artists Congress, served on committees, wrote public declarations. He worked hard for his convictions, but unlike many of his fellows he always separated the form of his political activism from the form of his painting. Davis always declared that art was a reflection of the man but that it was also a thing apart. "There is no such thing as non-political art in the sense that every artist is always in a specific political relation whether positively or negatively. But this political relation . . . is not the subject of his art, which consists of his own contribution to the *affirmation* of order in the materials of art."[4]

If Davis rightly insisted on his distance from his colleagues in the American Scene and from the Social Realists, he was also separate from his more like-minded contemporaries. He was born too late to have been part of the group of avant-garde Americans whose work was exhibited by Alfred Stieglitz in his seminal New York galleries (291, the Intimate Gallery, and An American Place), although the Stieglitz circle's work often seems close to Davis's in motivation and aspiration. Like Davis, Stieglitz artists such as Arthur G. Dove, Georgia O'Keeffe, and Charles Demuth were committed modernists whose work was rooted in their experience of their immediate surroundings. Of course, there are related painters, not directly associated with Stieglitz's gal-

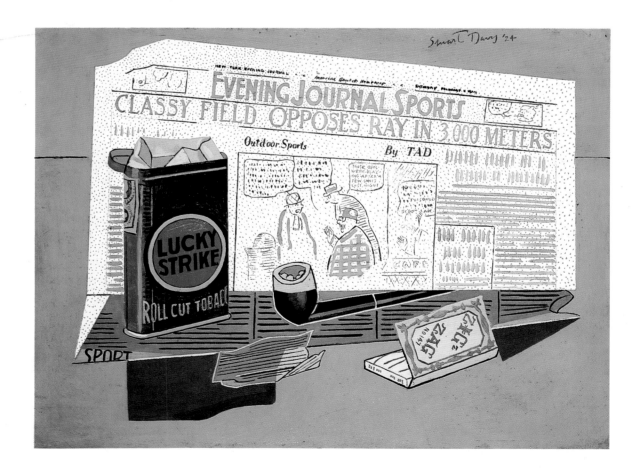

11. *Lucky Strike,* 1924
Oil on canvas, 18 x 24 in.
Hirshhorn Museum and
Sculpture Garden, Smithsonian
Institution, Washington, D.C.

15

12. Stuart Davis working on
Summer Landscape, c. 1930

leries, who can be described the same way—Charles Sheeler (Davis's near contemporary), for example. As a young painter, Davis met Demuth, and for most of his life Davis showed at the same gallery as Sheeler, so there was direct contact as well as affinity, but Davis's work refuses to sit comfortably with theirs, no matter how similar their intentions. His pictures seem more aggressive and more physically substantial than the elegantly finished, discreet pictures by Sheeler and the Stieglitz artists. Davis's language is more vernacular, his touch more vigorous.

Davis's relation to some of his closer contemporaries is even more equivocal. At first acquaintance, his work seems to have much in common with that of the slightly younger New York painters associated with the American Abstract Artists (AAA), a group that included Davis's friends Ad Reinhardt and Burgoyne Diller. For the most part, the members were too young to have been affected by the Armory Show (or even to remember it), but like Davis they based their art on European modernist prototypes, especially Cubism. More important, they shared Davis's belief in the freedom engendered by modernism's rejection of representation.[5]

As the AAA artists continued to exhibit together and to recruit new members, they demonstrated a preference for an art composed of what Piet Mondrian had called "pure plastic elements," divorced from specific associations. The AAA artists were knowledgeable about Russian Constructivism and similarly rarified movements, but their greatest admiration was for Mondrian, who joined the association when he came to the United States in 1940. Most members of the group were not as rigorous in their pursuit of geometric purity as their chosen ancestors—Mondrian had disassociated himself from De Stijl in 1925, after his colleague Theo van Doesburg introduced diagonal lines into his pictures—but even so, Davis found their approach too exclusive and too restrictive. It seemed to him reductive, where modern art ought to be inclusive or, as he said, "synthetic." "Synthetic form is not Abstract. It is Concrete. It is a new creation in Nature. Just as Chemistry has made thousands of new and useful combinations of chemical elements that had no previous existence in nature, so the artist can combine the three-dimensional elements of painting into new planal relations which have a new Content. This new Content is not abstract but is a new Reality."[6] Davis maintained that his own work, while in no way an imitation of anything that existed already, was not "nonobjective" (to use the then-fashionable phrase) or even "abstract" in the manner of the AAA group's. Davis's lifelong protest against both terms was not merely a semantic quibble but a reflection of his understand-

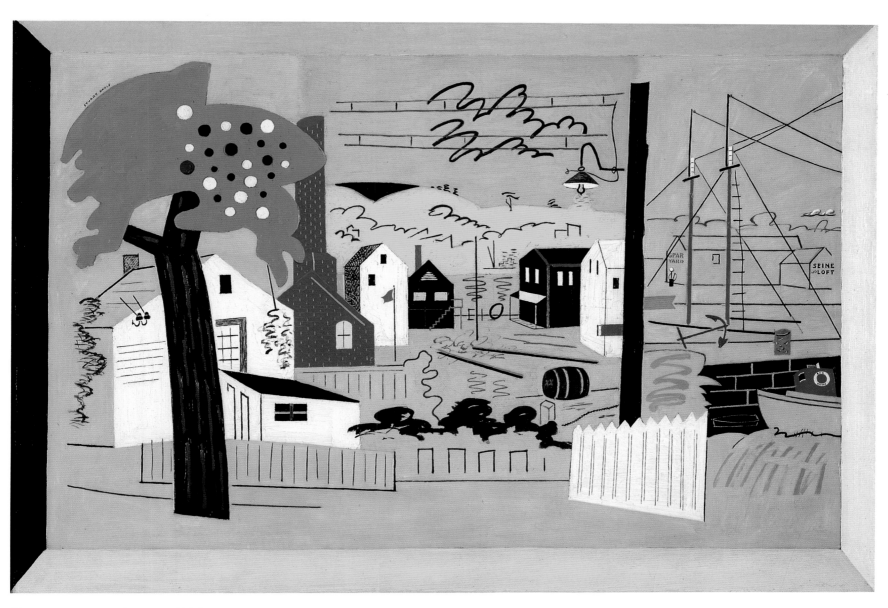

13. *Summer Landscape,* 1930
Oil on canvas, 29 x 42 in.
Collection, The Museum of
Modern Art, New York; Purchase

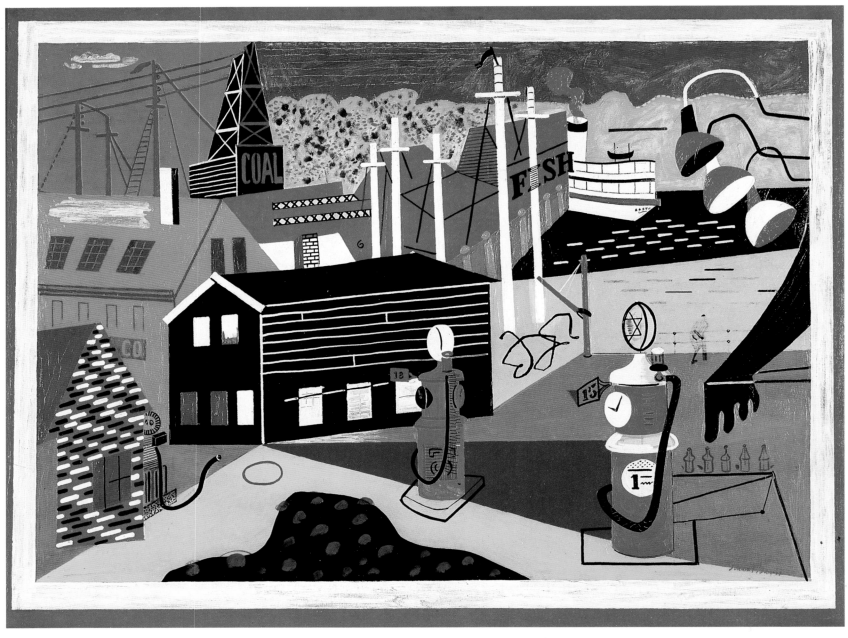

18

OPPOSITE, CLOCKWISE FROM TOP LEFT
14. *Study for "Garage Lights,"* 1931
Pencil and ink on paper, 8½ x 10⅞ in.
Earl Davis

15. *Study for "Garage Lights,"* 1931
Ink on paper, 8¼ x 11¼ in.
Earl Davis

16. *Garage Lights,* 1931–32
Oil on canvas, 32 x 42 in.
Memorial Art Gallery of the University of Rochester, Rochester, New York; Marion Stratton Gould Fund

LEFT
17. *Abstraction* (theme from *Garage Lights*), 1932
Oil on canvas, 12 x 16 in.
Earl Davis

ing of nonfigurative art. His kind of "abstraction" was derived from actuality, even though it was independent of it and equal to it. The freewheeling images that he created are very different from the purist, geometric constructions of the average AAA member.

If Davis was set apart by his aesthetic convictions, he was further isolated by the sheer excellence of his work. Against the folksy mediocrity of the American Scene painting and the self-righteous sentimentality of Social Realism, Davis's paintings set new standards of what art could be. Against the high-minded geometries of the American Abstract Artists, Davis's brilliantly colored, syncopated images are remarkable for their boldness, their eccentricity, and their unexpectedness. Even when we compare him to earlier American modernists, his work often seems more adventurous, less tied to the conventions of the past. Because Davis's pictures separate themselves so clearly from those of even his nearest colleagues, it is tempting to see his art as a bridge between the first beachhead of American modernism and the postwar New York School. Yet to see Davis only as a link, a transitional figure in the history of recent American art, is to distort his significance and underestimate his originality and complexity.

Davis invented a homegrown, personal brand of American Cubism that demonstrated to younger generations of painters and sculptors that it was possible to make serious, advanced art on this side of the Atlantic. He anticipated the development of the large-scale American

18. *Composition No. 4*, 1934
Brush and gouache on paper,
21⅜ x 29⅞ in.
Collection, The Museum of
Modern Art, New York; Gift of
Abby Aldrich Rockefeller

abstract picture in his murals of the 1930s, and by the 1950s he had increased the scale of his easel pictures, reflecting the generosity and exuberance of postwar painting in the United States. When he died in 1964, he was securely established as one of the founders of the flourishing new American abstraction and recognized as one of its most original and accomplished early practitioners.

Henry Geldzahler underscored this view when he included Davis in the Metropolitan Museum of Art's ambitious survey, *New York Painting and Sculpture: 1940–1970*. Davis, Edward Hopper, and Milton Avery represented the older generation of American-born painters. Hopper looked like a provincial Post-Impressionist; Avery, as always, occupied an enchanted, ambiguous territory all his own, while Davis looked surprisingly at home with the Pop painters who had formed their distinctive manners in the last years of his life (he more than held his own with them and his work often criticized theirs). Yet he looked quite unrelated to the Abstract Expressionists, despite their being closer to his own age and despite his personal connections with them. Seeing Davis's work with theirs simply emphasized the extreme differences between his beliefs and those of the generation that immediately succeeded him.

Davis's relationship to the Abstract Expressionists was a curious one. In the 1930s he knew many of them well—David Smith, Gorky, de Kooning—and encouraged their early forays into abstraction. He and

20

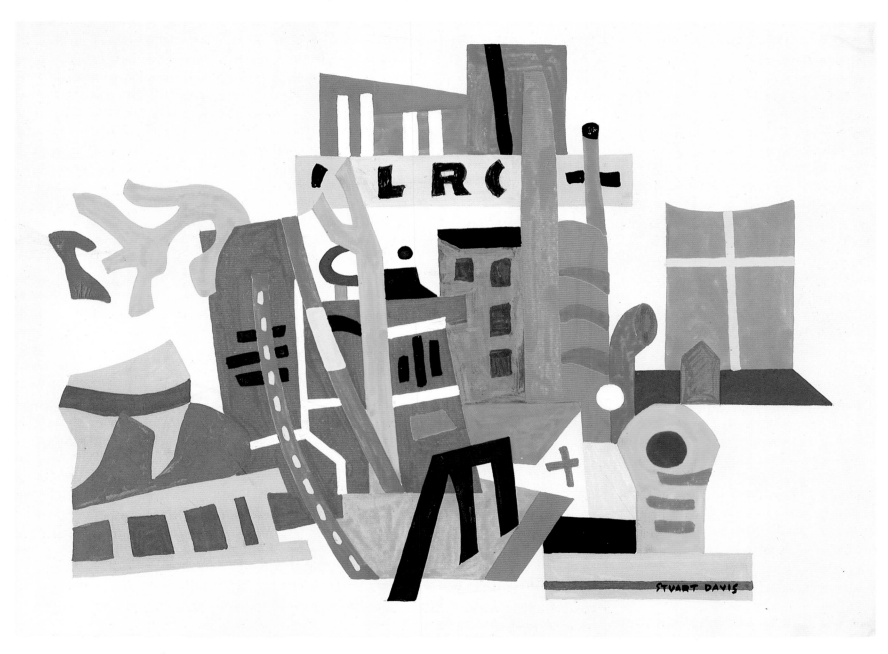

19. *New York Waterfront*, 1938
Gouache on paper, 12 x 15⅞ in.
Collection, The Museum of
Modern Art, New York; Given
anonymously

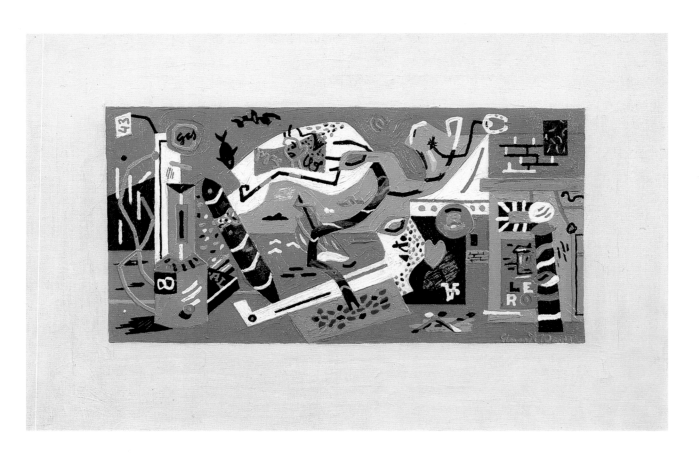

20. *Landscape with Clay Pipe,*
1941
Oil on canvas, 12 x 18 in.
Mr. and Mrs. Milton Lowenthal

Gorky particularly admired one another's work. John Graham, the painter-theorist who helped to keep the New York art world informed about the latest happenings in European art, was part of the group. They frequented Romany Marie's restaurant and often gathered at Stewart's Cafe, near where Davis lived and worked on Fourteenth Street in Greenwich Village. David Smith recalled that at Romany Marie's "we once formed a group, Graham, Edgar Levy, Resnikoff, de Kooning, Gorky and myself, with Davis being asked to join. This was short lived. We never exhibited and we lasted in union about thirty days. Our only action was to notify the Whitney Museum that we were a group and would only exhibit in the 1935 abstract show if all were asked. Some of us were, some exhibited, some didn't, and that ended our group. But we were all what was then termed abstractionists."[7]

They talked together, drank together, looked at each other's work. Davis was old enough to be an example to the younger men, sometimes a mentor. He had proved it was possible to ignore conventional expectations, to remain faithful to advanced ideas about painting, and to succeed in the United States. He had a certain authority, because of his age and his lifelong commitment to modernism. As someone who had seen the Armory Show and spent over a year in Paris, he was respected for having directly experienced the best European art. Smith described Davis "though at his least recognized or exhibited stage" as "the solid citizen for a group a bit younger who were

trying to find their stride." But no matter how good an example Davis offered, the younger New York painters looked to Europe, not to America, for cues during their formative years—as Davis himself had done. To them, Picasso was still *the* modern artist. No one local could compete. And to the generation that emerged in the 1940s, Davis's art came to seem limited. Cubism was less exclusively absorbing to the nascent Abstract Expressionists than it had been to him. New ideas, such as Surrealism and the biomorphic abstraction of Wassily Kandinsky and Joan Miró, offered fresh sources of imagery and alternative ways of constructing paintings.

Both Davis and his younger colleagues had learned their vocabularies from their chosen European ancestors. Davis was an inspired translator of Old World concepts into an unmistakably American colloquial idiom. The next generation learned from his example, if not precisely from his translations, but they also went to sources other than

21. *Max No. 2,* 1949
Oil on canvas, 12 x 16 in.
Washington University Art
Gallery, St. Louis

Davis's. They ended up inventing an entirely new language of painting and using it to propound ideas that Davis had never considered. He never learned this new language, nor thought it worth learning. At the end of his career, Davis was strongly opposed to the ideas explored by this volatile group of younger artists but overshadowed by them. Once again, he was apart. It would remain for the painters of the 1960s to demonstrate some affinity to Davis's approach.

It is the essence of revisionist art history to try to restore (or even to create) the reputations of artists whose work has settled into obscurity, often for good reasons, eclipsed by later, more vigorous efforts. Ob-

22. *Abstraction* (theme for *Eye Level*), c. 1949
Oil on canvas, 14 x 10 in.
Earl Davis

23. *Eye Level*, 1951–54
Oil on canvas, 17 x 12 in.
Private collection

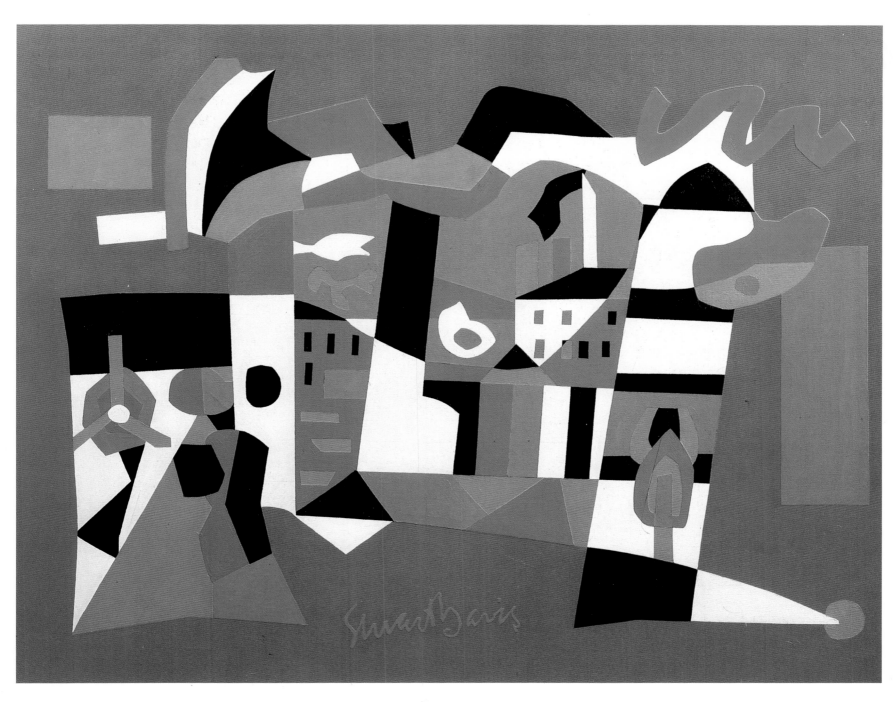

24. *Midi*, 1954
Oil on canvas, 28 x 36¼ in.
The Wadsworth Atheneum,
Hartford, Connecticut; The
Henry Schnakenberg Fund

CLOCKWISE FROM TOP LEFT

25. *Study for "Little Giant Still Life,"* 1950
Oil on canvas, 12 x 16 in.
Earl Davis

26. *Little Giant Still Life, Black-and-White Version,* 1950
Tempera on canvas, 33 x 43 in.
Earl Davis

27. *Little Giant Still Life,* 1950
Oil on canvas, 33 x 43 in.
Virginia Museum of Fine Arts, Richmond; The John Barton Payne Fund

OPPOSITE

28. *VISA,* 1951
Oil on canvas, 40 x 52 in.
Collection, The Museum of Modern Art, New York; Gift of Mrs. Gertrud A. Mellon

29. *Schwitzki's Syntax,* 1961–64
Oil and wax emulsion on canvas, 42 x 53 in.
Yale University Art Gallery, New Haven, Connecticut

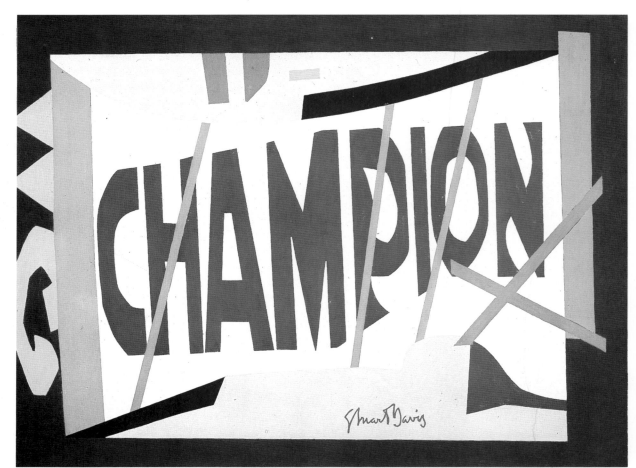

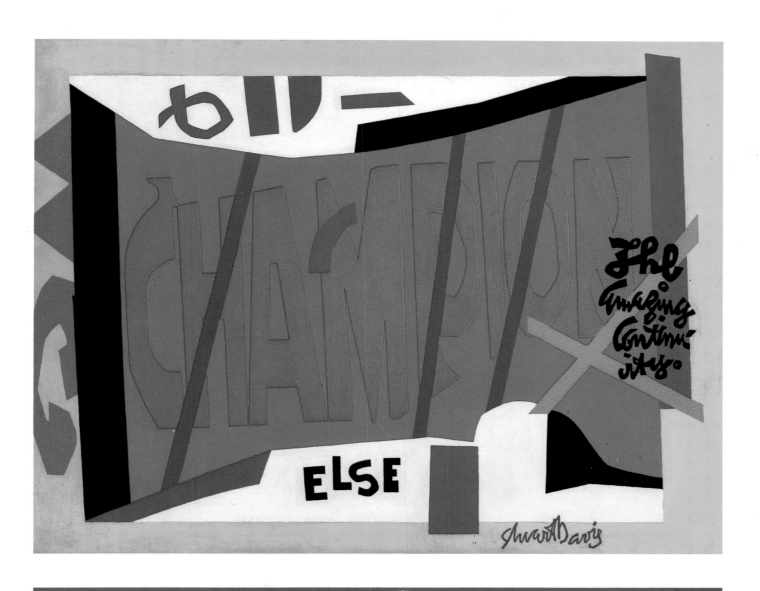

30. *Municipal*, 1961
Oil on canvas, 24 x 30 in.
Private collection

viously, Davis does not fit into this category. His work endures the test of time, outstanding in its own period and noteworthy in any context. Davis's art separates itself from that of his contemporaries because it is more ambitious and because it is often, quite simply, better. It is a benchmark for the art of his time and, unlike that of many of his fellows, it remains remarkably undated.

Even so, Davis's pictures cannot be detached completely from their era or from their place of origin. While they are good enough to transcend mere historical interest, and while they are free of a period look, they are also very much of their time, just as Davis himself was very much of his time. Even though he believed implicitly in good art's ability to declare itself independently, his pictures cannot be detached

28

completely from his life or from what we know of Davis's thinking. His importance is determined not only by what he did, but also by when and where he did it. In fact, Davis's real achievement is comprehensible only if we *do* take into account the context in which he worked. The evolution of Davis's art parallels the development of modernism in America, and his life as an artist, both private and public, is often both an indicator and a reflection of contemporaneous concerns.

Davis left a multiple legacy. In addition to his pictures in all media, his graphics, and his sketchbooks, he left voluminous records of his thinking about art. His writings are a running commentary on the issues most provocative to a forward-thinking artist in the first half of the twentieth century. Through thousands of pages of largely unpublished notes, we can follow the evolution of his ideas.[8] They are often contradictory, sometimes confusing, and frequently obscure, but always absorbing. Davis left us exhaustively worked-out theories of color and composition, meditations on what art can and ought to be, evaluations of artists, discussions of the validity of modern art itself. It is clear from Davis's pictures that he loved the randomness and visual clutter of the city, the speed and unpredictability of modern American urban life. His paintings bear witness, too, to his love of dissonance and spontaneity. It is equally clear from his published writings that he was a witty and articulate man, open and curious about new ideas. He was fascinated by technology, appreciated inventiveness and the unexpected. He loved jazz, hated pomposity and cant. Yet the man who so eagerly embraced the most challenging art of his time, out of what seems to have been pure, instinctive enthusiasm, spent much of his time trying to justify the kind of art he believed in. Why this private compulsion to explain and make rules for his art—often in the most laborious and arcane prose? Notions of time and place, of when and where Davis was formed and worked, can help provide an explanation.

Davis was born at the end of the nineteenth century into a society for which art-making was something associated with Europe, faintly unseemly and probably unmanly. Henry James dramatized this attitude in his novel *The Europeans,* making the difference between Old World and New World perceptions of the artist critical to an understanding of his characters.[9] In the book a young expatriate and his sister return to Boston to ingratiate themselves with their rich American relatives. The young man's charm and frivolousness are taken as evidence of his foreignness and make his steely New England cousins distrust him. Their suspicions are confirmed when they learn that he earns his modest living as a portrait painter; clearly, this is no fit profession for even a distant relation. Davis met with no such familial disap-

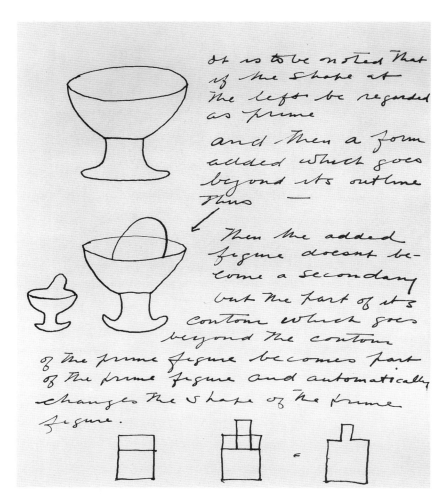

31. *Gloucester Drawing from Notebook No. 10,* c. 1932
Pencil on paper, 8 x 10¼ in.
Earl Davis

32. *Drawing from Notebook No. 8,* c. 1932
Pencil on paper, 9 x 7¾ in.
Earl Davis

proval, but even though he received encouragement in his chosen career at home, he was also aware of the general American climate. Throughout most of his life the great majority of his countrymen simply ignored the existence of any kind of art in the United States or, at best, were more conservative than the most conservative critic or curator. Davis's early espousal of modernism did little to make him more secure. At the beginning of his mature career, in the decade after World War I, the issue concerning much of the American art world was whether or not abstract art *was* art; by the 1930s, when Davis had begun to explore fully his own version of Cubist abstraction, nonfigurative art was deemed perniciously foreign, dangerously un-American, by some of the most respected art experts in the country.

Davis responded to this atmosphere of suspicion and indifference, at least in part, with curmudgeonly self-sufficiency: "The first thing to know about art is that it is none of the public's business. . . . All the public knows and hopes for is the usual and the practical. Art is the direct negation of this attitude and the public is continuously surprised and affronted by a new work of art. Later they accept it as a matter of habit and continue to misunderstand it. Knowledge of this fact is a

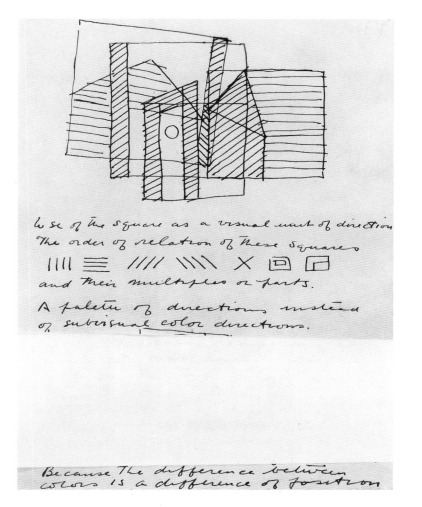

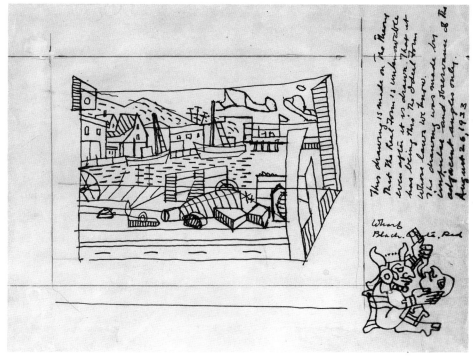

great stimulus to art production. It leaves the artist free to make discoveries and pursue unpractical ideas freely." [10]

Yet Davis spent years justifying to himself what he did. His notebooks are filled with recurring examinations of his intuitive notions of color and structure, with "equations" and diagrams that attempted to codify what he called his theory of color-space logic. In practice, these were simply shorthand ways of documenting his acute awareness of the way colors affect one another and his equally acute desire to make color pry apart his flatly painted planes. In the notebooks these purely visual concerns can seem obsessive, expressed in often murky, pedantic prose. Sometimes Davis attached his empirically determined notions and practices to existing scientific color theories. Long, repetitive passages describe the object known as "Ostwald's color solid"—an elaborate three-dimensional equivalent of the familiar color wheel—as a possible model for plotting the position of colors on a flat canvas in relation to their positions in space. Mercifully, none of this seems to have adversely affected Davis's paintings. His eye and his sense of quality always dominated, so that none of his pictures can be dismissed as mere demonstrations of theory. The most complex

33. *Theory Drawing from Notebook No. 16,* 1933
Ink on paper, 10 x 8 in.
Earl Davis

34. *Drawing from Notebook No. 16,* 1933
Dated August 26, 1933
Pencil on paper, 8 x 10 in.
Earl Davis

theorizing seems to follow things that Davis had already noticed oc-curring in his paintings, rather than the other way around. But the note-book entries suggest that he needed to make things clear to himself, as if to reassure himself and strengthen his convictions, at the same time that he wanted to record the discoveries he made in the course of painting and drawing.

Like any good painter, Davis was always alert to the demands of his pictures as they evolved and responsive to suggestions that arose in the course of working; but at the same time, he abhorred the un-controlled and the accidental. He preferred order and resolution into what he called "a perfect coherence" to even the happiest evidence of chance: "The painting which shows the construction lines, mistakes and successes alike, needs to be cleaned up. This is not in response to a desire for neatness. The fact is that the construction lines are themselves configurations which function like all the others in the pic-ture. They constitute small talk which confuses the issue and must be eliminated." [11]

His solution was to explore possibilities in small-scale studies and "detail studies" of compositions whose linear structures were carefully determined in advance. Variations and permutations were developed in subsequent pictures as he returned again and again to a number of favorite compositions. The original drawn configuration became a theme to be simplified, inverted, embellished, even dissected. Given Davis's love of jazz, it might be accurate to compare him to a first-rate jazz musician with a repertory of familiar tunes. Each one is recogniz-able every time he plays it, but each time it is new, squeezed into dif-ferent harmonies, different rhythms, different licks. The tension between careful planning and spontaneous invention is at the heart of Davis's painting, turning even the most fluid passage of calligraphy into a kind of immutable, stamped-out shape.

This tension comes also from Davis's paradoxical view that the se-rious artist ought to feel deeply and yet detach himself consciously from emotion. His notebooks repeatedly stress the superiority—even the necessity—of channeling the impulse to paint through reasoned deliberation: "Art is Pure Emotion BUT—Emotion made objectively con-crete in the materials of art, not simply strong emotional feelings. Emo-tion, not of the Body, but of the Intellect." [12] Davis believed that art sprang from intense responses to things seen or experienced, but that good art required that this experience be turned into an "objective" image whose formal concerns were, finally, the only thing that mat-tered. He thought, for example, that Picasso's *Guernica* was a wonder-ful picture whose powerful imagery answered the question, "Can ab-

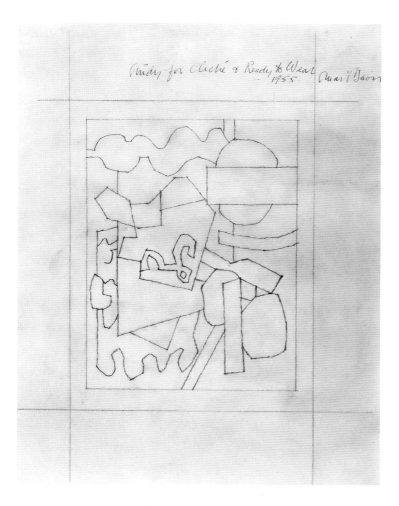

CLOCKWISE FROM TOP LEFT
35. *Study for "Cliché" and "Ready to Wear,"* 1955
Ink on paper, 14 x 11 in.
Earl Davis

36. *Detail Study for "Cliché,"* 1955
Ink on paper, 12¾ x 15 in.
Earl Davis

37. *Study for "Ready to Wear"* 1955
Gouache and pencil on paper, 9¼ x 7⅛ in.
Herbert F. Johnson Museum of Art, Cornell University, Ithaca, New York; Bequest of Helen Kroll Kramer, Dr. and Mrs. Milton Lurie Kramer Collection

PAGE 34
38. *Ready to Wear,* 1955
Oil on canvas, 56¼ x 42 in.
The Art Institute of Chicago; Sigmund K. Kunstadler Fund and Goodman Fund

PAGE 35
39. *Cliché,* 1955
Oil on canvas, 56¼ x 42 in.
Solomon R. Guggenheim Museum, New York

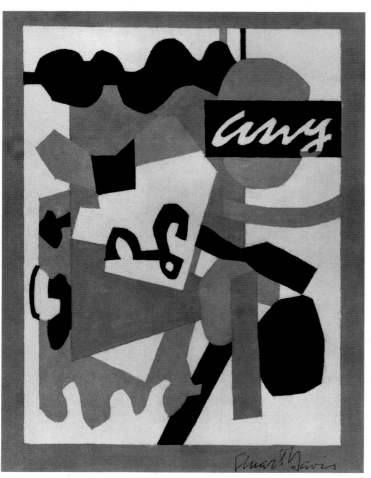

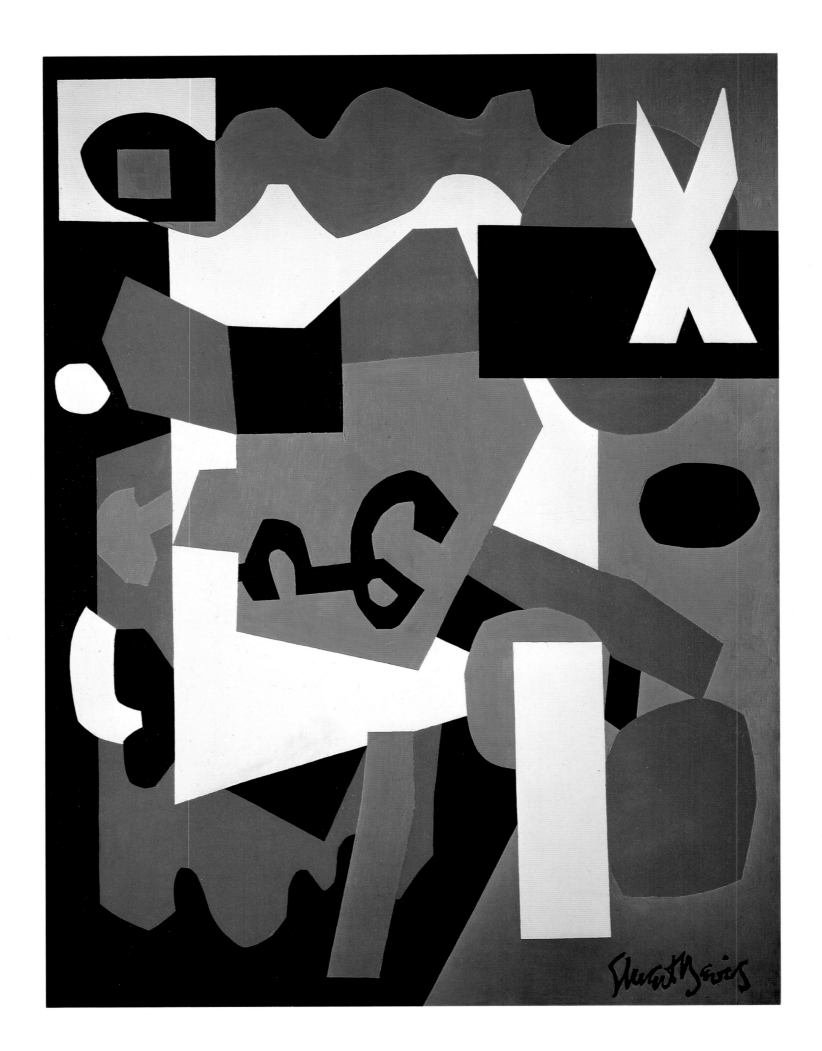

A SELECTION OF DAVIS QUOTATIONS

1923
The real question is not HOW TO PAINT but WHAT TO PAINT.

1934
The only corn-fed art that was successful was the pre-Columbian.

1936
The concept of Ideal Beauty implies the Static, the Complete and the Dead.

1939
Neatness doesn't count in art.

1940
Art is the love of the form of common things.

Art is never information; it is a direct event and experience.

There are two major audiences for Art: the small informed audience and the large misinformed audience.

There's nothing like a good solid ivory tower for the production of art.

A great art requires a great audience of at least one person.

In Art things do not get stronger as they get bigger—they get stronger as they get different from their environment.

The secret of art is order, and order means absence of confusion, and this means relaxation, and "take it easy."

stract art express profound human values?" but, he added, "If you take the Cubism out of *Guernica* there is nothing left." [13]

There is little more fruitless than speculation about an artist's state of mind or his intentions. As Davis put it: "The artist's feelings are his own affair. His paintings are everyone's concern." [14] Yet there is something provocative, even a little perverse, about Davis's desire to conceal himself in his pictures, his wish to dissemble, to overcome emotion. No matter how absorbing their formal construction, his paintings are also so obviously stamped with a particular, unmistakable personality and with particular enthusiasms that Davis's hope for dispassionate detachment seems completely beside the point.

From his published writings and his colleagues' recollections, a portrait emerges of Davis as a gruff, plainspoken "man's man." A caricature of the first session of the American Artists Congress in 1936 depicts a bull-necked Davis, muscular forearms folded across his chest, seated on the platform. Jacob Lawrence and his wife, Gwen, who knew Davis well in the 1940s, describe him as "sardonic" and "witty." [15] (This is quite a different image from the one suggested by his convoluted theoretical writings.) He was good at quotable aphorisms and one-liners, capable of throwaway asides like the single scrawled page in a notebook: "I was a Cubist until somebody threw me a curve." [16] When he spoke in public, he was always direct, to the point, and colloquial. The hip slang of his fellow jazz fans often seems to underlie even the most formal of Davis's public statements. The first impact of his mature art is similarly brash and street smart. His best-known paintings—those after 1950—seem to deal with extremes: full-throttle color, clashing shapes and patterns, loaded surfaces. (Davis once dismissed "the Minor Esthetic" as "concerned primarily with a talent for sensitivity, as achieved with paint textures, brush work, delicate color nuances." [17]) But Davis's tough-guy persona must have been exaggerated. The Lawrences remember him as "soft underneath, a good man." When Lawrence was discharged from the army at the end of World War II and finally met his fellow artists at the Downtown Gallery, where he had shown since 1941 and Davis had shown since 1927, he remembers Davis as being especially welcoming. "He had the reputation of never going north of Fourteenth Street," Lawrence recalls, "but he would often come uptown to Hamilton Terrace where we lived, to look at my paintings and Gwen's."

Just as further acquaintance with Davis revealed a warmth at first concealed by what Gwen Lawrence describes as "an austere exterior," further acquaintance with his paintings reveals complexities of structure and subtleties of color beyond their posterlike presence.

Similarly, the suggestive word games that Davis played with both titles and "messages" on his canvases reveal the tough guy to be playful and urbane. He teased by pairing unreadable squiggles with his signature or with plainly legible phrases such as "the amazing continuity"; he juxtaposed apparently banal words such as *any, complet, else,* or *now* so that they suggest new, unexpected meanings. Sometimes Davis's jazzy, alliterative or rhyming titles—*Rapt at Rappaport's* or *OWH! In San Pao,* for example—seem to exist as all but independent elements, adding aural counterpoint to his visual improvisations. At other times, as in *Package Deal* or *Something on the Eight Ball,* he wrenched familiar phrases into new meanings with the same audacity with which he approached familiar images.

Although no substitute for the pictures, the lifetime's accumulation of writings provides insight into Davis's sophistication and thoughtfulness. Because the documentation is so complete—almost forty years worth of ruminations and monologues—it offers a tantalizing sense of the person who filled these notebooks. For the same reason, what is omitted from the notebooks is as revealing as what is included. Davis lived through two great upheavals in Western thought, one headed by Karl Marx, the other by Sigmund Freud. The spread of Marxist ideas led to irrevocable changes in concepts of class structure and history; the initial success of the Russian Revolution led to widespread questioning of time-honored assumptions about how society worked. The gradual acceptance of Freudian thought had arguably even wider-reaching consequences, leading to equally irreversible revisions of notions about how the human mind worked. Davis was deeply attracted to the first of these revolutions in thinking. He was indifferent to the other.

Davis's writings about his political concerns are almost as comprehensive as his notations on art. Like many thoughtful people of the time, he was actively involved in progressive politics during the 1930s. Much of the political material in the notebooks has to do with his public activities—preparation for the speeches and published statements required for his role as spokesman for politically concerned artists—but there are also private entries, with a surprising amount related to books on political theory. The notebooks indicate that Davis's leftist views were more than the ordinary response to the difficulties of the Depression. It is plain that he read Marx and Lenin and a considerable amount of Marxist philosophy, but there is no indication that he read anything about Freudian thinking or psychoanalytic theory. (Since his library contained books by Freud and some of his colleagues, this is all the more surprising.) It seems remarkable that Davis, whose career was shaped by his curiosity and receptiveness to new ideas, was so

1942
A critic who is on the beam is about as rare as an aeroplane pilot who is not.

The picture is just as real as the subject that inspired it.

1943
Art is not the expression of an interest in life and nature. Such an interest leads to all kinds of activity except art.

1954
Talent is the poor man's substitute for art.

Talent is the poor relative of intelligence.

1955
There is nothing wrong with the leading contemporary American painters that a little talent wouldn't cure.

1956
The new is a Recovery not a Discovery.

ART is ARTificial so quit crapping around about Nature.

conspicuously untouched by the revolution fomented by Freud and his followers. Freud's discovery of the unconscious became an article of faith for modern urban man. Along with Jung's theory of the collective unconscious—the vast, shared repository of racial memory that cuts through time and across cultures—Freud's ideas claimed the imaginations of a majority of artists after World War I. For the Surrealists and later for the Abstract Expressionists, the unconscious was the avowed source of creativity. They regarded it as a storehouse that provided not only their imagery, but their very motivation for making art. Perhaps Davis's age made it difficult for him to embrace these beliefs. Certainly his desire for objectivity, his wish to go beyond "mere" emotion in his art, made him distrust any painting or sculpture that was purported to tap irrational, hidden sources directly. Davis's lack of interest in the interior landscape helps to explain his outright opposition to both Surrealism (except Miró) and Abstract Expressionism. Yet he faulted them on formal grounds as well. He disliked equally what he saw as the anti-modernist illusionism of orthodox Surrealism and the undisciplined formlessness of Abstract Expressionism.

Despite his role as American abstract painter emeritus, Davis became increasingly isolated—aesthetically—toward the end of his life. His infrequent exhibitions were greeted with interest and enthusiasm, but he remained somewhat apart, still pursuing the self-imposed goals that he had pursued for almost half a century. His concerns were, in the end, personal:

> Too much is expected of Art, that it mean all kinds of things and is the solution to questions no one can answer. Art is much simpler than that. Its pretensions more modest. Art is a sign, an insignia to celebrate the faculty for invention.[18]

> I could only keep looking at a manageable hunk of the world and keep trying to twist and shape it my way.[19]

1

THE ASHCAN SCHOOL AND THE ARMORY SHOW

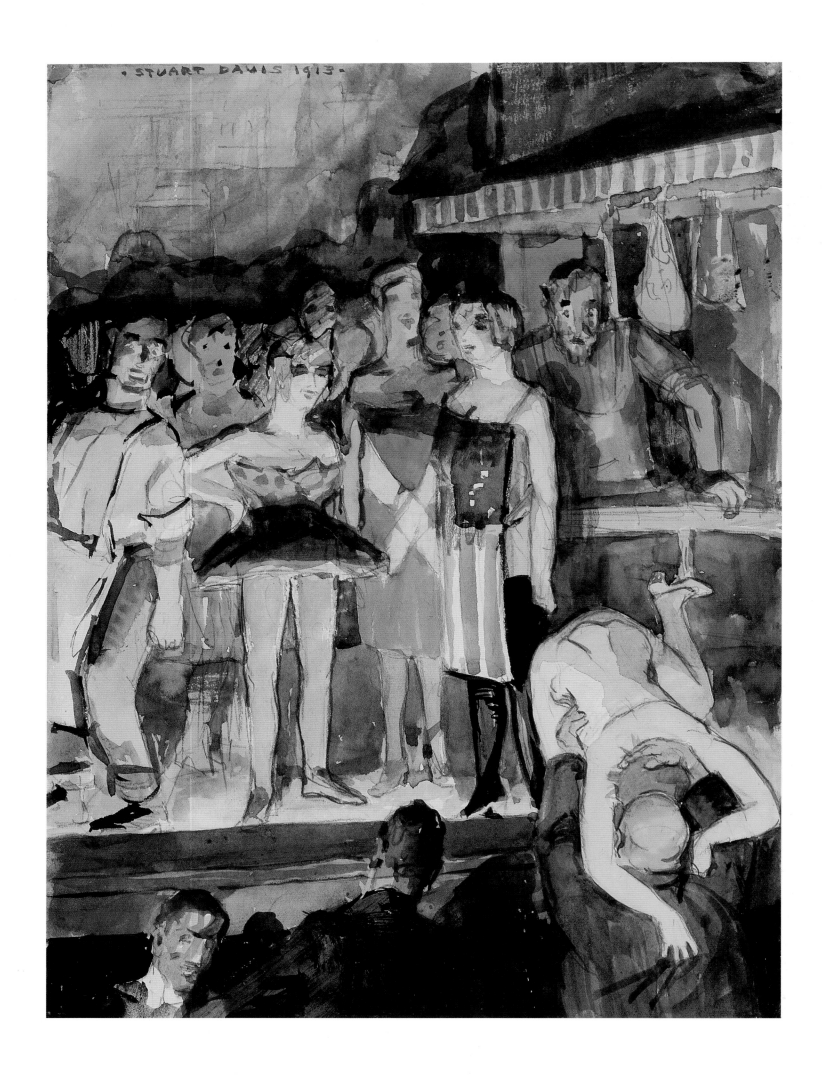

Stuart Davis grew up in an atmosphere in which making art was considered a natural, valuable way of spending time. His parents, Helen Stuart Foulke and Edward Wyatt Davis, had met as students at the Pennsylvania Academy of the Fine Arts, and when Davis was born, on December 6, 1892,[1] his mother was a practicing sculptor and his father the art editor of the *Philadelphia Press.* Edward Davis employed as illustrators such ambitious young local artists as John Sloan, George Luks, William Glackens, and Everett Shinn. They were later to become both notorious and acclaimed as members of the group known as the Eight, but in the 1890s, when they were contributing drawings to the *Philadelphia Press,* they were at the beginning of their careers, supporting themselves with commercial work. Under the guidance of the older painter Robert Henri they had already found their distinctive direction. Like Henri, they deliberately avoided academic conventions and turned in their painting to the subject of their newspaper illustrations: modern urban life. Their fondness for the unglamorous aspects of the city later earned them the nickname "the Ashcan School."

This sounds remarkably like the approach advocated a generation earlier by the champion of the French Impressionists, Charles Baudelaire, when he urged his friend Edouard Manet to paint "modern life," but the result was radically different. For the Impressionists, *how* something was painted was as important as *what* had been painted. For the Ashcan School, the subject matter and the artist's feelings about it took precedence over formal invention. Henri himself had studied in France in the late 1880s, acquiring a traditional beaux-arts training. He remained faithful to the old masters, especially to Velázquez and to Frans Hals, rather than embracing the innovations of his French contemporaries. Henri had some interest in the early "Spanish" Manet, but except for a brief early fling with Impressionism, he was generally unmoved by it. (Surprisingly, he seems to have urged his students to look at Post-Impressionism, even though he didn't like it.) He and his younger colleagues may have defied the pieties of the Academy in their choice of subjects, but their tenements, saloons, and back alleys

40. *Babe La Tour,* 1912
Watercolor and pencil on paper, 14^{15}/$_{16}$ x 11^{1}/$_{16}$ in.
National Museum of American Art, Smithsonian Institution, Washington, D.C.; Gift of Henry M. Ploch

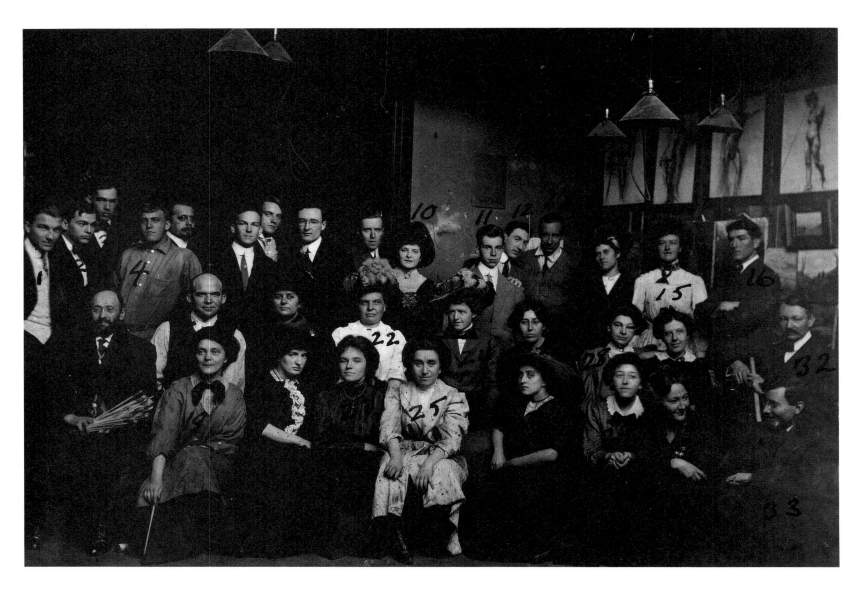

41. Robert Henri School
of Art, 1909. Stuart Davis is
number 11.

were rendered with the dramatic dark-and-light contrasts, the vigorous strokes, and the bravura drawing of traditional painterly illusionism. Stuart Davis's father obviously admired both the work and the ideas of the Henri circle, since its members were not only professional colleagues but friends. The connection endured even after the Davises moved to East Orange, New Jersey, in 1901, when Edward Davis began to work for the *Newark Evening News.* (The family later moved to Newark.)

Stuart Davis's early interest in drawing and painting was encouraged. His father is said to have accompanied the stories he told his first-born son with illustrations, and as Stuart grew older he was expected to do the same for his younger brother, Wyatt. Davis's wish to make a career of art was applauded by his family, and in the fall of 1909, when Davis was sixteen, he left high school, apparently with complete parental approval, to study art full time. Years later, in 1945, he wrote: "It is not unusual for artists to dwell on the obstacles they have had to overcome before gaining opportunity to study. But I am de-

prived of this satisfaction because I had none."[2] Davis's family continued their encouragement and support; Davis sometimes lived with his family during his early years (which he may have found more convenient after they moved from New Jersey to the Chelsea district of Manhattan), but even when he was living on his own, as a struggling young artist and illustrator, his parents seem to have provided some financial help. When Davis was permitted to leave high school, he enrolled at the Robert Henri School of Art, recently opened in New York by the Philadelphia artist. The esteem accorded Henri by the Davis family's artist friends (who had followed him from Philadelphia to New York) must have had something to do with this choice, although Davis's father had strongly recommended that his son study at the National Academy of Design. Since Edward and Helen Davis had received conservative art educations at the Pennsylvania Academy, known for its realist tradition, they may have feared that the progressive Henri School would not provide adequate fundamentals.

Davis's parents need not have worried. He spent more than three

42. *Gas House near East Orange*, 1909
Pencil on paper, 8 x 12 in.
Earl Davis

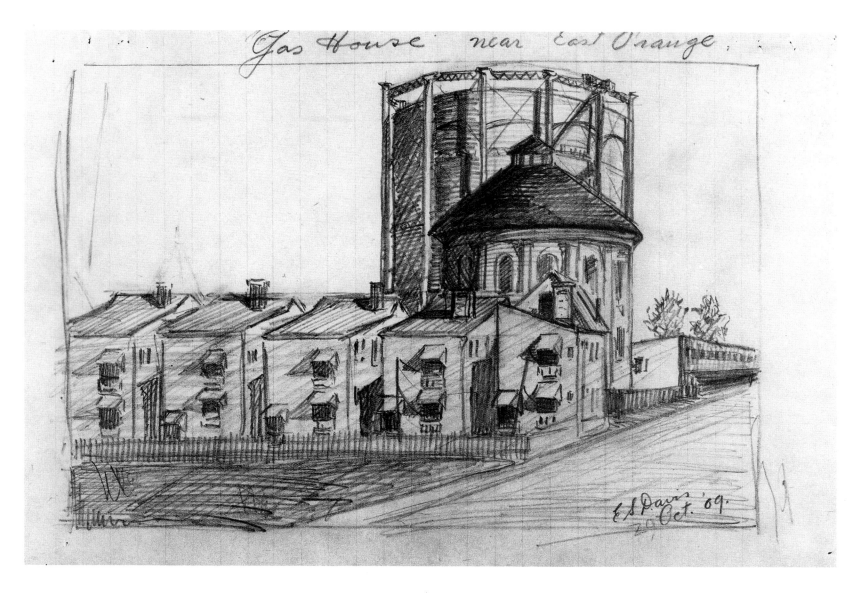

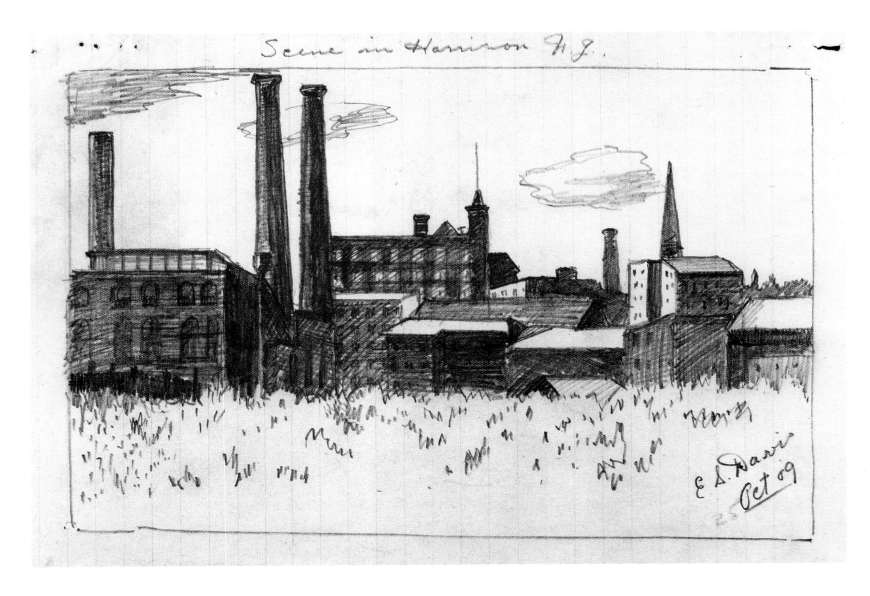

Scene in Harrison N.J.

E.S.Davis
Oct 09

43. *Scene in Harrison, NJ*, 1909
Pencil on paper, 8 x 12 in.
Earl Davis

years at Henri's school and always warmly credited the training he had received there as an important foundation for his later work. He described the program:

> The Henri School was regarded as radical and revolutionary in its methods, and it was. All the usual art school routine was repudiated. Individuality of expression was the keynote, and Henri's broad point of view in his criticisms was very effective in evoking it. Art was not a matter of rules and techniques, or the search for an ideal of beauty. It was an expression of ideas and emotions about the life of the time. We drew and painted from the nude model. The idea was to avoid mere factual statement and find ways to get down some of the qualities of memory and imagination involved in the perception of it. We were encouraged to make sketches of everyday life in the streets, the theater, the restaurant, and everywhere else. These were transformed into paintings in the school studios.[3]

The attitudes and, to a great extent, the approach learned at Henri's school remained with Davis for the rest of his life. No matter how seemingly detached from recognizable reality, Davis's pictures always have at their core the "expression of ideas and emotions about the life of the time." His earliest paintings and drawings are a record of his enthusiastic discovery of his city, as he and his fellow students Glenn Coleman and Henry Glintenkamp prowled back alleys, burlesque theaters, Harlem saloons, Chinatown, the Bowery, and Hoboken music halls (plates 44, 45). Ostensibly, they were in search of subjects recommended by Henri, although Davis was also indulging a newly discovered love of ragtime and jazz. There is more than a suggestion of a very young man's delight in exotica and the low life in the pictures he

44. *The Music Hall,* 1910
Oil on canvas, 26 x 32 in.
Earl Davis

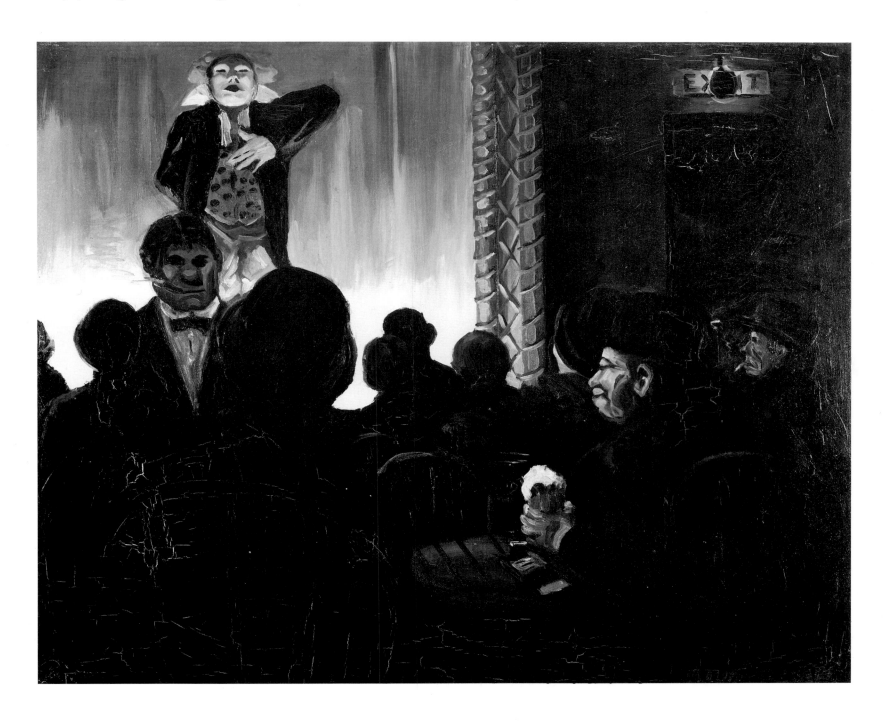

45

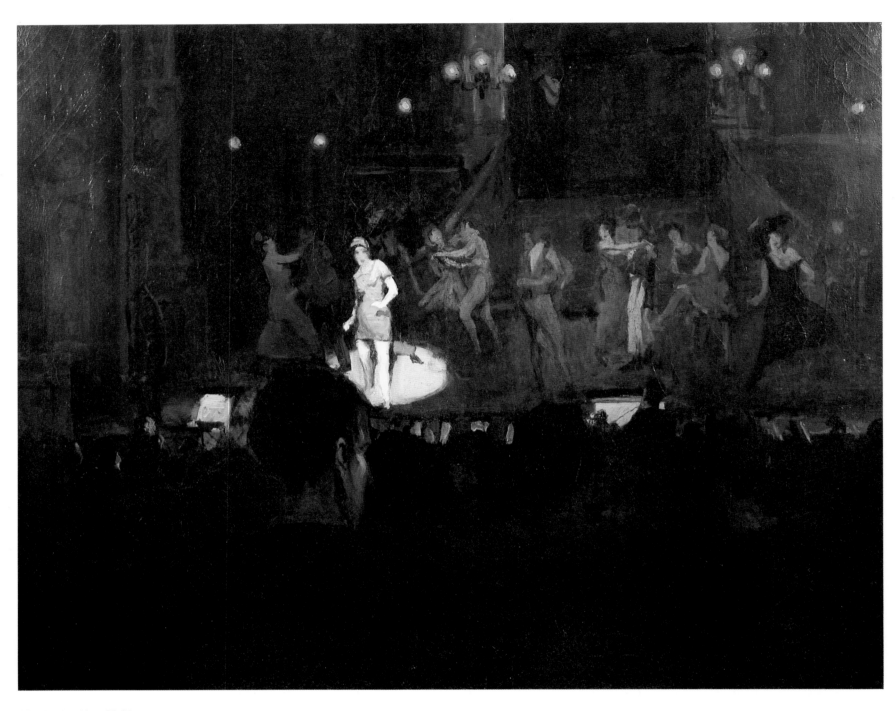

45. *Babette*, 1912
Oil on canvas, 30 x 37⅞ in.
Earl Davis

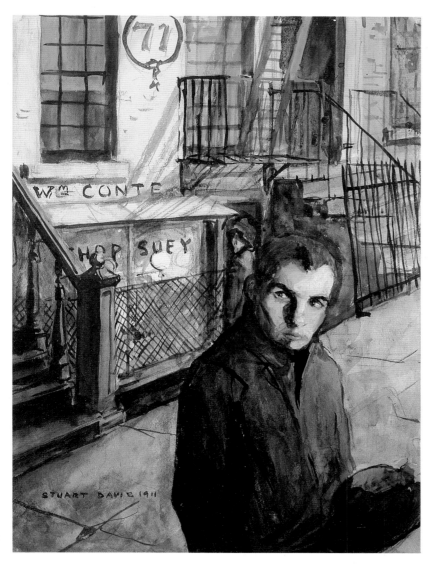

46. *Portrait of a Man*, 1911
Watercolor on paper,
15 x 11 in.
The William H. Lane Collection

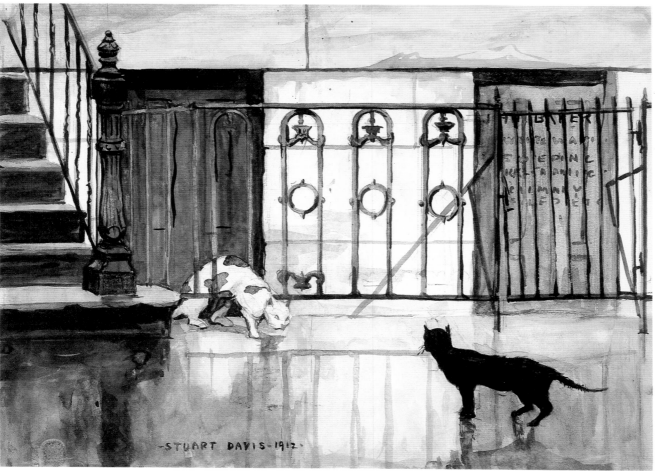

47. *Two Cats*, 1912
Watercolor on paper,
10⅞ x 14¾ in.
Philadelphia Museum of Art;
Given anonymously

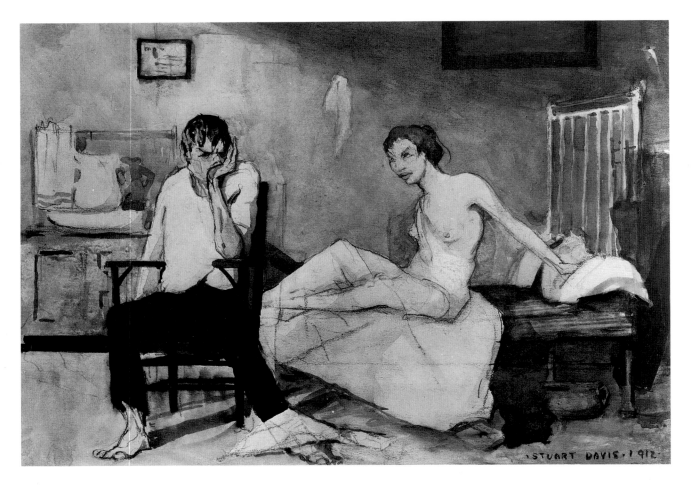

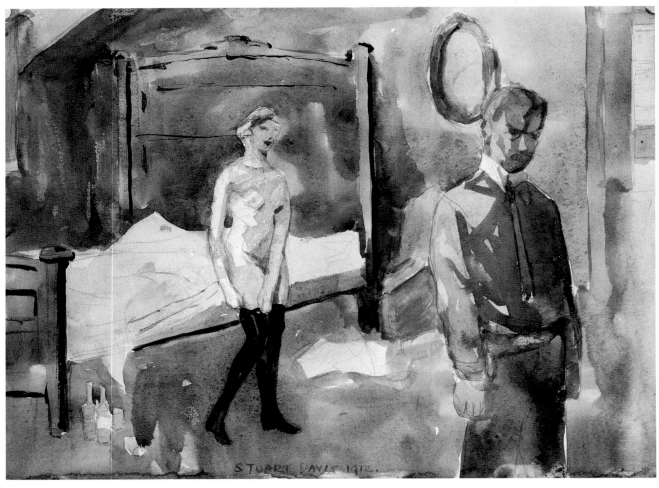

derived from these expeditions. Davis was never again as specific as he was in these early images of New York's seamier side, but even his last pared-down paintings, made more than half a century after he left Henri's tutelage, are still about the cacophony of the city, its flash and counterpoint, filtered through memory and personality.

Davis and John Sloan apparently became good friends while they were at the Henri School, despite the difference in their ages (Sloan was almost twenty years older). Like the other Philadelphia-trained members of the Eight, Sloan had come to New York soon after the Davises had moved to New Jersey, to concentrate on serious painting, in close association with Henri. Davis's few surviving works from his years at the Henri School suggest that he admired Sloan more than any other member of the group. Davis seems never to have aspired to the dazzling brushwork or the dramatic flickering light of Henri or Luks. Instead, his sober watercolors and canvases, whether of theatrically lit interiors or sunny back streets, echo the broad brushstrokes and workmanlike, generalized forms of Sloan's pictures of the period. Sloan may have guided, or at least reinforced, Davis's perception of the city as a visual collage. Pictures like Sloan's well-known *Hairdresser's Window* (plate 50), 1907, oddly anticipate some of Davis's later compositions. The figures seen in the window are framed by the wall of a building plastered with signs, creating a remarkably modern play of interlocking rectangles and establishing considerable tension between the flat lettering and the glimpsed space of the hairdresser's room. It is probable that Davis knew *Hairdresser's Window,* given his growing friendship with Sloan so soon after the picture was painted. Its vividly juxtaposed imagery is typical of Sloan's work of the period, and Davis must have found his friend's vision very sympathetic.

In 1912 Davis left Henri's school to share a studio in Hoboken with Henry Glintenkamp. (Another former classmate, Glenn Coleman, joined them when they moved to Manhattan a year later.) Davis and Sloan became even closer from this time on, and both Sloan and his wife, Dolly, seem to have been significant influences on the young man. The Sloans' deep involvement in progressive politics was apparently as attractive to Davis as John Sloan's art. In the fall of 1912 Sloan was able to consolidate his aesthetic and political interests by helping to revive the *Masses,* "A Monthly Magazine Devoted to the Interests of the Working People." [4] He helped to recruit Max Eastman as editor, and almost until the *Masses* ceased publication in 1917, Sloan acted as a kind of art editor ex officio, playing an important role in shaping the magazine's policies. He designed its layout and contributed illustrations; he also attracted a group of energetic young artists to provide draw-

48. *The Front Page (The Musician),* 1912
Watercolor, gouache, and graphite on paper, 11 x 15 in.
Collection, The Museum of Modern Art, New York; Purchase

49. *The Doctor (Interior),* 1912
Watercolor on paper, 11 x 15 in.
Elvehjem Museum of Art, University of Wisconsin, Madison; Gift of D. Frederick Baker, from the Baker Pisano Collection

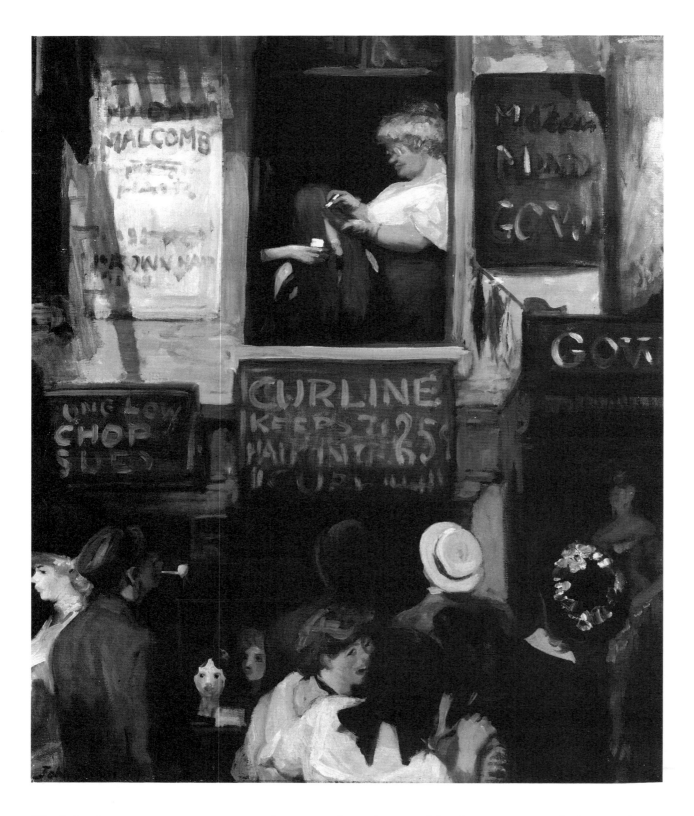

50. John Sloan
Hairdresser's Window, 1907
Oil on canvas, 31⅞ x 26 in.
Wadsworth Atheneum, Hartford,
Connecticut; Ella Gallup
Sumner and Mary Catlin
Sumner Collection

ings and cartoons. Most were associates or former pupils of Henri's, like himself. Among the first were Davis, Coleman, and Glintenkamp.

The most desirable thing about having work published in the *Masses* was the unusual degree of artistic control given to writers and illustrators. In most magazines the editors dictated precisely what they wanted, but the *Masses* treated its contributors with generosity and respect, in an effort to attract the best current writing, the best illustrations. (It has often been pointed out that while the magazine was

produced *for* the masses, it was certainly not produced *by* them.) Unfortunately, the magazine's finances were always precarious. Run as a sort of cooperative, it depended a great deal on the willingness of its contributors to donate their services. This they were apparently pleased to do, because of their enthusiasm for the magazine's political and artistic policies. Davis was a fairly frequent contributor, supplying covers and illustrations until 1916, when he and many other artists resigned to protest the addition of captions to their pictures (plates 51, 52). He also furnished cartoons for *Harper's Weekly,* presumably a more lucrative enterprise.

There was little difference between Davis's commercial and noncommercial work in these early years. Whether he was making drawings intended as illustrations or paintings intended as art, he explored the same subjects using the same forthright, naturalistic drawing and broad handling that he had learned from Henri and Sloan. It seems plain in most of these paintings that Davis was as yet unaffected by any of the radical developments that had changed the course of European art during his lifetime, but it is difficult to know just how much he knew about modernism at the time. His "official" recollections al-

51. *Barrel House—Newark* (drawing for *the Masses*), 1913
Ink and crayon on paper, 24¾ x 21¼ in.
Earl Davis

52. *"Gee, Mag."* (cover for *the Masses*), 1913
Brush, ink, and crayon on paper, 20 x 16 in.
Earl Davis

ways stress the revelation of the Armory Show, yet he often boasted that he had owned a book of Henri de Toulouse-Lautrec's work as early as 1912, at a time when few Americans, he said, had heard of him. It is conceivable that Davis's interest was due chiefly to Lautrec's choice of subjects—cabarets, dance halls, the Parisian demimonde—since Lautrec was an eminently traditional, if incisive, draftsman. Then, too, Davis's friendship with Sloan, an informed observer and collector, may have made him more knowledgeable than he liked to admit.

53. *Two Night People,* 1913
Watercolor on paper,
15 x 11 in.
Earl Davis

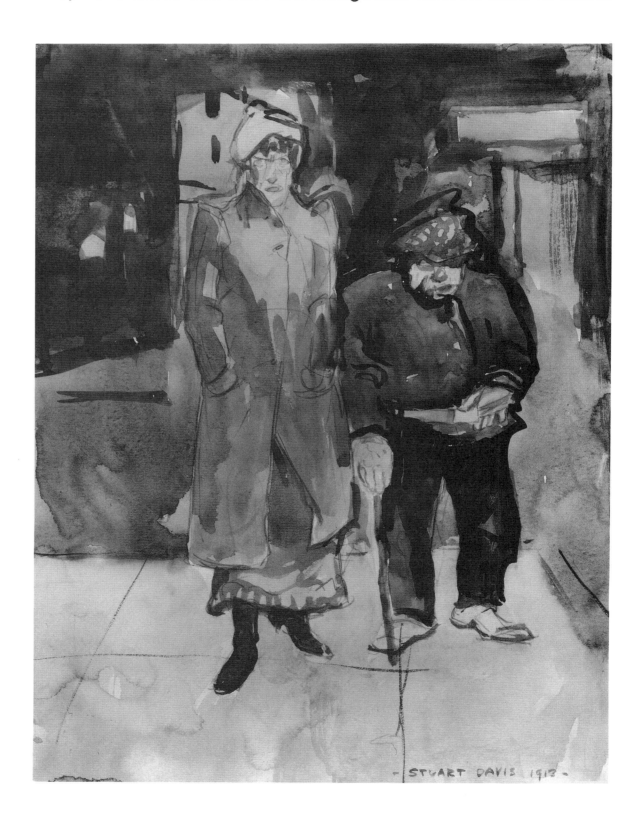

Sloan certainly was familiar with Honoré Daumier's work, for example, and it seems likely that Davis was as well.

Even if he later overstated the degree of his ignorance, it is not surprising that Davis was largely unaware of advanced European art. Alfred Stieglitz's Little Galleries of the Photo-Secession (later known as 291), which had opened in 1905, was one of the few places where New Yorkers could see exhibitions of vanguard painting and sculpture by Europeans and American expatriates. The distance between Stieglitz's circle and the Henri group was considerable. It could be described as the opposition of a misunderstood, unappreciated band of truly avant-garde artists and a group of successful, fundamentally traditional painters who nonetheless prided themselves on their open-mindedness. When Sloan and his colleagues organized the large *Exhibition of Independent Artists* in the spring of 1910, it was touted as a comprehensive survey of new American art, but some of the most adventurous and inventive Americans were missing. Neither Marsden Hartley nor John Marin nor Max Weber nor Alfred Maurer nor Arthur Dove—all associated in some way with Stieglitz—was represented. But the seventeen-year-old Stuart Davis, still a student at Henri's school, was included—doubtless because of his connection with Sloan. It was the first time that he exhibited.

It is worth noting that the next *Exhibition of Independent Artists,* organized the following year, included many of the artists who were not in the 1910 exhibition and excluded many who were. The change had been effected by requiring anyone submitting to the Independents' exhibition to pledge that he would not exhibit at the conservative National Academy of Design. For various reasons, including a dislike of restrictions of any kind, many of the antiacademic Henri group absented themselves from the 1911 exhibition, but Sloan was one of twenty-five artists entrusted with planning an even larger exhibition for 1912. Nothing came of the project until someone proposed that the show be international, a major survey of new European as well as American art. The result was the great artist-organized *International Exhibition of Modern Art*—the 1913 Armory Show.

The importance of the Armory Show cannot be overestimated. It was the largest, most comprehensive cross-section of modernist art yet seen in the United States. Almost sixteen hundred paintings, drawings, sculptures, and prints traced the evolution of the new European art from Romanticism to Cubism. The show was strongest in French painting: the Impressionists, Post-Impressionists, Fauves, and Cubists were particularly well represented, the German Expressionists less so, and the Futurists not at all. Even for someone who had been living in Eu-

rope throughout the turbulent development of modernism, the show would have offered an unprecedented range and quantity of major radical art. For most of the American visitors to the Sixty-ninth Regiment Armory and to the show's later venues in Boston and Chicago, it provided a first encounter with the European avant-garde. Marcel Duchamp's *Nude Descending a Staircase* provoked the most controversy, but there were also important works by Constantin Brancusi, Georges Braque, Paul Cézanne, Wassily Kandinsky, Aristide Maillol, Henri Matisse, Pablo Picasso, and Vincent van Gogh, among many others, set in a context of paintings and drawings by Jean-Baptiste-Camille Corot, Gustave Courbet, Jean-Auguste-Dominique Ingres, and Eugène Delacroix. The large American section—over half the exhibition—included five watercolors by Stuart Davis.

Davis had not been among the original group of artists invited to participate, even though the American works were selected by William Glackens, one of the original Eight. Initially, the show had been limited to invited artists from Europe and the United States; the European section was selected first, by a small traveling committee of American painters, guided by expatriates such as Alfred Maurer. As the show developed and rumors of its ambition and its contents circulated through the tiny New York art world, it aroused so much interest that many artists who had not been invited lobbied the organizers to allow unsolicited entries for consideration for the American section. Davis and Coleman were among a small group whose work passed the scrutiny of the Domestic Committee, as the hastily assembled jury was called.

Davis's five watercolors were, like all of his pictures at the time, vigorous, energetic, and fairly unremarkable. They ranged from crowded music hall and burlesque scenes, such as *Babe La Tour* (plate 40) and *The Musicians* of 1912, to the firmly structured, sunlit *Servant Girls* of 1913. Davis's drawing is relaxed and simplified, especially in the theatrical watercolors, and his use of color relatively spontaneous and nonspecific. In the context of the other American works on view, these sturdy, intense little paintings must have looked quite daring. Only a handful of the American entries could have been called modernist; Marin, Hartley, Maurer, Maurice Prendergast, Charles Sheeler, and Morton Schamberg were exceptions in a generally conservative selection. The real surprise of the American section was the emphasis awarded to Albert Pinkham Ryder. But in the context of the European section of the Armory Show, Davis's watercolors could only have seemed cautious and wedded to tradition, and that is how they came to appear to the young painter himself.

Davis always claimed that the Armory Show was the turning point in his life as an artist. As he put it: "Here indeed was verification of the anti-Academy position of the Henri School, with developments in un-dreamed of directions. Its challenge to all accepted standards caused a reaction among artists and students that was either violently pro or con."[5] Davis was violently pro. "I was enormously excited by the show, and . . . sensed an objective order in these works which I felt was lack-ing in my own. It gave me the same kind of excitement I got from the numerical precisions of the Negro piano players in the Negro saloons, and I resolved that I would quite definitely have to become a 'Modern' artist."[6]

Davis spent most of the next decade turning this resolution into re-ality. His work of the years following the Armory Show bears witness to his effort to meet the challenge of the European modernists, to dis-cover new ways of making pictures and new ways of thinking about art. In many of Davis's paintings from the experimental years—until about 1919—it is easy to identify the Europeans he was trying to emu-late. He recalled later that he had "responded particularly to Gauguin, Van Gogh and Matisse,"[7] all of whom were well represented in the 1913 exhibition. He explained his enthusiasm by saying that "broad generalization of form and the non-imitative use of color were already practices within my experience. . . ."[8] The works in the Armory Show gave Davis license to exaggerate those practices and, in doing so, to abandon the comfortable style of the Ashcan School. He did continue to use his Henri-derived style in his illustrations, so for the first time there was a noticeable break between Davis's commercial work and the pictures he made to please himself.

Davis's first real liberation seems to have come when he left New York to spend his summers painting by the sea, in Massachusetts. In the summers of 1913 and '14 he went to Provincetown, which was still a fish-ing town just beginning to become a bohemian retreat for artists and writers. Davis planned to spend his time in relative isolation, painting and rowing on the sea, in order to concentrate on the wealth of new possibilities that the Armory Show had thrust at him. The bright ocean-side light of the Cape helped him to make some of his pictures freer and more intense. "On clear days, the air and water had a brilliance greater than I had ever seen and while this tended to destroy local color, it stimulated a desire to invent high-intensity color intervals."[9] That Davis did not come immediately to these aspirations is demon-strated by two distinctly odd early Provincetown pictures, *Ebb Tide—Provincetown* and *Graveyard on the Dunes—Provincetown* (plates 54, 5). Their brownish palette and dramatic lighting seem atypically north-

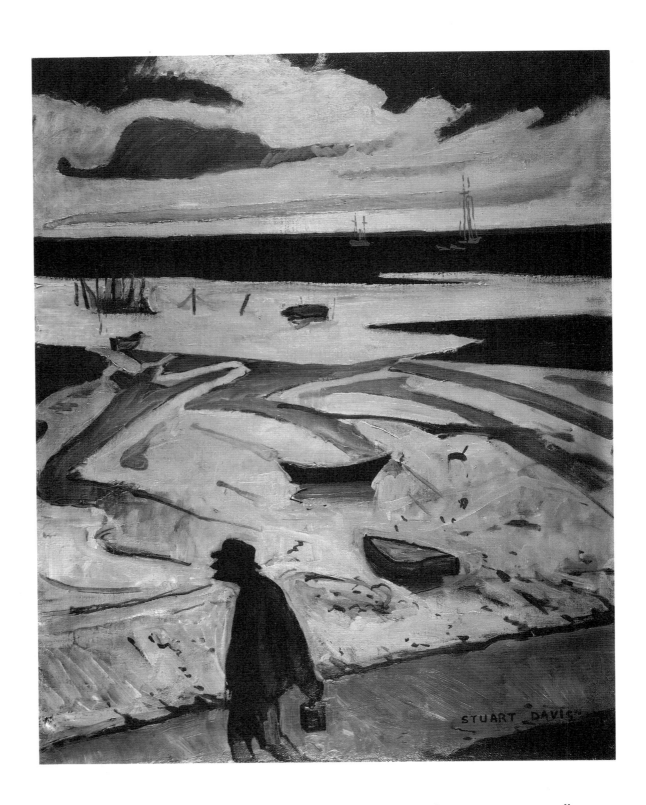

54. *Ebb Tide—Provincetown,*
1913
Oil on canvas, 38 x 30 in.
Earl Davis

ern and expressionist, yet the pictures also evoke sources as diverse as Albert Pinkham Ryder's moonlight paintings and N. C. Wyeth's illustrations, both known to Davis.[10]

Davis met many among the small colony of artists and writers in Provincetown—most importantly the painter Charles Demuth, who, as part of the Stieglitz inner circle, was thoroughly familiar with the modernist ideas that Davis was struggling with for the first time. Demuth was already experimenting with Cubist notions of space that Davis would not investigate for some years. Davis remembered Demuth with grati-

tude: "His superior knowledge of what it was all about was a great help to me." [11]

Davis spent the following summer (of 1915) in Gloucester. He always said that he made the trip because Sloan "raved" about the place; before long, Davis's entire family was spending summers there. The Sloans and the Davises shared a house for a while, but by the 1920s Davis's father owned a house on Mt. Pleasant Street, where his son kept a studio. Davis and Sloan remained close in spite of the changes in Davis's aesthetic. There is even evidence that Sloan was not indifferent to the new ideas that fascinated his younger colleague. The rhythmic strokes and vibrant color of some of Sloan's paintings of 1914,

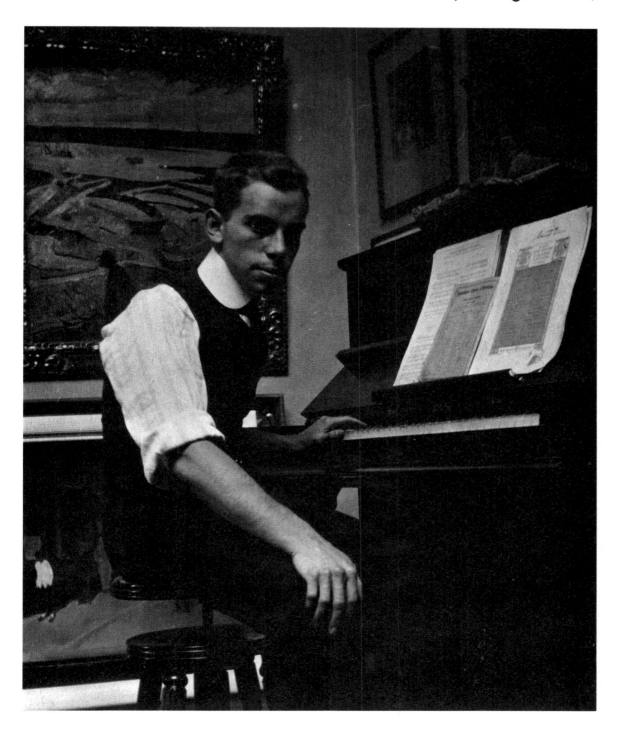

55. Stuart Davis at the piano

for example, suggest that the Armory Show had affected him as well. Davis liked Gloucester even more than he had Provincetown and returned there almost every summer until 1934. He was typically ironic and, at the same time, typically serious about his recollections of Gloucester: "It had the brilliant light of Provincetown, but with the important additions of topographic severity and the architectural beauties of the Gloucester schooner. The schooner is a very necessary element in coherent thinking about art. I do not refer to its own beauty of form but to the fact that its masts define the empty sky expanse. . . . They make it possible for the novice landscape painter to evade the dangers of taking off into the void as soon as his eye hits the horizon." [12]

In spite of having been painting seriously since his teens, Davis was, in fact, a novice landscape painter. Under Henri's guidance he had drawn and painted the life of the city, its crowded streets and packed public places. Henri had stressed self-expression, but not at the expense of the particular, and Davis, in his magazine illustrations and his noncommercial art alike, had emphasized details of place, costume, facial expression, and gesture, as if to locate his images in a specific context. Out of New York, Davis uncharacteristically began to concentrate on the big relationships of land, sea, and sky. He no longer focused on the small details of particular places but sought more universal "objective" relationships. It was a new way of thinking about art for him, divorced from the restrictions of illustration and anecdote, and in a sense it was contrary to his nature. Throughout his life, wherever he was, Davis delighted in the rich variety of his surroundings; his notebooks are full of lovingly rendered, eccentric details. But in the first years of his wholesale adoption of modernism, he seems to have set aside his native enthusiasms, at least for the moment, to concentrate on basic issues of color, surface, shape, drawing, and structure. It is as though Davis had put himself back in school, to learn the fundamentals of a new discipline.

Many of his Gloucester pictures of 1915 (plate 56) are constructed of landscape elements pared down to essentials: flat, clearly bounded silhouettes, thickly stroked and brightly colored. Davis's interest in Gauguin and Matisse is plain in the spareness of his compositions and their unbroken expanses of color; his fondness for van Gogh is evident in their robust surfaces and saturated palette. The economy of these images may also owe something to the Japanese prints that Davis seems to have been studying at about this time, perhaps in imitation of the Post-Impressionist painters he had come to admire. Despite Davis's changed aspirations, it is clear that the foundation provided by Henri had stood him in good stead. His subject matter was less literary

and his approach less literal, but Davis had not retreated from the "expression of ideas and emotions" advocated by his first teacher. Davis's first modernist paintings are not dry exercises, but juicy, deeply felt pictures. Intense color and vigorous paint handling become abstract substitutes for the anecdotal dramas of his Ashcan School paintings.

In a year, by 1916, Davis had developed a new, more simplified idiom, his own version of Post-Impressionism merged with a slightly tentative Fauvism. Gauguin, van Gogh, and Matisse were often still his primary influences, but if the clear structure and saturated color of Post-Impressionism and Fauvism attracted Davis first, he soon began to explore a wider range of possibilities, as his confidence in becoming a modern artist increased. Between 1916 and 1919 the adventurousness

56. *Hillside near Gloucester,*
1915–16
Oil on canvas, 18¾ x 22½ in.
Abraham Shuman Fund;
Museum of Fine Arts, Boston

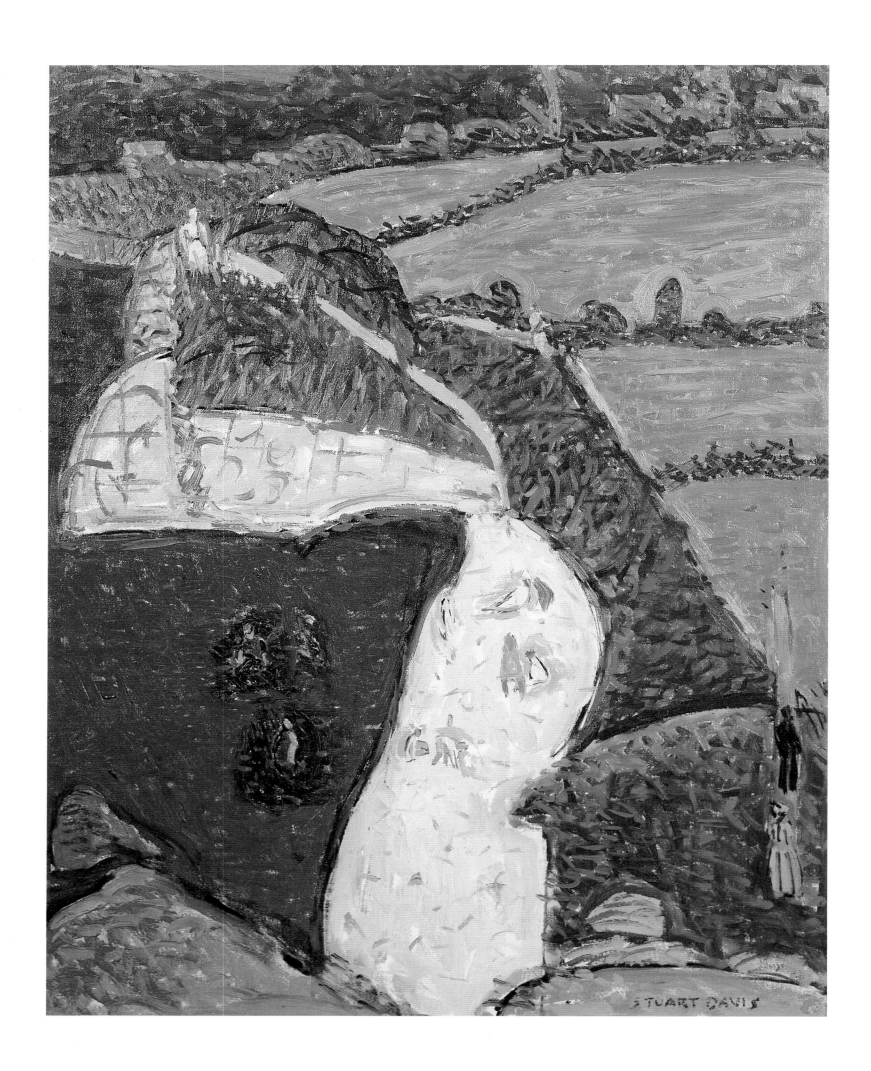

and variety of Davis's pictures is so great that as a group they can be confusing. During these experimental years (as indeed, throughout much of his life) Davis had no single approach to making a picture. There are wild swings in direction, apparent feints, and dead ends. He seems to have been intuitively, if rather randomly, working his way through modernism's main ideas about color and structure, more or less recapitulating many of its most important innovations.

The variations in his work are so great that it seems Davis could have developed into an entirely different kind of painter had he pursued the implications of some of these early efforts. The superb *Rockport Beach* (plate 57), 1916, with its bold, sinuous shapes and rich, muted color, evokes Gauguin and, oddly, Pierre Bonnard. The picture may also be a response to the work of the expatriate Canadian modernist James Wilson Morrice, a friend of Matisse's as well as of Henri's and Sloan's. His paintings are characterized by generously scaled flat shapes formed, like those of *Rockport Beach*, by rhythmic strokes of close-valued colors. Sloan, who greatly admired Morrice's landscapes, is supposed to have owned one, so it is likely that Davis knew his work.[13] Whatever its influences, *Rockport Beach* is one of Davis's finest pictures of the period, but one without close relatives or recognizable descendants in his own work. (Milton Avery's paintings are more obvious fulfillments of the promise of *Rockport Beach* than anything by Davis.) An equally fine, if modest, canvas of 1917, *Studio Interior* (plate 59), explores quite different territory. The setting may be the studio that Davis shared with Coleman and Glintenkamp in the Lincoln Arcade, but the painting is a direct homage to Matisse. Matisse's *Red Studio* (plate 58), 1911, was one of the most memorable pictures in the Armory Show, and Davis's little painting reveals how deeply it had impressed him. Like *The Red Studio, Studio Interior* is essentially a monochrome, its allover warm ochers and oranges punctuated by warmer red drawing and occasional notes of contrasting colors that describe the room's furnishings. Given Davis's love of music, it is not surprising that the room is dominated by a tall purple record-player cabinet, a kind of equivalent for Matisse's tall-case clock. The sketchy red circle of a record jacket at the base of the machine is perhaps a reversed echo of the face of the clock, while Davis's wicker armchair seems like a memory of the cagelike chair drawn in white in Matisse's painting. Its placement and shape parody the curling vine in *The Red Studio.*

Even in this early, admittedly derivative work, Davis had begun to declare himself. He no longer restricted himself to large, elemental relationships but tried to fuse his love of the particular with his desire for

57. *Rockport Beach,* 1916
Oil on canvas, 30 x 24 in.
Earl Davis

61

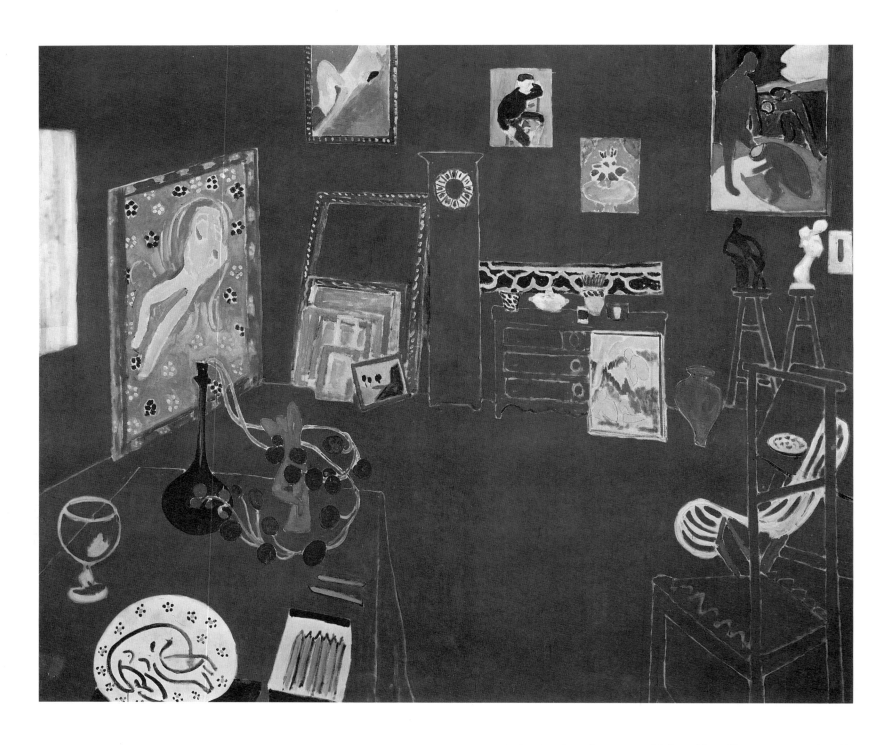

58. Henri Matisse
The Red Studio, 1911
Oil on canvas, 71¼ x 86¼ in.
Collection, The Museum of
Modern Art, New York; Mrs. Simon
Guggenheim Fund

"objective order." In *Studio Interior* he focused his attention on such diverse elements as the clutter of the painting table and the desk, the unexpected likeness between the wooden chair and the easel, the view out the window. Matisse, too, had absorbed an extraordinary assortment of objects into the terse formal unity of *Red Studio,* but these objects were treated as complex, disembodied drawn shapes. Davis presented the furnishings of his studio as relatively solid geometric blocks of color.

Similar blocks of color are the bases of Davis's first experiments with Cubist space, a series of Gloucester townscapes of 1916. Buildings are generalized as broad color patches in paintings such as *Gloucester*

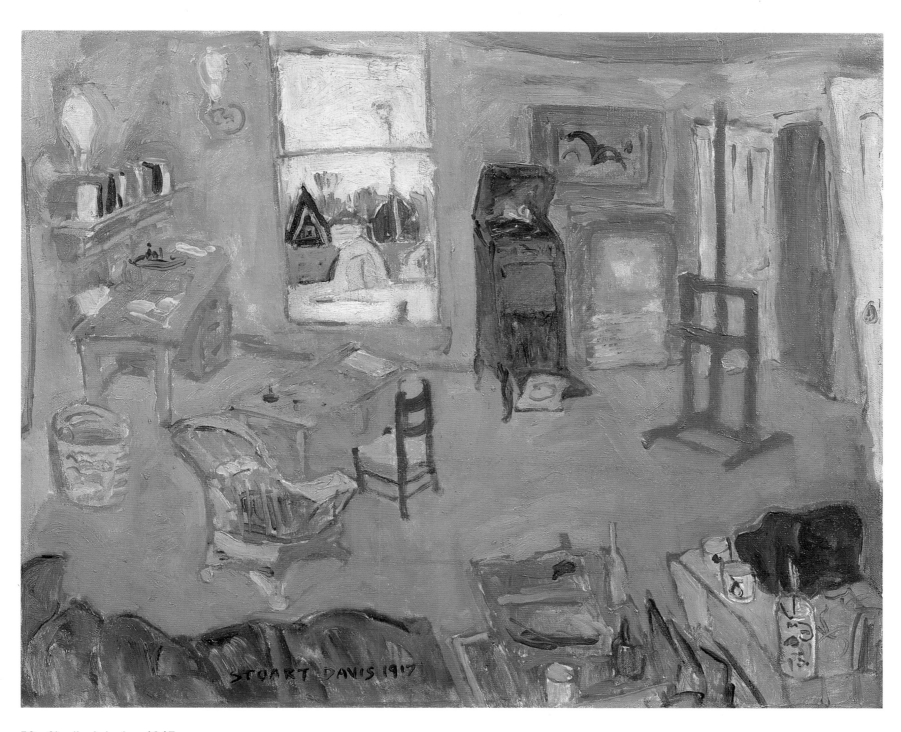

59. *Studio Interior*, 1917
Oil on canvas, 18¾ x 23 in.
Washburn Gallery, New York

60. *Gloucester Street,* 1916
Oil on canvas, 24 x 30 in.
The William H. Lane Collection

61. *Giles Char,* 1916
Oil on canvas, 24 x 30 in.
Earl Davis

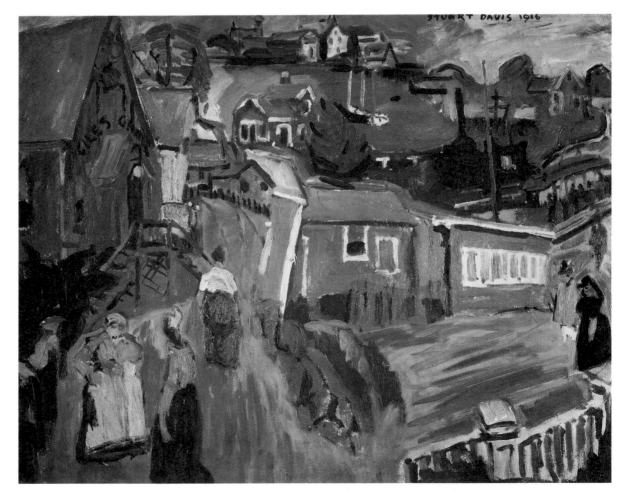

Street and *Gloucester Terraces* (plates 60, 62), among many others in the series. Perspective begins to tilt, while individual sections of the images declare themselves as discrete spatial units, visually but not necessarily logically related to the rest. *Giles Char* (plate 61) is probably the most successful of these "multiple-view" pictures, but like the others it depends largely on Davis's orchestration of hot, saturated color for its unity. There is ample precedent to be found in Davis's commercial illustrations, which often brought together a great many vignettes on a single page—spatially disconnected images linked by a common

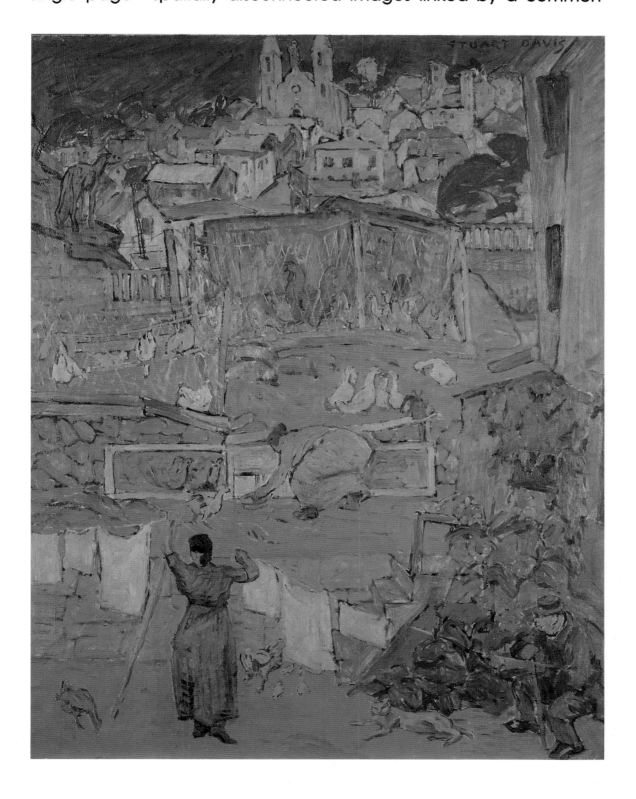

62. *Gloucester Terraces,* 1916
Oil on canvas, 37½ x 29½ in.
Earl Davis

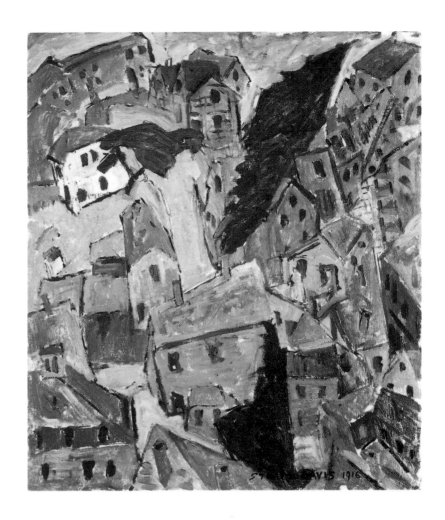

63. *Untitled (Town Shapes),*
c. 1916
Oil on canvas, 23 x 19½ in.
Earl Davis

64. *Yachts—Sketch,*
c. 1916–17
Oil on canvas, 19 x 23 in.
Earl Davis

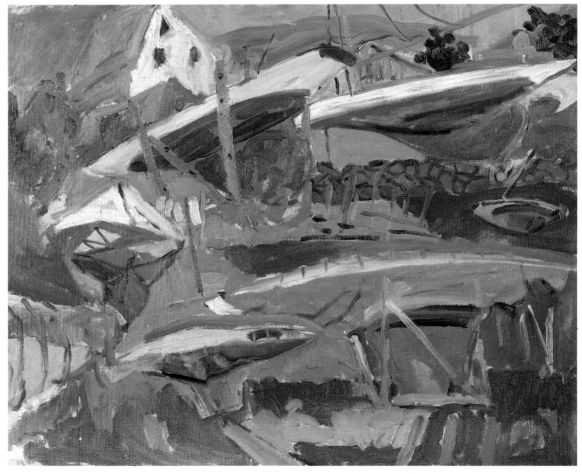

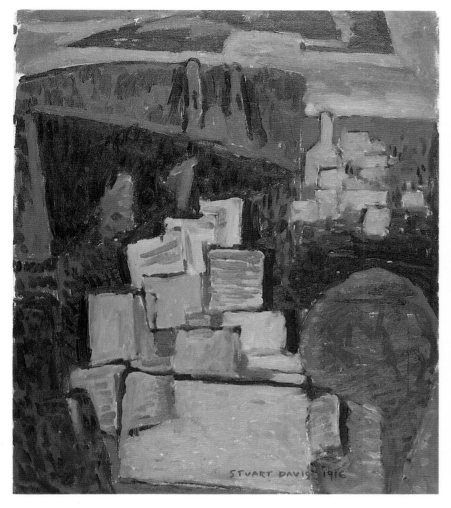

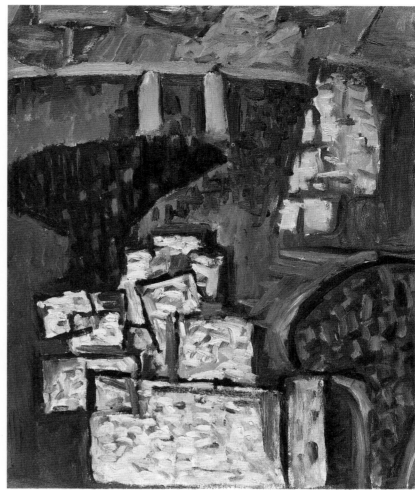

subject or an implied narrative. Some of the less successful Gloucester pictures of this period, in fact, explore this kind of literal-minded juxtapositioning, but the spatial flux of the best Gloucester townscapes owes nothing to anecdotal relationships. Rather, it indicates Davis's burgeoning awareness of nontraditional picture space.

Davis investigated the Cubist ideas implicit in the 1916 Gloucester townscapes in a group of purely experimental pictures executed the same year (plates 63, 65, 66). They are all the same size and use similar motifs, rendered with increasing degrees of Cubist simplification. Davis compressed the sloping landscape of the town into a single flattened surface and reduced houses, sheds, and even tombstones to simple flattened planes that jostle against one another. Color in these studies is often uncharacteristically subdued, as though Davis were concentrating on spatial structure at the expense of hue—something he would later declare impossible, after he had developed what he called his theory of color-space logic. (The role of color, Davis concluded, was to heighten the spatial implications of two-dimensional line drawing.) But in his early experimental works Davis seems to subject himself to the same discipline as the Cubists themselves when they foreswore bright

65. *Graveyard—Gloucester,* 1916
Oil on canvas, 23 x 19½ in.
Earl Davis

66. *Graveyard—Gloucester No. 2,* 1916
Oil on canvas, 23 x 19½ in.
Earl Davis

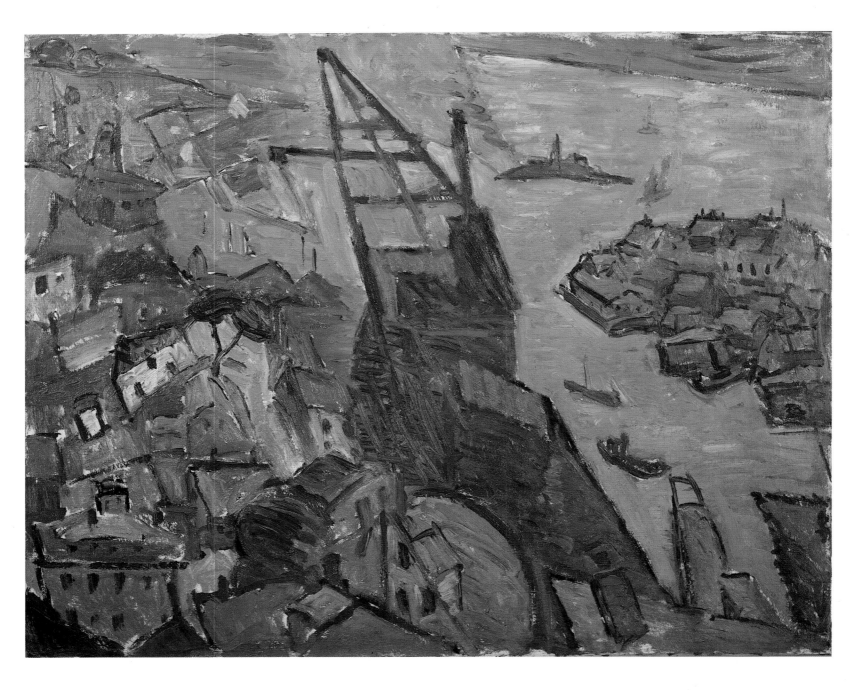

67. *Coal Derrick,* c. 1916–17
Oil on canvas, 24½ x 30¼ in.
Earl Davis

chromatic color in their paintings of the Analytical period. Returning to other preoccupations, Davis did not follow up the implications of his "proto-Cubist" paintings immediately or even directly; yet the effect of his seemingly erratic explorations was cumulative and told in his later paintings.

Not long after he began the Cubist townscapes, Davis painted a number of more or less literal filling-station and garage pictures that, at first sight, recall his earlier works. Pictures such as *Garage* and *Gas Station* (plates 68, 69), both painted in 1917, are haunted by the memory of the Ashcan School in their grayed color and vernacular imagery; but there is also a new foursquare, frontal abstractness of composition, a new boldness and clarity—to say nothing of the way Davis used lettering and geometric shapes—that could only have resulted from

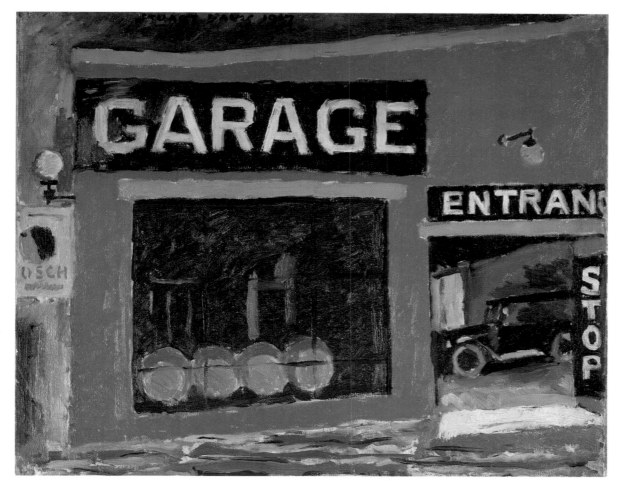

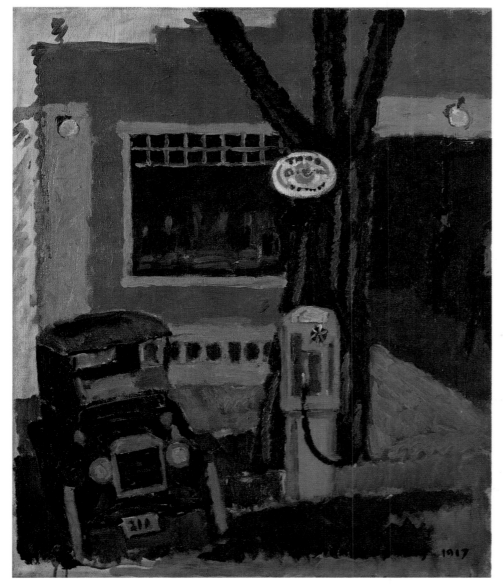

68. *Garage,* 1917
Oil on canvas, 19½ x 23½ in.
Earl Davis

69. *Gas Station,* 1917
Oil on canvas, 29 x 19 in.
Hirshhorn Museum and
Sculpture Garden, Smithsonian
Institution, Washington, D.C.

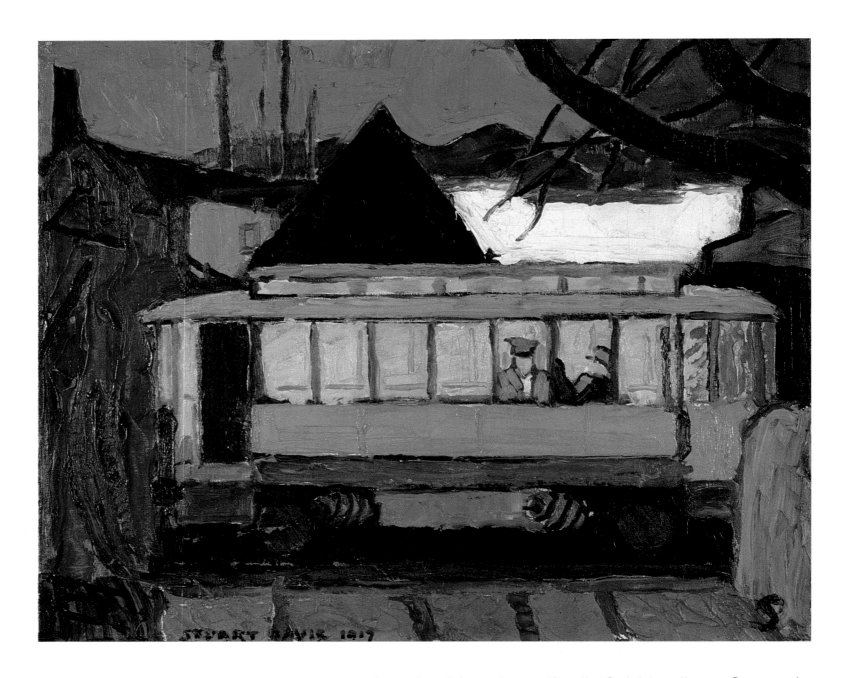

70. *The Last Trolley—
Gloucester,* 1917
Oil on canvas, 19 x 23 in.
Earl Davis

71. *Multiple Views,* 1918
Oil on canvas, 47 x 35 in.
Earl Davis

his exploration of modernist and specifically Cubist notions. *Garage* in particular, for all its superficial resemblance to earlier works, points more to what Davis's art would become than to what it had been. It is instructive to compare *Gas Station* with *Garage,* for the latter is like a more daring reworking of the former. In *Garage,* space is compressed. The facade of the building is made all but congruent with the picture plane, so that any vestiges of naturalistic space are squeezed out of the picture. Window and doorway are turned into flat geometric shapes, instead of illusionistic passages into deeper space, while signs reinforce this sense of reading across the surface rather than penetrating. The vertically written command to stop, at the right side of the picture, literally forbids the viewer to go mentally through the open doorway. Davis's thick, brushy paint further emphasizes surface, underscoring the picture's existence as object rather than representation.

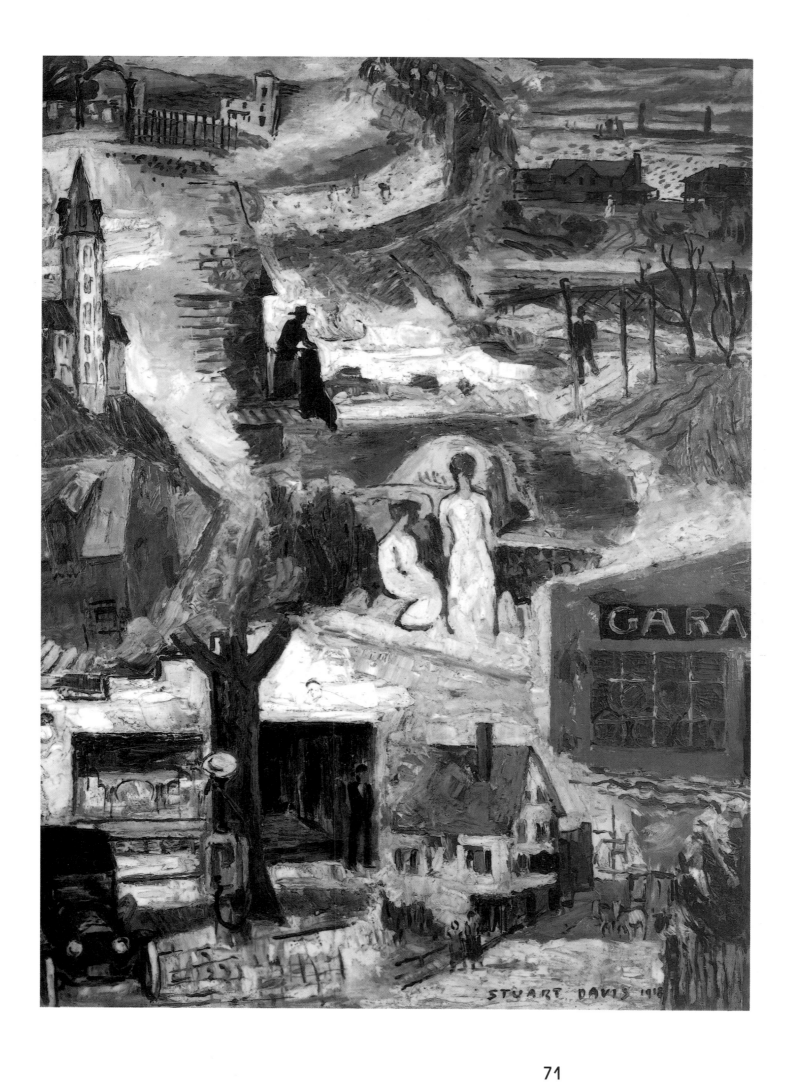

72. *Landscape—Tioga,
Pennsylvania,* 1919
Oil on canvas, 24 x 30 in.
Earl Davis

The Last Trolley—Gloucester (plate 70), also painted in 1917, is an even more extreme example. Davis made frontality and foursquareness the virtual subject of the picture, pulling the brilliant yellow trolley car parallel to the surface of the canvas and reducing it to a pierced rectangle of intense color floating against agitated brushstrokes.

The Tioga, Pennsylvania, landscapes of 1919 and the Havana watercolors of late 1919–early 1920 are further evidence of the diversity of Davis's ambitions in these formative years. The Tioga landscapes (plates 8, 72), painted while Davis stayed at a family summer place near the border between New York and Pennsylvania, are dense, solidified versions of the Gloucester townscapes. If Davis found real-life justification for Cubist planes in Gloucester architecture, he seems to have found an irresistible equivalence between the sun-drenched cornfields of Pennsylvania and van Gogh's views of the Provençal countryside near Arles. The Tioga oils, with their saturated color and agitated surfaces built of strokes piled on loaded strokes, are both deeply personal and deeply indebted to van Gogh. An astonishing self-portrait of the same period (frontispiece) shares the ferocity and energy of the landscapes.

A trip to Cuba with Coleman in December and January 1920 yielded a series of playful, bright watercolors. Cuba had probably been selected as a destination because it was relatively close, warm, exotic, and inexpensive, rather than for any special qualities as a place to paint. Nonetheless, Davis responded strongly, as usual, to the particularities of a new environment, and the pictures are full of anecdotal images of sinuous women, running animals, imposing policemen, pompous statues, and the like (plates 73–75). But the pictures are far from literal. Davis translated his observations into economical, generously scaled planes in a palette of hot colors. It is arguable whether the vivid color harmonies of the lively Havana pictures owe more to the effects of the brilliant tropical sun or to Davis's discovery of Fauvism, since he had already used colors very nearly as intense in painting chilly Gloucester. The arabesque shapes of the Havana watercolors have less clearly recognizable precedents and seem a direct response to the shapes of Spanish ironwork and tropical foliage.

Given the consistently high quality and the unified vision of the Tioga landscapes and the Havana watercolors, it comes as something of a surprise to see Davis abandoning this kind of domestic expressionism for a more restrained approach. It may be that he equated "objective order," which he ardently wanted to achieve, with a less overtly emotional, less painterly way of making pictures. Whatever the motivation, Davis's next coherent group of paintings, a series of still lifes

73. *Rurales, No. 1, Havana,* 1920
Watercolor on paper,
18 x 23½ in.
Earl Davis

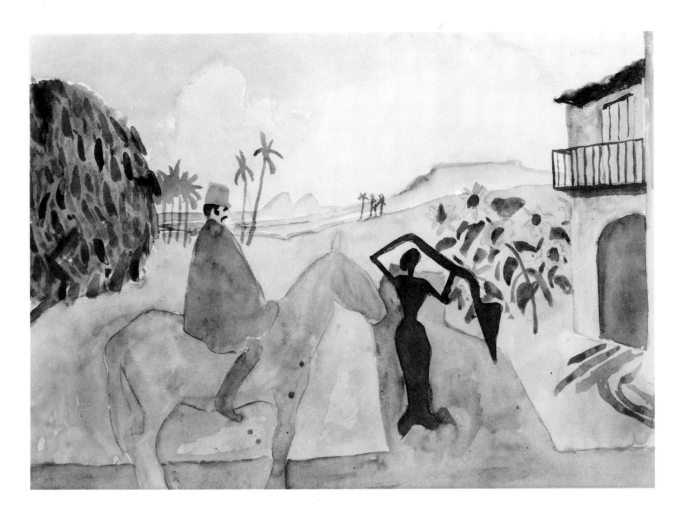

74. *Rurales, No. 2, Cuba,* 1920
Watercolor on paper,
18 x 23½ in.
The William H. Lane Collection

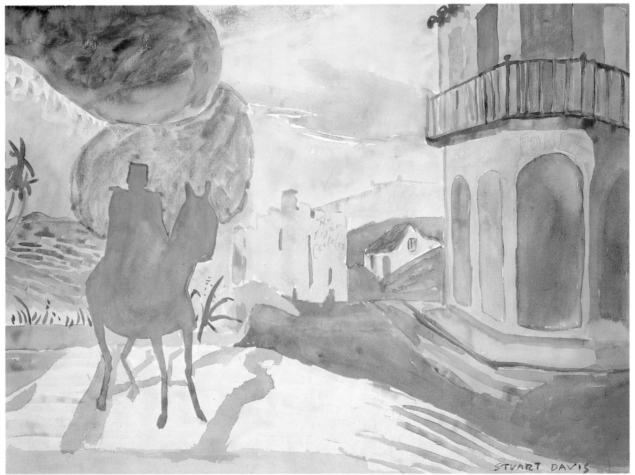

74

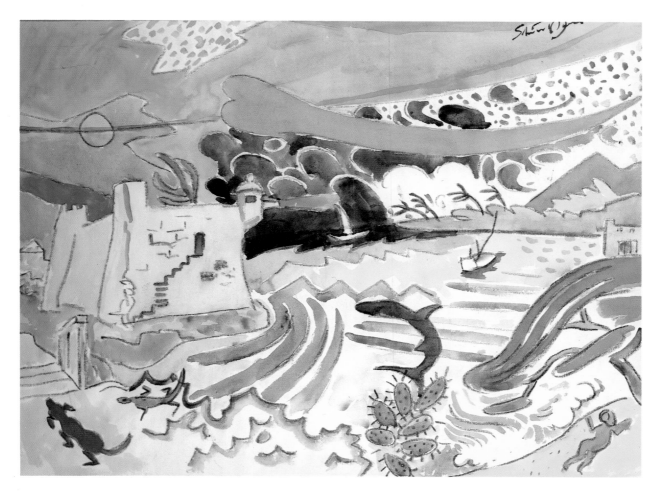

75. *Havana Landscape,* 1920
Watercolor on paper,
17¾ x 23¾ in.
Earl Davis

76. Stuart Davis, Havana, 1920

and still-life variations begun after his return from Cuba (plates 9, 87, 92), seem at first acquaintance to repudiate everything that preceded them. Rather than being vigorously painted, highly colored landscapes, they are cool geometric pictures with delicately brushed surfaces and subtle color harmonies. If the animated, detached color patches of the "proto-Cubist" Gloucester townscapes can be said to have coalesced into the interlocking shapes of the Tioga landscapes and the Havana watercolors, then, in the still lifes of the 1920s, these color areas begin to drift apart in a fluctuating Cubist-inspired space. The transformation of relaxed areas of paint into clearly bounded, articulated planes is an indication of Davis's growing assimilation of Cubist ideas; the smooth texture of these planes suggests that he had developed new ideas about surface based on the transparent Havana watercolors. Davis's paintings of the early 1920s, are, in fact, the first unequivocal indications of his mature style, and with the omniscience of hindsight, we can see them not as a departure from what had come before, but as a fulfillment. Since seeing the 1913 Armory Show, Davis had concentrated on particular elements of painting in modernist terms, sometimes at the expense of others. At various times, in various series, he emphasized color or shape or structure, until he could proceed with increased confidence and take new risks by amalgamating all of these elements. By 1920 he felt able to do so.

The years following the Armory Show, when Davis devoted his energies to becoming a modern artist, were also the years of "the war to end all wars," the cataclysm of 1914 to 1918. Davis was fortunate that World War I interrupted his private pursuit of modernism very little. During the last months of the war, in 1918, he worked as a mapmaker for the Army Intelligence Department, without having to leave the United States. He was mainly required to draft maps and charts for a special commission, headed by Walter Lippmann, that was entrusted with preparing materials for the coming peace conference. Apart from this brief period of military service, Davis was single-mindedly teaching himself a new language of art, assimilating a new visual grammar, and assembling his own vocabulary. At times, the difference between his pre– and post–Armory Show painting is so acute that it seems as though Davis was learning a new alphabet as well, yet he was able to express himself in his new language remarkably quickly. Less than ten years after his first real exposure to advanced modernist art, Davis was painting some of the most adventurous and surprising pictures in America.

2

BEING A MODERN ARTIST

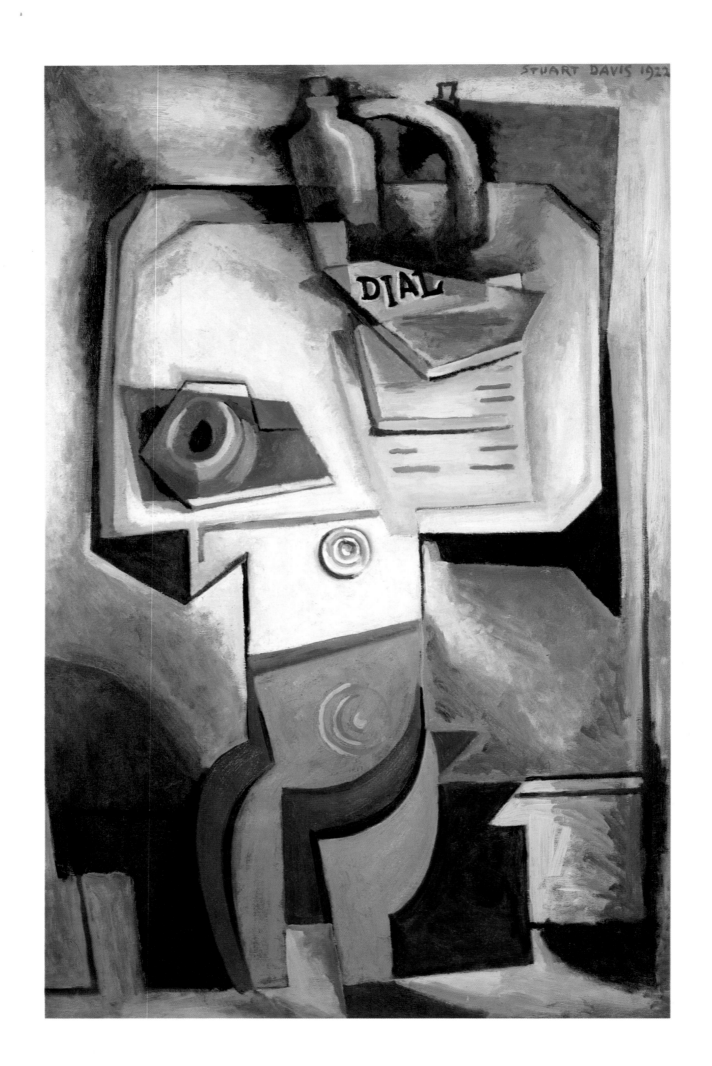

By 1920 Stuart Davis had become a far more sophisticated artist than the young man who had exhibited in the Armory Show seven years earlier. His taste was more adventurous and his understanding of European modernism broader. Davis remained fascinated by the urban subjects of his earliest years, but after about 1920 he rejected forever the sketchy realism of his first American teachers. Instead, he adopted the clear shapes, unbroken color, and formal daring of his new European heroes. By the end of the decade Davis was essentially formed as a painter, well entrenched in the territory he would explore for the rest of his life—an American brand of Cubism unmistakably his own.

Davis had been increasingly attracted to Cubism's radical new conceptions of space from as early as 1916, but his early Gloucester townscapes, such as *Gloucester Terraces* (plate 62), and the studies of the same period (plates 63, 65) are merely tentative in their Cubist tendencies. In the studies especially, Davis seems to have been aping the *appearance* of Cubism, seeking subjects that already looked like Cubist compositions. Following Cézanne's and Braque's lead, he "found" Cubist images in the angles of rooftops and shacks, and in rows of tombstones on a hill. Davis's natural tendency to square off shapes caused him to ignore anything in his subject matter that angled away from the picture plane, so that everything in these paintings was kept parallel to the surface, in receding layers of space, like the folds of a pop-up book. Yet by 1921 Davis was producing pictures such as *Garden Scene* (plate 80) and a year later, *Still Life with "The Dial"* and *Three Table Still Life* (plates 77, 78), all of which demonstrate a sure grasp of Cubism, both visually and intellectually. Davis's use of tilted perspective, broken strokes, and subdued color was undoubtedly inspired by traditional Cubist practice, as was his choice of large-scale tabletop displays as subject matter. At the same time, he also painted a group of inventive, noticeably original landscapes, such as *Untitled* (*From the Shore*) (plate 79). These little-known, seldom reproduced paintings of the early 1920s are powerful, spatially complex pictures, all the more

77. *Still Life with "The Dial,"* 1922
Oil on canvas, 49¼ x 32 in.
Earl Davis

78. *Three Table Still Life*, 1922
Oil on canvas, 42 x 32 in.
Private collection

79. *Untitled (From the Shore)*,
1921
Oil on canvas, 15 x 30 in.
Earl Davis

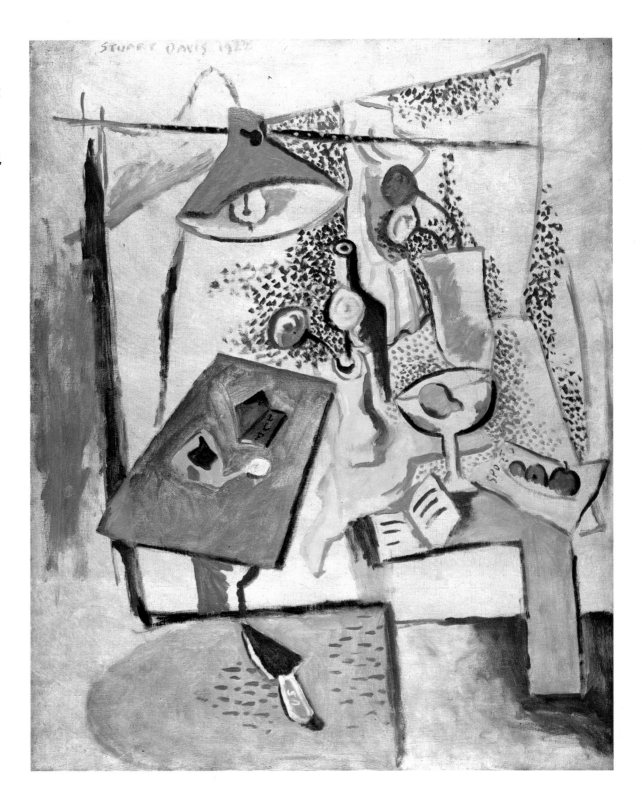

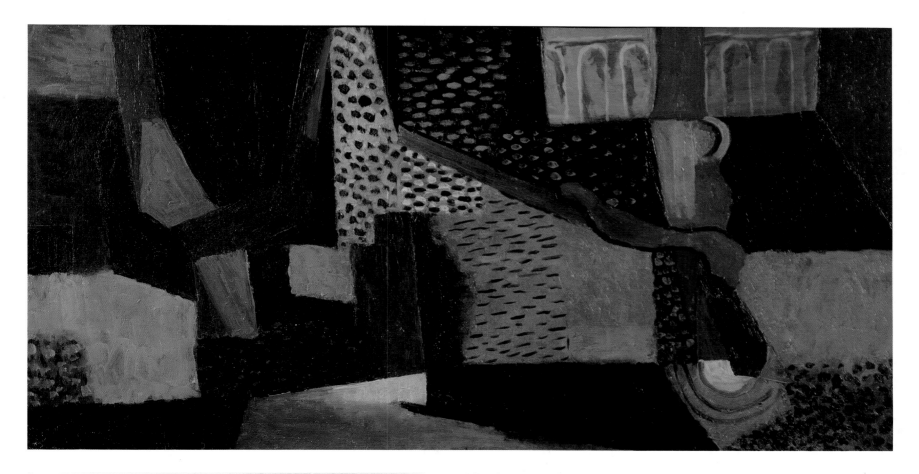

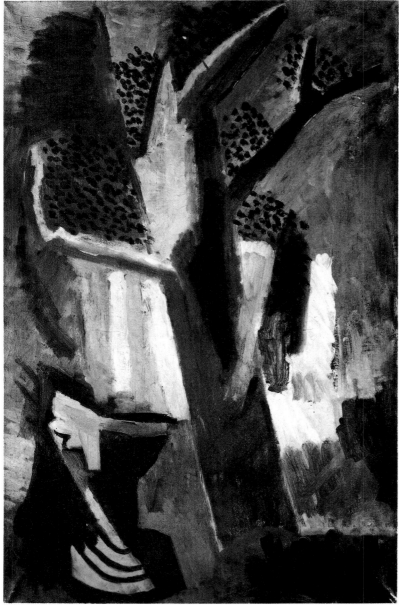

80. *Garden Scene,* 1921
Oil on canvas, 20 x 40 in.
Earl Davis

81. *Untitled (Tree and Vase),*
1921
Oil on canvas, 30 x 19 in.
Earl Davis

remarkable for having been made when they were, in the relative isolation of the United States. They signal the beginning of Davis's maturity as a painter. By 1927 he was making wholly original Cubist paintings that would be noteworthy in any context. While they are still indebted to Picasso, pictures such as *Percolator* (plate 101) and the Eggbeater series of 1927–28 (plates 106–11, 181, 182) make it clear that Davis was no longer emulating a style but using a new language fluently and idiomatically.[1]

This makes Davis's development sound straightforward and uninterrupted, when it would be more accurately described as a series of advances, sidesteps, and retreats. He made many different kinds of pictures during the 1920s, just as he had after having first resolved to become a "Modern artist" and just as he would throughout the rest of his career. The advent of characteristics associated with the mature Davis can be recognized, but they appear in a variety of guises. Drastically simplified compositions are followed by relatively anecdotal ones, severe abstractions by modified naturalism, generously scaled, economical structures by intricate ones verging on the overwrought. Yet despite these oscillations, Davis's alliance with Cubism was wholehearted, long lasting, and all things considered, formed with remarkable speed. By the early 1920s, before he was thirty-five, he had found his direction; moreover, he had begun to proceed with noticeable daring. The absorbing but perhaps unanswerable questions are why and how this accelerated growth took place when it did. It is tempting to look for some event, some influence that would explain Davis's transformation in the 1920s as neatly as his encounter with the 1913 Armory Show accounts for his first plunge into modernism. Alas for tidy-mindedness, there is no simple explanation.

Davis's burgeoning interest in Cubism must have been due, in part, simply to his greater firsthand experience of new European art. (It is interesting that despite their similar aims, Davis seems to have been less affected by what he knew of the American avant-garde; perhaps he felt that even the most adventurous—such as the Stieglitz artists— were in the same relation to advanced European art that he was.) While exhibitions of truly current work were still uncommon in New York, Stieglitz's gallery had been joined by a handful of other galleries, some short-lived, dedicated to the international avant-garde. Some of that avant-garde was even living in New York; for several years during the late teens and early 1920s, Marcel Duchamp, Man Ray, and Francis Picabia were all in the city, acting as the focal point and generating center of American Dadaist activity. In 1919 the Arden Gallery mounted the ambitiously titled *Evolution of French Painting,* which included draw-

ings and prints by Matisse, Picasso, Braque, André Derain, Duchamp, and Picabia, among many others. In 1920 the Société Anonyme, a kind of forebear of the Museum of Modern Art, was founded by Katherine S. Dreier, Duchamp, and Man Ray. The first exhibition included works by artists as diverse as van Gogh, Picabia, Jacques Villon, and the American Morton Schamberg, as well as by Duchamp and Man Ray themselves. Soon after, the Société showed work by Kurt Schwitters and Paul Klee for the first time in the United States, and in 1925 organized a major exhibition by Léger. Perhaps as a reflection of this burgeoning interest in new art, under its new owner, Scofield Thayer, the magazine the *Dial* completely changed its format and policies in 1920, becoming an illustrated monthly devoted to arts and letters. Until 1929 it published provocative essays by Clive Bell, Roger Fry, and Julius Meyer-Grafe; as if fearful of being too advanced, it also published work by the archconservative critic Thomas Craven and by Henry McBride, the *Dial*'s far from radical editor. (Davis contributed a number of drawings, mostly still lifes and portraits, to the *Dial* in 1922 and '23, and the magazine figures in one of his most ambitious canvases of 1922 [plate 77].)

Davis's friendship with the remarkable painter, connoisseur, theorist, and mystic John Graham may have provided a further spur to his interest in Cubism. Graham, who was born in Russia in 1886 into a family of Polish nobles, came to the United States in 1920, by way of Paris. He became an important figure in the small New York art world of the 1920s and '30s, a knowledgeable and influential force in the lives of many aspiring American modernists. Since he traveled frequently to Paris, where he claimed to know everyone, including Picasso, Julio González, and the Surrealist painters and writers, he kept his New York friends supplied with news of the latest radical art and ideas, illustrating his descriptions with works he owned—his three sculptures by González were the first to be brought to America—and with French art magazines such as *Cahiers d'art*. Graham was a catalyst. His conversation and the examples he furnished helped to focus the ideas of the young New York artists who surrounded him, and perhaps stimulated the development of their nascent personal styles. An impressive number of future Abstract Expressionists, among them de Kooning, Gorky, Gottlieb, and Smith, were deeply affected by Graham in their formative years.

It would have been perfectly in character for Graham to have encouraged Davis's desire to make more advanced art and to have fostered his attraction to Cubism. And it would have been perfectly in character for Davis to have been receptive to the exciting new ideas Graham espoused; it takes nothing away from Davis to say that his art

FORTY INNS ON THE LINCOLN HIGHWAY - NO. 2

82. *Gloucester Terraces,* 1916
Crayon and ink on paper,
19 x 15 in.
Earl Davis

83. *Forty Inns on the Lincoln
Highway,* 1916–17
Pencil and ink on paper,
23⅛ x 17¼ in.
Earl Davis

developed, especially at first, in response to other, more challenging art. The difficulty lies in establishing just when the two men met. Since Davis was about ten years older than the other members of the circle and therefore closer to Graham's age, he might have gotten to know Graham sooner than some of the younger artists. John Sloan could have introduced them in the early 1920s, since Graham studied with Sloan at the Art Students League from 1922 to 1924. All that is known is that Graham and Davis were friends by the end of the 1920s; in 1929 Graham introduced Davis and Gorky. (They all became so close that they were known as "The Three Musketeers.") Graham liked Davis's work enough to include him as one of a small number of "young outstanding American painters" in his 1937 book, *System and Dialectics of Art.*[2] Davis returned the compliment in a 1941 notebook entry, when he singled out Graham as one of America's few producers of "real art." [3] Their friendship had waned by the 1940s, when Graham repudiated his early enthusiasm for new art and for abstraction, even going so far as to deny the importance he had once accorded to Picasso. Graham's increasing mysticism and his retreat from modernism alien-

ated him from most of his younger artist friends, including Davis. But for a few years, during a critical moment in the history of American modernism, he was a vital link between the distant world of advanced European art and a generation of American artists hungry for news of that world.

It has been suggested that Davis was indirectly encouraged to follow his Cubist leanings by the poet William Carlos Williams. They met in 1920, when Williams, a passionate follower of American avant-garde painting (and a close friend of many of its practitioners), asked permission to reproduce one of Davis's 1916 drawings as the frontispiece for his collection *Kora in Hell: Improvisations* (plate 82). Davis and Williams saw each other only a few times as a result of that request and never seemed to have become friends, but it was a provocative encounter. The poet praised the drawing for its "impressionistic view of the simultaneous," saying, "It was graphically exactly what I was trying to do in words."[4] It is one of Davis's "multiple views," an assortment of isolated Gloucester scenes arranged on a single sheet, like a comic strip. The images do exist simultaneously, as Williams noted, but it is simultaneity of an anecdotal kind, anticipating Davis's commercial drawing *Forty Inns on the Lincoln Highway* (plate 83), 1916–17, where something different and amusing happens in each of the locales illustrated on the sheet. Unlike Cubist works that present multiple views of single objects, Davis's pictures of this type juxtapose single views of multiple objects. Cubism takes elements from the visible world and conflates them with their surroundings and with each other; space is expanded and compressed at the artist's will, according to the demands of the picture, and the whole complex assortment is organized in relation to a single frontal plane, in a shallow, pulsating space. Davis, in his mature pictures, presented the world around him in this way, but in his early "simultaneous" pictures, he set self-contained, naturalistic vignettes side by side, joining them to make a complicated surface, like a set of pigeonholes.

Davis's autobiography, published in 1945, furnishes a clue to these odd spatial conceptions. He described how he spent years working outdoors at Gloucester: "I wandered over the rocks, moors and docks, with a sketching easel, large canvases, and a pack on my back, looking for things to paint."[5] Eventually, he lost patience with this cumbersome method and substituted on-the-spot drawing, later developing his sketches in the studio. As he put it: "In my studio compositions, I brought drawings of different places and things into a single focus. The necessity to select and define the spatial limits of these separate drawings, in relation to the unity of the whole picture, developed an

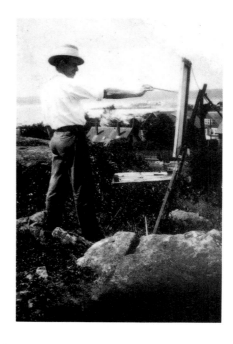

84. Stuart Davis painting in Gloucester or Rockport

objective attitude toward size and shape relations."[6] This is a character-istic description for Davis, whose notebooks record his obsessive desire to codify intuitive ways of working and empirical discoveries, but it makes clear the origins of the "multiple-view" pictures: their pieced-together quality results from the assembly of disparate, independent images.

The space of pictures like the frontispiece for *Kora in Hell* is unlike that of true Cubism, but as Davis's later work bears out, such paintings embody, albeit in a rather literal way, fundamental Cubist concepts. The Gloucester multiple-view pictures are, in a sense, primitive versions of the Cubists' attempts to incorporate notions of time and memory into what had been an art of the single, transfixed moment. Davis was indeed striving for the simultaneity that Williams remarked upon, and just as the poet felt an affinity to the artist's drawing, so Davis responded to what he perceived as common concerns in Williams's poems. In a letter about *Kora,* Davis wrote to Williams: "It opens up a field of possi-bilities. To me it suggests a development of word against word without any impediments of story, poetic beauty or anything at all except word clash and sequence."[7]

Davis is often charged with having had an illustrator's sensibility, but his delight in particularities was tempered by his desire for "objective" order. His mature art evolved out of a struggle to turn everyday experi-ence and finely tuned perceptions into nonspecific (but evocative) color-shapes. Part of Davis's maturation depended on freeing his im-ages from the "impediments of story" or the specifics of a given mo-ment. His enthusiasm for Williams's work, which he apparently had not known before the poet approached him, suggests that he was ready to eliminate even implied narrative from his paintings. The problem was to remain sufficiently attached to actuality to avoid lifelessness. As some of the early Gloucester paintings show, modernism, for Davis, could lead to generalized planes and patches of color that bore little relation to the details and variety that had originally stimulated him. Williams's collisions of "word against word" may have helped Davis to clarify his direction by suggesting ways of marrying the particular and the nonspecific. (The phrase is also provocative in light of Davis's later use of repeated words.)

It is, in any event, dangerous to make too much of Davis's training and continuing practice as an illustrator during the first years of his career. Even the most overtly anecdotal of his earliest works—such curious pictures as *The Doctor* (*Interior*) (plate 49), *The Front Page* (*The Musician*) (plate 48), and *Babe La Tour* (plate 40)—are lurid but impen-etrable. It is clear in these paintings that something untoward is going

on, but it is almost impossible to tell just *what* is happening or whether it has happened already. In the strictest sense, these odd pictures fail as illustrations since the essence of good illustration is to encapsulate a particular moment, whether or not the text is known to the viewer. The characters may not be identifiable, but their actions should be. In Davis's early figurative work this is not always so, and it must have been a great relief for him to discover that a painting need not tell a story. At most, Williams's poetry and his expressed admiration for the simultaneous in Davis's art may have encouraged the young painter to continue along a path he was already beginning to explore.

The idea of the simultaneous seems to have stayed with Davis. A more developed version of the multiple view is at the heart of *House and Street* (plate 142), 1931, where a random pileup of city buildings, seen from both near and far, is translated into a structure of flat planes held in a taut relationship to the surface of the canvas. The haphazard association of individual scenes in the *Kora in Hell* drawing and similar works has been replaced by a complex arrangement of more or less independent elements. It is not just a question of degree of abstractness. The buildings and street furniture of *House and Street* are still recognizable, but their documentary function is less important than their contribution to a new, invented whole. *House and Street* fulfills Davis's ambitions in ways that the earlier multiple-view pictures did not. It points to his fully evolved later paintings constructed of evocative shapes that define a world of pure color.

Yet for all his preoccupation with the multiple, Davis's best (and often most advanced) pictures tend toward singleness or at least toward images pared down to eloquent essentials. He frequently added ornaments or played countermelodies of small-scale elements against a firm ground bass—not always to the benefit of the painting—but in his most successful pictures the scaffolding that Davis called the essential "configuration" makes its presence felt. Among the first examples of his stripped-down style are the Tobacco Still Lifes of the early 1920s (plates 85, 86, 91, 92). At first sight, they seem closely related to Cubist collage, since they seem to incorporate wrappers and labels from cigarette papers, cigarettes, and loose tobacco, plus the occasional newspaper; in fact, they are not collaged at all, but meticulously painted.

The American tradition of the trompe l'oeil still life goes back at least to the end of the nineteenth century, with William Harnett and John F. Peto being perhaps the two best-known practitioners.[8] Their uncanny canvases of life-size hunters' trophies, crammed cupboards, and letter racks overflowing with papers were meant to fool the viewer, momentarily, into thinking that he was seeing an assortment of real

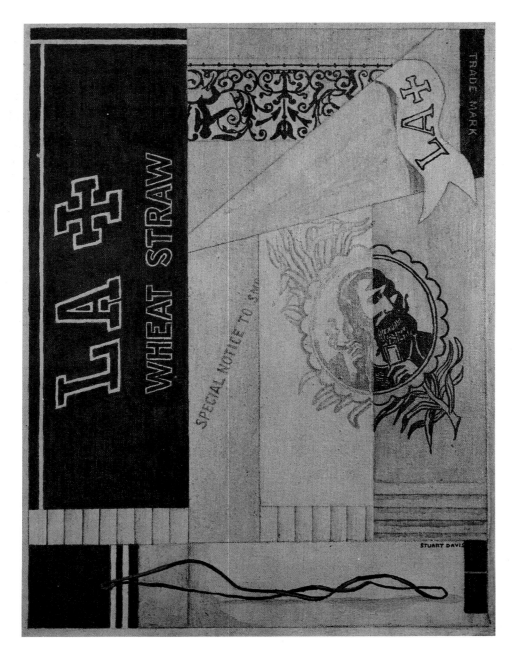

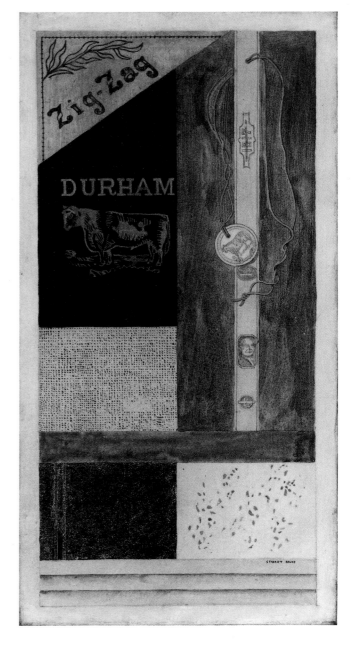

85. *Cigarette Papers,* 1921
Oil on canvas,
19 x 14 in.
Private collection

86. *Bull Durham,* 1922
Oil and watercolor on canvas,
30¼ x 15¼ in.
The Baltimore Museum of Art;
Edward Joseph Gallagher III
Memorial Collection

objects against a real wall. Davis's painted collages recall this tradition in a highly abstracted way, although obviously with a different intent. Harnett and Peto wanted us to believe their flat images to be made up of robustly three-dimensional objects that occupied our real space. Davis's illusionism is one of surfaces and textures rather than of space; he imitates the appearance of papers and labels that would have been tightly pressed to the surface of the canvas had they been real.

It seems odd to paint material that could quite easily have been used as is. There is precedent, of course. Braque used his decorator's training to paint wallpaper motifs, woodgrain, or papers on his canvases, and Picasso, too, sometimes resorted to mimicry. But for both artists, such illusions were only adjuncts to larger, clearly *painted* contexts. Had Davis misunderstood the nature of collage? If he had been dependent solely upon photographs of Cubist examples, this might

be plausible, but he wasn't, and his journals of the 1920s allude to the possibility of making a new kind of picture by combining a great variety of materials.[9] In later years Davis recalled having been impressed and liberated, as a young painter, by a Picabia beach scene in which the artist had added feathers, macaroni, and leather to his painted canvas.[10] Then, too, there is the evidence of a small number of fine collages by Davis, such as the animated, Picabia-like little painting, *ITLKSEZ* (plate 87), 1921. The title is an abbreviation for "it looks easy," a wry comment on modernism in general and Cubism in particular.

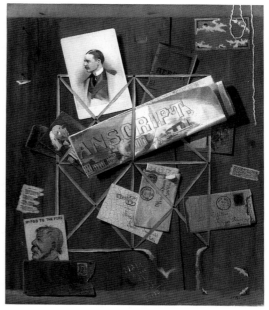

87. *ITLKSEZ*, 1921
Watercolor and collage
on paper, 22 x 16 in.
The William H. Lane Collection

88. John F. Peto
Card Rack, 1882
Oil on canvas, 24 x 20 in.
National Museum of American
Art, Smithsonian Institution,
Washington, D.C.; Gift of
Nathaly Baum in memory of
Harry Baum

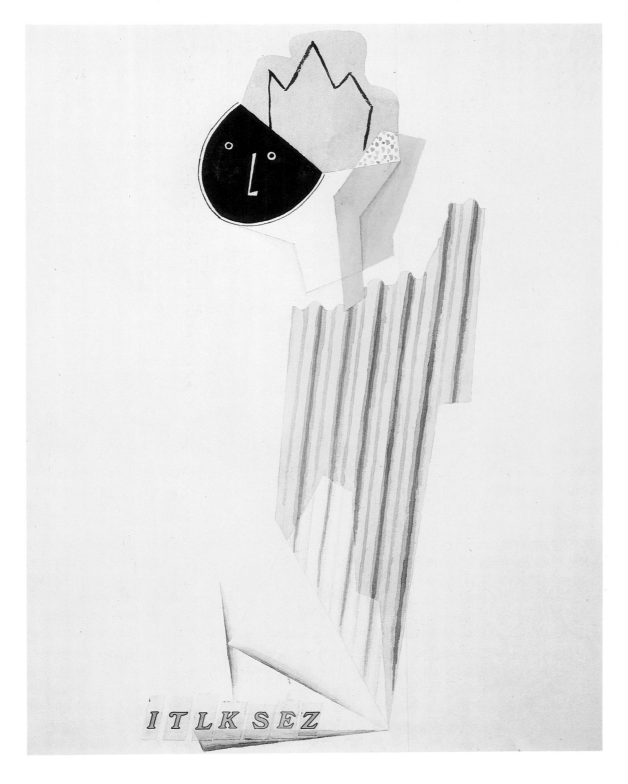

(Writing about his response to the Armory Show, Davis said: "That settled it. I would be a modern artist. So easy. Except for one small matter: How?"[11]) *ITLKSEZ* is a playful picture, distinguished chiefly by its sprightly image and its elegant, cool color. Davis exercised his virtuosity by imitating in watercolor the look of Cubist collaged papers, playing painted areas against applied pieces. The pasted sections of *ITLKSEZ* are minimal compared with their painted context, but they are proof that Davis was familiar with the methods and practices of collage. The illusionism of the Tobacco pictures must have been a deliberate choice.

For all their likeness to Cubist prototypes, the Tobacco paintings often seem jammed and flattened, like Davis's earlier trued-and-faired "Cubist" studies of 1916, such as *Graveyard—Gloucester* or *Untitled (Town Shapes)* (plates 65, 63). This is especially evident in comparison with Davis's splendid large Cubist Table Still Lifes, which were made at just about the same time. In the Tobacco paintings the metaphor of the piecework quilt often comes to mind, but the series is distinguished by its clearheaded compositions. The Tobacco pictures are unusually abstract, far more so, in fact, than paintings such as *Three*

89. *Untitled*, 1921
Pencil and collage on paper,
22½ x 16½ in.
Earl Davis

90. *Untitled*, 1921
Watercolor and pencil on paper, 23 x 17¼ in. (sight)
Earl Davis

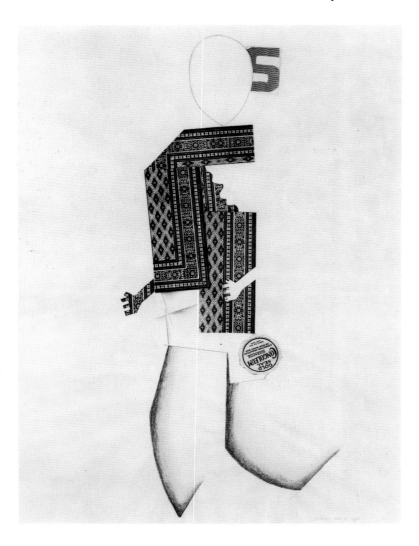

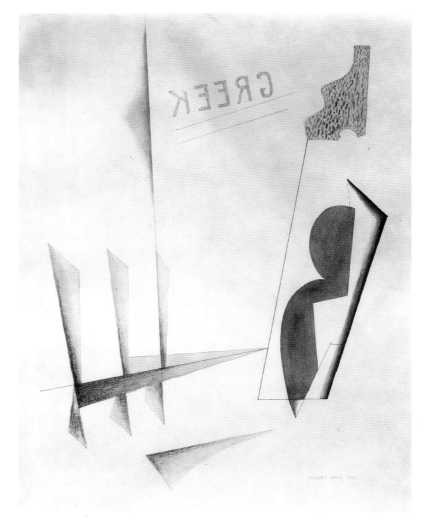

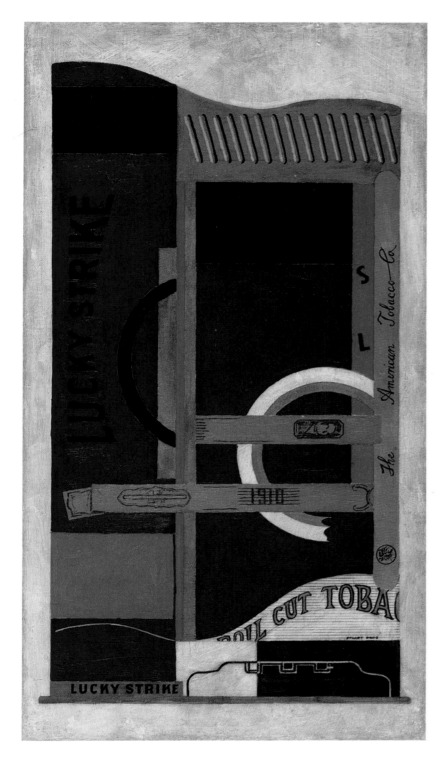

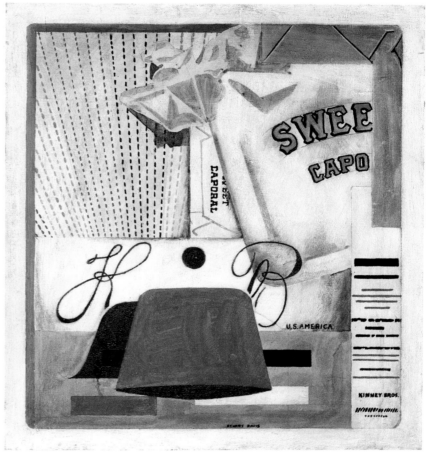

91. *Lucky Strike*, 1921
Oil on canvas, 33¼ x 18 in.
Collection, The Museum of
Modern Art, New York; Gift of the
American Tobacco Company, Inc.

92. *Sweet Caporal*, 1922
Watercolor and oil on canvas,
20 x 18½ in.
Thyssen-Bornemisza Collection,
Lugano, Switzerland

Table Still Life (plate 78). The large Table Still Lifes are more ambitious and more complex spatially, but in their spareness and economy, audacious Tobacco paintings such as *Lucky Strike* and *Sweet Caporal* (plates 91, 92) closely anticipate Davis's mature concerns.

Their abstractness is partly a function of their fragmentation. Unlike the larger Table Still Lifes, which remain, however freely and inventively painted, about things placed on a horizontal surface in a logical way, the Tobacco pictures are about wholly unreal relationships. The component elements retain their original patterns, textures, and texts but

are entirely divorced from their original forms. Instead, they are turned into discrete, flat areas, perfectly congruent with the surface of the canvas. The generous scale of the Tobacco pictures also contributes to their abstract quality; elements are presented more or less actual size, rather than reduced or enlarged. (Paradoxically, this is, of course, essential to the success of trompe l'oeil illusion.) We are made to consider "paper" shapes and patterns simply *as* shapes and patterns, rather than as depicted images. The result is the independent, autonomous reality that Davis always strove for: the fact of a new painted image, rather than a reflection of something preexisting.

But no matter how abstract paintings such as *Cigarette Papers* or *Bull Durham* (plates 85, 86) may be, their subject matter was obviously important to Davis. For all his later insistence that any subject would do, certain motifs recur throughout his career. The accoutrements of smoking frequently reappear, full of the "roll your own" machismo and Jazz Age sophistication of the days before the Surgeon General's warnings. The tobacco pouch—often a brand called Stud, whose emblem was a rearing stallion—figures in many of Davis's pictures, along with rolling papers and cigarette packages. Davis, a lifelong heavy smoker, obviously had these materials around him, but cigar stores and their signs also appear frequently in his sketchbooks and as painting elements. Like the barber shops and gas stations that punctuate Davis's townscapes, the cigar store is traditionally a male preserve, so smoking motifs may be associated with maleness itself. The most spectacular manifestation of tobacco iconography, in an unequivocal context, is the mural that Davis executed in 1932 for the men's lounge of Radio City Music Hall (plate 163).

Beyond the specific associations of tobacco, Davis was fascinated by labels and packaging in general. In a journal of the early 1920s he described the advent of packaging, as opposed to the barrels of the old-fashioned general store, as evidence of high civilization in modern life.[12] Of course, Davis's irony can't be discounted, but whether or not he found them to be evidence of high civilization, labels, like street signs, provided him with a lexicon of letters and words that could be richly associative and, at the same time, could help make the picture more self-sufficient and objectlike. Davis was obviously aware of the French Cubists' use of letters, both as fragments of headlines and as isolated shapes, but at first, the meaning of legible messages seems to have interested him most. It was a way of avoiding the anonymity of the geometric abstraction he disliked so much. "The lettering," he wrote in 1923, "introduces the human element."[13] Davis used signs and lettering (perhaps in emulation of Sloan) as early as his Ashcan School

days and in his first modernist pictures (plate 68), but in these they were part of a fairly naturalistic context. In the Tobacco paintings, we are meant to read and respond to the words and letters, but for the first time typography is wrenched free from rational explanation to become, as it would in Davis's later works, simultaneously a carrier of associative meaning and a key structural element. The meaning, both literal and punning, of Davis's words and titles always counts, from *ITLKSEZ* on, but as he wrote toward the end of his life, they had other functions as well: "Letters *Lock* Scale, Letters *Lock* Color." [14]

During the mid-1920s Davis shifted his attention from commercial packaging to equally ordinary domestic objects, lifting them from their familiar surroundings as he had his cigarette papers, isolating, enlarging, and altering them. Again, he was taking his cue from the European artists he admired. In the 1920s using familiar machine-made objects as subjects for painting was still a declaration of independence from tradition, an assertion of modernism. Traditional still-life painters had reveled in things remarkable for their shape and texture, their preciousness and rarity: exotic fruits, fine glassware and silver, the spoils of the hunt. Or they celebrated simple objects: humble kitchen copper and earthenware. Davis turned his attention to the twentieth-century kitchen, with its light bulbs, percolators, eggbeaters, soap boxes, and matchbooks.

Some years later, Davis suggested that his use of "unesthetic material, absurd material, non-arty material" owed something to Duchamp's example, particularly the famous urinal rejected from the 1917 Independents' Show. [15] But expediency, too, had something to do with it. Davis was painting what was at hand, the stuff of his domestic environment, just as the Cubists had painted the wine bottles, pipes, and newspapers of their daily lives (along with the ubiquitous studio props, the guitars and mandolins). But for Davis, there was added meaning. By selecting unlovely, everyday objects as still-life material, he was following the precepts of his training at Henri's school. Like Léger's and Picabia's machines, Davis's domestic hardware was both subject and metaphor. Packaging, kitchen gadgets, and tools were portable equivalents for Davis's principal theme—modern urban life in all its manifestations—just as the contemporary city was his substitute for traditional landscape. Even his Gloucester pictures, more often than not, are of docks, gas stations, and town squares rather than untouched nature.

Davis's response to the landscape of New Mexico, where he spent three or four months of the summer and fall of 1923 with John and Dolly Sloan, is testimony to this attitude. They had driven across the

93. Stuart Davis, New Mexico, 1923

country with Davis's seventeen-year-old brother, Wyatt, on the strength of Sloan's enthusiasm for the place. The actual drive west seems to have impressed Davis very little; there are no notebook references to the splendor of the prairies or the magnificence of the Southwest. (Davis family lore preserves stories of multiple flat tires on the rough country roads and of Wyatt's insistence on ordering steak in the restaurants they stopped at, to the intense annoyance of his brother, who was trying to keep them both on a hamburger budget.) Davis had always credited Sloan with having originally gotten him to Gloucester, which had certainly been to his liking, so he anticipated that New Mexico would be just as stimulating. Yet he said that he "did not do much work because the place itself was so interesting." [16] Davis might have been expected to find the desert landscape too uneventful, given his preference for crowded cities and the complexities of the New England harbor, but on the contrary, he found the surroundings overwhelmingly picturesque, almost ready-made as art. The mountains, desert, and brilliant light that delighted so many other artists put Davis off. "I don't think you could do much work there except in a literal way, because the place is always there in such a dominating way. You always have to look at it." [17]

Despite his protestations, Davis did, in fact, produce a respectable number of paintings during his stay in Santa Fe. The best of his landscapes subvert the obvious beauties of the place, translating conventional subject matter into modernist language. In *New Mexico Landscape* and *New Mexican Landscape* (plates 10, 94) Davis turned a travel poster view of desert hills, distant mountains, luminous sky, and cottony clouds into a series of sharply defined, virtually uninflected planes. Calligraphic drawing at once suggests landscape details in a stylized way—repeated dots evoke desert plants, for example—but this drawing sometimes breaks free of the shapes it purports to define and enrich and sets up independent rhythms. In both pictures the cluster of adobe buildings in the foreground is treated quite summarily, but it seems significant that Davis chose not only to include architecture in an otherwise unpopulated landscape, but to make the buildings equivalent in size and visual weight to the far-off mountains. The dark shape that isolates the buildings, rather than acting like a traditional *repoussoir* and pushing the rest of the picture into the distance, sinks back because of its color, just as the brilliant blue of the sky and bright white of the clouds push forward. The habitual reading of "up" as "back" in landscape painting is negated, and the picture flattens.

The sense of artifice is heightened by Davis's undulating painted borders. Unlike the more typical clean-edged inner frames of his later

paintings, which simultaneously isolate the picture and mediate between it and the rest of the world, the wavy New Mexico borders also seem like allusions to the traditional vignette. Their colors—a white inner band against gray—have irresistible associations with the ripply white edges of snapshots on an album page. Davis's most subtle declaration of his pictures' independence—the equality with nature that he spoke of so often—is found in both pictures in the middle, desert section. He pulls the tip of the ocher plane over the painted border, implying that his version, at least, of ageless hills and inspiring spaces must be seen as a momentary gathering of fictive two-dimensional planes. Several of John Marin's watercolors of Taos, New Mexico, painted in 1929 and 1930 are remarkably close to Davis's Santa Fe images, even allowing for the influence of place and Marin's habitual use of inner frames. Since Marin was associated with the

94. *New Mexican Landscape,*
1923
Oil on canvas, 32 x 40¼ in.
Amon Carter Museum,
Fort Worth

95. *Egg Beater,* 1923
Oil on canvas, 37 x 21¾ in.
Earl Davis

95. *Egg Beater,* 1923
Oil on canvas, 37 x 21¾ in.
Earl Davis

Downtown Gallery, where Davis showed his New Mexico pictures, it is conceivable that the older artist knew and was stimulated by the younger man's work.

As if in defiance of the vaunted scenery around him, Davis also painted a series of overscaled familiar objects while he was in New Mexico: a naked light bulb on its chain, a giant saw, a monstrous egg-beater (plate 95). It is a distinctly peculiar group of pictures and difficult to account for, since the everyday subject matter is presented verbatim, not used as a springboard for formal invention. Each object is

drawn with uncompromising clarity, posed at its most recognizable angle, and centered on the canvas. One explanation suggests itself. Davis commented on how struck he was by the relics of New Mexico's ancient Indian civilizations, on how aware he was of the region's prehistoric past: "Then there's the great dead population. You don't see them but you stumble over them. A piece of pottery here and there and everywhere. It's a place for an ethnologist not an artist."[18] It is possible that Davis painted his curious "portraits" of twentieth-century household objects not just as a relief from an overly picturesque landscape but as a record of his own civilization's artifacts.

Davis was clearly not entirely satisfied with the work he produced in Santa Fe. His final word on the place was one of dismissal: "Not sufficient intellectual stimulus. Forms made to order, to imitate. Colors—but I never went there again."[19] Paradoxically, the paintings he had made as a reaction against the New Mexican landscape proved seminal. The ordinary objects of modern urban life continued to be the subjects of Davis's studio setups after his return from New Mexico. Pictures such as *Odol, Electric Bulb,* and *Edison Mazda* (plates 96–98) were produced the year following the New Mexican trip, while paintings of

96. *Odol,* 1924
Oil on cardboard, 24 x 18 in.
Cincinnati Art Museum; The Edwin and Virginia Irwin Memorial

97. *Electric Bulb,* 1924
Oil on board, 24 x 18 in.
Earl Davis

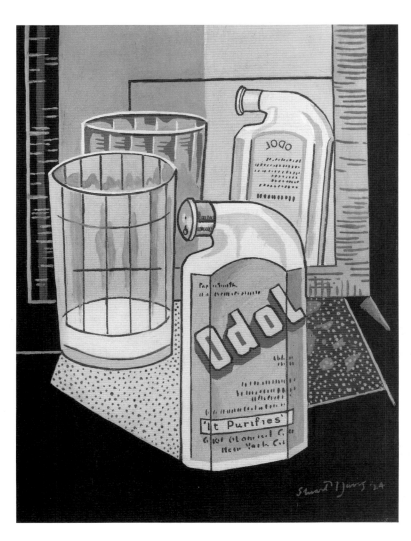

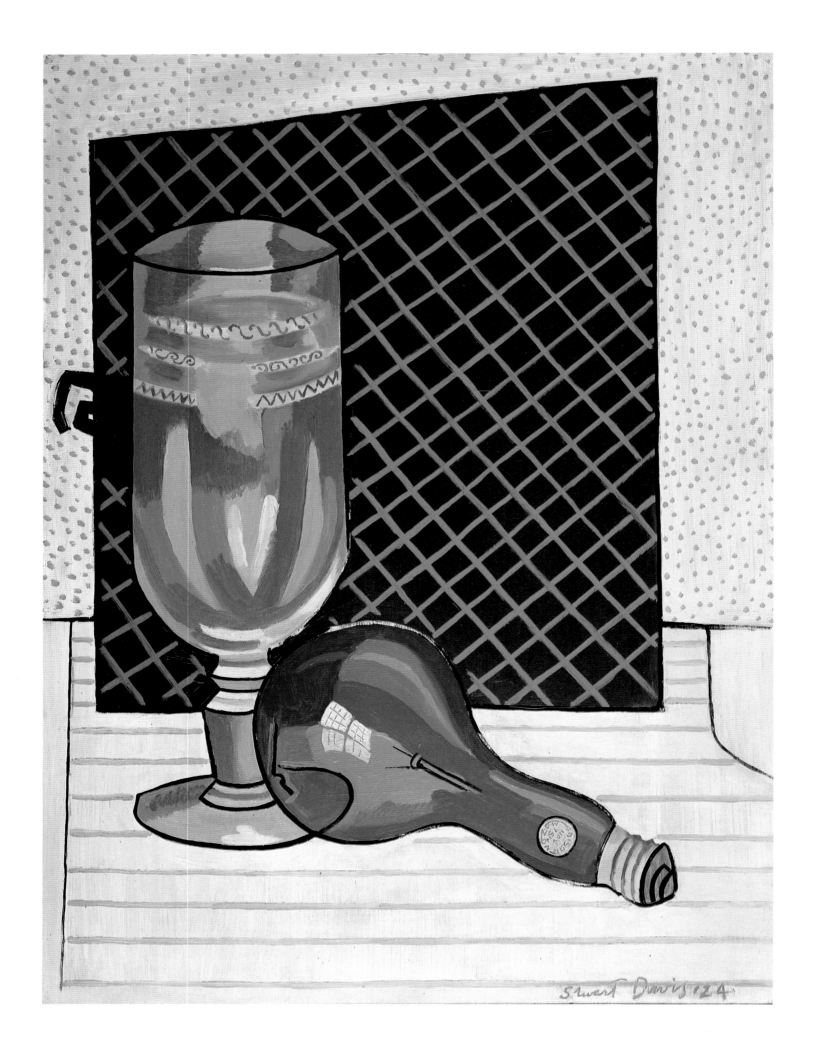

percolators (plate 101), matchbooks (plate 104), eggbeaters (plate 107), and radio tubes (plate 236), among other paraphernalia, bear witness to his continuing preoccupation with these motifs. There is a surprising likeness in spirit, if not altogether in style, between these pictures and some of the few surviving works by the American expatriate Gerald Murphy. It is not just the general hard-edgedness and clarity of the two men's paintings that united them, for others were working in similar modes. Davis and Murphy are further linked by their similar subject matter and by the generous scale of their images. Murphy's giant razors and cogs were painted in the south of France, more or less concurrently with Davis's oversized New York coffee pots and light bulbs. Murphy and Davis were probably unknown to each other, but their common interest in Léger may provide a connection. Murphy knew Léger well and frequented his studio; Davis had seen Léger's pictures in the Armory Show, although he had to wait until 1925, when the Société Anonyme organized a solo exhibition in New York, for a more comprehensive view.

Léger painted some of his most accomplished machinist pictures in the 1920s, so the 1925 exhibition of his images of contemporary life, filtered through the omnipresent machine and translated into clearly bounded, brightly colored planes, must have been particularly impressive. For Davis, who responded quickly to good modernist art in general and had particular sympathy for Léger's themes, the show must have had unusual impact. It is not surprising to catch echoes of Léger's outstanding works of the 1920s in Davis's paintings, yet there is often a sense of affinity rather than direct influence. Davis, for example, rarely modeled or shaded forms as Léger did in the 1920s, preferring to abut more or less unbroken color planes. In the few instances where Davis did experiment with modeling, he never achieved—nor attempted—the delicacy or exquisite subtlety of Léger's tonal shifts.

In his notebooks Davis ranked Léger high. "Cézanne, Matisse, Picasso, Léger, Seurat have produced the greatest paintings of all time," he wrote.[20] But he usually praised Léger for his choice of subject rather than for his formal inventions: "Léger is good because he came to grips with the subject matter of contemporary life in its industrial aspects. He incorporated its forms into his pictures."[21] Despite his respect and interest, Davis was cautious about Léger's approach. He saw his imagery and his style as potentially too concerned with geometry, and geometric subjects were "intellectual, anti-human, cold and totalitarian."[22] (This belief was part of Davis's quarrel with Mondrian and his admirers.) According to the same notebook entry, there was a progression from Cézanne, whose "objectivity" Davis esteemed greatly,

98. *Edison Mazda*, 1924
Oil on cardboard,
24½ x 18⅝ in.
The Metropolitan Museum of Art, New York; Purchase, Mr. and Mrs. Clarence Y. Palitz, Jr., gift in memory of her father, Nathan Dobson, 1982

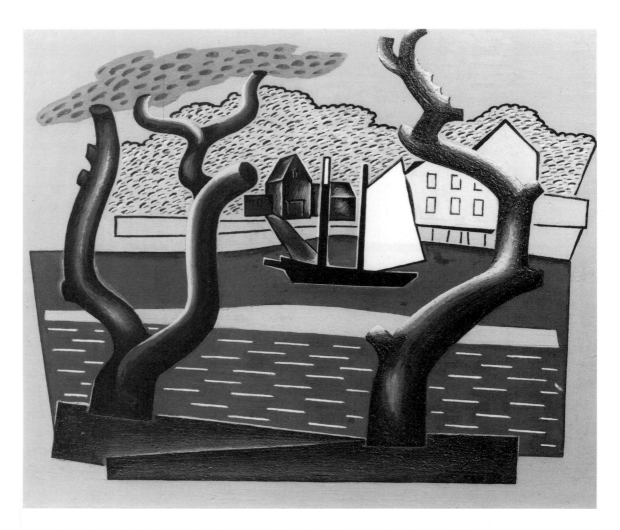

"to Cubism to Léger to Geometric Art." Léger's view of the world around him as machinery was specific and eccentric enough for Davis to be interested in it, but it also seems to have represented an outer limit that Davis felt might be perilous to cross. Just beyond that limit was Mondrian, with his insistence on the right angle and his disdain for the unexpected irregularities of the workaday world that so delighted Davis.

There is surprisingly little detailed discussion of Léger's work in Davis's notebooks. Greater attention and praise are accorded to Georges Seurat, whose clarity, stillness, and contained forms appealed deeply to Davis. (His broken stroke did not.) In a 1923 notebook entry Davis ranked Seurat higher than Monet, whom he singled out as a pioneer of the effort "to reproduce in paint a direct visual stimulation by means of the actual pigment on the panel" but faulted for producing "timeless chaos." Seurat is better, according to Davis, because of the greater definition of his shapes and forms.[23] Davis characterized the "general mood" of "Seurat's content" as "serenity." [24] It is not altogether farfetched to suppose that the Léger-like qualities of some of Davis's pictures resulted more from the combination of industrial subjects with a desire for clarity and "serenity" in the Seurat manner than from a deliberate emulation of Léger.

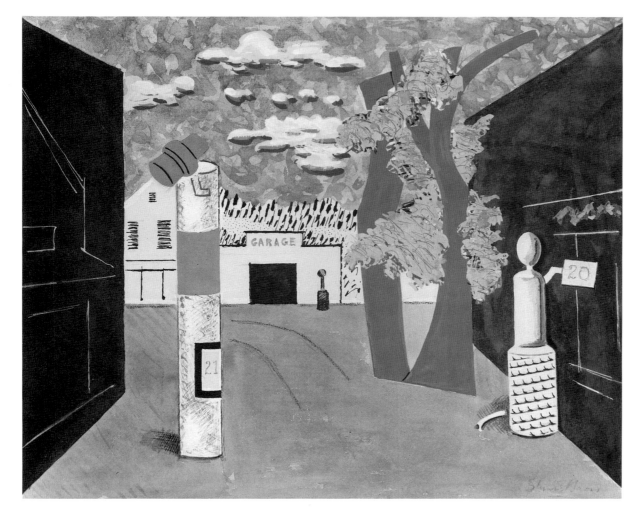

100. *Town Square,* 1925–26
Watercolor on paper,
15⅜ x 22½ in.
The Newark Museum, Newark,
New Jersey; Purchase, 1930,
the General Fund

Superficially, Davis's "industrial portraits" of 1923 are among the most Léger-like of his paintings. In these large-scale variants of traditional still life (which predate the 1925 Société Anonyme Léger exhibition), the objects under scrutiny are presented virtually intact, as simplified, drawinglike near-monochromes. In them, Davis seems to have withdrawn from the implications of the Tobacco paintings and returned to a far larger degree of naturalism. A few elegant landscapes of the mid-1920s are evidence of even greater withdrawal (plates 99, 100), but in pictures of 1927, such as *Percolator* or *Matches* (plates 101, 104), Davis began to take more liberties with the structure of his enlarged, isolated subjects and present them in terms of subtly nuanced color planes. The clear, pale color of these canvases is used to force the planes apart, adding a kind of visual pulse absent from the earlier, jammed Tobacco pictures. For almost the first time Davis seemed to be building his paintings according to what he came to call color-space logic, his phrase for his disciplined but intuitive method of using prismatic color relationships to suggest spatial relationships. It is as though he realized that the neutrality of inanimate objects allowed him to investigate space and structure in new ways.

"The culmination of these efforts," he wrote, "occurred in 1927–28,

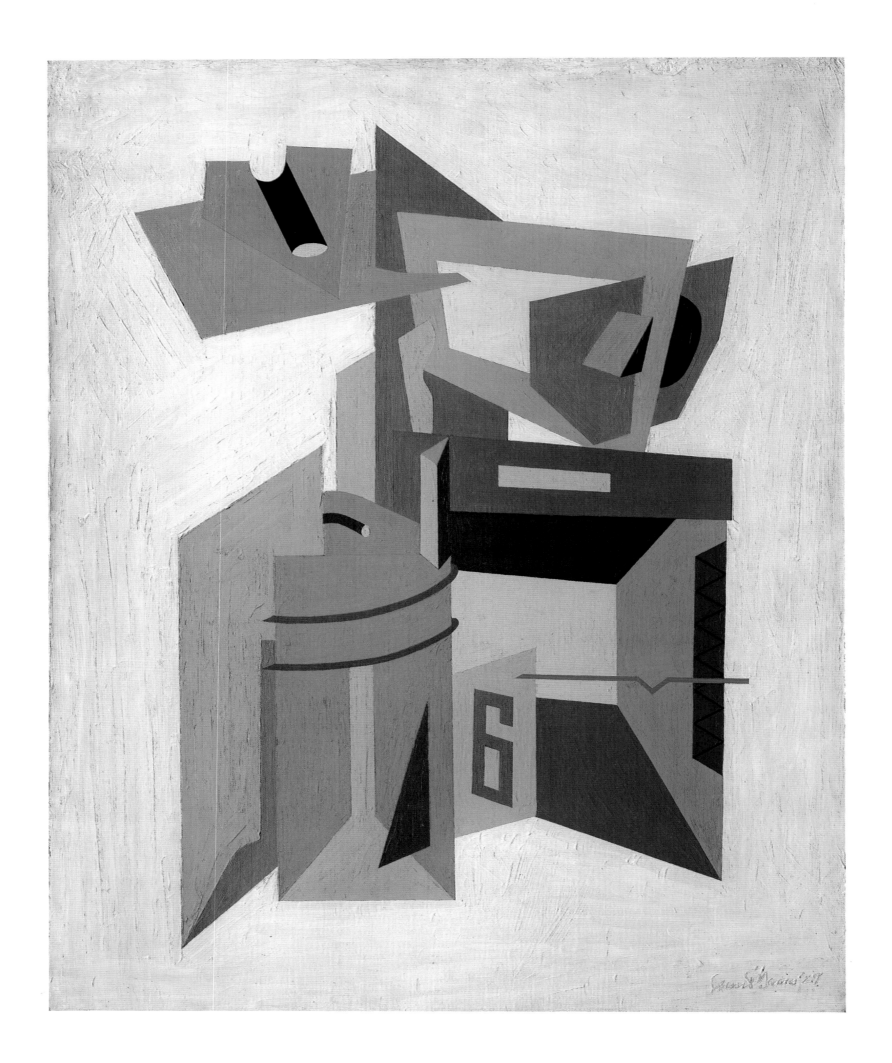

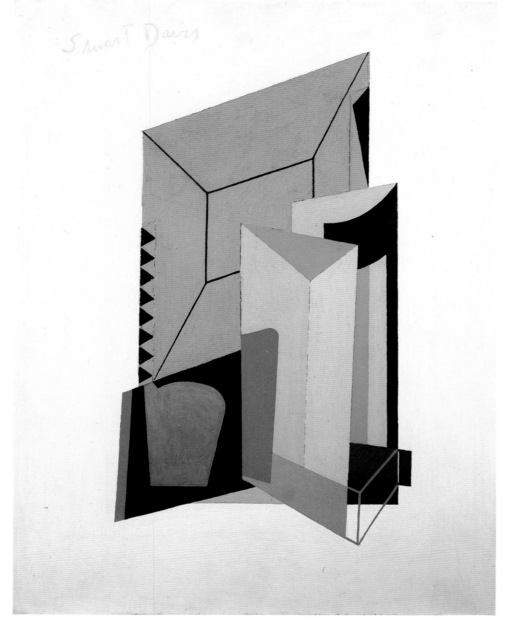

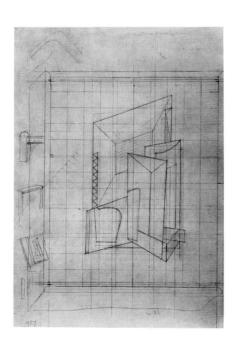

101. *Percolator,* 1927
Oil on canvas, 36 x 29 in.
The Metropolitan Museum of
Art, New York; Arthur Hoppock
Hearn Fund, 1956

TOP
102. *Study for "Percolator,"* 1927
Dated June 17, 1927
Pencil on paper, 20 x 14½ in.
Earl Davis

ABOVE
103. *Study for "Percolator,"* 1927
Pencil on paper,
18⅛ x 14¾ in.
Earl Davis

ABOVE
104. *Matches,* 1927
Oil on canvas, 26 x 21 in.
The Chrysler Museum, Norfolk,
Virginia; On loan from
Walter P. Chrysler, Jr.

LEFT
105. *Drawing for "Matches,"*
1927
Pencil on paper, 18⅛ x 12½ in.
Earl Davis

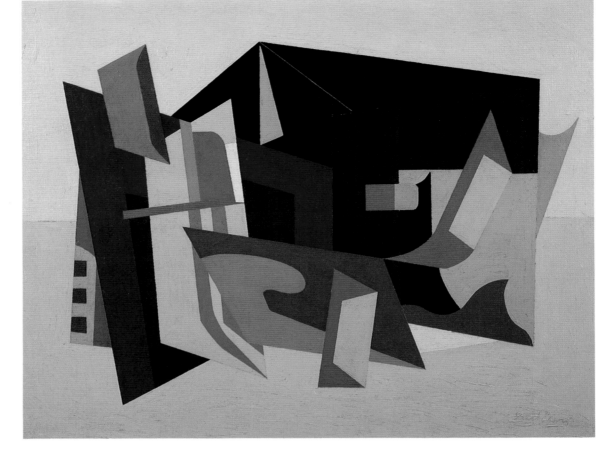

106. *Drawing for "Eggbeater No. 1,"* 1927
Dated November 3, 1927
Pencil on paper,
15½ x 19¾ in.
Earl Davis

107. *Eggbeater No. 1* (formerly known as *No. 2*), 1927
Oil on canvas, 29 x 36 in.
Whitney Museum of American Art, New York

when I nailed an electric fan, a rubber glove and an eggbeater to a table and used it as my exclusive subject matter for a year. The pictures were known as the *Eggbeater* series and aroused some interested comment in the press, even though they retained no recognizable reference to the optical appearance of their subject matter." In Davis's words, "The 'abstract' kick was on."[25]

It was abstraction based on distillation (not on "simultaneity" in William Carlos Williams's sense), as Davis's careful preparatory drawings show. The pencil drawings for *Percolator, Matches,* and the Eggbeaters bear witness to his meticulous adjustment of shape to shape, his weighing of angles and densities, his fine-tuning and tinkering with what appears, in the finished result, to be a spontaneous, sure departure from observed reality. Once achieved, the final "configuration," to use Davis's term, was traced and then squared off for enlargement on canvas. All evidence of hesitation, doubt, change, and evolution was barred from the finished canvas. But the final configuration was not just a plot for painting; it was a complete, self-sufficient work of art. Davis later insisted that "A Drawing is the correct title for my work."[26] Color, however subtle, rich, or bright, was used only to clarify the spatial perception that had provoked the original image, and it was mutable in a way that the drawing was not. The relationship of Davis's early draw-

ings to the paintings derived from them provides a key to his later working methods and explains, at least in part, the uncanny way that Davis's pictures look at once effortlessly improvised and absolutely immovable.

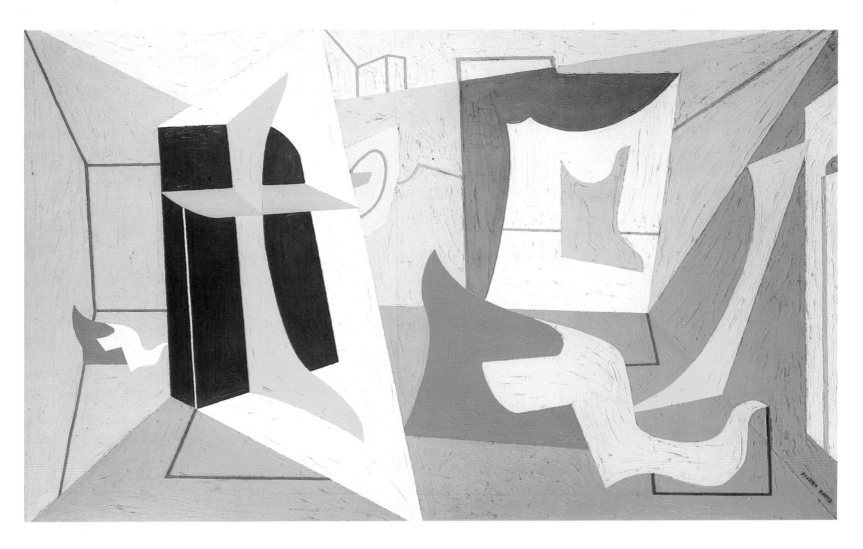

108. *Eggbeater No. 3,* 1928
Oil on canvas, 25 x 39 in.
The William H. Lane Collection

109. *Drawing for "Eggbeater No. 3,"* 1928
Dated January 16, 1928
Pencil on paper, 15 x 20 in.
Earl Davis

For Davis, a drawing was a dispassionate transposition of the artist's feelings and emotions into a clear, linear structure, a response to something seen or experienced, but not a replica of it. If this linear structure was good enough, it could serve as a skeleton that would support and strengthen a good painting or even several paintings. And as the black-and-white pictures executed toward the end of Davis's life demonstrate, the drawing could even be reexcavated to stand alone. A good drawing, a telling configuration, was not exhausted by a single variation nor by a single set of associated meanings.

The Eggbeater series is an early demonstration of these beliefs. While each version is different from the others and seems to explore different ways of faceting the illusory space of the canvas, details are repeated—the hand grip of the beater, for example—and the general layering of planes is consistent. The variations have to do with how the layered planes are described, whether they are bounded by curves or by straight lines, whether they overlap or abut, and so on; the general layout remains intact. The precise configuration of *Eggbeater No. 2* (plate 182) continued to challenge Davis; he used it again in 1940 as the basis of one of his finest paintings of the period, *Hot Still-Scape in Six Colors—Seventh Avenue Style* (plate 184). (Similarly, the configurations of *Percolator, Matches,* and other works of the early 1920s all became the bases of paintings made in the 1950s.)

Davis's paintings of the early 1920s made him visible as a determined member of the small American avant-garde and helped attract the attention of Juliana Force, director of the Whitney Studio Club, the forerunner of the present Whitney Museum of American Art. At the time, it was a fairly informal gathering and exhibition place, not far removed from its origins as Gertrude Whitney's sculpture studio, but it was one of the few places that seriously fostered adventurous American art. Davis had shown his Fauvist landscapes there in 1918, and in 1921 his recent work appeared in a three-man exhibition entitled *Stuart Davis, J. Torres-García, Stanislaw Szukalski.* Torres-García, a peripatetic South American who spent considerable parts of his life in Paris, Barcelona, and New York, was a very good painter who eventually developed an individual approach to Cubism. He is probably best known for his Pictographs: reductions of cityscapes and still-life objects arranged on painted scaffolds. At the time of the exhibition at the Whitney Studio Club, Torres-García was painting geometric street scenes similar in spirit to Davis's Havana landscapes, but despite his European connections, his pictures demonstrated a far less profound understanding of Cubist space than Davis's Table Still Lifes.

Over the next few years Davis was increasingly recognized as a

110. *Drawing for "Eggbeater No. 4,"* 1928
Dated February 9, 1928
Pencil on paper,
15¼ x 19¼ in.
Earl Davis

111. *Eggbeater No. 4* (formerly known as *No. 1*), 1928
Oil on canvas, 27 x 38 in.
The Phillips Collection,
Washington, D.C.

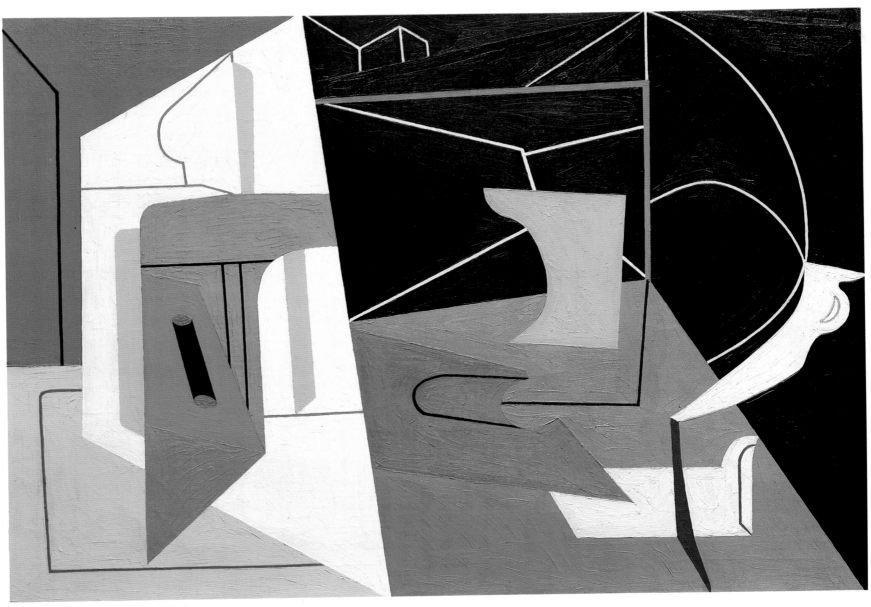

young painter to be reckoned with. In 1925 he had a one-man exhibition (his first in a museum) at the Newark Museum, which was, like the Whitney Studio Club, under enlightened leadership. On December 8, 1926, the Studio Club opened *A Retrospective Exhibition of Paintings by Stuart Davis,* no doubt a heady experience for a man who had celebrated his thirty-fourth birthday two days before. Later that month he was included in the *International Exhibition of Modern Art,* arranged by the Société Anonyme for the Brooklyn Museum. In 1927 he had his first showing at Edith Halpert's Downtown Gallery, which was the beginning of a long, if stormy, connection. Halpert—who was to be Davis's dealer for the rest of his life, with one interruption (caused by a dispute over money) and what seem to have been numerous differences of opinion—was Stieglitz's successor as the champion of daring American art. During his lifetime, Stieglitz allowed Halpert to show the work of artists in his stable, and after his death she became their New York representative. Along with Davis, she showed the work of Charles Sheeler, Charles Burchfield, Marguerite and William Zorach, and many others. Halpert was not only a thoughtful dealer but also a discriminating collector and an imaginative promoter who attracted (and kept) the attention of a handful of supporters of American modernism. Abby Aldrich Rockefeller, for example, a founder of the Museum of Modern Art, became one of Halpert's chief patrons.

But for all Halpert's support and all the growing attention, Davis's industrial still lifes and urban landscapes were not received with unqualified enthusiasm. One reviewer, discussing Davis's 1927 show at the Downtown Gallery, pronounced *Percolator* and *Matches* "quite incomprehensible."[27] The audience for advanced painting remained small, and Davis, while in the happy position of being esteemed by his peers, sold almost nothing. Any degree of financial security was still almost twenty years away. His show of paintings and watercolors at the Valentine Gallery in the spring of 1928 was exceptional in yielding an unexpected sale to someone who had been watching Davis's progress for several years. As he described it in his autobiography: "In May 1928, Mrs. Juliana R. Force, of the then Whitney Studio Club, bought several of my pictures. Having heard it rumored at one time or another that Paris was a good place to be, I lost no time in taking the hint. With one suitcase I hopped a boat and arrived in the center of art and culture in the middle of June."[28]

3
AN INTERVAL
IN PARIS

Davis plunged into the legendary late 1920s Paris. He later said that although he knew no French, he felt immediately at home and recalled "no feeling of being isolated from America, as I met practically everyone I had ever known at one time or another during the year."[1] Davis had already arranged to sublet a studio in Montparnasse, at 50 rue Vercingétorix, from Jan Matulka, the Czech-born Cubist who was one of the most progressive and influential teachers at New York's Art Students League. From his Gloucester days Davis also knew Elliot Paul, an established member of the American expatriate community, who provided Davis with an instant introduction to what Paul called "Paris in its best American days." Paul was a writer and a founder, with Eugene Jolas, of *transition,* the experimental magazine that published some of the most advanced current writing. (The magazine's list of contributors noted: "And Gertrude Stein sends what she wishes and when she wishes and she is pleased and we are pleased."[2]) Paul knew everyone, from distinguished international painters, sculptors, and writers to a rowdy gang of amateurs, Montparnasse hangers-on, and ne'er-do-wells. Davis was particularly fascinated by one of the expatriate circle, an American polymath named Hilaire Hiler, whom he met through the painter Niles Spencer. The son of a New York theatrical producer, Hiler was described by the writer Robert McAlmon as looking "rather like a handsome frog," but as being absolutely remarkable for "his ability to learn languages, argot, and to get intimately friendly at once with people of all classes and types." Furthermore, McAlmon continued, Hiler "sings and plays the piano: blues, jazz, Trinidad Negro, cowboy and French songs" and he "is not only a serious painter but a good one."[3] Hiler must have been the ideal companion for Davis, newly arrived in Paris. Hiler made at least one momentous contribution to Davis's life: he played the first Earl Hines record that Davis had ever heard.[4]

Given Davis's history, it would be reasonable to expect his painting to have become more adventurous during his stay in Paris. The city was, after all, the center of the modernist art he admired most. But

112. *Place Pasdeloup,* 1928
Oil on canvas, 36¼ x 28¾ in.
Whitney Museum of American Art, New York

111

Davis's response to his year abroad was complex and did not produce simple changes in his work. Clearly, the city itself had an overwhelming effect on him. Davis had resisted the picturesque allure of New Mexico, but he capitulated to Paris at once. As a connoisseur of urban life, he was seduced by the city; its otherness entranced him. His sketchbooks record his pleasure in everything unmistakably French: mansard roofs, café tables, an overblown hotel arm chair, syphon bottles, a Turkish toilet (plates 113–18).

Davis had brought with him a few of his New York paintings of the previous year, perhaps as passports to the world of advanced French art, perhaps just as aids to help him work in a new place; but none of his Paris pictures seem to have much to do with the ambitious inventions of the Eggbeater series. Davis explained that "the year before, in New York, I had looked at my eggbeater so long that I finally had no interest in it. But over there, in Paris, the actuality was so interesting I found a desire to paint it just as it was."[5] Davis found Paris so absorbing that he seems never to have left it during his year abroad, except for day trips to the country. His letters home corroborate his fascination with the city. A few months after his arrival, Davis wrote to his father: "I am principally interested in the streets. There is great variety, from the most commonplace to the unique. A street of regular French working class homes of 100 years ago is interesting because they are all different in regard to size, surface, number of windows, etc."[6] In the same letter he described various places that had first caught his imagination, including "the Hotel du Sens, built in 1500, a regular medieval castle." But Davis was still the same concerned young man who had donated his work to the *Masses;* the Hotel du Sens interested him, too, because "it is occupied by Polish Jews who pay $20 a year rent. They have just been ordered out by the city amid great protest because it is in danger of falling down, burying all its inhabitants in debris." The letter also describes the exquisite Place des Vosges (which Davis painted several times) and catalogs many other buildings in the Marais, the heart of seventeenth-century Paris, giving their dates and capsule histories. Like most Americans in Europe for the first time, Davis was deeply impressed by the age of the cities, the evidence of continuous habitation.

Later, after his return to New York, with the aura of expertise conferred upon him by having lived in Europe, Davis liked to declare his admiration for French art and culture; but his letters home, somewhat facetiously, stress the convenience of a way of life that encouraged sitting for long periods in public places. He was impressed, too, by Parisian driving: "There is no left or right. Everything goes as it chooses. . . .

The drivers of taxis have devilish skill. . . . Do they stop when coming to heavy traffic? No. They plan so that when they skid they will be where they want to be. No bus driver will let any vehicle pass him if he can help it. When you get out of a bus you know you have been for a ride."[7]

Nevertheless, Davis was there because Paris was the center of art and culture, and he was outspoken throughout his career in his belief that the best new American art, including his own, developed from the discoveries of French innovators. Ten years after his return from France, he still referred to Paris as "the place where art is produced," and he later praised French art as "masculine," in contrast to American art, which he said was "schoolgirlish in its expression."[8] America compared most unfavorably to France as a dwelling-place for painters and sculptors: "America has no culture in art. There are no marks of the art-brain on the environment. The tall cathedral surrounded by peasant huts is culture, the impact of the spirit on the landscape. The Paris café, chair on the street, is culture, impact of philosophy on the facades. But America is pure practicality and utilitarianism."[9] (Davis's self-appointed task was to stamp the pure practicality and utilitarianism of the American city with the marks of *his* art-brain, at least within the boundaries of his canvases.)

Despite his liking for the place and his admiration for French modernism, Davis's letters home chronicle his disappointment in the art exhibited in the city. He told his family that he was working well, producing many pictures, but he complained: "I just saw the Société des Independents. Over 4000 paintings of the vilest nature conceivable. The NY Independents is just as bad but when you see a mile of galleries with the worst paintings in the world all packed together it is a different effect. The Salon Tuilleries is better and also the Salon d'Automne. But none of the good artists send to them."[10] Older art apparently had few charms for Davis. In a letter to his cousin Hazel Foulke, who was studying at the Pennsylvania Academy, he wrote: "I have seen more bad art here than I ever saw before also a few good ones. The Louvre and the Luxembourg are terrible."[11] Unfortunately, Davis did not expand on these comments in his letter, nor are there clues to his opinions about pre—nineteenth-century art in his notebooks.

The "official" version of Davis's recollections, the autobiography he prepared in 1945, is probably accurate in intimating that his real affection was reserved for the city and its amenities, not for its art. Just as he had done in his letters to his parents and his cousin, Davis emphasized the beneficial effects on his own work of being abroad, but he made little mention in the autobiography of seeing art or other artists. Even

allowing for Davis's usual deadpan humor, this excerpt is not a description of a man who had plunged into the world of vanguard French painting: "I had the feeling that this was the best place in the world for an artist to live and work, and at that time it was. The prevalence of the sidewalk café was an important factor. It gave easy access to one's friends and gave extra pleasure to long walks through various parts of the city. The absence of American drive and tempo was not missed. . . . There was a seeming timelessness about the place that was conducive to the kind of contemplation essential to art." [12]

At first sight, Davis's Paris paintings seem more naturalistic and more specifically about place than anything he had been working on in New York. They record, more or less literally, the idiosyncracies of the Parisian street. Davis focused on the small, telling details of his new surroundings at the expense of the broader, more abstract forms that he had emphasized in his still lifes of the previous years. The balconies, rooftops, awnings, and café appurtenances that appear in his sketchbooks are equally present in his canvases. *Rue des Rats, No. 2* (plate 119), for example, celebrates a child's drawing of a horse's head that Davis had seen on a wall and faithfully copied into a sketchbook (plate 120). But Davis's explanation that he wanted to paint the actuality of Paris just as it was is belied by the paintings, which are more complex than they seem at first glance. Davis took surprising liberties with the actuality he purported to respect, flattening the planes of buildings and streets, turning the small elements of architecture and street scene into stylized patterns. The apparent literalness of the pictures is due largely to his frequent refusal to interrupt or cancel out any part of the streetscape or to alter its scale. In the Eggbeaters he had visually disassembled the objects he had painted so often, so that the eggbeater, the electric fan, and the glove became all but unrecognizable and their actual spatial relationships ambiguous. In his images of Parisian streets, Davis kept everything more or less intact, as though the character of the city was so powerful that he was unable to eliminate or shift any portion of what he saw. (For most of his career he suffered from similar inhibitions when he painted figures, often to the detriment of those pictures.)

Longer acquaintance with the Paris paintings makes it clear that Davis tried to subvert their inherent naturalism with color and texture. The street scenes, in fact, support larger-scale "abstract" configurations established by blocks of nonnaturalistic color, varied paint surfaces, and schematic patterns. In *Place Pasdeloup* (plate 112), for example, bands of flatly applied red and blue turn the facade of a white building into a kind of French flag, while these strips are in turn interrupted

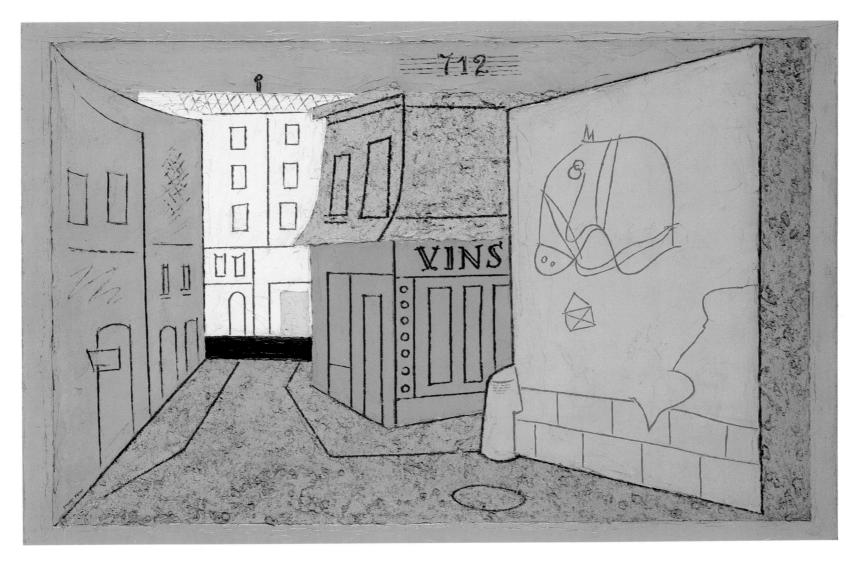

OPPOSITE

117. *Drawing from Paris Sketchbook,* c. 1928
Pencil on paper, 8½ x 10⅝ in.
Earl Davis

118. *Drawing from Paris Sketchbook,* c. 1928
Pencil on paper, 8½ x 10⅝ in.
Earl Davis

119. *Rue des Rats, No. 2,* 1928
Oil and sand on canvas,
20 x 29 in.
Hirshhorn Museum and
Sculpture Garden, Smithsonian
Institution, Washington, D.C.; Gift
of Joseph H. Hirshhorn, 1972

120. *Horse's Head (Child's Drawing),* c. 1929
Pencil on paper, 12 x 8½ in.
Earl Davis

and flattened by windows whose colors—candy pink and green on the red and blue green on the blue-set up counterrhythms at a smaller scale. The dazzling color and crusty sections of *Rue des Rats No. 2* similarly detach planes from their literal context and defeat the illusion of enterable space. His subject may have been that of the souvenir postcard and the travel poster, but the colored superstructure of *Place Pasdeloup,* like the gritty textures of *Rue des Rats No. 2,* makes it clear that Davis was thinking in terms other than the recording of actuality "just as it was." And the inventive color and lucid but complex space of *Adit, No. 2* (plate 121), one of the subtlest of Davis's Paris paintings, offer testimony that he was completely au courant with contemporary Cubism.

As a group, the Paris pictures suggest that Davis's focus had changed since his days at Henri's school. He concentrated on what Paris looked like, on the appearance of the streets, not on the life of the streets, as he had in Hoboken and during his early days in New York. This may have had something to do with a sense of being an outsider, isolated by his incomprehension of the language. "It is a great misfortune not to speak French. It is like being deaf and dumb and it is impossible to learn in a short time. The pronunciation is mysterious, arbitrary and obscure. In fact I don't think the Frenchmen know what they are saying half the time. People learn to read and understand much easier than to speak." [13] After six months in Paris, Davis was still writing in the same vein: "I like it here very much (I don't really like anyplace as [Marsden] Hartley says) but I like it here better than America. Of course I can't speak a word of the language and never will I'm sure. The bloody Frenchmen can't even understand each other so what chance have I got?" [14] But Davis's turning the Paris streetscape into a theme for formal manipulation—as much as his strong feelings about the place permitted—was not simply the result of feeling distanced by the language barrier. This kind of detachment was also part of modernist practice and part of Davis's more usual way of working in the years before his trip to Europe. And in spite of his difficulties with French, Davis was far less isolated from the world of advanced Parisian art than his public recollections would suggest.

His letters reveal that rather than remaining apart and concentrating on his own work, Davis quickly made contact with the expatriate members of the avant-garde and a few who were not expatriates. It is true that he repeatedly said that he came across just about everyone he had ever known during his year in Paris, but that is not the same as seeking out introductions. In his first letter to his father, written soon after his arrival in June, Davis wrote that Elliot Paul had promised to

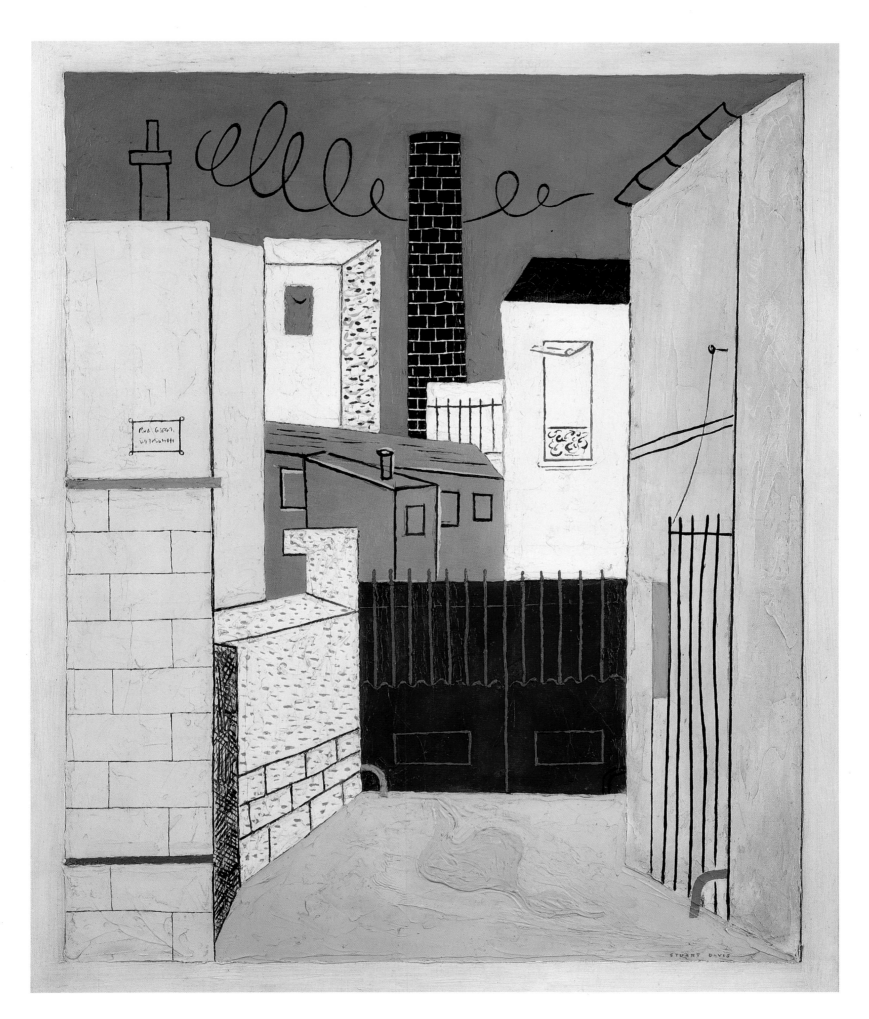

take him to Picasso's studio. The visit had apparently not taken place by September, but it was still in the offing and Davis was evidently eager to go.[15] The absence of any further mention of a meeting suggests that it never happened, for Davis would certainly have described such a momentous event. Paul was more successful in making an almost equally important introduction. Since he was a special favorite of Gertrude Stein's, he was able to arrange for her to visit Davis's studio. (Paul himself was enough of a fan to write a piece on Davis's painting for *transition* and to reproduce some of his work, so making the Stein–Davis connection was clearly intended for the benefit of both artist and collector.) Davis hoped that this well-known supporter of modernist art would buy one of his pictures—she didn't—but he did visit the celebrated apartment on the rue de Fleurus several times. "Gertrude Stein came to see my paintings," he wrote home. "She is the famous patron of Picasso. And I went to her place and saw all her Picasso and Gris paintings. I am going again, tomorrow night."[16] Davis never seems to have become a regular at the Stein–Toklas evenings, but seeing her collection must have been an exhilarating experience for him.

The most interesting encounter, never alluded to in his autobiography, is described in more detail than the visit to Gertrude Stein's: "I went to the studio of Fernand Léger, internationally famous modernist painter. He showed me all his newest work. Very strong. Next day he came to see my work. He liked the Egg Beaters very much and said they showed a concept of space similar to his latest development and it was interesting that 2 people who did not know each other should arrive at similar ideas. He thought the street scenes I am doing here too realistic for his taste but said they were drawn with fine feeling. He invited me to send something to a show he is organizing in January."[17]

The greater simplification of some of Davis's Paris pictures, such as *Adit, No. 2* and *Rue des Rats, No. 2*, may have been a response to Léger's criticism, but it is difficult to establish an exact sequence for the paintings. Léger's stripped-down still lifes of the period, with their large geometric planes and schematic profiles, seem quite unlike Davis's small-scale urban landscapes. Davis's pictures did not become as spare or as generously scaled as Léger's until the 1950s. Again, it is difficult to establish direct influence; affinity, or at least *informed* affinity, seems closer to the mark.

Davis began to make prints in Paris, his first since a single etching and two monotypes of about 1915. The eleven lithographs that he produced in 1928 and 1929 are based closely on a selection of his Paris streetscapes (further evidence of Davis's thrifty reuse of con-

figurations that pleased him). The prints translate the inventive color and varied textures of the paintings into rich orchestrations of black and white, supporting Davis's claim that drawing was the primary aspect of his work, despite his evident gifts as a colorist. It seems likely that, like many of the American artists in Paris, Davis produced his prints under the guidance of the master lithographer Edmond Desjobert, although this is not proven.[18] John Graham, who was living in Montparnasse near Davis during the summer of 1928, was almost certainly working at the Atelier Desjobert.[19] If Graham and Davis were both at the workshop (or if they had met in New York earlier in the decade), Graham could easily have introduced Davis to anyone he wished to meet—assuming Graham's claims of intimacy with the leading members of the Parisian art world were true. However, there is no mention of Graham in Davis's letters, and it is possible that they had not yet met.

Davis did meet some of the more sophisticated and accomplished American artists and writers of the period, probably through Elliot Paul, although he seems to have known some of them before coming to Paris. Niles Spencer is mentioned many times in Davis's letters home as someone known to his family; he sometimes appears as "Niles Suspenders." The Francophile American poet Bob Brown and his wife, Rose, arrived in Paris soon after Davis; they were old friends from the *Masses* days, when Brown had been the only writer to resign in sympathy with the artists in the dispute over editorial policy. Marsden Hartley is mentioned as well, and while the letters are not explicit, the two men probably had a good deal to talk about, despite differences in ages and tastes (Hartley was fifteen years older than Davis). They had both painted for extended periods in Provincetown and Gloucester; both had found New Mexico unsympathetic. Hartley was close to Charles Demuth, who had been so helpful to Davis when he was first trying to be a "Modern artist," and Hartley's long friendship with William Carlos Williams was another link. Davis seems to have shared some of the expatriate community's enthusiasms and aversions. Contemporary accounts of Alexander Calder's first performances of his wire circus often imply that he wasn't taken altogether seriously. Davis seems to have agreed: "Tonight we are going to the opening of Sandy Calder's exhibit on the Rue de Boëtie (son of Sterling Calder). Nobody is much interested in his work but it is an excuse for a lot of people to bump into each other."[20]

Davis was obviously more informed about the Paris art world than he later cared to admit. After not quite a year in the city, he was well enough known as a member of the artists' community to warrant a

mention in the Paris edition of the *New York Herald:* "Now that the weather is sufficiently warm for outdoor sketching, Stuart Davis may be seen each morning in a large cafe of which the pillars are decorated with bad paintings and which has a water fountain in the centre and a soda fountain in one corner. Shortly after noon, however, he starts out with his pad and pencil. . . ."[21] Perhaps his official version of the Paris stay was meant to suggest that he had remained uninfluenced, even while in close proximity to the artists whose work had taught him so much from early in his career. Perhaps it was a canny defense against the views of reactionary critics. (He complained later that "American artists who sought to continue the discoveries of Paris were denounced as un-American."[22])

Whatever the explanation, the evidence of Davis's pictures plus the revelations of his letters contradict his avowal that all he wished to do was paint Paris as it was. A passing reference in his autobiography provides a clue to what he was after: "There was so much of the past, and the immediate present, brought up together on one plane." This could be a description of his own first attempts to make a range of disparate events and places coexist on the same canvas—the "simultaneity" of the Gloucester pictures—although the Paris paintings have no obvious "multiple views" in the Gloucester sense. Bringing things "up together on one plane" sounds like the Cubist habit of conflating a variety of perceptions to make a new unified image, but Davis's Paris pictures have little of the spatial structure of Cubist paintings. Instead of reading as an arrangement of fluctuating planes, all related to a single surface plane, as Cubist pictures do, Davis's Paris streetscapes often seem to exist in terms of two not quite integrated spatial concepts: a relatively traditional urban landscape and a superimposed abstract layer of extraordinary color, texture, and pattern, the whole bound uneasily together by a sharply defined painted border. The abstract superstructure appears to be a brilliant, flat—if interrupted—surface independent of the illusionistic space of the street scene. What makes this confusing is the double role of the drawn patterns; collectively, as detached drawing, they serve to reassert the flat, painted surface of the canvas; but at the same time they are derived from the richly specific linear elements of Davis's Paris sketchbooks: shutters, wrought iron, mullions, signs, and so on. Far from knitting the past (the urban fabric of Paris) into a seamless whole with the present (modernist attitudes toward imagery), Davis forced them into a visually unstable association.

Davis's 1945 autobiography gives the impression that he was alone in Paris, but he had traveled there with a companion, Bessie Chosak,

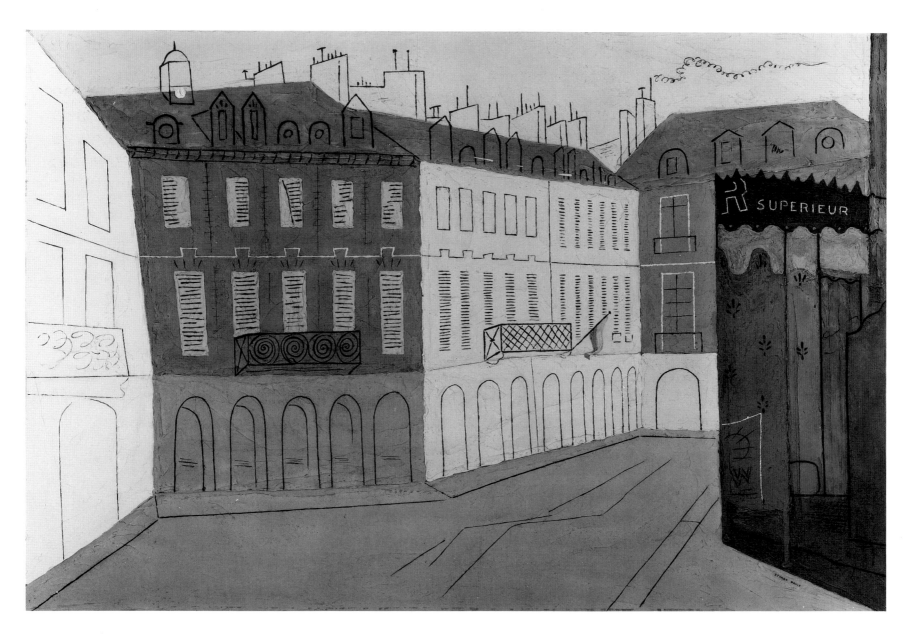

122. *Place des Vosges No. 2,* 1928
Oil on canvas, 25⅝ x 36¼ in.
Herbert F. Johnson Museum of
Art, Cornell University, Ithaca,
New York; Bequest of Helen
Kroll Kramer, Dr. and Mrs. Milton
Lurie Kramer Collection

a native of Brooklyn. Davis's family evidently disapproved of Bessie and refused to acknowledge her existence, so the private records of Davis's Paris year are no more informative about her than the public. There seem to be no photographs other than on her passport, no references to her in any of Davis's papers. Davis dutifully wrote home at regular intervals—his parents insisted on separate letters to each of them—but he never spoke of Bessie in any of these reports. There is the occasional first-person-plural construction, but no sign that "we" meant anyone other than Davis and his Paris cronies. Family disapproval notwithstanding, Bessie Chosak and Stuart Davis were married in Paris in 1929.

A few years after leaving Paris, Davis wrote that his stay in Europe had enabled him "to spike the disheartening rumor that there were hundreds of talented young modern artists in Paris who completely outclassed their American equivalents. . . . It proved to me that one might go on working in New York without laboring under an impossible artistic handicap. It allowed me to observe the enormous vitality of the American atmosphere as compared to Europe and made me regard the necessity of working in New York as a positive advantage." [23]

Even so, Davis's decision to return to the United States after more than a year in Paris was not entirely voluntary. He had exhausted the funds provided by the sale of his pictures to Juliana Force, and while his father seems to have furnished some financial aid (in spite of his reservations about Bessie), it must have seemed sensible for the newly married couple to return to a place where some employment might be possible. Davis said that he left Paris "with regret" but "this is not to say that it was my wish to remain planted in France. On the contrary, at the time of leaving I already had the idea that six months more would be about enough, providing frequent returns were possible." [24] Davis had a good deal to show for his time abroad: a large body of paintings, drawings, and lithographs that he hoped to exhibit (and sell) once he was back in the city. In August 1929 Bessie and Stuart Davis sailed on the maiden voyage of the *Bremen*. Davis never came back.

ART AND SOCIAL ACTION

4

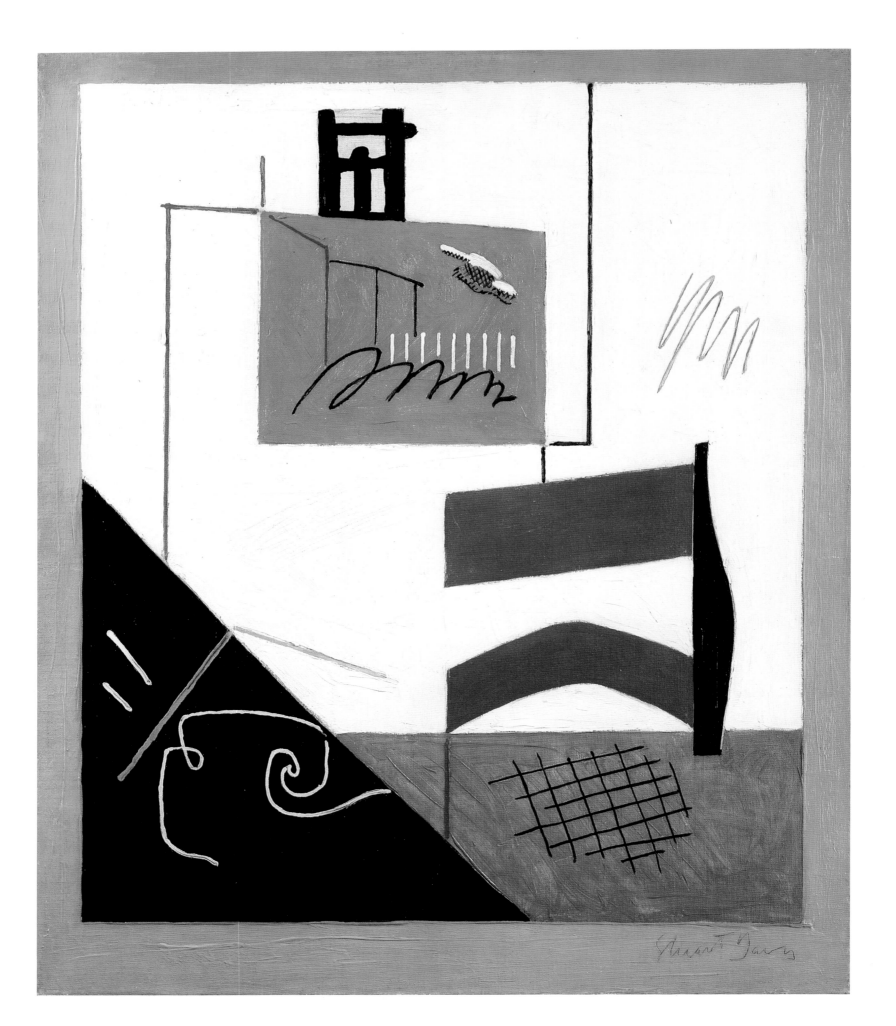

The Davises arrived in New York just in time for the last feverish months of the prosperous 1920s. Davis later recalled: "On my arrival in New York I was appalled and depressed by its giantism. Everything in Paris was human size, here everything was inhuman. It was difficult to think either of art or oneself as having any significance whatever in the face of this frenetic commercial engine."[1]

The stock market crash of October 1929 slowed, and nearly stopped, the "frenetic commercial engine" within a frighteningly short time. The Depression quickly turned Davis into a frontline organizer for social reform, to the point where he had little time to be a studio artist. (It also eliminated his hopes of "frequent returns" to Europe.) As for thousands of Americans, the early 1930s were a time of acute economic difficulty for Davis, and it soon became a time of acute personal difficulty, as well. Things began well enough after his return from France. Edith Halpert was eager to exhibit Davis's new work and arranged for several showings. The Davises settled into Greenwich Village, first at Thirteenth Street and Seventh Avenue, then near St. Mark's Place, and Davis taught for a year at the Art Students League. Eventually, however, he was forced to teach private pupils, and since these classes were held mornings and afternoons, they seriously disturbed his painting schedule. Then, in June 1932, Bessie died suddenly of peritonitis after a badly performed abortion.

Remarkably enough, Davis's paintings of the period seem in many ways curiously untouched by the hardships that surrounded him, but it is difficult to generalize about them; variety, rather than consistency, is his hallmark for most of the 1930s, an even greater variety than his habitual multiplicity of approaches. Throughout the decade Davis produced relatively few works, but he constantly changed scale, medium, and method, making easel paintings, ink drawings, murals, lithographs. His works of this period range from near illustration to radical abstraction, from cartoonlike figures to inspired color-space improvisations—and just about everything in between. It is tempting to

123. *Interior,* 1930
Oil on canvas, 24 x 20 in.
The William H. Lane Collection

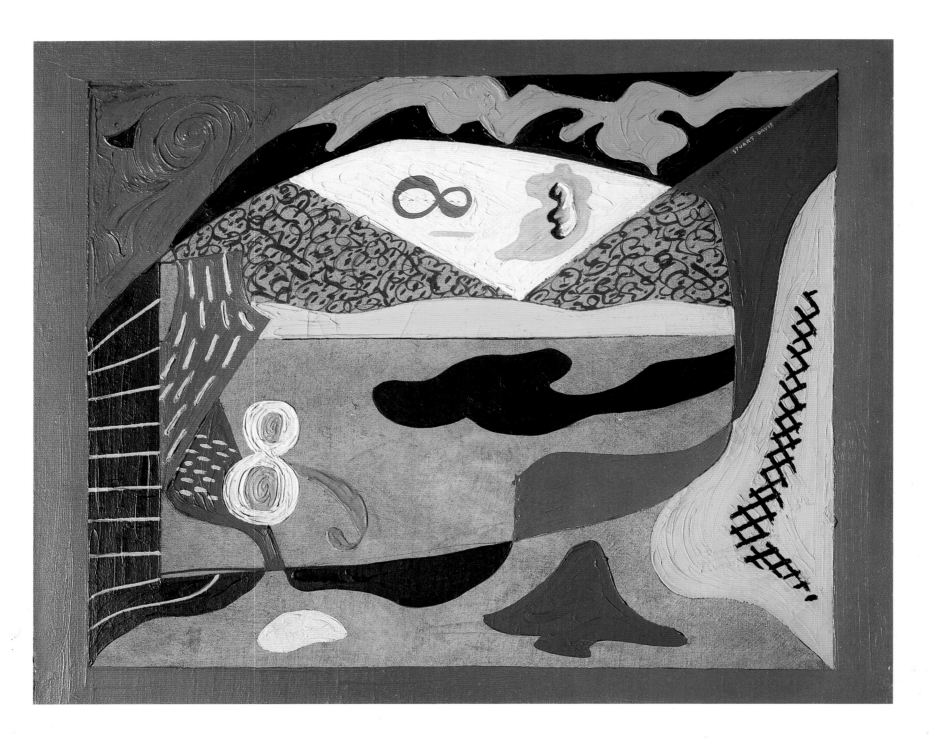

124. *Lawn and Sky*, 1931
Oil on canvas, 18⅝ x 22⅝ in.
Archer M. Huntington Art
Gallery, The University of Texas
at Austin; Lent by James and
Mari Michener

blame the erratic swings that characterize Davis's works of the period
on his interrupted working schedule or his preoccupation with social
issues, yet the pictures he made in New York and Gloucester imme-
diately after his return from Paris, when he still maintained more or less
normal studio habits, are equally diverse.

The 1930s, like the early 1920s, was a period of experimentation
and consolidation for Davis. It seems to have taken him some time
to come to terms fully with the effects of his stay abroad. Especially in
the first years of the 1930s he seemed to be testing the limits of the
modernist vocabulary he had so painstakingly assembled and to be
measuring his French experience against his acute sense of his own

CLOCKWISE FROM TOP LEFT

125. *Drawing for "Spring Blossoms,"* c. 1931
Pencil on paper, 14¼ x 18¼ in.
Earl Davis

126. *Drawing from New York
City Sketchbook #1,* c. 1930–31
Ink and pencil on paper, 10¾ x 14½ in.
Earl Davis

127. *Spring Blossoms,* 1931
Oil on canvas, 22 x 36 in.
Mr. and Mrs. William C. Janss

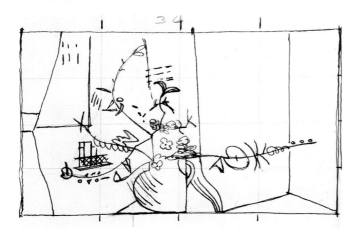

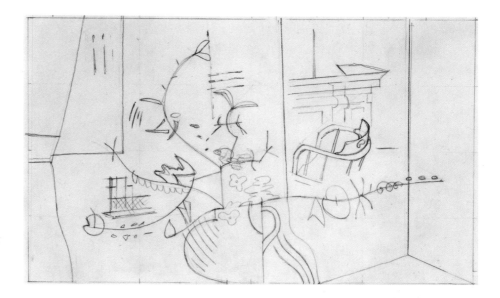

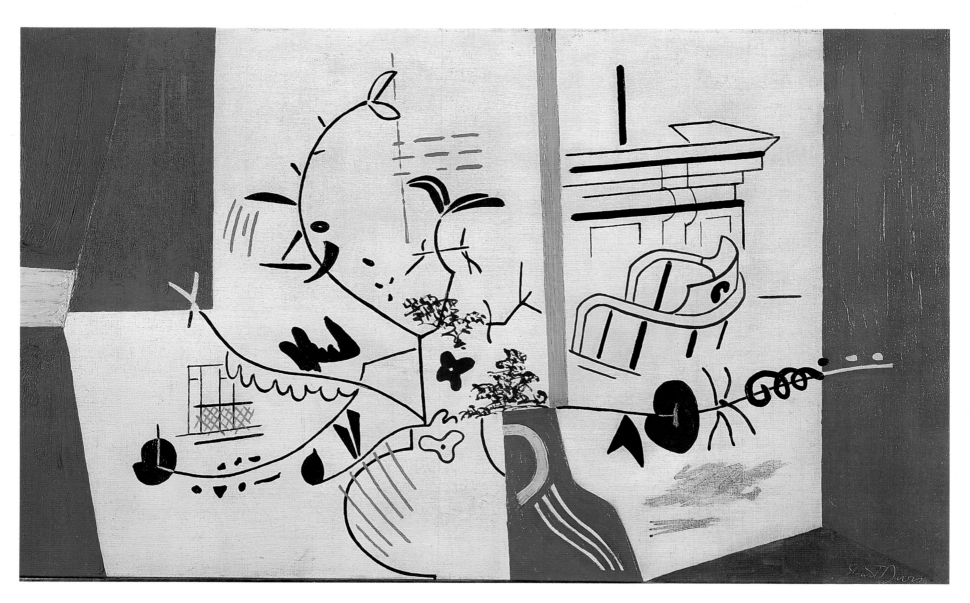

Americanness. Soon after his return, he tackled his Eggbeater theme once again, as though trying to pick up where he had left off before sailing for France. But the stylized naturalism of *Eggbeater No. 5* (plate 128), 1930, is closer to the Paris streetscapes than to any of the earlier paintings in the series. Instead of the disembodied planes of the first Eggbeaters, Davis set firmly drawn, recognizable objects, solid enough to cast shadows, on a Victorian table. The mass-produced, nonart objects of the original setup—the electric fan and the rubber glove—are replaced by familiar atelier props: a mandolin and an odd vaselike object, whose hatched pattern suggests both the syphon bottles that Davis drew in Paris and the intricacies of cut glass. The all-American eggbeater is a foreigner among the typical elements of a European still life. Is *Eggbeater No. 5* a surrogate self-portrait, a retrospective image of Davis in Paris?

The painting is far more subtle and more "advanced" than it seems at first sight. The color is especially sophisticated (and Picassoesque), with the black and white of the tabletop and its objects made more startling by the atmospheric blue ground and the saturated red-brown of the table legs. The lavender of the spindle helps to hollow out a pocket of space in the lower part of the canvas—an effect heightened by the darker blue ground in this zone—while the acid yellow border makes the entire image flat and frontal. Davis assigned *Eggbeater No. 5* to a series predating his stay in Europe; yet it is one of the most "French" of his paintings, surprisingly close to the kind of modernist still life of the late 1920s that he must have seen in Paris. Davis's debt to Picasso, Léger, and Gris is perhaps more evident in *Eggbeater No. 5* than in any of the paintings he made in France. The stylized mandolin, the tipped table, the machinelike spindle of the table base all have precedents in the School of Paris, as though Davis felt freer to follow their example once he was at a safe remove.

Eggbeater No. 5 neatly summarizes Davis's experience of French art of the late 1920s. Certainly it seems more informed by his encounters with French modernism than the New York–Paris paintings made about a year later, even though they were intended to define just what Davis had carried away with him from France. The series (plates 137, 138) compares his recollections of Paris with his renewed awareness of the United States, expanding the notion of simultaneous past and present that he explored in his Paris streetscapes. On his return to New York, Davis rediscovered his city. The Paris sketchbooks exalt the minutiae of the French street, and his New York sketchbooks of the 1930s (plates 129–36) itemize the American equivalents: typical shopfronts, the El, tenement cornices, street lights, the towers of the old downtown

128. *Eggbeater No. 5*, 1930
Oil on canvas, 50⅛ x 32¼ in.
Collection, The Museum of Modern Art, New York; Abby Aldrich Rockefeller Fund

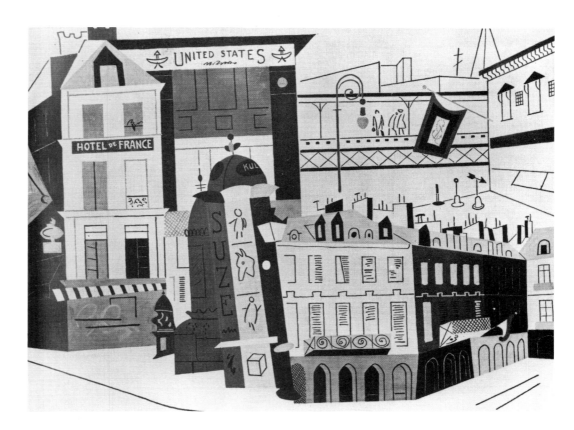

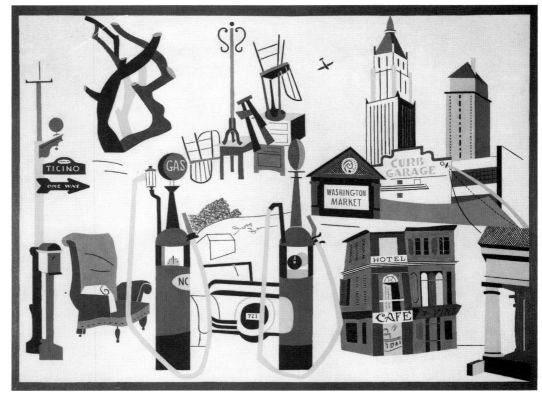

skyscrapers, and the fantastic new skyline of midtown. In the New York–Paris series Davis used these acute observations of his American present quite literally and set them beside equally literal images of his recent foreign past. But the French images are distanced by having already been made into art: they are quotations from Davis's Paris streetscapes. In *New York–Paris No. 2* (plate 137), a French kiosk tow-

133

ers above a schematic Place des Vosges, both backed by the ubiquitous New York El. In *New York–Paris No. 3* (plate 138), the present dominates: Parisian buildings are dwarfed by their New York context.

The series is not wholly successful. As in the earlier "simultaneous" Gloucester pictures, the juxtaposition of disparate parts, with accompanying shifts in scale and viewpoint, results in something more like a group of vignettes than a pulsing Cubist space. Davis tried to overcome the difficulty by setting his assorted images against neutral, continuous backgrounds, but the various parts of the pictures never quite coalesce. It may be that Davis's shorthand allusions are too close to illustration or that he hadn't yet purged himself fully of the illusionism of the drawing in his French pictures. But the French streetscapes are redeemed by their inspired color, and this is most conspicuously lacking in the New York–Paris series. Compared, for example, to the glowing pinks, oranges, and grays of *Rue des Rats, No. 2* (plate 119), which are the structural "bones" of the picture, the sour tones of *New York–Paris No. 2* merely distinguish one shape from another.

Whatever its merits or faults, the New York–Paris series explores intriguing ideas. Davis would return again and again to the task of encompassing his multiple perceptions and feelings about urban life, in all its aspects, in his paintings and drawings. He continued to examine new ways of dealing with this task in the early 1930s, in pictures such as the "simultaneous" *House and Street* (plate 142), 1931, and the ambitious, complex *New York Mural* (plate 144), 1932. He also kept probing ideas that had absorbed him before leaving for Europe, perhaps to reestablish the rhythm of working, perhaps to test how much he had

RIGHT
140. *Drawing for "House and Street,"* 1931
Ink on paper, 10¾ x 14½ in.
Earl Davis

OPPOSITE, TOP
141. *Study for "House and Street,"* 1931
Graphite and watercolor on paper, 23½ x 40 in.
The Carnegie Museum of Art, Pittsburgh; Edith H. Fisher Fund, 1984

OPPOSITE, BOTTOM
142. *House and Street,* 1931
Oil on canvas, 26 x 42¼ in.
Whitney Museum of American Art; Purchase

143. *New York Cityscape*, 1932
Pencil on paper, 9 x 7¾ in.
Earl Davis

144. *New York Mural*, 1932
Oil on canvas, 84 x 38 in.
Norton Gallery and School of
Art, West Palm Beach, Florida

learned. Davis restated his kitchen abstraction motif with great daring and simplicity in the superb *Salt Shaker* (plate 145), 1931; interestingly enough, this was painted at about the same time as he worked on the New York–Paris pictures. An enormous salt shaker fills the canvas, its sheer size removing it from the realm of reality. Floating calligraphic shapes, suggestive of Miró, anticipate both the patterning of Davis's seminal paintings of the 1940s and the scaled-up words of his last works. The Picasso-inspired striped ground and the dry, thick paint make the image seem almost heraldic and, by contrast, make the unanchored shapes of the "figure" even more lively and mobile. The color is unusually restricted and theoretical for Davis at this time, but by

136

limiting himself to black and white and a few notes of primaries, he disassociated *Salt Shaker* from his earlier kitchen abstractions, with their delicate halftones. The result is a paradoxical and engaging painting, at once austere and playful, whose seeming geometry is repudiated by eccentric drawing and a staccato rhythm of color accents.

The large scale and dominant black and white of *Salt Shaker* suggest some connection to Davis's fine series of lithographs of 1931 (plate 147). Unlike his earlier Paris prints, which dealt quite directly with streetscape images already developed in his paintings, the five New York prints are independent and complex inventions that incorporate urban and Gloucester images with Mirólike organic forms. Some of the motifs are recognizable from Davis's drawings, but they are combined in ways new to him. The swelling, figurelike forms and geometric cityscape elements achieve a kind of monumentally scaled patterning that seems allied to *Salt Shaker*. The sumptuous range of black-and-white patterns that gives the series much of its tonal richness also seems related to the emphasis on pattern and severely reduced color in the painting. That very richness of tone, a sign of great accomplishment in the medium, suggests that Davis made these prints, like his French lithographs, under the supervision of a master printmaker. Unfortunately, it is not known whom Davis worked with, although it is likely to have been George C. Miller. A highly skilled printmaker who gave demonstrations at the Whitney Studio Club, where Davis had several exhibitions, Miller printed for artists who, like Davis, showed at the Downtown Gallery.[2]

Good as many of Davis's pictures of the early 1930s are, as a group they oscillate between extremes of inventive simplification and illustrative elaboration. For each painting like *Eggbeater No. 5* or *Salt Shaker* that invents a new, economical abstract space, there are others, like those in the New York–Paris series, that hold on to the relative naturalism of the Paris streetscapes. It is not a question of subject matter, although figures always presented special problems, as paintings such as *Men and Machine* (plate 152), 1934, attest. (Davis was an accomplished draftsman, but he rarely arrived at a wholly satisfactory way of translating the complexities of faces and bodies into color-space.) In general, Davis's formal daring seems independent of his choice of motif. *House and Street* explores urban imagery with a new sparseness and a new tightness of focus that link it to *Salt Shaker* rather than to the seemingly related New York–Paris pictures.

Davis's restless investigation of different approaches and varying degrees of abstractness could suggest that he was looking for alter-

OPPOSITE
145. *Salt Shaker*, 1931
Oil on canvas, 49⅞ x 32 in.
Collection, The Museum of Modern Art, New York; Gift of Edith Gregor Halpert

146. *Drawing for "Salt Shaker,"* 1931
Ink on paper, 6 x 4 in.
Earl Davis

139

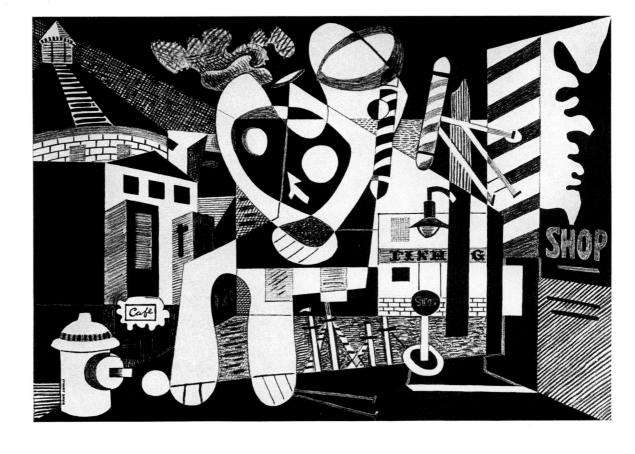

147. *Barbershop Chord,* 1931
Lithograph, 13½ x 18⅞ in.
Amon Carter Museum,
Fort Worth

148—50. *Drawings from
Notebook No. 8,* c. 1932
Pencil on paper, 7¾ x 9 in.
Earl Davis

natives to the way he had painted in Paris. Yet there is no indication that he was displeased with the work he did in Europe. Quite the contrary, he was eager to exhibit these pictures, and once he was back in the United States he did so with remarkable frequency even during the Depression. Just at the time of the stock market crash, his work was included in *Americans Abroad* at the Downtown Gallery. A month later he showed watercolors at the Whitney Studio Club. Early in 1930 Halpert exhibited the Paris pictures in *Stuart Davis: Hotels and Cafés,* and the following year both Halpert and the Crillon Gallery in Philadelphia offered solo shows by Davis. He showed again with Halpert in 1932, 1933, and 1934. As usual, Davis's exhibitions attracted modest acclaim. They also provoked a surprising amount of controversy, given the naturalism of the street and harbor scenes that he showed in the 1930s.

By the mid-1930s, most of Davis's energy was given not to art but to social action. In December 1933 he enrolled in the newly formed Public Works Art Project, later reorganized as the Works Progress Administration Federal Art Project. He worked in the Graphic Arts Division and as a muralist until 1939, when the Project began to dissolve. These relief groups were organized by the government in response to pressure exerted by the growing Artists Union. For the first time, artists were beginning to view themselves—and, more important, to be viewed by others—as unemployed workers, not simply as volunteers ready to

151. *Composition No. 5,* 1932
Brush and ink on paper,
22 x 29⅞ in.
Collection, The Museum of
Modern Art, New York; Gift of
Abby Aldrich Rockefeller

152. *Men and Machine,* 1934
Oil on canvas, 32 x 40 in.
The Metropolitan Museum of
Art, New York; Gift of Mr. and
Mrs. Jay R. Braus, 1981

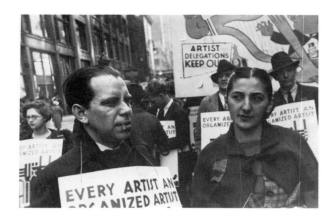

153. Stuart Davis and Roselle Springer at May Day parade, 1934

154. American Artists Congress, 1936

155. Stuart Davis, 1936

supply banners, posters, and the like whenever a demonstration was organized. Obviously, Davis's joining the Federal Art Project was a way to deal with economic necessity, but he was active as far more than just a paid producer of art. Similarly, when he joined the Artists Union, he soon made himself visible as an articulate spokesman for artists' causes, ready to defend fellow artists when he felt they had been slighted or treated badly, quick to formulate position papers and to write letters of protest. He was soon elected president of the Union. In 1935, when the Artists Union started *Art Front*—apparently intended to be a combination of showcase, information sheet, and propaganda organ—Davis served as its first editor, contributing illustrations, covers, and articles. Davis's cover for *Art Front* in May 1935 could serve as the banner of his beliefs. The tools of the artist's trade—a brush, pencil, palette knife, tube of paint, palette, and scraper—are juxtaposed against a saw and a hammer marked "solidarity," framing a panel with the date "May 1st". Around the edges, ribbons carry concise statements of the Union's desires: union wage scale for artists, social insurance, long-term government support of art projects, free expression.

Davis left his position at *Art Front* because of his growing involvement in founding a new, wider-reaching organization, the American Artists Congress. When it convened for the first time in February 1936, Davis was among the inaugural speakers. The first chairman was Max Weber; Davis, at first executive secretary (no doubt because of his willingness to write), became national chairman in 1938.

The Union and the Congress were intended to give artists a collective voice, and in this they succeeded admirably. But they were also meant to encourage the government to expand and continue its support of the arts, a goal they never achieved. The WPA projects were tolerated because they were expedient and temporary. They had little backing apart from President Roosevelt's personal enthusiasm, and Congress refused even to consider making the projects permanent. But a sense of community had been generated among people whose work had traditionally kept them isolated; artists were in contact with other artists, and connections were made that lasted well into the next two decades.

Davis's activities left him little time to make art, as he later recalled: "This meant meetings, articles, picket lines, internal squabbles. Everything was hectic. Lots of work was done, but little painting."[3] His absence from the studio was a choice he made deliberately, in response to a moral imperative, and he was scornful of artists who refused to make the same choice. Years later he wrote disparagingly of his former friend Arshile Gorky, who "still wanted to play" during these difficult

years.[4] Gorky had not been willing to abandon the studio to work for social reform, and his political apathy helped to destroy his friendship with Davis.

No matter how passionate his involvement with the Union and the Congress, Davis kept what art he managed to produce separate from his politics. If he had contempt for artists who were not politically engaged, he had equal contempt for those who turned their art into propaganda. As he put it: "Art is not politics nor is it the servant of politics. It is a valid, independent category of human activity."[5] Davis's notebooks of the 1930s are filled with his efforts to find common ground between his political conscience and his allegiance to high art.

Davis worked hard to define his position for himself, inventing an elaborate justification for abstraction that, on paper at least, joined his notion of what a good society ought to be with his notion of what good art ought to be. Since "a reactionary social viewpoint" could not produce "a vital art," Davis postulated vital art as the inevitable product of a progressive social viewpoint.[6] Of course, for him, vital art was equated with modernist abstraction. The difficulty lay in finding equivalences between abstract art and the progressive social viewpoint. Davis had read his Marx, so his conclusion is couched in familiar terms: "Abstraction is the only art that deals with its subject dialectically and as a whole . . . the only art that concerns itself with the material world in motion and not as a world of absolutes and static entities."[7]

But by abstract art Davis meant his own brand of color-space investigations: simplified planes distilled from observed reality in all its manifestations. He did not mean "Pure Art, Universal Plastic Values, Significant Form" that "seeks to make the subject matter of art art itself."[8] (At this stage, Davis was no admirer of Clive Bell.) "Arguments for pure art simply mean arguments for the perpetuation of the status quo," Davis wrote, "because in the artificial and unreal isolation of the artist's function implied in this concept, is implicit a refusal to admit the dynamic and moving quality of life. It is an undialectical and static concept."[9] The artist's true function, Davis declared, "is to express through the medium of art a positive view of social values." In order to do so, the artist had to be clear about his notion of the good society and, for the artist of the 1930s, there could be only one choice—Marxism, "because it is the only scientific social viewpoint."[10] Davis's conception of Marxism was, however, notably individual and intimately linked with modernism and abstraction. Hopes for a new social order ran parallel to hopes for a new aesthetic order. Abstraction, Davis maintained, could free the artist and make him a better painter or sculptor. It could even make him a more responsible citizen: "the powerful urge to or-

156. Henry Glintenkamp and Stuart Davis at American Artists Congress exhibition, 1937

157. *Notebook Drawing*
Dated May 30, 1938
Ink on paper, 7¾ x 9¾ in.
Earl Davis

ganization in Abstract art may well be . . . the forerunner of a better social order." [11]

Davis was never a Communist Party member. His sympathies were frankly leftist—like the majority of the New York culturati and intelligentsia—but he was too independent to subscribe to outside directives. He once likened "American reds" to "mail order art students who get these lessons by mail every week and are promised a good job at the end of the course." [12] Davis's apology for abstract art (written at least a year after the Communist Party had officially jettisoned abstraction as unsuitable to the aims of the revolution) is couched in conventional Marxist polemic and seems ideologically tidy, if unorthodox. Yet his sense of quality, his eye, would not let him be seduced by his own rhetoric. He had to admit that good art, even great art, could be disassociated from "good social thought." Cézanne, for example, had a "scientific attitude toward painting and at the same time socially reactionary ideas." [13] Davis might have preferred Cézanne, one of his heroes, to have been more progressive in his political beliefs, but he could not argue with his own perception of excellence.

Davis saw little difference between the Social Realism promoted by the extreme left and the art championed by the extreme right. Both glorified everyday life in a legible, figurative mode. "Official" leftist painting was exemplified by Diego Rivera's murals, that of the "official" right by the work of the American Scene artists (no matter what the politics of the artists themselves). With only slight changes in subject (and allowing for the greater sentimentality of the American Scene painters) the two were virtually interchangeable.

Davis tried to conform to a "politically correct" view of what he called "Mexican muralism, the fetish of fresco" [14]: "Here is an advanced realistic ideology, based on experience, and definitely progressive as a group movement. It has its own technology (fresco mural) and is developing its own space-color sense which is very nationalistic and primitive." [15] But Davis had trouble with the Mexican art movement. Just as he believed that "a reactionary social viewpoint" could not produce "a vital art," he was equally certain that a progressive social viewpoint, as evidenced by ideologically correct, relevant images, could not guarantee progressive painting. "A people's art is not to be achieved by turning art into illustration." [16] *How* something was painted was as important as *what* was painted. "Subject matter is not alone the 'name objects' used in the picture. Subject matter is the *position* taken by the artist in relation to certain objects." [17] Six months after Davis praised Mexican art for being "definitely progressive," he concluded that, quite the contrary, it was "culturally reactionary in the international

144

sense because its art forms are historically obsolete."[18] He saw Diego Rivera as a lapsed Cubist who should have known better.[19]

Whatever his quarrels with Social Realism, the full force of Davis's opposition was reserved for the painters of the American Scene. He loathed their vision of contemporary life in the United States. After *Time* magazine published an article extolling the work of Thomas Hart Benton, Grant Wood, and John Steuart Curry, Davis wrote in *Art Front:* "Are the gross caricatures of Negroes by Benton to be passed off as 'direct representation'? The only thing they represent directly is a third rate vaudeville character cliché with the humor omitted. . . . The same can be said of all the people he paints including the portrait of himself which is reproduced on the cover of *Time.* We must at least give him credit for not making any exceptions in his general underestimation of the human race."[20] It is hard to say which outraged Davis more, Benton's and Curry's attitude toward their subjects or their way of painting. The social content of American Scene works, Davis pronounced, was "uncritical and uncreative. It accepts contemporary social realities with placid smugness." Still worse, "Its Art Form is an eclectic melange equally uncritical and smug."[21]

Davis's anger at the popular success of American Scene painting was no doubt exacerbated by accusations that his own work was un-American and overly French. The issue of Americanism was to color critical perceptions of Davis's work. The mainstream critic Henry McBride, for example, generally liked Davis's *Hotels and Cafés* exhibition, but thought the pictures too French in style, too influenced by Picasso. Davis, always argumentative, complained in a letter published in *Creative Art* that he had been described as "a swell painter whose value to American art was nullified . . . because I had a French style."[22] This was absurd, Davis said, since there was no such thing as an American art without European influence; differences in American styles were simply the result of differences in the European influences chosen. Quality, not nationality, was the real issue. "If Picasso were a practicing artist in Akron, Ohio, I would have admired his work just the same."[23]

Two years later Davis asserted his claims to be an interpreter of America by titling his 1932 exhibition at the Downtown Gallery, *American Scene: Recent Paintings, New York and Gloucester, Stuart Davis.* This was a deliberate challenge to Curry, Benton, and company; Davis would show them how it was done in a modernist idiom, using color-space configurations instead of illustration. The show included such radical pictures as *Salt Shaker* and *House and Street,* but it was praised for its American subject matter.[24] Davis was still defending the cause of French art and still sniping at his chauvinist colleagues in 1938: "The

158. *Notebook Drawing*
Dated May 30, 1938
Ink on paper, 7¾ x 9¾ in.
Earl Davis

145

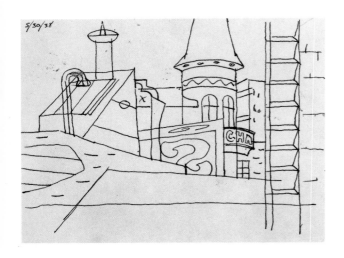

159. *Notebook Drawing*
Dated May 30, 1938
Ink on paper, 7¾ x 9¾ in.
Earl Davis

American Scene school has said that French art is dead. This reminds me of the story about the man who said, 'They dug my grandfather up after he had been buried for 2 years and he looked better than you do right now.' Well, French art may have been dead for 50 years but it still looks better than American art does right now." [25]

As late as 1940 the question of Americanism in art was still pressing enough to warrant a symposium at the Museum of Modern Art. Davis was invited to discuss "What is alien to American art?" along with proponents of American Scene painting and Social Realism. He prepared for the event, filling his notebooks with clear and subtle arguments on the topic. In his view, the best American art, including his own, had been influenced by French art, but this in no way compromised the national identity of American painters and sculptors, if their art was good enough. "Art can only have validity when it is regional in character," Davis wrote. The problem was that "regionalism and provincialism are often confused." [26] Davis attacked critics who, in the name of national identity, supported art that he found provincial (rather than regional); he complained that they "preach an Americanism in art which seems to carry with it many of the qualities which would be considered reactionary in other fields." Grumpily, he added that he "would welcome the sight of some kinds of American art being menaced by alien trends." [27]

Davis hated the conviction of both the American Scene school and the Social Realists that theirs was the only art to accurately reflect contemporary society. For Davis, this single-mindedness presupposed "a uniform and standard experience for . . . artists in their intellectual and emotional lives. Such uniformity is not the object of the contemporary struggle for progress. Such uniformity is the goal of Fascists." [28]

Despite his outspokenness and the idiosyncracies of his beliefs— or perhaps because of them—Davis was respected as an activist and as an organizer, and trusted by radicals and liberals alike. He had authority, too, as an artist. In the 1930s Davis was a vigorous man in his forties, younger than the established artists he had known since his earliest days and older than the future Abstract Expressionists, who were just emerging. (Jacob Kainen, who knew Davis from the Graphic Arts Division of the WPA, recalls that "anyone over thirty-five was an older artist," so Davis had real seniority; Kainen also recalls being very gratified when Davis, whom the younger crowd looked up to, admired one of his prints. [29]) The younger painters saw Davis as a modernist who had not compromised.

The murals that Davis executed for the WPA bear out these perceptions. They admirably fulfill their mandate to address public issues,

to be public art. They are plainly legible, even to the visually unsophisticated, but at the same time, they are among the most ambitious, adventurous works of their kind done at the time. Unlike the rather didactic, socially relevant efforts by the majority of his colleagues, Davis's murals are faithful reflections of his aesthetic concerns. Neither uplifting narratives nor heroic allegories, they are light-hearted declarations of his preoccupations with form and color.

Davis was clear about how he regarded murals: "An art of real order in the material of paint doesn't say: 'Workers of the World Unite,' it doesn't say 'Pasteur's Theory had many beneficial results for the human race,' and it doesn't say 'Buy Camel cigarettes'; it merely says 'Look, here is a unique configuration in color-space.'" [30] Davis had a chance to test his theories of large-scale decoration years before the Federal Art Project was created. In 1932, after the death of his wife, Davis was asked to do a mural for the new Radio City Music Hall. His sister-in-law, Mariam, the wife of his brother, Wyatt, and a close friend of Bessie's, had arranged for the commission, in part to help Davis back to life as an artist. Rockefeller Center was attempting to fuse art and architecture in its spectacular city-within-a-city, and the Music Hall was not only to be a temple of popular culture, but also a showcase for painting, sculpture, and decorative art.

The mural was Davis's first since about 1921, when he had decorated a Newark soda fountain with the stylishly lettered names of its offerings, but the setting, a men's smoking lounge, suggested motifs that were already part of his vocabulary. He returned to the themes of his Tobacco Still Lifes of the 1920s and conflated them with Gloucester and New York images. (Davis painted another version of the Tobacco Still Lifes, *Cigarette Papers* [plate 165], in 1933, after he had completed the Radio City mural.) Like the New York–Paris paintings, the Radio City mural isolates elements against a neutral background, but that neutrality is compromised by the suggestion of a horizon line and floating clouds. Oversized still-life "props"—the familiar Stud brand tobacco pouch, along with cigarettes, a pipe, a cigar, and playing cards—are forced into an uneasy relationship with a car, schematic buildings, and a sailboat. Violent shifts in scale imply abrupt shifts in space. The spatial complexity is intensified by the inclusion of such unequivocally frontal objects as a barber pole, a gas pump, and a telephone booth at more or less actual size. Despite all this activity, the mural stays visually flat. Because of its broadly handled color planes, its crisp, open drawing, and its generous scale, it remains a wall with something applied to it, "a flat surface decorated by hand," as Davis put it, rather than dissolving into illusion. [31]

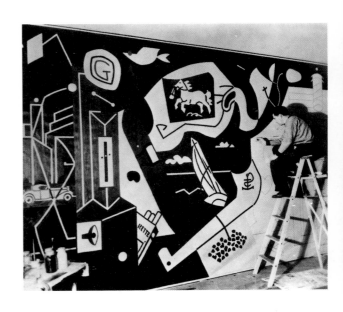

160. Stuart Davis at work on *Men Without Women,* 1932

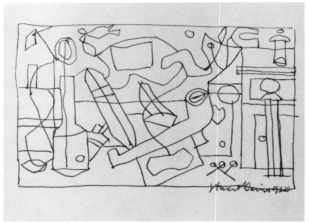

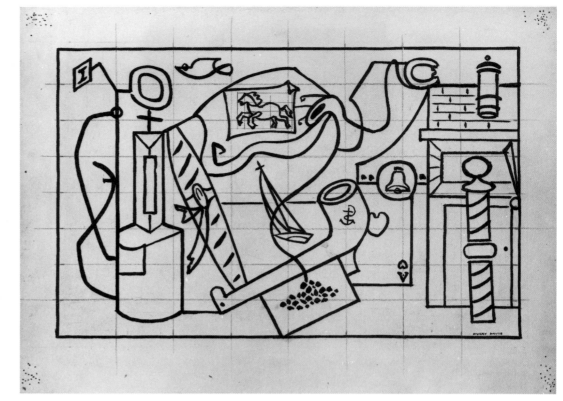

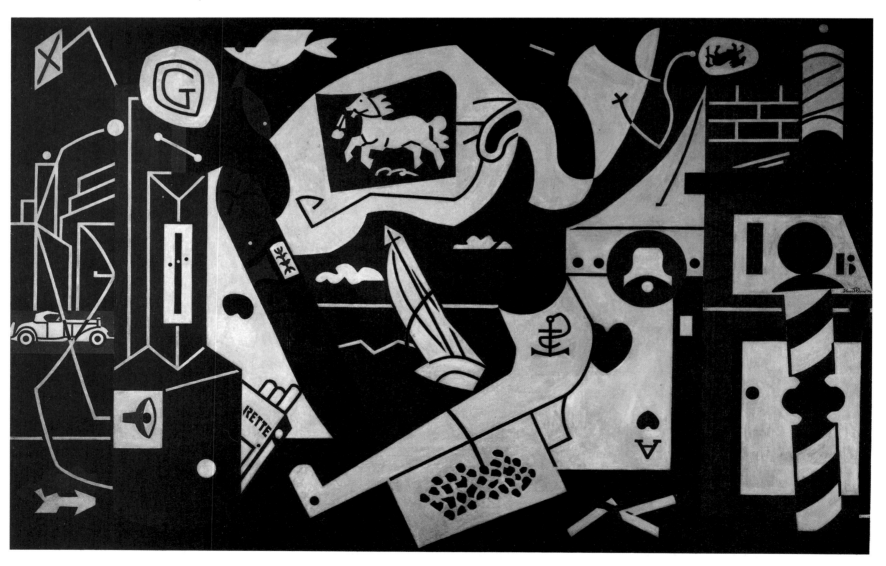

The jaunty Radio City mural anticipates the economy of Davis's later works and must have influenced them, for it seems impossible that he would not have been deeply affected by the experience of working so large. In 1932, after all, mural scale was very different from that of the typical easel painting—in contrast, say, to the often over-sized canvases of the 1960s or '70s—so the impact of thinking about oversized planes in a painting 11 by 17 feet must have been profound. Certainly there are notable changes in Davis's work of the 1940s, im-mediately after his first concentrated bout of mural painting, and it is conceivable that the ampleness and clarity of his works of the 1950s were suggested, at least in part, by his working at a monumental scale at intervals throughout the 1930s and '40s. Apart from its influ-ence on Davis's other art, the Radio City painting is an important work in its own right, probably the most playful and energetic of all his mu-rals. It gives no sign of the depressed state of mind that had prompted his concerned sister-in-law to urge him to accept the commission. The title, however, may be significant: *Men Without Women.*

The first of Davis's WPA murals, now lost, seems to have been done for Brooklyn College in 1937. The next, *Swing Landscape* (plate 166), was painted in 1938 for a Brooklyn housing project, but never installed there. A dense shuffling of Gloucester images, it is identical in concep-tion and rhythm to the best of Davis's landscapes of the period, pic-

OPPOSITE, CLOCKWISE FROM TOP LEFT
161. *Study for Radio City Mural ("Men Without Women"),* 1932
Pen and ink on paper, 7¾ x 9¾ in.
Collection, The Museum of Modern Art, New York; Gift of Mrs. Gertrud A. Mellon

162. *Study for Radio City Mural ("Men Without Women"),* 1932
Pen, ink, and pencil on green ground, 15⅛ x 20⅛ in.
Collection, The Museum of Modern Art, New York; Gift of Gertrud A. Mellon

163. *Men Without Women,* 1932
Oil on canvas,
16 ft. 11⅞ in. x 10 ft. 8⅞ in.
Collection, The Museum of Modern Art, New York; Gift of Radio City Music Hall Corporation

ABOVE, LEFT
164. *Drawing from Notebook No. 15,* c. 1933
Pencil on paper, 8 x 10 in.
Earl Davis

ABOVE, RIGHT
165. *Cigarette Papers,* 1933
Oil on composition board,
12 x 12⅜ in.
Holger Cahill

166. *Swing Landscape,* 1938
Oil on canvas, 7 ft. x 14 ft.
Indiana University Art Museum, Bloomington

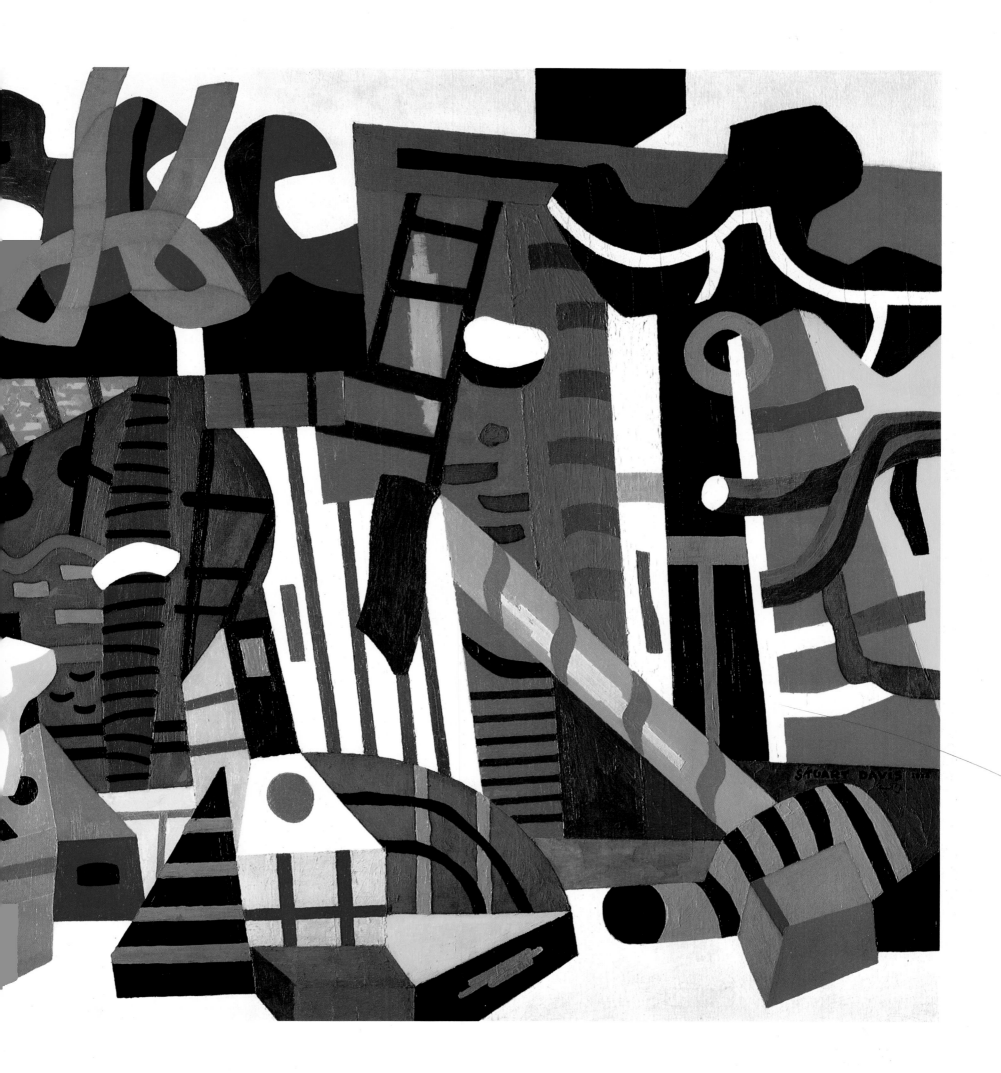

167. *New York Waterfront,* 1938
Oil on canvas, 22 x 30¼ in.
Albright-Knox Art Gallery,
Buffalo; Room of
Contemporary Art Fund, 1943

168. *Gloucester Harbor,* 1938
Oil on canvas mounted on
panel, 23¹⁄₁₆ x 30⅛ in.
Museum of Fine Arts, Houston;
Museum purchase with funds
provided by the Agnes Cullen
Arnold Endowment Fund

169. *Study for "History of
Communication Mural,"* 1939
Ink on paper, 9⅝ x 29⅞ in.
Minnesota Museum of Art,
St. Paul

152

tures such as *New York Waterfront* and *Gloucester Harbor* (plates 167, 168). The following year, 1939, he worked on two major projects, a mural (plate 170), for a broadcasting room at the WNYC radio station, and the monumental *History of Communication* (plate 169), for the Communications Building at the New York World's Fair. The WNYC mural is one of the most ravishing in color and most economical in composition of Davis's images of the period. Far less dense than *Swing Landscape,* it depends on a few large, eloquently spaced planes, anchored by overscaled "drawing." The colors are seductive: pinks and blues against a field of luminous beige. The imagery is especially ambiguous—part technology, part musical instrument, part rigging—echoing configurations developed in drawings throughout the 1930s. The emphasis on drawing is not surprising, for Davis's political activities left him little time for painting, and ink drawing seems to have become a substitute. It was a rapid medium, one that could be picked up with little ceremony and set aside without difficulty. Drawing allowed Davis to preserve some sense of continuity in his life as an artist, despite

170. *Municipal Broadcasting Co.,* 1939
Oil on canvas, 7 ft. 2 in. x 11 ft.
The Art Commission of the City of New York

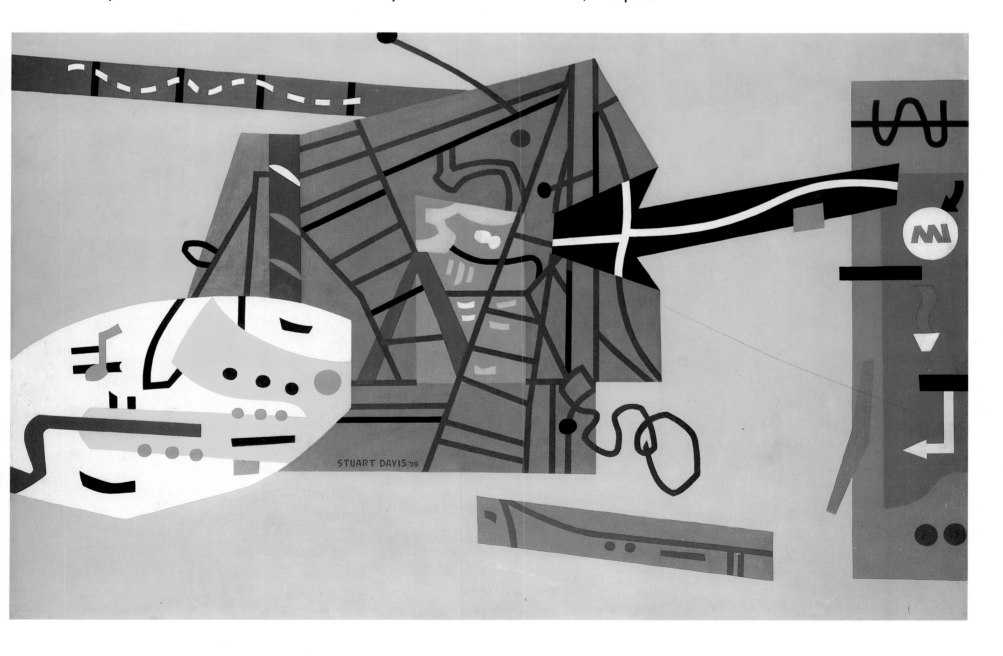

171. *The Terminal,* 1937
Oil on canvas, 30⅛ x 40⅛ in.
Hirshhorn Museum and
Sculpture Garden, Smithsonian
Institution, Washington, D.C.

other demands on his time. It was also good preparation for the murals and prints that he was executing for the WPA. More important, Davis had long believed that drawing in black and white was not only the basis for all painting, but that it could even take the place of painting in color.

As if to reinforce the importance of drawing, Davis made the *History of Communication* mural a graphic tour de force. The work, now destroyed, was 140 feet long. Perhaps because of this daunting size (and because it was to be executed by sign painters), Davis decided to limit his palette to black and white and to keep all elements linear and of equal weight, although his belief that a mural should respect the surface it enlivened may have reinforced this decision. Interlaced drawn images illustrate the evolution of communications technology from the most primitive to the state-of-the-art in 1939. Davis's premise that the "History of Communication is mechanical objectification of the human Eye, Ear, Voice, and Hand"[32] was translated into images of

154

devices that have expanded the range of the human senses, from pigeons and smoke signals to radio tubes, transmission towers, and cameras, along with alphabets, sign language, film, and what seems to be a stylized Mercury-type runner. These complex images are reduced to severe outlines, so that they become a kind of hieroglyphic writing, itself a form of communication.

Probably because of its large scale, the mural never degenerates into the cartoonlike illustration that Davis was occasionally guilty of in his more anecdotal images. It is useful to compare the *History of Communication* with a picture such as *The Terminal* (plate 171), 1937. Like the mural, the canvas is full of recognizable elements—the barrels, dollies, and crates of a warehouse, along with a few workmen—but it seems pedestrian and literal in comparison. Only the neo-Rococo pastel color of *The Terminal* shows Davis's real powers, but the colored planes never break free from the schematic versions of the objects they represent, nor does drawing function other than as descriptive detail. Davis evidently felt able to be more experimental and inventive at mural scale.

Davis made three prints for the Graphic Arts Division of the WPA during the last year of his tenure, about the same time that he worked on the *History of Communication* mural. The WPA prints differ radically from Davis's previous lithographs, which were remarkable for their virtuoso suggestion of tones. Like the Paris prints, the WPA lithographs are based on configurations that Davis had developed earlier as paintings and drawings, but they are stripped down to bold black-and-white drawing. The single color print of the series, a version of a recurrent image entitled *Shapes of Landscape Space* (plate 174), is a similar line drawing imposed on three pastel color shapes. It is slightly surprising that Davis should have affiliated himself with the Graphic Arts Division. Printmaking in the 1930s was often associated with the production of socially relevant images, in multiples, to be distributed to the masses. Davis was certainly not interested in art as polemic, but he was interested in enlarging his repertory of techniques. The equipment at the Project's graphics studio on East Thirty-ninth Street was excellent. There were other advantages, as well, as Jacob Kainen recollects. Davis had recommended the Graphics Division to him over the Easel Project because printmakers could work when they pleased, and keep proofs of the prints they produced; easel painters had to donate their works to public collections and conform to a fixed schedule.[33]

Davis later described the WPA project as "a lifesaver" since it allowed him to make art instead of being primarily a political organizer. The support of the WPA was particularly important since Davis had left

the Downtown Gallery in 1936, after a disagreement with Edith Halpert about prices and related financial matters. He no longer had a New York gallery, and jobs for artists—apart from the WPA—were nonexistent. The sketchy record of Davis's living arrangements during the 1930s gives some indication of his situation. In 1933 he is supposed to have been living in a room over Romany Marie's Eighth Street restaurant. The following year he was staying with his brother and sister-in-law at their apartment at Fourteenth Street and Eighth Avenue. Later that year, in July 1934, when he was a full-fledged member of the Painting and Sculpture Division of the WPA, Davis established a studio and apart-

172. *Drawing from Notebook No. 13*, c. 1932
Dated September 2, 1932
Pencil on paper, 8 x 10 in.
Earl Davis

173. *Landscape*, 1932
Oil on canvas, 25 x 22 in.
Brooklyn Museum, New York;
Gift of Mr. and Mrs. Milton Lowenthal

OPPOSITE
174. *Shapes of Landscape Space*, 1939
Oil on canvas, 36¼ x 28⅛ in.
Neuberger Museum, State University of New York at Purchase; Gift of
Mr. Roy R. Neuberger

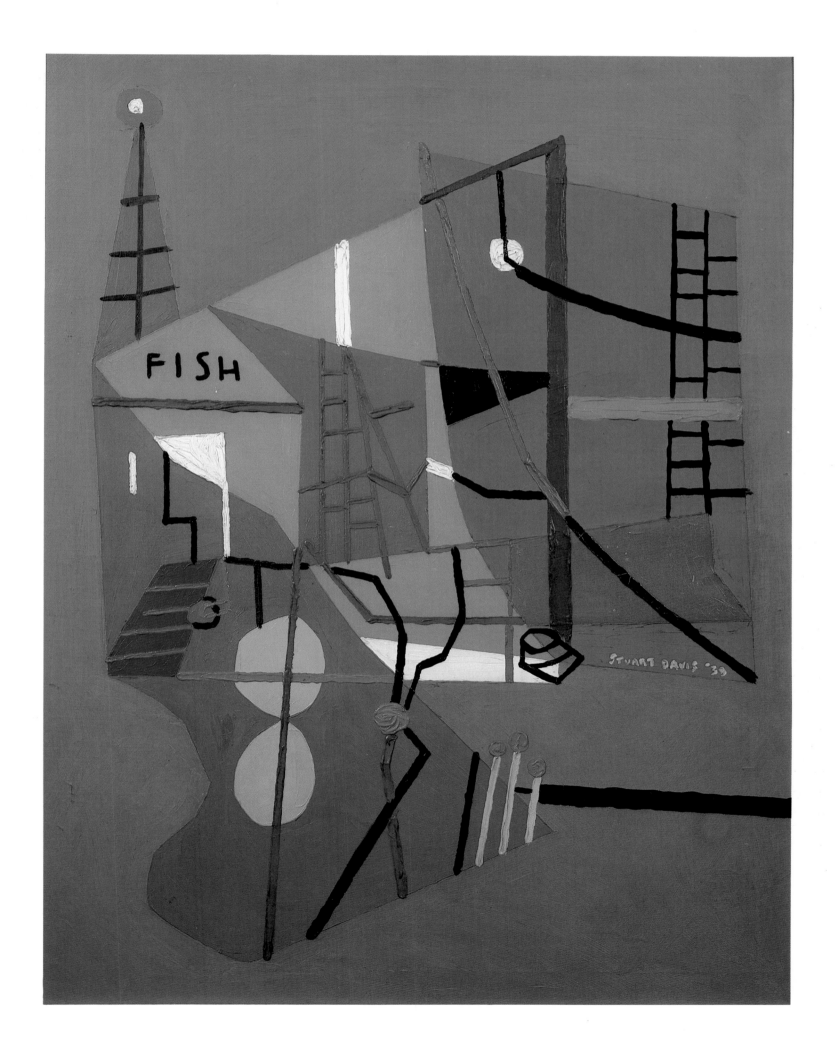

ment at 43 Seventh Avenue, where he would remain for the next twenty years. Characteristically, Davis's 1945 autobiography is somewhat misleading. As he tells it, in 1939, at the end of his five-year period of legal tenure in the Federal Art Project, he was "suddenly out without a cent. . . . Having no money I did the conventional thing—I hired myself a studio and devoted myself to painting."[34] It is more dramatic in Davis's version, of course.

Davis's pictures of the period following his stint with the WPA give evidence of how much his work had evolved since his return from Europe, in spite of his erratic working patterns and his divided attention. His methods seem to have changed as well. Pictures such as *Bass Rocks No. 1* and *Shapes of Landscape Space* (plates 176, 174), both painted in 1939, are touchstones of quality for the period and illustrate the complexity of Davis's ways of working. Although made at more or less the same time, the two paintings are very different in conception. *Bass Rocks No. 1* is a sharply honed, open arrangement of pastel planes held in place by an interlace of colored lines. *Shapes of Landscape Space* is an inward-turning, closed structure, a self-contained prism of intense, saturated color. Both are based on earlier black-and-white drawings. *Bass Rocks No. 1* is a stilled version of a remarkably fluid line drawing of 1938 (plate 175), while *Shapes of Landscape Space* derives from an energetic notebook sketch and a harder, clearer version of the same dockside study, both done in 1932. There is nothing unusual in Davis's returning to earlier configurations, given his belief that a good drawing could generate any number of paintings. From this time on, in fact, he increasingly turned to his own work as a point of departure, using his recorded perceptions as he had once used nature. What is notable is that he was not content to use the generating images of *Bass Rocks No. 1* or *Shapes of Landscape Space* solely as the basis for paintings; not only do these motifs recur on canvases until 1954, but they appear as drawings, gouache and tempera studies, a silkscreen, and a lithograph. This marks the beginning of what Davis called "the amazing continuity" of his work and also of his sense of the interchangeability of media.

If Davis was spending more time in the studio during the late 1930s, it was not just because his stint with the WPA was officially over; he had withdrawn from much of his political activity by the end of the decade. This was a time when even the most firmly held convictions were tested and the longest established loyalties strained. It was clear that Italy and Germany's new regimes were totalitarian dictatorships, and rumors of Stalin's excesses made even diehard leftists question their own beliefs. Reports of Stalin's Moscow Trials deeply upset the Ameri-

175. *Study for "Bass Rocks,"* 1938
Ink on paper, 7⅜ x 9¾ in.
Amon Carter Museum,
Fort Worth

176. *Bass Rocks No. 1,* 1939
Oil on canvas, 33 x 43 in.
Wichita Art Museum, Wichita,
Kansas; The Roland Murdock
Collection

can left, creating rifts of opinion that can still provoke anger and disgust. Davis, oddly, signed a group statement affirming that the Moscow Trials were justified by the weight of the evidence, but the Nazi–Soviet Pact and the Russian invasion of Finland quickly destroyed whatever earlier admiration he had had for the USSR. When the board of the Artists Congress approved a statement supporting the invasion of Finland as tactically justified, Davis joined a group of anti-Stalinist dissidents who protested. Along with Milton Avery, George Biddle, Adolph Gottlieb, Lewis Mumford, Mark Rothko, Meyer Schapiro, and many others, Davis condemned the USSR for having replaced revolutionary ideals with Stalin's personal ideology. In the wake of this violent division of opinion, Davis was the first to resign from the Congress he had helped to found. He did so, he said, without wanting to harm the organization; he just could no longer support the USSR. Davis's enthusiasm for the Soviet social experiment and even for Marxism had expired completely by the 1940s, as his vitriolic notebook entries show, but the separation was nonetheless painful.

The decade following Davis's return from France was a tempestuous one. The economic and social upheavals that eventually challenged and altered his political beliefs were paralleled by more private dramas: the death of his wife, a split with his dealer, and violent disruption of his routine as a studio artist. But there were happier aspects to the period as well. Davis's work had grown freer and more adventurous during the ten years between 1929 and 1939. He seemed fully capable of allowing the cacophony of the street and the miscellany of modern life into his studio and of transforming it into his color-space logic. And Davis's domestic life was greatly enriched. About 1934 he had met a beautiful young woman who was to become his devoted companion for the rest of his life. In October 1938 Roselle Springer and Stuart Davis were married. During the early years of their life together she worked at a great variety of jobs to supplement their income—in a bank, as a social worker, as a textile designer; later she acted as Davis's general assistant and kept his studio records. Davis began a new decade with a new wife, new ways of spending his time, and a (relatively) new studio. Small wonder that his paintings of the next years show dramatic changes.

THE ACE OF
AMERICAN MODERNISTS

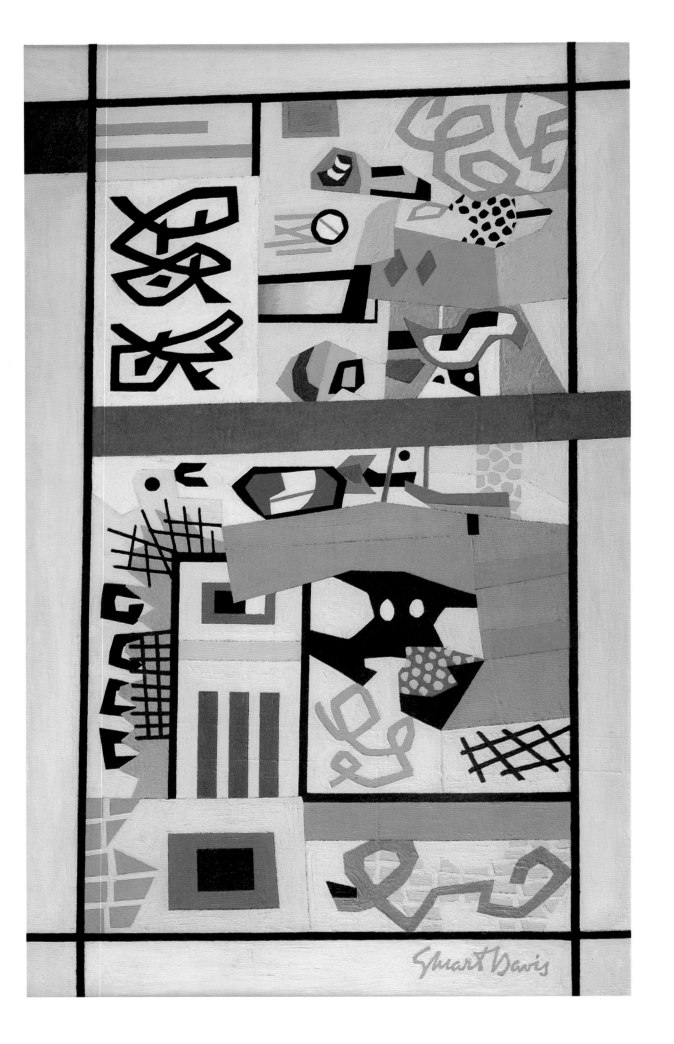

avis's prestige had grown steadily since the 1930s. As early as 1932 he had been called "the ace of American modernists" by the *New York Sun*,[1] and not long after that both the Museum of Modern Art and the Whitney Museum (admittedly both fledgling institutions) included his work in surveys of contemporary modernism. In 1941 the Cincinnati Museum of Fine Arts organized a two-man exhibition of works by Stuart Davis and Marsden Hartley. Since both artists had worked on the Atlantic coast, similarities of motif may have inspired the association, but this pairing with a respected member of the first generation of American vanguardists is a provocative indication of how Davis was coming to be regarded, at least in enlightened circles.

When Davis had a one-man show early in 1943 at the Downtown Gallery (he had resolved his differences with Edith Halpert for the time being), *Artnews* published his long discourse on aesthetics, "The Cube Root."[2] Halpert's famous persuasiveness and marketing skills may have been partly responsible for the magazine's attention, but it is also evidence of the interest aroused by Davis's first solo show in New York in many years. The gathering of paintings and gouaches from 1938 through 1942, made after Davis's release from the Federal Art Project and from his duties as an organizer, rewarded this interest. The show's catalog reads like a list of Davis's best work of the period: *Bass Rocks No. 1, Shapes of Landscape Space, Report from Rockport, Hot Still-Scape in Six Colors—7th Avenue Style, Arboretum by Flashbulb, Ultra-Marine.*

It was a remarkably consistent group of pictures, as though Davis had at last come to terms with the multiple implications of his earlier work. He concentrated on themes that had preoccupied him for years—the modern city and the coastal town—but he treated them far less literally than ever before and with a new single-mindedness of approach. This is not to say that Davis's paintings of the late 1930s and early 1940s are wholly unprecedented. His 1920s Cubist still lifes anticipate the spatial complexity of a painting like *Report from Rockport* (plate 179) while his Paris streetscapes prefigure its coloristic richness. But for the first

177. *G & W,* 1944
Oil on canvas, 18¾ x 11⅝ in.
Hirshhorn Museum and Sculpture Garden, Smithsonian Institution, Washington, D.C.; Estates of Marion and Gustave Ring

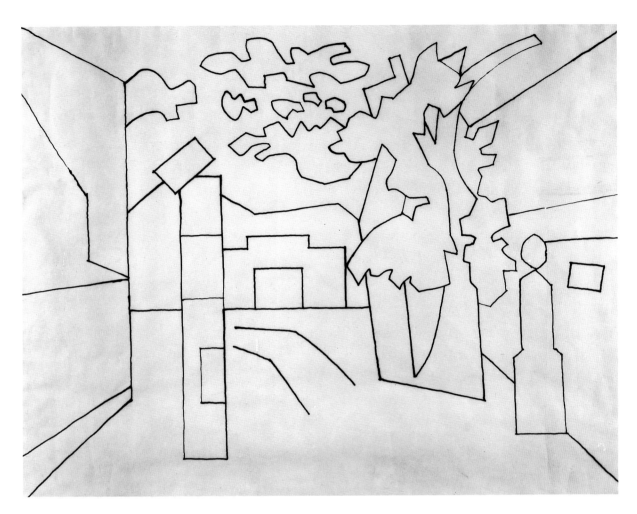

178. *Study for "Report from Rockport,"* 1940
Ink on paper, 21½ x 30½ in.
Earl Davis

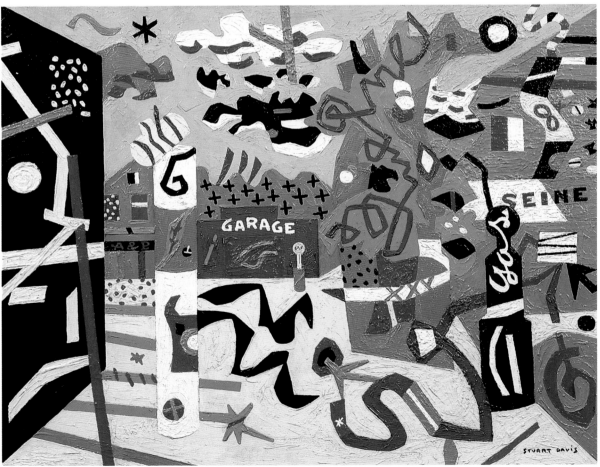

179. *Report from Rockport,*
1940
Oil on canvas, 24 x 30 in.
Mr. and Mrs. Milton Lowenthal

time in over a decade, Davis returned to the all-out formal adventurousness of the Eggbeaters. In paintings such as *Report from Rockport* and *Arboretum by Flashbulb* (plate 185), freewheeling planes and syncopated patterns take the place of the coherent spaces and recognizable images of, say, the Paris pictures. To make a jazz analogy, which is always tempting given Davis's declared passion for hep music and hip talk, his approach is like that of a brilliant scat singer. Faithfully recorded details—the words of the song—are replaced by ecstatic improvisation.

Yet Davis was obviously still sensitive to the particulars of place. We catch glimpses of things familiar to us from his more overtly naturalistic pictures—a schematized version of a barber pole or gas pump, patterns that evoke urban detail and dockyard litter, swirls of line that suggest iron railings and hanging lamps—even though these high-speed allusions are no more important than any other aspect of the complex piling of shapes and patches. These references come as no surprise. Although Davis always insisted on the autonomy of the work of art and on its equality with both nature and actual experience, he also insisted that only by directly addressing the actual, with all its irregularity and unexpectedness, could he discover the unnameable shapes and fresh configurations that he valued so highly. "Abstract art is always associated with things in the contemporary environment but is concerned with them exclusively as art Space," Davis wrote.[3] "The content [of the picture] consists of observed accidental relations of nature."[4] Davis deeply mistrusted ungrounded invention.

His acute response to all aspects of his surroundings is at the core of even the most abstract of Davis's pictures of the late 1930s and early 1940s. Some of his "straight" landscapes of about 1916, such as the fine *Hillside with Stone Walls* (plate 7), even appear, in retrospect, to be precursors of paintings of the *Arboretum by Flashbulb* type; the contrast of small, irregular shapes and large, simplified planes, the counterpoint of jagged lines and spotty patterns are already present, as motifs derived from landscape elements. But in the later works Davis's long-standing interest in simultaneity, his avowed wish to synthesize his experience of the world around him into new objects are manifest. He may have described *Arboretum by Flashbulb* as being based on a garden he loved, but the painting is plainly not about landscape alone. The staccato play of sharp and curved edges, of broad and broken planes, of geometric and organic shapes, can best be explained as a perceptual collage. Davis conflated observed snatches of the natural and the man-made environment with invented elements that stand for the intangible parts of daily life. He dislocated

shapes, patterns, textures from a great variety of sources and recombined them to make an entirely new kind of structure.

Hot Still-Scape in Six Colors—7th Avenue Style (plate 184) is one of the clearest examples of this amalgamation of disparate images. Davis described the painting as follows:

> *Hot Still-Scape in Six Colors—7th Avenue Style* is composed from shape and color elements which I have used in painting landscapes and still lifes from nature. Invented elements are added. Hence the term "Still-Scape." It is called "Hot" because of its dynamic mood. Six colors, white, yellow, blue, orange, red, and black, were used as the materials of expression. They are used as the instruments in a musical composition might be, where the tone-color variety results from the juxtaposition of different instrument groups. It is "7th Avenue Style" because I have had my studio on 7th Avenue for 15 years.
>
> The subject matter of this picture is well within the everyday experience of any modern city dweller. Fruit and flowers; kitchen utensils; Fall skies; horizons; taxi-cabs; radio; art exhibitions and reproductions; fast travel; Americana; movies; electric signs; dynamics of city sights and sounds; these and a thousand more are common experience and they are the basic subject matter which my picture celebrates.
>
> The painting is abstract in the sense that it is highly selective, and it is synthetic in that it recombines these selections of color and shape into a new unity, which never existed in Nature but is a new part of Nature.[5]

Hot Still-Scape is synthetic in yet another way; based on Davis's 1928 painting *Eggbeater No. 2* (plate 182), it is a combination of the artist's past and present concerns. The underlying configuration of *Eggbeater No. 2* remains readily visible, but the changes and embellishments that Davis has made to the original structure are revealing. In *Hot Still-Scape* the severe, clearly defined planes of *Eggbeater No. 2* are overwhelmed by an extraordinary assortment of spots, hatchings, and squiggles, its cool, delicate tones replaced by saturated hues at nearly maximum contrast. An elegant, distanced, harmonious construction has become slangy, insistent, strident. For all its abstractness, *Eggbeater No. 2* still retains vestiges of illusionism, a suggestion of centralized image in a setting; *Hot Still-Scape* has none. Davis has reworked the angled "background" planes of mauve, blue, off-white, and green seen in the earlier painting into a single plane of brilliant

red, making the later version uncompromisingly frontal and flat. *Hot Still-Scape* presses forward in a series of planes, both defined and implied by floating patterns, all parallel to the surface of the canvas; this forward thrust is held in check by the strong two-dimensional assertions of allover patterning and color heated to equal brilliance throughout. The painting's confrontational spirit is heightened by its robust facture: thick pigment, which bears the imprint of the stiff brush that applied it, creates a dense surface that seems the natural habitat of the crowded planes. The restrained, cerebral *Eggbeater No. 2,* a clearheaded demonstration of Davis's spatial investigations of the late 1920s, has been recapitulated in terms of even greater abstractness, with exceptional assurance, urgency, and brashness. Davis's 1940 definition of "Modern and Abstract Art" provides a clue to this transformation: "Modern and Abstract Art gives the joy of optical exercise. It brings distant planes close—it pushes near planes in the background and simplifies at will the relations in the areas. It is an Art Form Play in harmony with the scope of modern consciousness." [6]

Hot Still-Scape and the paintings that followed it in the next few years provide ample proof that by the early 1940s Davis had matured completely as an artist. For the past twenty-five years, since his student days with Henri, he had known what he wanted to paint. Now he knew exactly how he wanted to do it. This is not to suggest that Davis became complacent or that his work failed to develop. Quite the opposite. But over the next twenty-five years he would intensify characteristics already present in his paintings of the early 1940s: the streetwise vocabulary of shapes, the superheated color, the dense, worked surfaces, the sense of confrontation. Compared to the erratic swings of his earlier career, Davis's development from about 1940 seems relatively straightforward and single-minded, but he never entirely gave up his propensity for exploring a variety of directions at more or less the same time. Even his confident paintings of the mid- and late 1940s examine quite different notions of what a picture can be. Some, like the brilliant *The Mellow Pad* (plate 225), 1945–51, expand the ideas of elaboration and alloverness first proposed in works like *Ultra-Marine* (plate 186). Others, such as *For Internal Use Only* (plate 187), 1945, or the superb *Pad No. 4* (plate 224), 1947, anticipate the telling economies of Davis's last works. Davis would follow both paths until his death, although gradually moving in the direction of greater simplification and clarity. The elaborations of his later pictures would enhance structure, not, as in earlier works, obscure it.

Davis's seminal paintings of the early 1940s differ from his later pictures most obviously in terms of scale, and that difference can be criti-

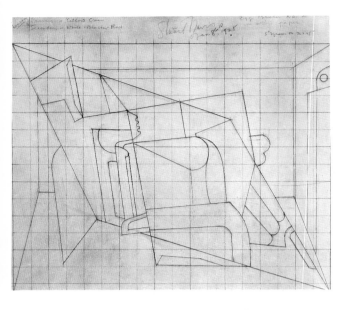

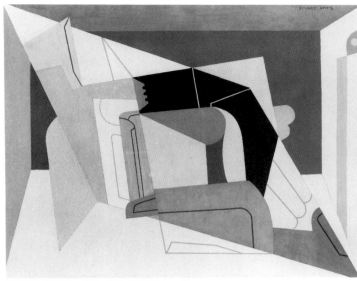

180. *Drawing for "Eggbeater No. 2"*
Dated January 8–10, 1928
Pencil on paper, 16½ x 18½ in.
Earl Davis

181. *Eggbeater No. 2* (formerly
known as *No. 4*), 1928
Gouache on watercolor board,
14½ x 18 in.
Munson-Williams-Proctor
Institute, Utica, New York

182. *Eggbeater No. 2* (formerly
known as *No. 4*), 1928
Oil on canvas, 29¼ x 36¼ in.
Mr. and Mrs. James A. Fisher

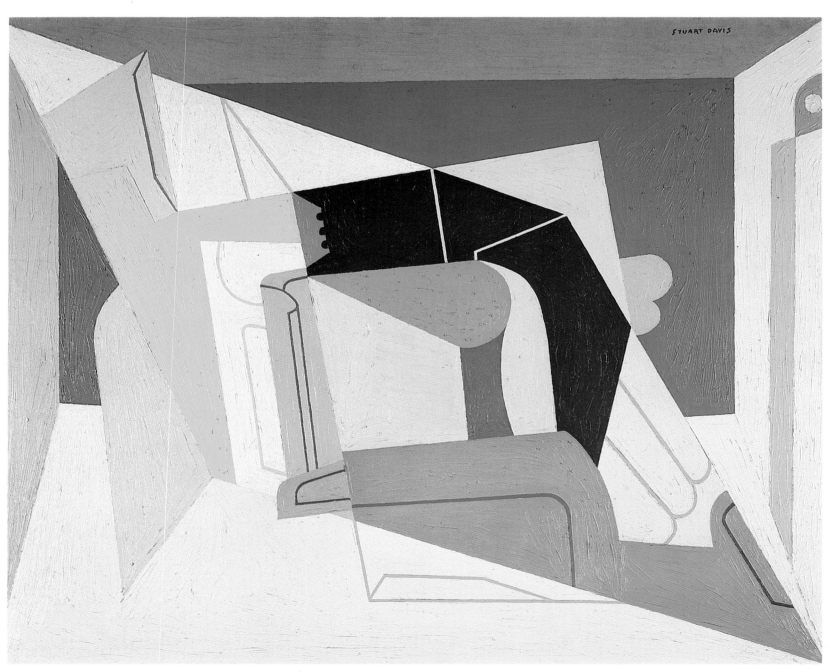

183. *Study for "Hot Still-Scape,"* 1940
Oil on canvas, 9 x 12 in.
Collection, The Museum of Modern Art, New York; Given anonymously

184. *Hot Still-Scape in Six Colors—7th Avenue Style,* 1940
Oil on canvas, 36 x 45 in.
Museum of Fine Arts, Boston; Gift of the William H. Lane Foundation and M. and M. Karolik Collection, by exchange

185. *Arboretum by Flashbulb,*
1942
Oil on canvas, 18 x 36 in.
Mr. and Mrs. Milton Lowenthal

cal. The later paintings are notably generous and expansive, while the densely packed mid-career works, good as they are—and they are among the very best pictures being made in the United States at the time—can sometimes seem miniaturized. This is especially surprising given Davis's experience with large-scale murals during these years. Even though the helpful precedent of *Swing Landscape* (plate 166), for example, is obvious in the long horizontal formats and firmly layered structures of *Arboretum by Flashbulb* and *Ultra-Marine* (plates 185, 186), the economy of the murals is lacking. The complexity of the canvases may be due to pure exuberance, a manifestation of Davis's pleasure in being able to invent, improvise, and elaborate, without practical considerations. (The spareness of the murals, on the other hand, is undoubtedly due, in part, to the demands of working very large.) But the reduced size and large number of elements in *Arboretum by Flashbulb,* for example, is further evidence of Davis's dependence on landscape and urban themes in even his most abstract pictures of the period. Traditional landscape painting, after all, presupposes that the artist has shrunk the vast spaces of the out-of-doors—whether untouched nature or the built environment—to the size of his canvas. Still-life objects, unlike landscape forms, are usually closer in size to the average easel painting. The clarity of Davis's still lifes bears out this notion. He frequently painted still-life motifs larger than life (or life-size), and this scaling-up led to paintings, from the To-

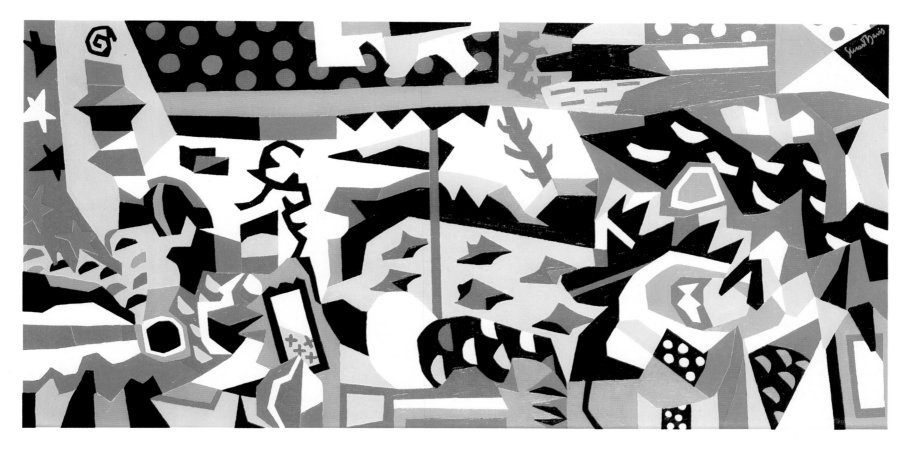

bacco Still Lifes to *Percolator* to *Salt Shaker,* that are notable for their pared-down compositions. Davis's late canvases, often based directly on the configurations of his early "giant still lifes," share their thrift and simplicity.

Yet the sheer quantity of elements in a picture like *Report from Rockport* may also owe something to Davis's devotion to his evolving color theory.[7] His notebooks of the 1940s indicate that he was attempting to turn his intuitive and empirical discoveries of how colors affected one another into a system, a quasi-scientific method for making particular colors and color relationships correspond to spatial relationships. Abstruse diagrams and charts purport to codify his color-space logic. The notebook discussions are convoluted, repetitious, and sometimes contradictory. One of the most lucid definitions of Davis's art theory appeared in 1957, many years after he first began to explore the idea of creating an objective formulation:

As far as the term "color-space" goes, it is simply a phrase I invented for myself in the observation and thought that every time you use a color you create a space relationship. It is impossible to put two colors together, even at random, without setting up a number of other events. Both colors have a relative size: either they are the same size or they are not. And they are either the same shape or they are not the same shape.

186. *Ultra-Marine,* 1943
Oil on canvas, 20 x 40 in.
Pennsylvania Academy of the Fine Arts, Philadelphia; Joseph E. Temple Fund Purchase

They also have, always and automatically, a positional relationship to some necessary, basic, coordinative referent. So the notion that thinking of color as a thing by itself seemed inadequate. For my own personal use I simply called the things that happen when you use two colors, and the process of drawing and painting, a color-space event.[8]

Davis seems never to have allowed theory to interfere with what his eye told him that his pictures required, but he was evidently fascinated with the possibility of formulating an objective system. It is conceivable that he multiplied the elements in his paintings of the period simply to demonstrate (at least to himself) the spatial capabilities of his system. That the densely packed pictures could appear somewhat airless and jammed because of their complexity and their saturated color was an unforeseen reversal of intent. Paradoxically, the proliferation of elements, with its concomitant danger of overloading and crowding, constitutes part of the originality of the paintings in Davis's 1943 exhibition. By distributing small events evenhandedly across the canvas and by repeating colors in units of more or less equal intensity, Davis created pictures in which no part is more important or more eyecatching than any other. They have no center of interest in the traditional sense. In *Ultra-Marine,* for example, the colored planes—red, green, light blue, orange, black, and white—are carefully adjusted to be equal in quantity and visual weight across the surface, so that areas of greater incident simply read as eddies in a dense patchwork. Landscape space has been transformed into two-dimensional, allover pattern. Davis's later pictures would substitute large scale and luminous clarity for the ebullient crowding of his pictures of the early 1940s, but they would retain the sense of equal intensity and equal emphasis in all their parts.

This conception of a painting as a continuous, albeit active and inflected, surface challenges not only traditional ideas of pictorial space, but Cubist notions as well. Picasso and Braque reversed time-honored illusions of perspective by tipping space and substituting angled planes, densely layered in the center of their pictures and flattened at the edges, for the receding distances and solidly modeled forms of the old masters. Yet for all Cubism's radical inversion of traditional picture space and its shattering of traditional modes of representation, Cubist paintings remained essentially centered and contained. Often, they looked like buildable planar objects depicted against neutral grounds. Matisse, in marked contrast, transsubstantiated the three-dimensional world into disembodied (but spatially ex-

pressive) planes of luminous color, in pictures that demand and reward attention accorded to every portion of the canvas; nothing is peripheral or subservient. Davis's allover paintings of the early 1940s obviously owe more to Picasso's and Braque's example than to Matisse's, but in pictures like *Ultra-Marine,* Davis has pried loose the structural planes of Synthetic Cubism. He presents us with the possibility (if not always with the full realization) of a new type of structure: a floating, dense, but infinitely expandable flutter of planes, held only momentarily in check by the boundaries of the canvas and the pull of shape against shape, color against color.

This kind of picture space is not entirely unprecedented in Davis's own work. The saturated color and insistent stroking of his van Gogh—like landscapes of the late teens produced a similar equalization of emphasis, but as by-product rather than by design. In the Tioga landscapes (plates 8, 72), for example, the two-dimensional patterning of hot color and agitated brushwork appears at odds with their nominal subject matter. By contrast, the intentional evenhandedness of Davis's paintings of the 1940s is fundamental to their conception. They depend upon relationships of similarly sized, similarly textured units of various colors for their rhythm and pulse.

Davis was not alone in this groping toward a new kind of picture space. Something similar was emerging in the work of many of his younger colleagues. In fact, a burgeoning alloverness, born out of a deep admiration for Cubism, characterizes some of the best American abstraction of the 1940s. Jackson Pollock, for example, was building Picasso-inspired images out of thickly stroked curving planes and superimposed "signs," while Adolph Gottlieb was covering his canvases with rows of personal hieroglyphs. Like Davis, these younger men were subtly altering Cubist ideas of structure, but their reasons for doing so and their eventual solutions were markedly different from his. Davis's departure from strict Cubist practice came from his desire to find images and structures for the whole spectrum of modern urban life as he perceived it. No matter how simplified his pictures became, no matter how idiosyncratic his imagery, Davis remained faithful to the external world of appearances and phenomena. In the same way, no matter how apparently independent the planes of his compositions, no matter how evenhanded the emphasis, Davis's debt to Cubism remained palpable. Pollock, Gottlieb, and their fellows were seeking ways to make modernist forms accommodate intangible emotions and, at the same time, ways to eliminate the distinction between what a picture was of and how it was made. They searched for direct visual equivalents for the dramas of their interior lives. Cubism, even in the altered

state proposed by Davis, proved inadequate to their needs. In the end, they invented a new pictorial language and a new, seamless, non-Cubist space never explored by Davis. But for a moment, in the 1940s, there was a common vocabulary shared by the older, steadfast modernist and his younger friends and acquaintances in the new vanguard. Given the smallness of the New York art world of the period (made still smaller by the various political alignments of its members) and given the eagerness with which New York modernists looked at each other's work, it is impossible to discount mutual influence.

In a sense, Miró is another common ancestor, provocative to the younger artists because of his surreal imagery, and of interest to Davis because of his clarity and abstractness. Especially in his densely packed paintings of the early 1920s and the Constellations of the early 1940s, Miró's floating shapes offered an alternative picture structure to that of the closed planes of Cubism. Matisse's work did, too, of course, but his was perhaps more difficult to appropriate. In any case, Miró's art was more visible in New York in the 1930s and '40s than Matisse's. Davis surely saw a great deal of Miró's work, both in Paris and in New York, at the Pierre Matisse Gallery, where Miró showed quite regularly. In 1941 the Museum of Modern Art mounted a large and important Miró retrospective, whose influence can be seen in the prevalence of biomorphic abstraction in so much New York painting of the early 1940s. The exhibition's impact was reinforced by the Miró canvases acquired by the museum and later, in the mid-1940s, by Miró's extended working sojourn in New York. Davis, while evidently immune to biomorphism, seems to have profited from Miró's example as much as any of his colleagues, as many of the paintings in his 1943 exhibition clearly demonstrate. *Report from Rockport, Arboretum by Flashbulb,* and *Ultra-Marine* bear witness to influences other than those at work in, say, *Shapes of Landscape Space.* The latter, with its self-contained, centralized configuration, seems to owe primary allegiance to Picasso.

From the vantage point of the present, it is easy to see Davis's 1943 exhibition as a landmark in his career and his pictures of the period as critical to his development. Even at the time, the show was enthusiastically received. Clement Greenberg, in the *Nation,* spoke from a position of empathy with the emerging talents of his own generation—artists such as David Smith, Adolph Gottlieb, and Jackson Pollock—and with firmly held views about what painting could be that were rather different from Davis's, but even so, Greenberg acknowledged progress in Davis's work: "Davis has stayed too long within a formula: the Dufy-esque dance of line against flat areas of high, dry acidic color. It is encouraging to see the artist abandoning this formula by

188. *Study for "Flying Carpet,"*
1942
Gouache on paper,
10 x 14 in.
Earl Davis

using more compact shapes in new greens and blacks. 'Arboretum by Flashbulb' is particularly successful. But 'Report from Rockport,' painted in 1940, is, for all its echoes of Miró, even more so."⁹ Not all reviewers were convinced, however. The same week, Peyton Boswell wrote in *Art Digest* that Davis was "O.K. if you like Jazz, but don't confuse Jazz with Music."¹⁰

The significance of Davis's paintings of the early 1940s was underlined when the Museum of Modern Art mounted a full-scale retrospective of his work in 1945. It was an appropriate tribute. Davis was fifty-two, with more than three decades of dedication to advanced art and consistently high-quality painting behind him. His most recent work was clearly among his best. The show emphasized the continuity of Davis's art, beginning with a pre–Armory Show self-portrait of 1912 and ending with one of his most ambitious paintings of the 1940s, *For Internal Use Only* (plate 187), 1945. It was a well-deserved honor, a summing up of his career to date.

There is a gap of nearly two years in Davis's production, between 1943 and 1945. Only one picture, *G & W* (plate 177), is dated 1944. It is true that he complained increasingly of working with agonizing slowness during the last decades of his life, but at no other time was there complete stoppage. It is hard to account for this hiatus, unless the combined pressure of his 1943 show at the Downtown Gallery and the Museum of Modern Art's retrospective usurped his studio time. The gap is particularly noticeable since the last two decades of Davis's life were

otherwise years of great accomplishment. Many of his best-known and best canvases were painted after 1945: *The Mellow Pad, Visa, OWH! In San Pao, Something on the Eight Ball, Rapt at Rappaport's, Ready to Wear, Blips and Ifs, Combination Concrete,* and others. He also produced murals—the elegant 30-foot-long *Allée* (plate 201) for Drake University and the playful *Composition Concrete* (plate 205) for the Heinz Corporation—and designed a carpet for the weaver V' Soske (plate 188), and a *Time* magazine ad for the Container Corporation of America. Castleton China reproduced one of his drawings on a new line of dinnerware; he made two color serigraphs and a color lithograph and designed a jacket for Columbia Records—appropriately for a recording of music by the American modernist composer Charles Ives—as well as a cover for *Poetry* magazine. This was all part of his effort to earn his living as an artist, but it also indicates the breadth of his interest and his inventiveness. Davis never made distinctions between media. He was ready to tackle anything that offered him an opportunity to apply his abilities. Davis treated the carpet as though it were one of his paintings, designing a typical "Davis" configuration in edible pinks and greens and relying on the clipped wool to provide the surface inflections that he would otherwise have extracted from the way he applied his paint. His color prints and the china pattern were based on existing paintings and drawings, while the magazine

189. *Still Life—Feasible No. 2,* 1949–51
Oil on canvas, 11⅞ x 16⅛ in.
The Saint Louis Art Museum; Gift of Morton D. May

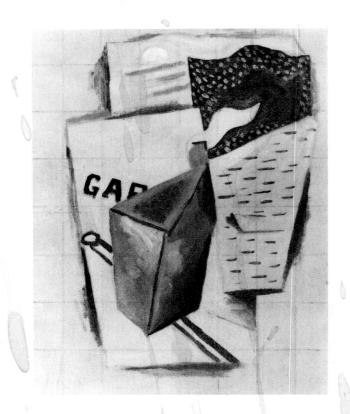

190. *Still Life*, 1922
Oil on board, 16 x 12 in.
Earl Davis

191. *Rapt at Rappaport's*, 1952
Oil on canvas, 52 x 40 in.
Hirshhorn Museum and
Sculpture Garden, Smithsonian
Institution, Washington, D.C.; Gift
of Joseph H. Hirshhorn
Foundation, 1966

ad and the record jacket are similarly indistinguishable from any of Davis's fine-art efforts. No material or application was more precious than any other. To Davis, all were potentially significant.

Davis's last two decades were a time of growing recognition and undoubted personal satisfaction, with even some degree of financial stability. He had gradually acquired a number of devoted admirers, most notably William H. Lane and Mr. and Mrs. Milton Lowenthal, whose collections are still essential to any understanding of Davis's work. Museums across the country began to acquire his paintings. He was represented in many prestigious exhibitions and won several prizes and purchase awards. In terms of popular perception, there was his inclusion in *Look*'s 1948 list of the ten best painters in America; in terms of more sophisticated judgment, Davis was asked to represent the United States at the 1952 Venice Biennale, and that same year he received a John Simon Guggenheim Memorial Fellowship. The year 1952 was special for Davis in another important way; in April his only child, George Earl Davis (named for two of his father's favorite jazz musicians, George Wettling and Earl Hines), was born. Five years later the Walker Art Center organized a major Davis retrospective that toured the United States.

In 1950 Davis was able to give up his job at the New School for Social Research, where he had taught for ten years. The following year he accepted a post as visiting art instructor at Yale University. In 1955 the family left the Village, where Davis had lived most of his adult life, and moved uptown to a studio building on West Sixty-seventh Street. Davis was having problems with his eyes (fortunately corrected by cataract surgery) during this time of professional and personal well-being, but he was able to work, very slowly but steadily, and his infrequent exhibitions were met with serious attention. Despite his growing fame, Davis's life seems to have changed very little through the late 1940s and the '50s. His enthusiasms remained the same—good modern art, jazz, baseball, urban life—and his circle of friends included artists and musicians he had known for years: Ralston Crawford, Carl Holty, Yasuo Kuniyoshi, Niles Spencer, Eddie Condon, George Wettling, among many others.

Davis's working methods and techniques were well established by this time. He seems to have given up sketching out of doors, for the most part, although he did occasionally use still-life elements as models. Most often he began with a configuration derived from one of his own earlier pictures. Davis explained this reasoning in an interview about two works of the mid-1950s—a gouache, *Package Deal*, and a canvas, *Premiere* (plates 194, 195), that is based on it: "[*Package Deal*] is pretty good sized and after I had done it I had the feeling I could do

178

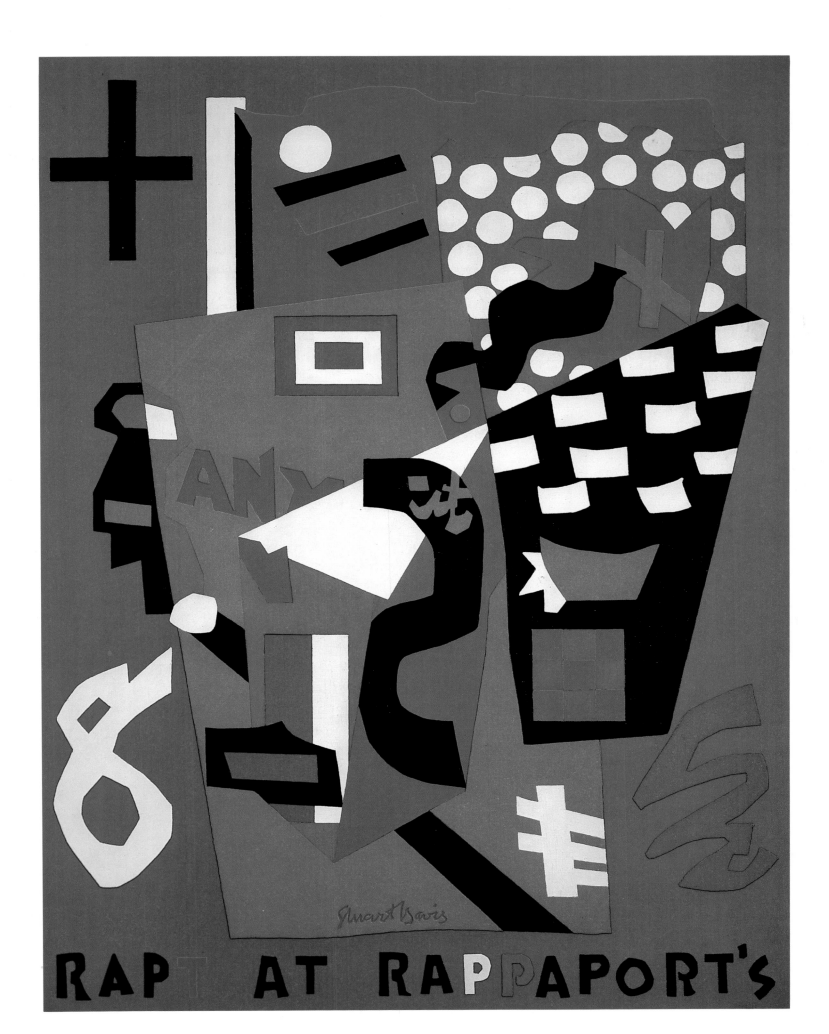

192. *Detail Study No. 1 for "Package Deal,"* 1956
Gouache on paper,
13 x 9½ in.
Leo S. Guthman

193. *Detail Study No. 2 for "Package Deal,"* 1956
Gouache on paper,
12½ x 10 in.
Salander-O'Reilly Galleries, New York

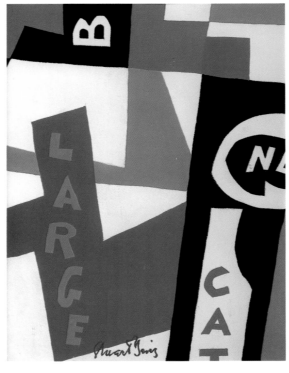

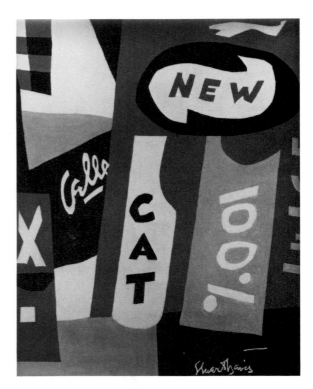

194. *Package Deal,* 1956
Gouache on paper,
20¾ x 18 in.
Private collection

OPPOSITE
195. *Premiere,* 1957
Oil on canvas, 58 x 50 in.
Los Angeles County Museum of Art

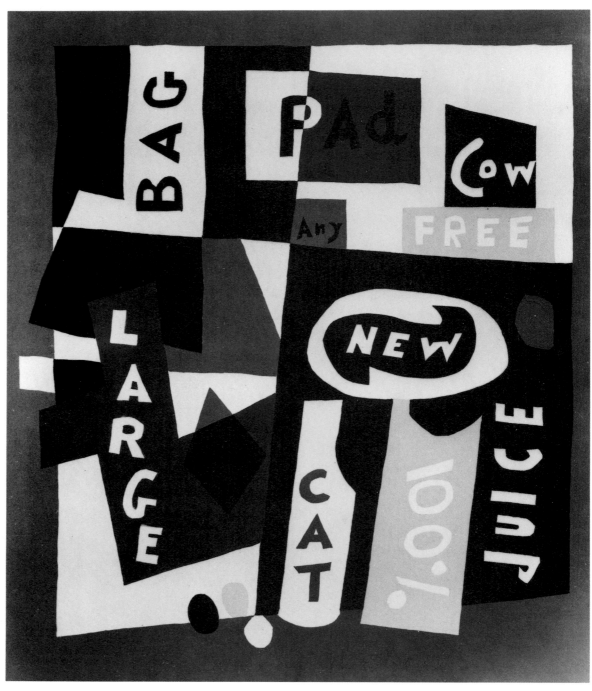

something more with it. . . . I was interested in this idea about yellow which I had used in several canvases. I used to use Lemon Cadmium Yellow. I used it over a number of years and then my ideas about intervals of the color positions developed. I thought this was out of place, that the interval between black and white and Cadmium Yellow was off beat." [11] The revision of *Package Deal* that resulted in *Premiere* was made, then, in response to Davis's notions of how colors suggested positions in space in relation to one another. By changing colors and their relative positions from one picture to another, Davis was able to explore new spatial relationships—one of his prime concerns in the last two decades of his life.

Once a general configuration was established (usually, but not always, based on an earlier painting or drawing that Davis still found stimulating), the spatial complexities of the picture were meticulously adjusted. Davis used charcoal and tape guidelines on his canvases during this preliminary black-and-white stage. The tapes helped to establish large relationships and, at the same time, to isolate areas for consideration as "detail studies." A painting might exist as a black-and-white "drawing" for weeks, while Davis gradually established what he called the relationship of "intervals," by introducing elements that varied the basic geometric theme.[12] His signature, for example, might be introduced at an early stage, as just one of many possible shapes. (After about 1950, he frequently made full-size black-and-white linear versions of the developed configuration on canvas, as complements to the colored versions of similar images.) While Davis adjusted his charcoal drawing, he made black-and-white and colored detail studies of sections of the painting, which were complete in themselves and sometimes became the basis of new variations on a theme. When he was at last satisfied with his drawing on canvas, the tapes were removed and a colored underpainting applied, usually of thinned-down oil paint mixed with turpentine, but occasionally in tempera. Final color decisions were made and Davis applied a rather thick, opaque layer of pigment, using fairly wide brushes. It was a slow and painstaking process, but necessary to the sense of absolute inevitability that Davis demanded of his paintings.

During the 1940s and '50s Davis withdrew almost totally from social activism, although he could be counted on to declare himself when the occasion warranted it. He still believed in the ideal society that he had worked for in the 1930s, but his notebooks record his deep disillusionment and pessimism. Davis's break with the left was complete. During World War II he bitterly equated the totalitarianism of Fascist Italy and Nazi Germany with that of Stalinist Russia. In marked contrast to his

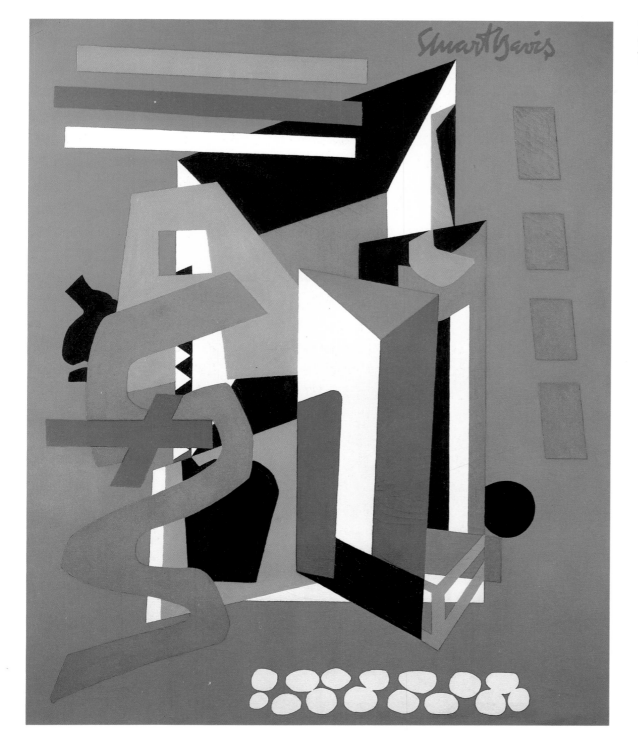

196. *Medium Still Life,* 1953
Oil on canvas, 45 x 36 in.
The William H. Lane Collection

scrupulous separation of art making and social action in the 1930s—
and his insistence on the importance of doing both—Davis now dis-
cussed the relationship of the artist and society in different ways. "Be-
fore art can exist there must be someone who wants it. If there are only
people who want sound economic relations, art would never ap-
pear."[13] He saw painting and sculpture as part of the "moral freedom"
essential to a moral society. "The only service an artist can give his
country in time of war or peace is to produce art, free art," he wrote in
1942, a month after Pearl Harbor.[14] (Davis was forty-nine when he wrote
this, too old for active service.)

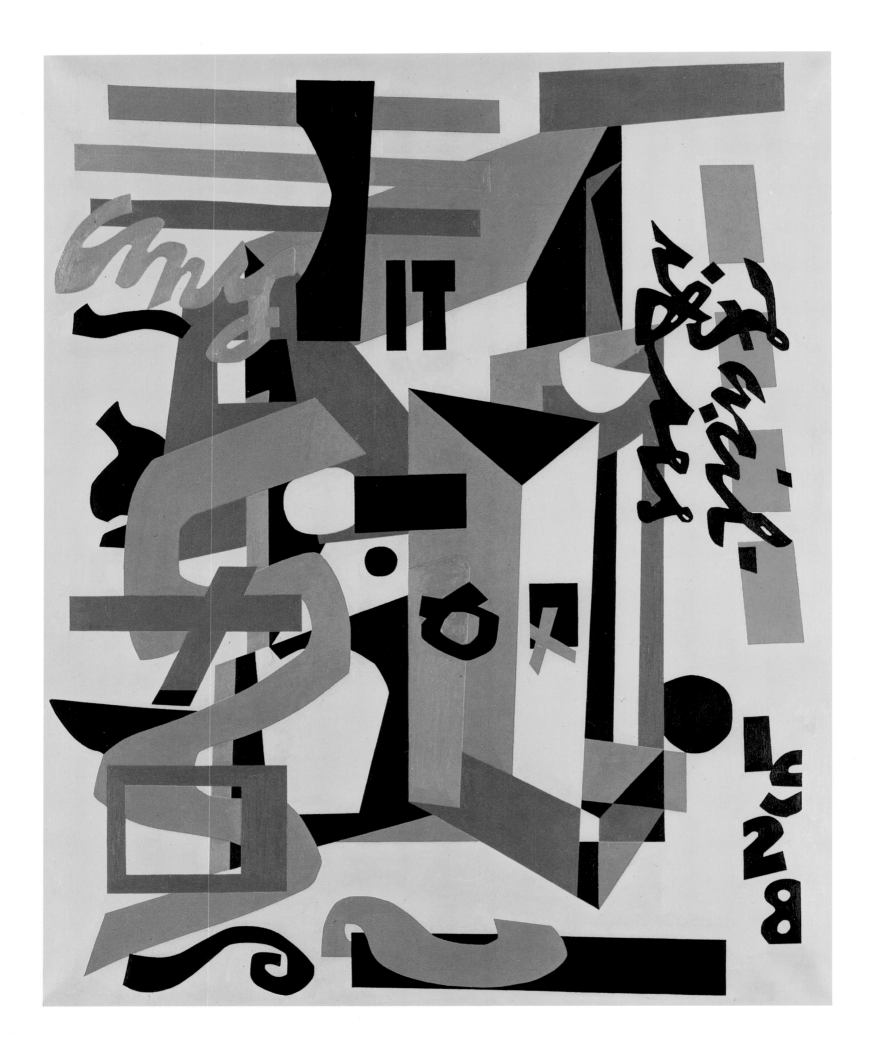

Davis criticized the rejection of modernist art by totalitarian re-
gimes, but he was equally critical of his own country's attitude. "The
Hitler-Stalin totalitarian concept suppresses free art systematically in
accord with its entire concept of culture. America does it through ig-
norance." [15] "There is now," he wrote, "a struggle between the Borscht-
wazee and the Bourgeoisie." [16] Davis longed for a new people who
would produce a new order. He fantasized the growth of "Color-Space
People," "a technological aristocracy" quite unlike the existing middle
class, politically enlightened or otherwise. "Color-Space People" would
want real art. "The taste of the New People will be anti-carpet, what-
knot [sic], and pug-dog. . . . It will be a spontaneous taste emerging
from the aeroplane way of life and the spaces, speeds, and materials
connected with it." [17] Davis was optimistic in 1948: "Truman's victory stands

199. *Tournos,* 1954
Oil on canvas, 35⅞ x 28 in.
Munson-Williams-Proctor
Institute, Utica, New York

for something great. It means that common sense liberalism is a fact in the people, and that in spite of every effort to suppress it from opinion creating sources it expressed itself with firmness. Now we know that everything is not shot to hell, and what were thought to be human values still are a living fact." [18]

But instead of observing the rise of the "Color-Space People" in prosperous postwar America, Davis watched, with horror, the rise of McCarthyism and found himself—along with the cream of American thinkers, artists, writers, and performers—under attack. Perhaps out of morbid fascination or out of a well-developed sense of black humor,

Davis saved among his press clippings and generally enthusiastic reviews an issue of the 1956 *Congressional Record* that reprinted a hysterical diatribe by Congressman George A. Dondero of Michigan.[19] Dondero gleefully recounted how the government had stopped a traveling exhibition of twentieth-century painting organized by the American Federation of Arts. He described the exhibition as "one of those determined drives by the AFA to free acceptance of counter-culturalists at the expense of the American taxpayer." Most of the artists proposed for the show, he claimed, were "known Communists" and "Red stooges." His list included the European-born Surrealists Yves Tanguy and Max Ernst; he also denounced as "vulgarian" and "not representative of American culture" Robert Gwathmey, Philip Evergood, Max Weber, Jack Levine, Jacob Lawrence, Ben Shahn (the "Red photographer and so-called artist"), and "abstract artist Stuart Davis." Dondero accused Davis of condoning the Stalinist purges and described him as "an initiator of the officially cited 'Communist created and controlled' American Artists Congress," who had been "active in supporting Communist and Communist-front activities for decades." Dondero gloated further about having stopped another exhibition, which included "the late John Sloan notorious Red painter." Dondero's tirade continued with further absurdities that demonstrated his facts to be suspect, at best, his logic torturous, and his conclusions irresponsible; unfortunately, his beliefs and his use of association and innuendo are a hideously accurate reflection of the times.

Davis, like most thinking people in the United States, recoiled from the excesses of the witch-hunters. It would be natural to assume that he found refuge in the forward-thinking circles of the art world, his place secured by his long-time support of the most advanced and ambitious painting. But Davis found himself curiously out of touch with the new generation of American abstract artists. In the view of the most progressive dealers, curators, and critics, during the 1940s the emerging Abstract Expressionists had gradually supplanted Davis in his role as standard-bearer of the avant-garde. By the 1950s the New York

200. *Study for "Allée,"* 1955
Gouache on paper,
8 ft. x 35 ft.
Earl Davis

PAGES 188–89
201. *Allée,* 1955
Oil on canvas, 8 ft. x 30 ft.
Drake University Art
Department, Des Moines, Iowa

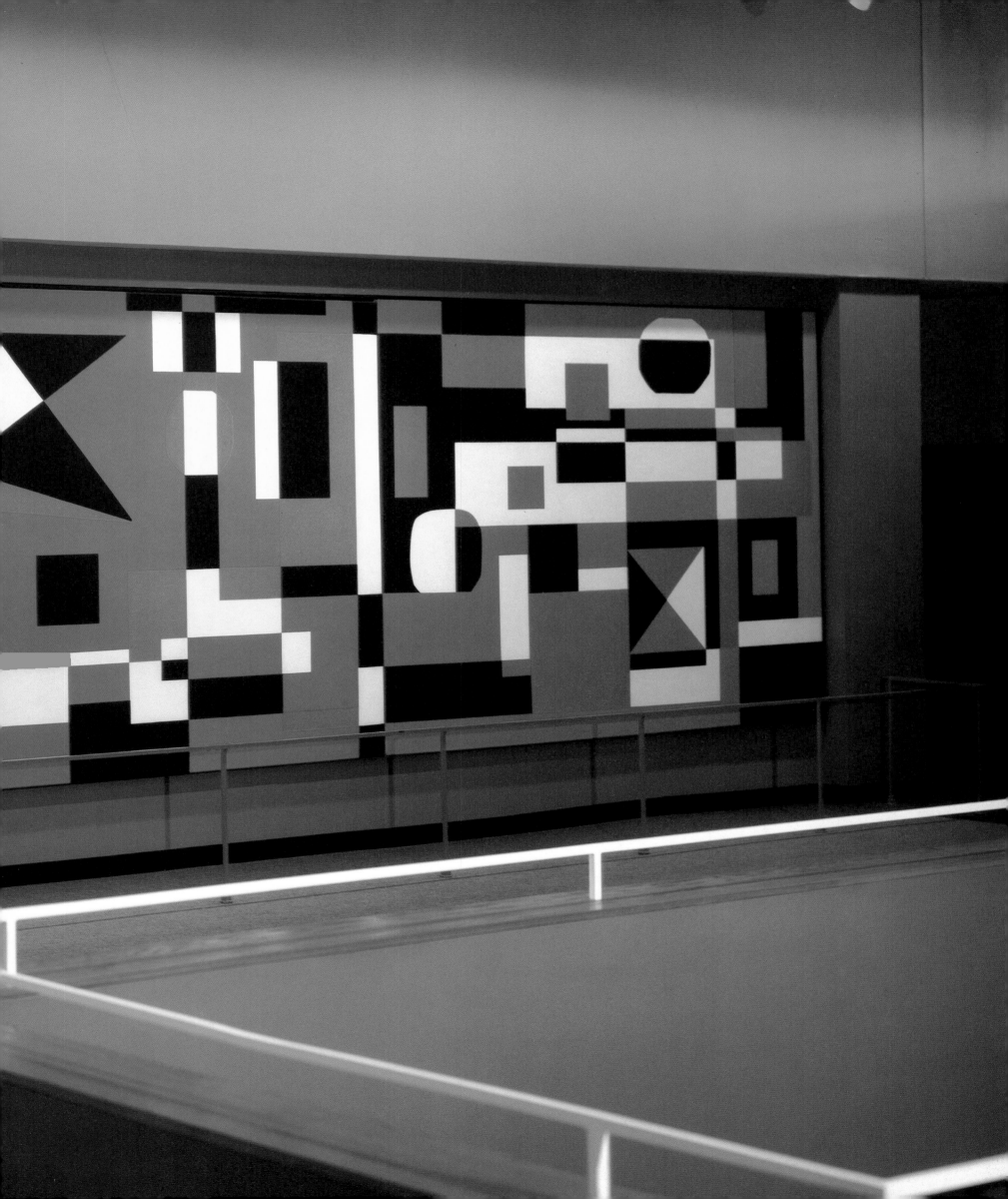

202. *Memo,* 1956
Oil on linen, 36 x 28¼ in.
National Museum of American
Art, Smithsonian Institution,
Washington, D.C.; Gift of the
Sara Roby Foundation

203. *Stele,* 1956
Oil on canvas, 52 x 40 in.
Milwaukee Art Museum
Collection; Gift of Harry Lynde
Bradley

School's notoriety had made them visible to a wide and increasingly receptive audience. In spite of his position as a senior American modernist, Davis found himself eclipsed by artists younger than himself, many of whom he had championed at the beginning of their careers. This might have been less painful had Davis been enthusiastic about their current work, but he was unable to accept the aims (or the forms) of developed Abstract Expressionism. Its formal basis in Cubism had initially given Davis and his younger colleagues some common ground,

204. *Mural for U.N. Conference Room No. 3—Study*
Oil on canvas, 28 x 70 in.
Museum of Fine Arts, Boston;
M. and M. Karolik Collection, by exchange

but Abstract Expressionism's fascination with Surrealist theory—the idea of mining one's inner world as a source of art—alienated him. "Surrealism denies the objective world and is escapist," Davis wrote in his notebook. "It denies the classic function of art—bold assimilation of the environment." [20] Abstract Expressionism was worse. "Abstract Expressionism is an SOS hence not actually art," Davis told a Houston audience. He grudgingly admitted that it had some vitality. "At the same time it shows that the lost are still alive. I affirm it in that sense." [21]

The vituperation that Davis had directed at the American Scene painters in the 1930s was now aimed at the Abstract Expressionists, for some of the same reasons. He had hated the sentimentality of the American Scene, and he found the emotional unbuttonedness and psychological intensity of Abstract Expressionism no more palatable. Pollock's work he dismissed as "Ballad-type lyricism in large economy size. Barefoot Balladry." [22] Davis had disliked the traditional forms adopted by the American Scene painters and had called them reactionary in terms of the history of art, but he found the Abstract Expressionists' avant-garde approach just as unacceptable. Where others saw energy and spontaneity, Davis saw only self-indulgence and incoherence: "the Dogma of Dirt," "ANY method instead of Logic-Method." [23] In 1922 Davis had written that a work of art should be "first of all impersonal in execution, that is to say it should not be a seismographic chart of the nervous system at the time of execution." [24] Twenty years later, he wrote: "Emotion, Sensibility, Stimulation does not produce Art except when it is integrated with an emotionally conscious theory of dimensional structure." [25] "Abstract art is an art of structure as opposed to an art of Sentiment." [26] He had not changed his mind. It is, however, typical

205. *Composition Concrete,* 1957
Oil on canvas,
16 ft. 10¾ in. x 8 ft. ³⁄₁₆ in.
The Carnegie Museum of Art,
Pittsburgh; Gift of the H. J. Heinz
Company, 1979

206. *Composition Concrete
(Variation),* 1957–60
Waterbase medium on canvas,
65 x 26½ in.
Earl Davis

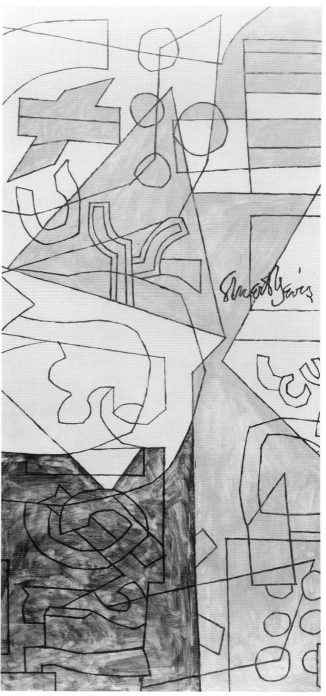

207. *Notepad Drawing,*
c. 1950
Ink on paper, 4⅞ x 7⅞ in.
Earl Davis

from DeKooning

from Kline

of Davis's general receptiveness to new art that his notebooks also contain several serious, nonderogatory configurations based on the work of de Kooning and Franz Kline, at least one of which became the basis of a painting (plates 207, 208).

The testimony of his pictures makes it clear that Davis turned increasingly inward after 1945. His age, his political estrangement from both the old left and the new right, his detachment from both the new American avant-garde and the old conservative art world are only partial explanations. For whatever reasons, Davis's subject matter, or rather his point of departure, became more and more his own art of the past. He was still acutely tuned in to his surroundings. He still delighted in the technological advances of the mid-twentieth century, still reveled in the complexities of urban life, the manifestations of popular culture. He is reported to have kept a television set in his studio, tuned to sports programs with the sound off, while he worked. Davis's full-bodied paintings of his last years reverberate with the clangor of the modern city, its myriad changes and random alignments, but the framework of these pictures is, as often as not, a configuration arrived at many years before. *Rapt at Rappaport's,* 1952, and *Combination Concrete,* 1958 (plates 191, 211), both have their origins in modest paintings of the 1920s (plates 190, 209). *OWH! In San Pao,* 1951; *Medium Still Life,* 1953; and *Something on the Eight Ball,* 1954 (plates 212, 196, 197), are all based on two of Davis's most ambitious paintings of 1927, *Percolator* and *Matches* (plates 101, 104). Even newly minted configurations, such as those of *Little Giant Still Life,* 1950, and *Ready to Wear,* 1955 (plates 27, 38), were reexamined and reinterpreted to produce

208. *Town & Country*, 1959
Oil on canvas, 10 x 10 in.
Barbara Mathes Gallery,
New York

paintings such as *VISA*, 1951; *Schwitzki's Syntax*, 1961–64; and *Cliché*, 1955 (plates 28, 29, 39). It is ironic that having rejected—or having failed to grasp—Abstract Expressionism's notion of personal inner history as the genesis of art, Davis should turn to his own past as subject. But characteristically, it is his own past at one remove, already distanced and made into a self-sufficient object.

It is not that Davis relied on earlier work because he lacked invention. His earlier configurations were spurs to new ideas, just as any other experience was. Davis continued to believe in the enduring power of a good drawing to generate many canvases (or gouaches or prints), but even the best configuration was simply one among an infinite variety of stimuli to painting. To his familiar litany of things that made him want to paint, Davis added: "I can work from Nature, from old studies and paintings of my own, from photographs and from other works of art. In each case the process consists of a transposition of the spirit of the forms of the subject into a coherent objective color-space continuum, which evokes a direct sensate response to structure." [27]

When Davis used other art as his starting point, it was always in a spirit of critical reevaluation and reinvention. It is probably significant that he did so most often after 1945—that is, after the period of his most concentrated exploration of color-space theory and his most strenuous efforts to codify and define his ideas of picture structure. It is as though after this intense period of examination he wished to redo his earlier pictures according to his new methodology and newly formulated theory. But, in fact, the progression is not quite so neat. For example, the restricted, repeated, "codified" color so characteristic of Davis's later works is first seen in his pictures of the late 1930s and early '40s, while the radical transformation of *Eggbeater No. 2* into *Hot Still-Scape* dates from 1940. Once again, Davis's theorizing followed his intuitive inventions, rather than the other way round. Yet it is also true that whenever Davis created new versions of his own and, on at least one occasion, another artist's work, the changes that he made were consistent. They suggest that rather than trying variations for the sake of variety, he was following, to some extent, a coherently revised notion of what painting could and should be. *G & W* (plate 177), 1944, and *For Internal Use Only* (plate 187), 1945, are based rather loosely on Mondrian's *Composition* of 1935–42 in the collection of Mr. and Mrs. Burton Tremaine. The Mondrian painting serves as a model for the largest divisions of the Davis paintings, a sort of scaffolding on which he has hung his familiar repertory of eccentric shapes and patterns. For all his admiration of Mondrian, Davis never lost his reservations about the restrictions of pure geometry, so *G & W* and *For Internal Use Only* can be

209. *Curve—Go Slow*, 1922
Gouache on paper,
16 x 12 in. (sight)
Earl Davis

PAGE 198
210. *Black and White Combination Concrete No. 2*, 1958
Tempera on canvas,
60 x 45 in.
Earl Davis

PAGE 199
211. *Combination Concrete*, 1958
Oil on canvas, 71 x 53 in.
Private collection

212. *OWH! in San Pao,* 1951
Oil on canvas, 52¼ x 41¾ in.
Whitney Museum of American
Art, New York

seen not just as homage to Mondrian, but also as criticism of his approach. Davis may have been suggesting how strict geometry could be brought to life according to his theories of color-space.

The relationship between Davis's 1927 canvas, *Percolator* (plate 101), and his powerful 1951 painting, *OWH! In San Pao* (plate 212), is similar and revealing. *Percolator* is a slightly earlier manifestation of the cool analysis of the Eggbeaters. The familiar kitchen appliance has been enlarged and dissected into sharp-edged geometric parts, which have, in turn, been reassembled into an intricate but lucid construction, like a diagram for sculpture. The percolator has been reduced to essential structural planes, isolated and clarified by being set against a continuous background of densely brushed, luminous pigment. As translated into *OWH! In San Pao,* the percolator seems at first far more solid, because of overlapping planes and color shifts, but the implied illusionism of the earlier work, the sense of object in setting, has vanished. Davis has introduced new elements that expand the original configuration and change the centralized composition into an open and fragmented one. Instead of the single object, however enlarged and altered, set against a subordinate, neutral ground, we are confronted by a lively, wholly abstract assembly of planes in which it is impossible to establish foreground and background.

The high-key pastel color of *Percolator* is also radically changed. Davis has not simply heated up earlier color relationships to change the mood. As in the transformation of *Eggbeater No. 2* into *Hot Still-Scape,* the revisions of hue alter the picture space. In *Percolator* a continuous, loosely brushed, pale background color extends behind the centralized image, penetrating the isolated subject of the painting and accenting the difference between figure and ground. Slight variations in the trapped planes of background color within the figure give proof of Davis's subtlety as a colorist. *Percolator* is noteworthy for the richness of its fragile, close-valued hues; unnameable quartertones, off-shades of gray, cream, and peach make the picture one of the most delicate and beautiful of Davis's early industrial still lifes. These luminous pastels read here as a single plane, there as several. In *OWH! In San Pao,* Davis limited his palette to a group of pure hues at maximum saturation and opposition: hot pink, blues, green, two oranges, black, and taxi yellow. In marked contrast to the pale sculptural articulations of *Percolator,* these repeated contrasting colors are used to lock a complex structure into a single plane.

To a lesser degree than the Mondrian composition did for *G&W* and *For Internal Use Only,* the configuration of *Percolator* serves as a support for improvisation in *OWH! In San Pao.* The severe, economical

figure of the early picture is simultaneously opened by means of color relationships and obscured by an overlay of new, cursive elements. Against the basic *Percolator* layout, Davis played a range of new motifs—including dots, bars, loops, and calligraphic writing—as though the original drawn object were coming apart and its planes floating across the canvas. The most notable and dramatic of these are words and letters, "signs" in both the literal and the philosophic sense. Their linearity opens the densely interlocked planes of the supporting structure of *OWH! In San Pao* because of their similarity to the narrowest elements of the original configuration. These inner strips read not as borders or frames attached to larger planes, but as slender, independent shapes, visually related to the lettering.

The isolated words are not merely formal devices. Like Davis's punning and rhyming titles, the words within his paintings are both discrete visual elements, chosen for their shapes the way titles were for their sounds, and wry comments on what the artist was up to. Words and letters are, at one level, abstracted fragments of Davis's environment. Any urbanite is familiar with the way commercial signs flash discontinuous exhortations at us (as is any suburbanite, since the growth of the modern shopping strip), and Davis, as the quintessential celebrant of modern urban life, delighted in the accidental meanings that could be extracted from randomly associated signs, labels, and posters; the accidental anagrams of marquees with burned-out letters; advertising messages perceived at high speed; and so on. There is some evidence that Davis was aware of Cubist poetry, probably through the poet Bob Brown, an old friend from New York and Paris, who practiced something like the image-poetry of Guillaume Apollinaire.[28] Then again, Davis's taste for isolated messages may have had something to do with the clash of word against word that he had responded to in the work of William Carlos Williams.

Whatever their other references, the floating words in Davis's later pictures are always specific to his own beliefs and situation. In *OWH! In San Pao, ELSE* may allude to the fact that the picture is a restatement of an earlier theme or, more generally, to the possibility of variation and reinvention. *Used* and *NOW* are similar references to the painting's previous and present existence. (The number 6 has been retained from the original image. Was the percolator that served as model in 1927 a six-cupper?) Some references are specific to particular paintings. In *Something on the Eight Ball* (plate 197), *facilities,* split into *facil* and *ities,* creates a bilingual pun that recalls the acronym of the collage *ITLKSEZ*—"it looks easy." The overscaled *CHAMPION* of *Little Giant Still Life, VISA,* and *Schwitzki's Syntax* (plates 27–29) apparently derives

from an ad for spark plugs on a matchbook. In *Combination Concrete* (plate 211), *1922* refers to the date of the gouache on which the canvas is based, while the word *NEW* points to Davis's reuse of the configuration.

Other words and phrases are repeated in many paintings, like recitations of a personal credo. *ANY,* which recurs in many later paintings, appears in the notebooks in assertions that *any* subject matter can be valid for painting. (The word *else* is sometimes attached to this notion, and also to spatial theorizing.) Certain quasi-mathematical signs—X's, pluses, and a kind of floating loop, like an inverted *e*—all have equivalents in Davis's notebooks, in the "equations" and formulas he devised to clarify his color-space theories. The floating *e,* for example, is used to symbolize the word *configuration,* while the X sometimes stands for *external*—as opposed to *internal*—which Davis described as the generating "dynamic forces" of two-dimensional composition. These symbols, like the shorthand words incorporated into the paintings, often change meaning. The inverted, floating *e,* for example, also appears identified as "the free drawing gesture." In the paintings Davis's name is almost always turned into an elaborate floating character, while other wordlike images resist decoding. They are probably meant to tease. If they do contain specific meanings, Davis seems to have preferred that they remain private and unreadable. The most eloquent of Davis's messages is the starkly legible *FIN,* added to his last painting (plate 232), which was left unfinished when he died suddenly of a stroke.

Some critics have chosen to string these allusive, elusive messages into brief sentences, but it seems unlikely that Davis meant his paintings to be read like rebuses. His sense of the fragmentation of the modern world, reflected clearly in the increasing fragmentation of his picture structure, seems to preclude reading his words and letters as coherent texts. Davis's notebooks attest to his love of language, despite his rather convoluted prose style, while his sketchbooks bear witness to his love of the minutiae of the city, bits of detail extracted from context. At the simplest level, the words and letters of his paintings are simply allusions to the sights and possibly the sounds of the commercial street with its signs and ads. But just as signage, like labels and advertising, can attract and direct the inhabitants of the real world, the floating words of Davis's paintings can be decorative (in the best sense of the word) eyecatchers and, at the same time, can serve as signposts to his perceived and invented world of color-space.

Despite Davis's invention of a recurring vocabulary of calligraphic shapes and patterns, despite his fascination with the layers of allusion

213. *Untitled* (black-and-white variation of *Pochade*),
c. 1958—64
Tempera on canvas,
45 x 56 in.
Earl Davis

(both in terms of space and of reference) that could be imposed by floating word-shapes, the paintings of the last decade of Davis's life are increasingly pared-down and severe. The number of planes in a basic configuration seems limited, and color, too, seems restricted, often to black, white, and two or three saturated hues—as in *Schwitzki's Syntax* and *Unfinished Business* (plates 29, 215) (in this context, Davis's infrequent use of gray or a single accent color becomes startling). While Davis was clearly capable of positioning a great range of shapes and planes in complex relationships, he seems, in these last works, to have been testing how economically he could do so. These paintings are characterized by a plentiful use of white. Colors are applied in large, unbroken expanses, juxtaposed in order to make carefully contained planes separate from one another, and the compositions ap-

214. *Pochade*, 1958
Oil on canvas, 52 x 60 in.
Thyssen-Bornemisza Collection,
Lugano, Switzerland

215. *Unfinished Business*, 1962
Oil on canvas, 36 x 45 in.
The William H. Lane Collection

216. *Closed Circuit,* 1962
Casein on paper, 11 x 13¼ in.
Barbara Mathes Gallery,
New York

pear generous and open. The pictures seem lucid and spare, as
though Davis were attempting to lay bare the most elemental aspects
of his color-space construction. This is no less true of the small-scale
pictures of the last decade, such as *Closed Circuit* (plate 216), 1962,
than of the major canvases. Intimate scale simply produced greater
drama, since nuances of texture and drawing are emphasized by the
picture's smallness. We are forced to draw close, to consider each sim-
plified, thickly stroked color plane as an all but separate entity in a
tightly knit whole.

Probably the most extreme examples of Davis's apparent search
for ultimate economy are the ten enigmatic black-and-white "line
drawings" on canvas that date from about 1958 to 1964 (plates 213,
218, 219). They recapitulate, more or less full size, configurations from
some of his most ambitious and most successful paintings. Given Davis's
history of careful preparation for his large paintings, color studies, de-
tail studies, and the like, it would be logical to assume that these ele-
gant drawings were the definitive studies for meticulously worked-out
compositions, twentieth-century equivalents of the Renaissance car-
toon. But why, then, would Davis have done them on canvas? And
since they *are* on canvas, why do they still exist? Wouldn't Davis have

begun with a drawn armature and then continued with color on the same support? The black-and-white canvases turn out not to be studies at all, but self-sufficient complete works. They were done after the fact, as final distillations of paintings first developed in color. (The only exception is a black-and-white version of the large mural, *Allée* [plate 200], 1955, which is a preparatory study.) Since we tend to think of Davis primarily as a colorist or, at least, as a painter whose work depends on a clear architecture of brilliantly colored planes, it seems astonishing that these large-scale, black-and-white drawings were final resolutions. Yet we also know that Davis regarded drawing as fundamental. The drawn configuration that generated each painting was its most important, irreducible element; it encapsulated, in objective terms, the artist's original experience. As the black-and-white canvases attest, that configuration could stand as the picture's most developed, ultimate form.

In a 1932 sketchbook Davis wrote: "One must learn to see the space not simply the boundaries of objects. One must see the 'shapes' of the space not the shapes of the objects that occur in it. The color is never the cause of the interest because it is only the means by which ideal space relations are made visible." [29] Thirty years later, Davis's work testified to his continuing belief in these principles.

IN PERSPECTIVE

avis's paintings are unmistakably American, for all their indebtedness to French modernism. In the same way John Philip Sousa turned typically French military marches into quintessentially American parade and circus music, Davis translated French Cubism into a colloquial but sophisticated American idiom. It is not just that the things that made Davis want to paint were typically American—gas stations, skyscrapers, electric signs, kitchen utensils, jazz music, and the like—although that certainly contributes to the flavor of Davis's work. Just as Sousa imposed new vernacular harmonies and flourishes on French structure, raising a familiar form to new levels of invention, so Davis changed Cubist spatial analysis into something no less complex but more irreverent and forthright.

Several perceptive writers have contended that any definition of American art must take into consideration American artists' insistence on fidelity to object character, that is to say, on the special qualities of whatever is being represented.[1] (This is not restricted to the visual arts; Henry James's writings have been discussed in similar terms.) The trompe l'oeil still lifes of Harnett and Peto are extreme examples in which objects have been not merely represented but virtually replicated, though there are many less literal instances. From the startling verisimilitude and intensity of John Singleton Copley's eighteenth-century portraits to the glowing sunsets and shimmering mists of the Luminists' nineteenth-century landscapes, American painters have concentrated on the physical properties of their subjects—their characteristic shapes and masses, their colors and textures. This tendency persists, in altered form, in more recent work: Abstract Expressionism shifted the emphasis from what was depicted to the act and materials of painting. Minimalism can be seen as the most literal version of the phenomenon, an austere inversion of Harnett's and Peto's illusions. Whether this obsession with the object is due to American pragmatism or to a transcendental relationship with nature and objects alike, or whether it springs from a desire to establish fixed, comprehensible nodes in a large and still evolving country, is open to speculation.

217. *Blips and Ifs*, 1963–64
Oil on canvas, 71⅛ x 53⅛ in.
Amon Carter Museum, Fort Worth

218. *Letter and His Ecol,*
Black and White Version No. 1,
c. 1962–64
Tempera on canvas,
24 x 30 in.
Earl Davis

Davis rarely painted faithful replicas of his chosen subjects—not after the illusionistic papers of the 1920s Tobacco Still Lifes—but his conception of the configuration as an immutable distillation of experience could be interpreted as part of the American impulse to clarify and fix whatever has been perceived. The solidity and innate naturalism of a rather atypical still life of his Tobacco series, *Lucky Strike* (plate 11), 1924, seems less unusual if we see Davis as sharing the national desire to remain faithful to the object. The picture is far less abstract than most of the series. In essence, it is a Cubist collage, rationalized, in almost the same way that Cubist fragmentation is rationalized in the massed roofs and buildings of Davis's experimental paintings of the mid-teens (plates 63, 65). In *Lucky Strike* an image of a folded newspaper substitutes for the pasted paper planes of classic collage. The lettering that Davis used with such freedom in other Tobacco Still Lifes is logically accounted for as newspaper type and package labels. The pipe at the center of the picture tucks behind the folded newspaper, so the effect of fragmented intersecting planes has a similarly reasonable explanation. It is a curious picture, distinguished mainly by its subtle, tawny color, but it suggests, as do the "Cubist" hillside pictures of 1916, that Davis may initially have been uncomfortable with

219. *Letter and His Ecol,*
Black and White Version No. 2,
c. 1962—64
Tempera on canvas,
24 x 30 in.
Earl Davis

dissection of form, much as he was attracted to Cubist layout and to the general look of Cubism.

As his understanding of Cubist space deepened, Davis became more audacious, eventually inventing his own authoritative kind of structure: color-space logic. The configurations he devised became more unpredictable, less and less attached to the logic of the generating image. Not only was Davis likely to fragment objects (rather than to suggest fragmentation by obscuring parts), but he also became fascinated by the intervals between objects. Both fragment and interval, however, were always presented as firm, brushy expanses of paint, each with a discrete presence and a clear boundary. Abstracted planes were made into self-contained objects. In the same way, Davis's thickened calligraphy, especially in the later pictures, turns words themselves into objects, so that abstract "signs"—in every sense—become discrete forms in a new painted structure. Davis's often-repeated assertion that his paintings were concrete objects, equivalent to anything in nature without imitating anything in nature, is in the broadest sense a declaration of the integrity of the object. The internal painted frames, the colored borders of so many of Davis's pictures, emphasize his paintings' independent objecthood and their separateness from anything

213

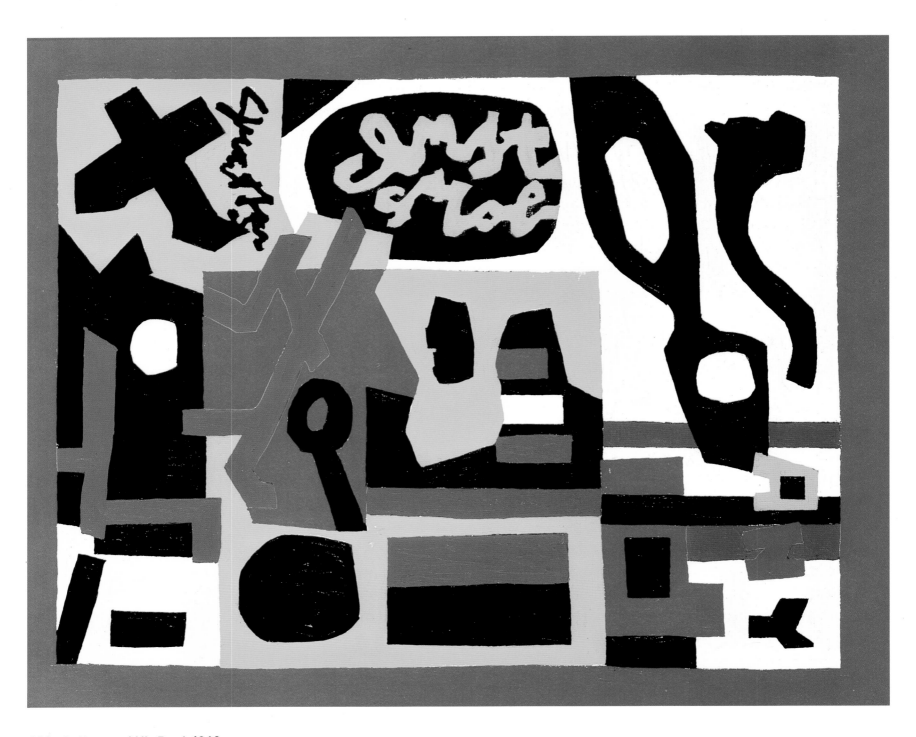

220. *Letter and His Ecol,* 1962
Oil on canvas, 24 x 30¼ in.
Pennsylvania Academy of the
Fine Arts, Philadelphia; John
Lambert Fund Purchase

else. The meaning of the word *object* has shifted from the thing depicted to the painting itself, but the American obsession with object character is still present.

The manifest Americanness of Davis's paintings does not dilute the strength of his connection to his European forebears, a connection he always acknowledged with pride. He may have dissembled his familiarity with particular artists' work—such as Léger's—but he was open about his relationship with French art in general. (Davis was not alone in this, of course. The best postwar American art can be seen as a continuation and development of the most adventurous French art of the first part of the twentieth century.) Yet for all Davis's frank admiration of European modernism, identifying precisely what his influences were is a less than straightforward task. Davis's originality declared itself early, even though it is easy enough to document the painters who first impressed him. While his early modernist work can be read like a chart of the artists who engaged his attention—van Gogh, Gauguin, Cézanne, Matisse, Picasso, and Braque all make their presence felt—it is not always possible to identify just *what* Davis saw *when*. Was the Armory Show quite as much of a revelation as Davis always claimed it was? It soon becomes even more difficult to isolate direct influences on Davis's work. He seems, at various times and with varying degrees of enthusiasm, to have been aware of Léger and Miró, as well as Japanese prints, commercial illustrations, Picabia, and probably Raoul Dufy, to judge by the evidence of the pictures, although Davis's own early work often seems as likely a source for his later paintings as any external stimulus. To further confuse the issue, artists whom Davis praised in his notebooks, such as Seurat, often seem to have had little visible influence. The mature Davis turned increasingly to his own work as the starting point of new pictures, but there is evidence that he remained responsive to challenging art of high quality (except Abstract Expressionism) throughout his career.

There are, for example, obvious changes in Davis's paintings after about 1950 that make a comparison with Matisse's cutouts irresistible. The clarity, simplification, and general scaling-up of Davis's late pictures, coupled with their increased openness and detached patterning, suggest some relation with the cut-paper works and particularly with *Jazz,* the book based on Matisse's cutout-style compositions. The question is when Davis might have seen *Jazz* or any of the other cutouts. And if he did see them, how much attention did he pay to them? Davis obviously admired Matisse, as he admired many advanced French artists. He figures in Davis's notebooks, as most major European modernists do, but without special emphasis. Davis transcribed pas-

sages from a book on Matisse and included him in his definition of "psychological content" in the work of the artists he liked best. "The general mood of the content," as Davis puts it, is itemized as follows:

Fantasy	—	Miró
Sensuousness	—	Matisse
Invention	—	Picasso
Serenity	—	Seurat
Objectivity	—	Cézanne[2]

The most interesting of the Matisse references (in relation to Davis's own work) is a rumination on scale written in 1948, just about the time that Davis's pictures began to be more ample and less packed with incident. He observed that Matisse's large pictures often had fewer elements than the small ones, but concluded that scale was simply a function of use: "mural is big, easel painting is smaller—relationship of parts are what matter."[3]

Davis had the opportunity to see a good deal of Matisse's work, including some of the cutouts, in the late 1940s and early '50s. In the spring of 1948 the Philadelphia Museum of Art mounted a Matisse retrospective that included *Jazz*. It is possible that Davis went, since he still had some connections with Philadelphia. (In 1947 he was included in an exhibition called *5 Prodigal Sons . . . Former Philadelphia Artists,* at the city's Coleman Gallery.) In 1948, too, *Jazz* was shown in New York, and it is hard to imagine someone with Davis's tastes not paying close attention to a cycle of Matisse works with that particular title. In 1949 Pierre Matisse showed a group of his father's paper cutouts in his New York gallery, and from November 1951 through January 1952 the Museum of Modern Art presented a major Matisse exhibition that included the cut-paper maquettes for the windows and vestments of the Vence chapel, plus two other paper cutouts.

It is nonetheless difficult to prove a definite cause-and-effect relationship between Matisse's cutouts and Davis's later work. There are evident likenesses, but there are also clear precedents in Davis's early work for the elements that evoke Matisse in his pictures after 1950. The thickened loopy calligraphy and floating signs of paintings such as *Rapt at Rappaport's* and *Blips and Ifs* (plates 191, 217) seem obviously Matissian at first glance. Davis had used detached written elements as early as the 1920s and used them without a break for the rest of his life, but the large fluid word-shapes of *Blips and Ifs* and its fellows seem closer to Matisse's deeply indented leaf shapes than to any of Davis's previous lettering. The word-shapes are unlike the delicate typog-

raphy of his still lifes of the 1920s and unlike the fragile drawing of the Paris streetscapes. They make even the relatively robust drawing of pictures such as *Report from Rockport* and *Hot Still-Scape* (plates 178, 184) seem a little attenuated. But was Davis responding to Matisse's example or was he simply intensifying images already present in his own work and making them more substantial? Similarly, the dots and hatches of *Rapt at Rappaport's* could derive from the dense patterns of *Report from Rockport* or *Hot Still-Scape,* but they could also relate to the reticulated "net" in *Jazz's* trapeze image. The dislocated letters in *Jazz's Le Cirque,* in the same way, could easily have provided Davis with confirmation of his direction, if not an indication of other possibilities. The similarities are undeniable, but as with Davis and Léger, it is hard to establish anything but informed affinity in the relation of Davis's late paintings to Matisse's cutouts.

If Davis's relationship to his predecessors resists precise categorization, it is no easier to determine his influence on younger artists. It was not immediate. Abstract Expressionism had become virtually an academic movement by the last decade of Davis's life; the surviving originators were flourishing, and often producing powerful work, but art schools and galleries were filled with people trying to paint like de Kooning. For younger artists of the period who were reacting against the thick paint, flamboyant strokes, and unbridled emotion of Abstract Expressionism (and who were working their way toward an abstraction based on insubstantial expanses of color), Davis could have served as a welcome precursor of a cooler, more restrained approach. But, as with Davis's own generation, European forebears still seemed to have more authority, and it was Matisse's example that was paramount for the emerging generation of color-field painters. Of their American predecessors, Jackson Pollock was the most significant influence, and beside his intuitive skeins of paint, Davis's carefully planned and composed pictures looked almost traditional. In a *New York Times* article in January 1964, Brian O'Doherty saw "Davis's snapping staccato color contrasts" as part of the ancestry of the new color abstraction of the time.[4] He saw him as a forerunner of Morris Louis, Kenneth Noland, Jules Olitski, and Lawrence Poons, which is truer in terms of affinity and appearance than it is in terms of real influence. Kenneth Noland, for example, says that he always respected Davis for what he calls the "authenticity" of his work (something he found in short supply among the artists of Davis's generation).[5] He was far less interested in the specific look of Davis's art, even though he feels that Davis is an artist to be reckoned with. Of Noland's slightly younger colleagues, Frank Stella seems to have most sympathy with Davis. Stella's geometrically laid-

221. *Still Life—Three Objects,*
1925
Oil on canvas, 26 x 34 in.
The Wadsworth Atheneum,
Hartford, Connecticut; Gift of
Mr. and Mrs. Stuart Davis

out canvases of the 1960s and 1970s, with their blazing color and flat, impersonal paint application, are like abstractions of Davis's abstractions. They replace Davis's allusive imagery, his quirky, off-beat color, and his sensuous surfaces with a kind of supercool essence. Stella's more recent works—the Indian Bird series, for example—seem to have even more in common with Davis. The reverberations of the contemporary street in these elaborately wrought constructions, Stella's artful use of graffiti and glitter, along with the complex geometric armatures that underlie their encrusted surfaces, make it possible to describe the series as a 1980s equivalent for Davis's hip Cubist versions of a less violent, more civilized New York.

Davis's idiosyncratic art acquired a new and unprecedented context with the burgeoning of the American Pop movement of the 1960s.

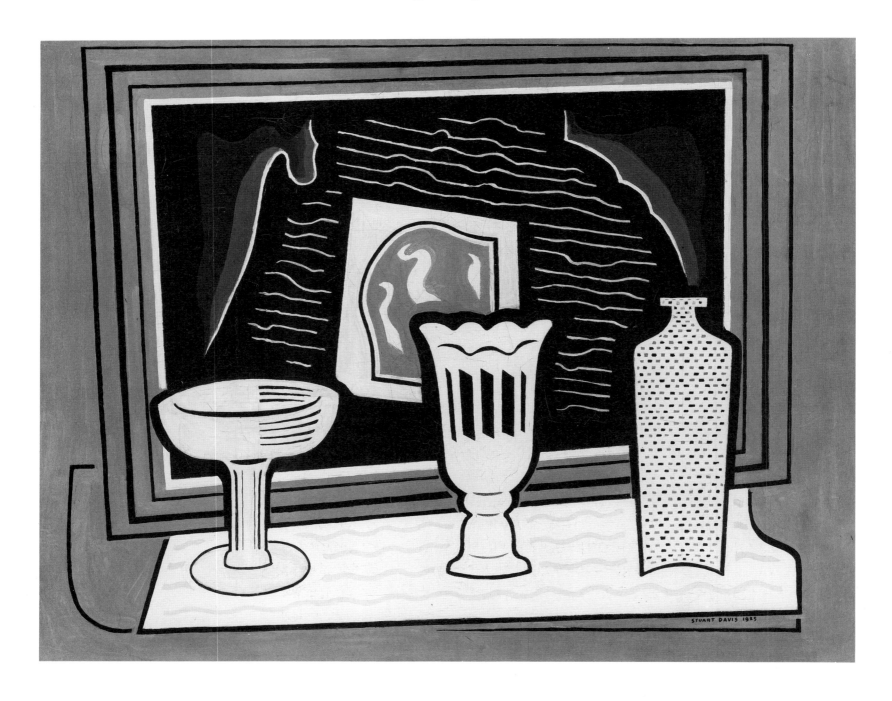

His fiercely individual paintings suddenly seemed prophetic. His life-long delight in packaging and labels, in electric signs and storefronts, provided ancestry for the work of painters such as Robert Indiana, James Rosenquist, Jim Dine, and Andy Warhol. Davis's belief that *any* subject could generate good art seemed to provide a context for the work of Roy Lichtenstein and Jasper Johns, even for Robert Rauschenberg's combines and Claes Oldenburg's soft sculptures (which could also be interpreted as literal manifestations of the Ashcan School's fascination with the less glamorous parts of urban life). But for all these similarities, Davis ultimately stands apart from these younger artists as he does from so many others. The resemblances to his work—the choice of subject matter, the brashness, brightness, and clarity of Pop art—prove on closer inspection to be only superficial likenesses and less than meaningful.

Davis's pleasure in commercial packaging and in labels and signs seems one of his strongest bonds with the iconography of the Pop painters. The great difference is in how he used them. In 1956 *Fortune* magazine invited a group of seven artists to interpret the traditional theme of the still life in contemporary terms, asking "What would artists see in a morning's haul from the supermarket?" [6] Davis described his response: "That's all I did—bought a lot of groceries from the store and laid them down there on the floor and looked at them and made several compositions over a number of days until I found something that looked like a painting, or was paintable. And then I did it and the names in it . . . have a certain wit." [7]

The various Package Deal pictures—studies, detail studies, the completed gouache, and the later large canvas, *Premiere* (plates 192–95)—are all based on a firm and generous structure of intensely colored planes, typical of Davis's work of the late 1950s and early 1960s. They depend a good deal on the playful shuffling of familiar advertising slogans, here legibly printed and logically oriented, in contrast to the disguised, flipped calligraphy of more or less contemporary works. At first reading, the words all seem to have come from the grocery packages: *large, new, free, 100%, bag, juice, cow.* But front and center among all these workaday fragments are Davis's personal watchwords: *any* and *pad. Any* is the familiar allusion to the validity of any subject, an appropriate comment on the subject matter assigned to him. *Pad* recalls the series of pictures that includes *Pad No. 4* and *The Mellow Pad* (plates 224, 225), among others, but it also has a larger meaning. As the hip word for home, the place where the groceries have been taken, it metaphorically locates the floating words. And the juxtaposition of *pad* with *cat,* placed directly below, removes us

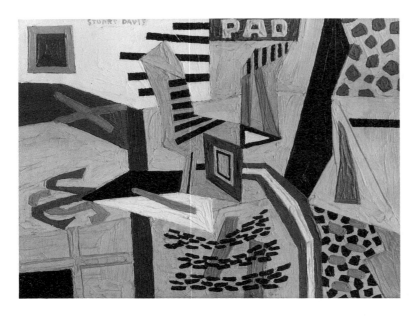

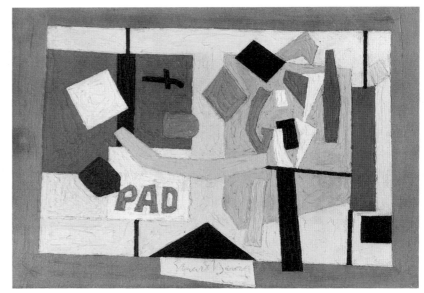

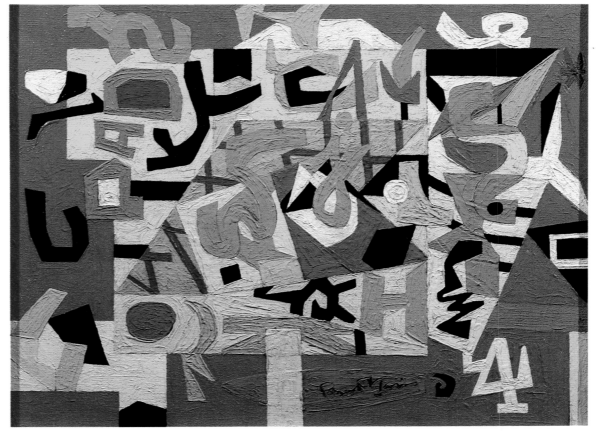

CLOCKWISE FROM TOP LEFT
222. *Pad No. 1,* 1946
Oil on canvas, 9⅞ x 12¾ in.
Honolulu Academy of Arts; Gift
of Friends of the Academy, 1948

223. *Pad No. 3,* 1947
Oil on canvas, 10 x 14 in.
Private collection

224. *Pad No. 4,* 1947
Oil on canvas, 14 x 18 in.
Mr. and Mrs. Milton Lowenthal

OPPOSITE
225. *The Mellow Pad,* 1945—51
Oil on canvas, 26 x 42 in.
Mr. and Mrs. Milton Lowenthal

from the realm of pet food, which we might reasonably expect from the supermarket context, and returns us to Davis's world of jive-talking jazz fans.

Davis clearly enjoyed the game, but using groceries and packages as an impetus for painting was nothing new to him. Commercial packaging, like any other manifestation of modern urban life, was one of the things that made Davis want to paint. As he put it: "I just made a composition which was directly inspired by sensory impacts

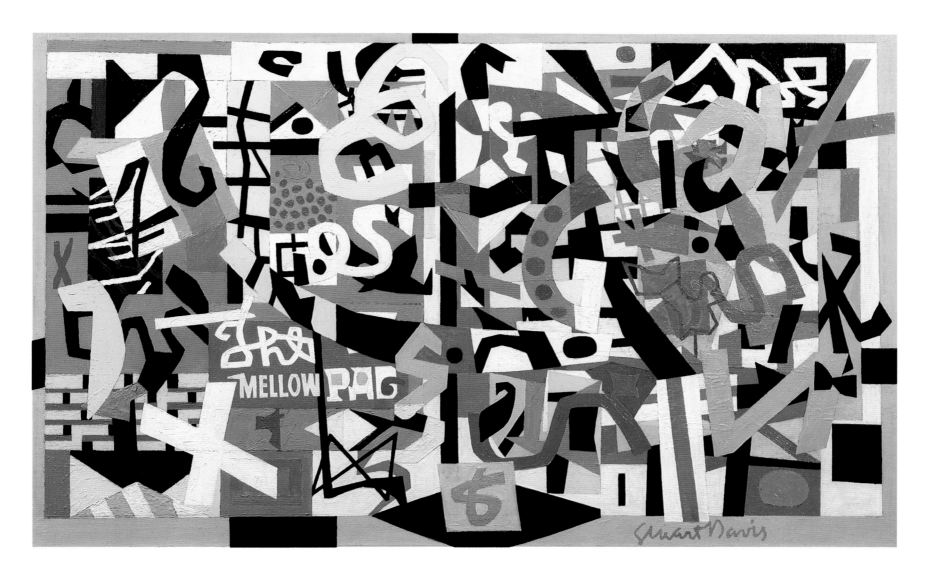

of the stuff. I can't seem to get away from that." [8] "The stuff," however, was not an end in itself, but a starting point.

The relation of the Pop painters to similar subject matter was quite different. Not only did they treat advertising images and commercial packaging with the deference that earlier generations had accorded the features of commissioning patrons, but they treated the conventions of commercial and advertising art with the cautious respect that the earlier generation had reserved for academic prescriptions. They kept their everyday subjects intact and clearly recognizable and they deliberately mimicked the look of commercial and advertising art. Davis took his usual liberties with his subjects, transforming "the stuff" by means of color-space logic into his usual Cubist-derived construction with colored planes. Davis described his colloquial subject matter in the language of high art. His younger colleagues used the language of the street and the supermarket. It is no less difficult to identify Davis's influence on present-day painters. Among currently fashionable young artists, his name is sometimes mentioned as a source for "appropriations," but since many of these painters treat the entire history of art as

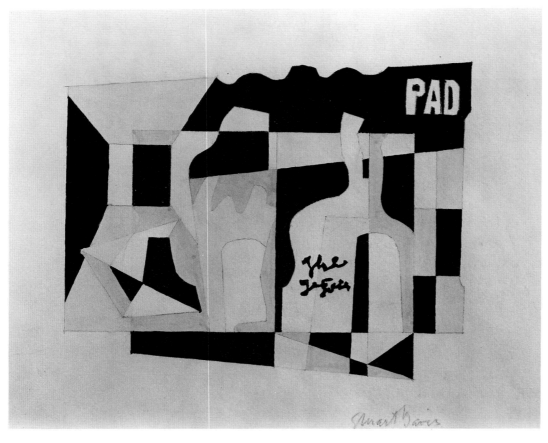

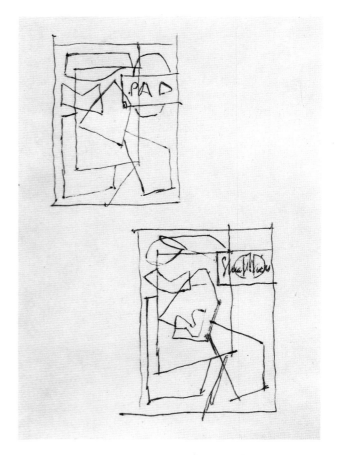

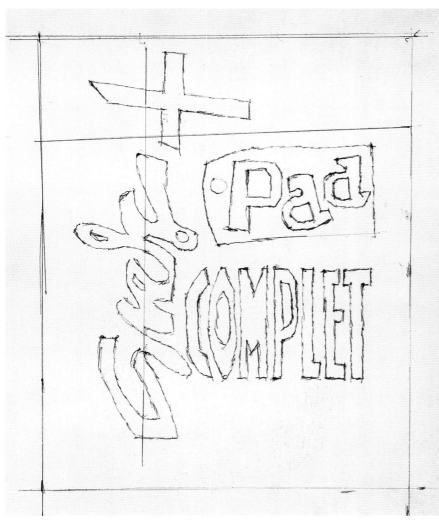

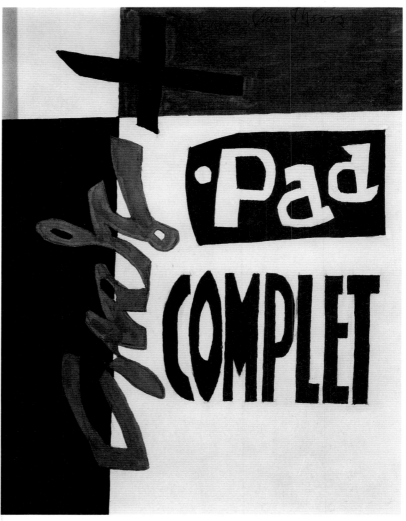

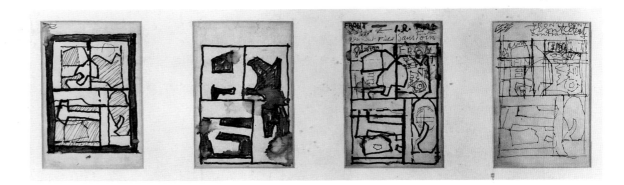

231. *Four Sketches for "Last Painting,"* c. 1962–64
Ink on paper, 10½ x 25¾ in.
(frame)
Earl Davis

232. *Untitled (Last Painting),* 1964
Tempera and tape on canvas,
71 x 53 in.
Earl Davis

a kind of grab bag yielding an infinity of available images, it is difficult to make much of the reference.

In the end, Davis remains as much odd man out, aesthetically, as he appeared to be when he took that surprising fourth place in *Look's* 1948 survey—indeed, as he was throughout his life as an artist. He forged his version of Cubism almost single-handedly, without direct American ancestors; he left no direct disciples. Often misunderstood, in his early years, as being too difficult and too radical, by the time of his death in 1964, his work was well regarded but somehow consigned to the past. Davis has suffered, too, from more recent perceptions, slipping as he does between the two conventional points of focus in the history of twentieth-century American art. Too young to have been part of the so-called pioneer generation of expatriates who helped introduce modernism to the United States, he was still considerably older than the New York artists who made postwar America the center of innovative art, and he was overshadowed by them. Within his own generation he seems even more isolated. But if Davis's art is difficult to categorize, it should only make us admire his independence of mind all the more. The excellence of his painting speaks for itself. It is not an overstatement to call him the best American painter of his generation.

NOTES

Introduction (pages 7–38)

1. Stuart Davis Papers, Harvard University Art Museums, on deposit at Houghton Rare Book Library, Harvard University. Reel 2, June 6, 1940, and reel 4, November 1941. Some pages are dated, others are dated and numbered; the papers have been indexed by John R. Lane. Reel numbers refer to microfilm copies of the papers; there are no frame numbers. All Davis Papers at the Harvard University Art Museums are copyright 1987 by President and Fellows of Harvard College.

2. Stuart Davis, "The Cube Root," *Artnews* 4 (February 1, 1943): 33–34.

3. Davis Papers, reel 14, November 4, 1954.

4. Davis Papers, reel 2, April 3, 1940.

5. See Susan C. Larsen, "The Quest for an American Abstract Tradition," in *Abstract Painting and Sculpture in America 1927–1944,* John R. Lane and Susan C. Larsen, eds. (Pittsburgh: Museum of Art, Carnegie Institute; New York: Harry N. Abrams, 1983).

6. Davis Papers, reel 2, May 8, 1938.

7. Garnett McCoy, *David Smith* (New York and Washington: Praeger Publishers, 1973), 86.

8. These notes deal exclusively with aesthetic, rather than personal, issues.

9. *The Europeans,* set around 1878, was first published in 1903.

10. Davis Papers, reel 5, October 18, 1943, 1–2.

11. Davis Papers, reel 5, September 16, 1942.

12. Davis Papers, reel 3, July 17, 1940.

13. Davis Papers, reel 4, January 8, 1942.

14. Davis Papers, reel 14, March 21, 1957.

15. Conversation with author, January 1987.

16. Davis Papers, reel 14, November 13, 1957.

17. Davis Papers, reel 14, October 21, 1956.

18. Davis Papers, reel 14, November 27, 1956.

19. Rudi Blesh, *Stuart Davis* (New York: Grove Press, 1960), 14.

1. The Ashcan School and the Armory Show (pages 39–76)

1. I am greatly indebted to Robert Hunter, who is preparing a dissertation on the early work of Stuart Davis, for his newly revised chronology, and to William C. Agee, who is preparing the Stuart Davis catalogue raisonné, for revised dating of the pictures and for his insightful comments.

2. Diane Kelder, ed., *Stuart Davis* (New York: Praeger Publishers, 1971), 19. Such support was evidently characteristic of the family; Davis's brother, Wyatt, became a photographer, and a cousin, Hazel Foulke, studied at the Pennsylvania Academy. For information about the Davis family, I am indebted to conversations with Earl Davis during 1984–87.

3. Ibid., 20.

4. For a complete history of the magazine, see Rebecca Zurier, *Art for The Masses 1911–1917: A Radical Magazine and Its Graphics* (New Haven, Conn.: Yale University Art Gallery, 1985).

5. Kelder, *Davis,* 23–24.

6. Ibid.

7. Ibid., 24.

8. Ibid.

9. Ibid.

10. William C. Agee has noted a resemblance between the simplified pictures of this period and Japanese prints, which Davis was studying at about this time.

11. Kelder, *Davis,* 24.

12. Ibid., 25.

13. I am grateful to Sandra Paikowsky, director of the Art Gallery of Concordia University, Montreal, for calling my attention to the connection between Sloan and Morrice.

2. Being a Modern Artist (pages 77–108)

1. The similarity between the Eggbeater series and Picasso's paintings of the late 1920s has often been noted. Davis, like many of his contemporaries, paid close attention to Picasso but knew his work chiefly from reproductions. Picasso's pictures of this type were not shown in New York until Davis was well into the Eggbeater series.

2. Marcia Epstein Allentuck, *John Graham's "System and Dialectics of Art"* (Baltimore: Johns Hopkins University Press, 1971), 54.

3. Davis Papers, reel 4, November 24, 1941.

4. Dickran Tashjian, *William Carlos Williams and the American Scene 1920–1940* (New York: Whitney Museum of American Art; Berkeley and Los Angeles: University of California Press, 1978), 62.

5. Kelder, *Davis,* 27.

6. Ibid., 26.

7. Tashjian, *Williams,* 62.

8. Davis's dealer, Edith Halpert, exhibited works by Harnett.

9. John R. Lane, *Stuart Davis: Art and Art Theory* (New York: Brooklyn Museum, 1978), 96.

10. Blesh, *Davis,* 16.

11. Ibid., 13.

12. Lane, *Davis,* 94.

13. Davis Papers, reel 1, March 13, 1923.

14. Davis Papers, reel 14, May 2, 1962.

15. Blesh, *Davis,* 17.

16. James Johnson Sweeney, *Stuart Davis* (New York: Museum of Modern Art, 1945), 15.

17. Ibid.

18. Ibid.

19. Ibid.

20. Davis Papers, reel 1, January 27, 1937.

21. Davis Papers, reel 4, September 1941.

22. Davis Papers, reel 4, March 1942.

23. Davis Papers, reel 1, March 11, 1923.

24. Davis Papers, reel 4, November 28, 1941.

25. Kelder, *Davis,* 26.

26. Davis Papers, reel 14, October 31, 1954.

27. *Chicago Post,* November 29, 1927.

28. Kelder, *Davis,* 26.

3. An Interval in Paris (pages 109–24)

1. Kelder, *Davis,* 27.

2. Janet Hobhouse, *Everybody Who Was Anybody: A Biography of Gertrude Stein* (New York: G. P. Putnam's Sons, 1975), 154.

3. Robert McAlmon, *Being Geniuses Together 1920–1930* (San Francisco: North Point Press, 1984), 255.

4. Sweeney, *Davis,* 20.

5. Ibid.

6. Davis, to father, September 17, 1928.

7. Davis, to mother [month and day illegible], 1928.

8. Davis Papers, reel 2, April 24, 1938, and reel 3, December 12, 1940.

9. Davis Papers, reel 7, June 14, 1943.

10. Davis, to mother, January 25, 1929.

11. Davis, to Hazel Foulke, January 28, 1929.

12. Kelder, *Davis,* 27.

13. Davis, to father, September 17, 1928.

14. Davis, to Hazel Foulke, January 28, 1929.

15. Davis, to father, June [day illegible] 1928 and September 17, 1928.

16. Davis, to mother, November 5, 1928.

17. Davis, to father, September 17, 1928.

18. Jane Myers, ed., *Stuart Davis: Graphic Work and Related Paintings* (Fort Worth, Texas: Amon Carter Museum, 1986), 25.

19. For information on Stuart Davis and John Graham, I am grateful to Eleanor Green, who is preparing a major exhibition of Graham's work for the Phillips Collection, Washington, D.C.

20. Davis, to mother, January 25, 1929.

21. Stuart Davis Scrapbook, Archives of American Art, Smithsonian Institution, Washington, D.C. Reel N584, frame 225.

22. Davis Papers, reel 4, August 1941.

23. Stuart Davis, "Self-Interview," *Creative Art* 9 (September 1931): 211.

24. Kelder, *Davis,* 27.

4. Art and Social Action (pages 125–60)

1. Sweeney, *Davis,* 22.

2. Myers, *Davis Graphics,* 10.

3. Sweeney, *Davis,* 29.

4. Stuart Davis, "Arshile Gorky in the 1930s: A Personal Recollection," *American Magazine of Art* 44 (February 1951): 58.

5. Davis Papers, reel 1, 1936.

6. Ibid.

7. Ibid.

8. Ibid.

9. Davis Papers, reel 1, October 1, 1935.

10. Ibid.

11. Davis Papers, reel 1, 1936.

12. Davis Papers, reel 3, June 25, 1940.

13. Davis Papers, reel 1, 1936.

14. Kelder, *Davis,* 117.

15. Davis papers, reel 1, March 24, 1937.

16. Davis Papers, reel 2, March 9, 1938.

17. Davis Papers, reel 1, 1936.

18. Davis Papers, reel 1, September 1937.

19. Davis Papers, reel 1, March 24, 1937.

20. Kelder, *Davis,* 152.

21. Davis Papers, reel 1, September 30, 1937.

22. Letter to Henry McBride, *Creative Art* 6 (February 1930): supp. 34–35.

23. Kelder, *Davis,* 11.

24. Edward Alden Jewell, "Stuart Davis Offers a Penetrating Survey of the American Scene," *New York Times,* March 10, 1932, 19; and Henry McBride, "Stuart Davis . . . Downtown Gallery," *New York Sun,* March 21, 1932, 6.

25. Davis Papers, reel 2, April 24, 1938.

26. Davis Papers, reel 3, January 28, 1940.

27. Davis Papers, reel 3, January 16, 1940.

28. Davis Papers, reel 1, June 15, 1936.

29. Francis V. O'Connor, ed., *The New Deal Art Projects: An Anthology of Memoirs* (Washington, D.C.: Smithsonian Institution Press, 1972), 167.

30. Davis Papers, reel 2, c. 1940.

31. Kelder, *Davis,* 17.

32. Ibid., 73.

33. Myers, *Davis Graphics,* 12.

34. Sweeney, *Davis,* 30.

5. The Ace of American Modernists (pages 161–208)

1. Henry McBride, "Stuart Davis . . . Downtown Gallery," *New York Sun,* March 21, 1932, 6.

2. *Artnews* 4 (February 1, 1943): 22–23, 33–35.

3. Davis Papers, reel 2, February 29, 1940.

4. Davis Papers, reel 2, May 8, 1938.

5. Theodore E. Stebbins, Jr., and Carol Troyen, *The Lane Collection* (Boston: Museum of Fine Arts, 1983), text to plate 82, n.p.

6. Davis Papers, reel 3, June 30, 1940.

7. For a detailed analysis of Davis's color theory, see Lane, *Stuart Davis: Art and Art Theory.*

8. H. H. Arnason, *Stuart Davis* (Minneapolis: Walker Art Center, 1957), 44.

9. Clement Greenberg, "Stuart Davis: Selected Paintings at the Downtown Gallery," *Nation* 156 (February 20, 1943): 284.

10. Peyton Boswell, "Painted Jazz," *Art Digest* 17 (February 15, 1943): 3.

11. James Elliott, "Premiere," *Los Angeles Museum Art Bulletin* 14, no. 3 (1962): 10–11.

12. See Dorothy Gees Seckler, "Stuart Davis Paints a Picture," *Artnews* 211 (Summer 1953): 30–33, 73–74.

13. Davis Papers, reel 2, June 1, 1940.

14. Davis Papers, reel 4, January 8, 1942.

15. Ibid.

16. Davis Papers, reel 3, June 17, 1940.

17. Davis Papers, reel 5, May 20, 1942, 3–4.

18. Davis Papers, reel 8, October 3, 1948.

19. Davis Scrapbook, reel N696, frames 95–96.

20. Davis Papers, reel 4, January 8, 1942.

21. Davis Papers, reel 14, March 21, 1957.

22. Davis Papers, reel 14, August 14, 1955.

23. Davis Papers, reel 14, November 18, 1956.

24. Davis Papers, reel 1, December 30, 1922.

25. Davis Papers, reel 7, October 29, 1943.

26. Davis Papers, reel 3, November 10, 1940.

27. Davis Papers, reel 6, November 21, 1942.

28. See Lewis Kachur, "Stuart Davis and Bob Brown: *The Masses* to *The Paris Bit,*" *Arts Magazine* (October 1982): 70–73.

29. Sketchbook 13, c. 1932, Estate of Stuart Davis.

6. In Perspective (pages 209–25)

1. See especially Barbara Novak, *American Painting in the Nineteenth Century* (New York: Praeger Publishers, 1969).

2. Davis Papers, reel 4, November 28, 1941, p. 11.

3. Davis Papers, reel 8, October 10, 1948. An entry, dated June 13, 1956 (reel 14), makes it clear that Davis saw at least some of Matisse's cut-outs.

4. Brian O'Doherty, "Color and a New Abstraction," *New York Times,* January 5, 1964.

5. Kenneth Noland, conversation with author, January 1987.

6. Elliott, "Premiere," 9.

7. Ibid.

8. Ibid.

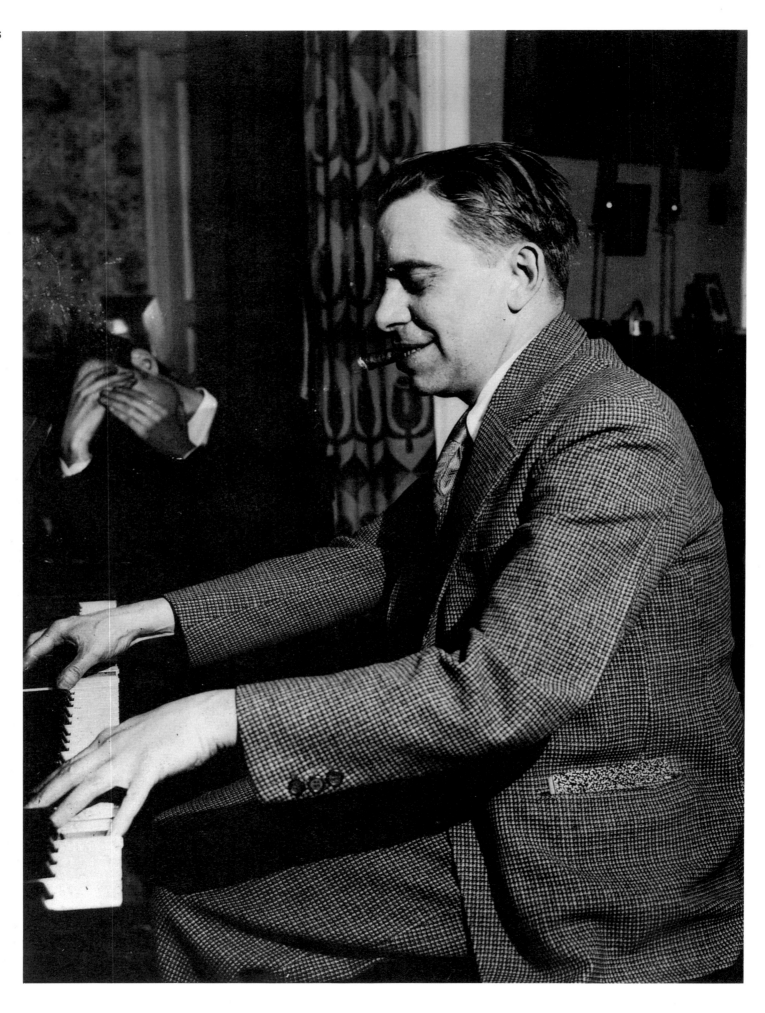

233. Stuart Davis
at the piano

CHRONOLOGY

1892

December 6—Stuart Davis is born in Philadelphia to Edward Wyatt Davis and Helen Stuart Davis (née Foulke). Father is art editor of the *Philadelphia Press,* to which John Sloan, William Glackens, George Luks, and Everett Shinn all contribute during the 1890s. Mother is a sculptor.

1901

Family moves to East Orange, New Jersey, when Edward Davis becomes art editor and cartoonist with the *Newark Evening News;* he later works at *Judge* and *Leslie's Weekly,* both of New York. By 1910, the family moves to Newark. Summers are spent at Avon and Belmar, New Jersey.

1906

February 14—birth of only brother, Wyatt Davis.

1908

Enters East Orange High School.

1909

Fall—leaves high school to study with painter Robert Henri at the Robert Henri School of Art, 1947 Broadway, New York. Begins friendships with John Sloan, Glenn Coleman, and Henry Glintenkamp.

1910

Shares apartment on James Street, Newark, with two young men. April 1–30—his work exhibited for the first time, in *Exhibition of Independent Artists,* 29 West Thirty-fifth Street, New York.

1912

Leaves the Henri school. Establishes studio with Glintenkamp in the Terminal Building, Hudson Street, Hoboken, New Jersey. Ends formal education. Fall—begins working for the *Masses.*

1913

February 17–March 15—shows five watercolors in *International Exhibition of Modern Art,* Sixty-ninth Regiment Armory, New York. Summers in Provincetown, Massachusetts. Establishes studio with Glintenkamp and Coleman in the Lincoln Arcade, 1931 Broadway, New York. Joins staff of the *Masses,* under art editor John Sloan. Does cartoons for *Harper's Weekly.*

1914

Summers in Provincetown.

1915

At the suggestion of John Sloan, summers in Gloucester, Massachusetts, where Davis returns almost annually until 1934. By mid-1920s, his family acquires a house at 51 Mount Pleasant Avenue, Gloucester, where he maintains a studio.

1916

Resigns from the *Masses* after argument over editorial policy.

1917

December—first solo exhibition opens: *Stuart Davis: Watercolors and Drawings,* Sheridan Square Gallery, New York.

1918

Does service in World War I as a mapmaker in the Army Intelligence Department, preparing materials for the peace conference.

1919

Occupies apartment on Greenwich Avenue, New York. Stays and paints at a family summer place in Tioga, Pennsylvania. December 26—travels with Coleman to Cuba, where they remain about a month.

1920

William Carlos Williams selects an untitled 1916 drawing of Gloucester for the frontispiece of his book of poems *Kora in Hell: Improvisations.* Davis contributes a drawing to the *Little Review* 7 (July–August 1920) for first publication of "Nausicaa," a section of James Joyce's *Ulysses.*

1921

Begins Tobacco Still Life series and a series of Cubist landscapes. Executes group of collages.

1922

Family moves to 356 West Twenty-second Street, New York. Davis contributes still-life and portrait drawings to the *Dial* (continues in 1923). Paints Cubist Still Life series.

1923

Spends summer painting in Santa Fe, New Mexico, with John and Dolly Sloan and his brother, Wyatt.

1925

February—his first solo exhibition in a museum opens at the Newark Museum, Newark, New Jersey.

1927

Edith Gregor Halpert, of the Downtown Gallery, 113 West Thirteenth Street, New York, becomes his dealer and presents his first show there. Davis begins Eggbeater series.

1928

May—Juliana Force of the Whitney Studio Club purchases two of Davis's paintings, enabling him to go to Paris. June—sets up studio at 50 rue Vercingétorix. Paints and makes series of lithographs. Fall—does cover for *transition,* no. 14 (Fall 1928), a magazine founded in Paris by Elliot Paul and Eugene Jolas.

1929

Marries Bessie Chosak, a native of Brooklyn, in Paris. Late August—returns to New York. Lives and works in Greenwich Village in an apartment at Thirteenth Street and Seventh Avenue. Spends late summer in Gloucester. John Graham introduces him to Arshile Gorky.

1931

Teaches at Art Students League, New York (through 1932). Makes series of lithographs. Lives and works in apartment near Saint Mark's Place. Paints New York–Paris series.

1932

June 15—Bessie Chosak Davis dies. Davis is persuaded by his sister-in-law, Mariam Davis, to paint mural, *Men Without Women,* for men's lounge, Radio City Music Hall, New York.

1933

Family moves to the Chelsea Hotel, 222 West Twenty-third Street. Davis takes a room above Romany Marie's restaurant, Eighth Street. December—joins the Public

234. *Book Jacket for "Concert Pitch," by Elliot Paul,* 1938
Gouache on paper, 20½ x 15 in.
Vassar College Art Gallery,
Poughkeepsie, New York

Works Art Project (which is incorporated into the Works Progress Administration, or WPA, in 1935).

1934
Joins Artists' Union and is soon elected president. Enrolls in Emergency Relief Bureau for Artists. Shares top floor of a building at Fourteenth Street and Eighth Avenue with his brother and sister-in-law. Meets Roselle Springer about this time. July—establishes studio and apartment at 43 Seventh Avenue (remains there until 1955).

1935
January—becomes editor of *Art Front,* published by the Artists' Union (serves until January 1936). Enrolls in Works Progress Administration's Federal Art Project.

1936
Becomes charter member of the American Artists Congress and is elected executive secretary. Terminates relationship with the Downtown Gallery.

1937
Executes first WPA mural, for Brooklyn College (now lost). Does book jacket for *Concert Pitch,* a novel by Elliot Paul, published by Random House in 1938. Is elected national chairman of American Artists Congress. Executes first WPA mural, *Swing Landscape,* for Williamsburg Housing Project (now installed at Indiana University, Bloomington). October 12— marries Roselle Springer.

1939
Executes *History of Communication* mu-

ral for Hall of Communications at New York World's Fair, subsequently destroyed. WPA sponsors mural for Studio B of radio station WNYC, Municipal Broadcasting Corporation. Executes three colored prints for Graphic Arts Division, WPA. Leaves the WPA.

1940
Resigns from Artists Congress. Teaches at New School for Social Research, New York (through 1950).

1941
Rejoins the Downtown Gallery, now at 43 East Fifty-first Street, New York.

1942
A rug, *Flying Carpet,* is commissioned by weaver V' Soske for a special exhibition of rugs designed by ten American painters.

1944
The Terminal, 1937, wins first prize in *Portrait of America* exhibition sponsored by Pepsi-Cola; the painting is reproduced on 600,000 1945 Pepsi-Cola calendars as the illustration for January. Wins honorable mention at the Carnegie Institute *International Exhibition,* Pittsburgh, for *Arboretum by Flashbulb.*

1945
October 17—retrospective exhibition opens at the Museum of Modern Art, New York. Davis wins J. Henry Schiedt Memorial Prize at *140th Annual Exhibition* of the Pennsylvania Academy, Philadelphia.

1946
A book on Davis is included in a series of pocket-size volumes on leading American contemporary artists, published by American Artists Group; each artist supplies a foreword about his work. Wins the Norman Wait Harris Bronze Medal and $300 at the *Fifty-seventh Annual American Exhibition of Watercolors and Drawings of the Art Institute of Chicago.* Executes a painting for a Container Corporation of America advertisement, published in *Time* magazine, September 16, and in *Fortune* magazine, October.

1947
Wins the Hallowell Prize at the St. Botolph Club, Boston.

1948
Look magazine includes him on a list of the ten best painters in America, based on a poll of museum directors and critics.

1949
Castleton China reproduces a Davis drawing from the Museum of Modern Art on a new line of china.

235. *Deuce,* 1954
Oil on canvas, 26 x 42¼ in.
San Francisco Museum of Modern
Art; Gift of Mrs. E. S. Heller

1950
Wins John Barton Payne Medal and Purchase Prize at the Virginia Museum of Arts, Richmond.

1951
Is visiting art instructor at Yale University, New Haven, Connecticut. October—work is included in *1 Bienal de São Paulo,* Museu de Arte Moderna, São Paulo, Brazil. Wins Ada S. Garrett Prize at *60th Annual American Exhibition: Paintings and Sculpture* of the Art Institute of Chicago.

1952
June 14—solo exhibition opens at the American Pavilion of the *XXVI Biennale di Venezia,* Venice. Wins John Simon Guggenheim Memorial Foundation fellowship. April 17—son, George Earl Davis, is born.

1953
William H. Lane (who becomes Davis's major patron) purchases first pictures, *Rurales No. 2. Cuba,* 1919, and *Egg Beater No. 3,* 1928.

1954
Becomes member of the directing faculty of the Famous Artists Painting Course, Westport, Connecticut (until 1964).

1955
Moves studio and apartment to 15 West Sixty-seventh Street, New York. Designs jacket for a record of chamber music by Charles Ives, for Columbia Records. Executes mural, *Allée,* for Drake University, Des Moines, Iowa.

1956
Elected to the National Institute of Arts and Letters. Work is included in the *XXVII Biennale di Venezia,* Venice.

1957
March 30—retrospective opens at Walker Art Center, Minneapolis. Executes mural, *Composition Concrete,* for H. J. Heinz Research Center, Pittsburgh. Wins the Brandeis University Fine Arts Award for Painting.

1958
Work is included in *Primera Bienal Interamericana de Pintura y Gravado,* Mexico. Wins the Solomon R. Guggenheim Museum International Award.

1959
Work is included in *American Painting and Sculpture,* Moscow.

1960
Wins the Guggenheim Museum International Award for a second time.

1961
Wins the Witkowsky Cash Prize of the Art Institute of Chicago.

1962
Wins Fine Arts Gold Medal of the American Institute of Architects.

1964
Wins the Mr. and Mrs. Frank G. Logan Medal and Prize at the *Sixty-seventh Annual American Exhibition: Directions in Contemporary Painting and Sculpture* of the Art Institute of Chicago. June 24—dies of a stroke in New York.

EXHIBITIONS

Solo Exhibitions

1917 *Stuart Davis: Watercolors and Drawings,* Sheridan Square Gallery, New York, December.

1918 Ardsley Gallery, Brooklyn, New York.

1925 *Stuart Davis,* Newark Museum, Newark, New Jersey, February.

1926 *Retrospective Exhibition of Paintings by Stuart Davis,* Whitney Studio Club, New York, December 8–22.

1927 *Stuart Davis Exhibition: Recent Paintings, Watercolors, Drawings, Tempera,* Downtown Gallery, New York, November 26–December 9.

1929 *Watercolors by Stuart Davis,* Whitney Studio Club, New York, November 27–December 7.

1930 *Stuart Davis: Hotels and Cafés,* Downtown Gallery, New York, January 21–February 10.

1931 *Stuart Davis,* Downtown Gallery, New York, March 31–April 19.
 Stuart Davis, Crillon Galleries, Philadelphia, December 5–21.

1932 *American Scene: Recent Paintings, New York and Gloucester . . . Stuart Davis,* Downtown Gallery, New York, March 8–21.

1934 *Stuart Davis: Recent Paintings, Oil and Watercolor,* Downtown Gallery, New York, April 25–May 12.

1939 *Stuart Davis: Paintings,* Katharine Kuh Gallery, Chicago, February.

1943 *Stuart Davis: Selected Paintings,* Downtown Gallery, New York, February 2–27.

1945 *Stuart Davis,* Museum of Modern Art, New York, October 17–February 3, 1946.

1946 *Retrospective Exhibition of Gouaches, Watercolors and Drawings, 1912 to 1941,* Downtown Gallery, New York, January 29–February 16.

1952 American Pavilion, *XXVI Biennale di Venezia,* Venice, June 14–October 19.

1954 *Recent Paintings by Stuart Davis,* Downtown Gallery, New York, March 1–27.

1956 *Stuart Davis: Exhibition of Recent Paintings,* Downtown Gallery, New York, November 6–December 1.

1957 *Stuart Davis,* Walker Art Center, Minneapolis, March 30–May 19, and tour to Des Moines Art Center, Des Moines, Iowa; San Francisco Museum of Modern Art; Whitney Museum of American Art, New York.

1958 *Exhibition of Recent Paintings,* Downtown Gallery, New York.

1960 *Exhibition of Twelve of the Paintings Used as Color Illustrations in "Stuart Davis" by Rudi Blesh,* Downtown Gallery, New York, May 10–June 4.

1962 *Stuart Davis: Exhibition of Recent Paintings, 1958–1962,* Downtown Gallery, New York, April 24–May 19.

1964 *The Work of Stuart Davis,* Peale House Galleries of the Pennsylvania Academy of the Fine Arts, Philadelphia, September 30–November 8.

1965 *Stuart Davis Memorial Exhibition,* National Collection of Fine Arts, Smithsonian Institution, Washington, D.C., May 28–July 5, and tour to the Art Institute of Chicago; Whitney Museum of American Art, New York; Art Galleries, University of California at Los Angeles.

1966 *Stuart Davis: 1894–1964,* traveling exhibition circulated by U.S. Information Agency, Musée d'Art Moderne, Paris, February 15–March 14, and tour to Amerika Haus, West Berlin; London Chancery Building; American Embassy, London.

1971 *Major Drawings, on Canvas and Paper,* Lawrence Rubin Gallery, New York, January 30–March 1.

1976 *Stuart Davis: Murals,* Zabriskie Gallery, New York, January 27–February 14.
 The Prints of Stuart Davis, Associated American Artists, New York, November 1–24.

1978 *Stuart Davis: Art and Art Theory,* Brooklyn Museum, January 21–March 19, and tour to Fogg Art Museum, Cambridge, Massachusetts.
 Stuart Davis: The Hoboken Series, Watercolors, Hirschl and Adler Galleries, New York, February 4–March 4.

1979 *Stuart Davis: Works on Paper,* Grace Borgenicht Gallery, New York, January 6–January 31.
 Stuart Davis: Paintings of the Early Twenties, Esther Robles Gallery, Los Angeles, April 6–May 31.

1980 *Stuart Davis: A Concentration of Works from the Permanent Collection of the Whitney Museum of American Art,* Whitney Museum of American Art, New York, August 20–October 12.
 Stuart Davis: Still-Life Paintings, 1922–24, Grace Borgenicht Gallery, New York, September 27–October 23.

1983 *Stuart Davis: Havana Watercolors,* Grace Borgenicht Gallery, New York, January 8–February 3.
 Stuart Davis: The Formative Years (1910–1930), Rahr-West Museum, Manitowoc, Wisconsin, March 31–May 8, and tour to Terra Museum of American Art, Evanston, Illinois; Minnesota Museum of Art, St. Paul.
 Stuart Davis: Works from 1913–1919, Washburn Gallery, New York, November 3–December 23.

1985 *Stuart Davis' New York,* Norton Gallery of Art, West Palm Beach, Florida, October 26–December 8, and tour to Museum of the City of New York; Columbus Museum of Art, Columbus, Ohio.
 Stuart Davis: Black and White, Salander-O'Reilly Galleries, New York, November 6–December 28.

1986 *Provincetown Paintings and Drawings,* Grace Borgenicht Gallery, New York, April 1–26.
 Stuart Davis: Graphic Work and Related Paintings, Amon Carter Museum of Western Art, Fort Worth, Texas, August 26–October 26.

Selected Group Exhibitions

1910 *Exhibition of Independent Artists,* 29 W. Thirty-fifth Street, New York, April 1–30.

1913 *International Exhibition of Modern Art,* Sixty-ninth Regiment Armory, New York, February 17–March 15.

1915 Panama-Pacific International Exposition, San Francisco, Fine Arts Pavilion, February 20–December 4.

1917 *First Annual Exhibition of the Society of Independent Artists,* Grand Central Palace, April 10–May 6.
Exhibition of Landscapes, Whitney Studio Club, New York, December 12–January 2, 1918.

1921 *Stuart Davis, Joaquín Torres-Garcia, Stanislaw Szukalski,* Whitney Studio Club, New York, April 15–May 15.

1926 *International Exhibition of Modern Art Arranged by the Société Anonyme for the Brooklyn Museum,* Brooklyn Museum, New York, November 19–January 1, 1927.

1928 *Exhibition—Paintings and Watercolors: Glenn Coleman and Stuart Davis,* Curt Valentin Gallery, New York, April 23–May 12.

1929 *Americans Abroad,* Downtown Gallery, New York, October 8–28.

1932 *Murals by American Painters and Photographers,* Museum of Modern Art, New York, May 3–31.
The First Biennial of Contemporary American Painting, Whitney Museum of American Art, New York, November 22–January 5, 1933. Also included in Whitney biennials and annuals in 1934, 1936–38, 1940–43, 1945–48, 1951–53, 1955–58, 1961, 1963.

1934 *Modern Works of Art,* Museum of Modern Art, New York, November 20–January 20, 1935.

1935 *Abstract Painting in America,* Whitney Museum of American Art, New York, February 12–March 12.

1939 *Art in Our Time: An Exhibition to Celebrate the 10th Anniversary of the Museum of Modern Art, and the Opening of Its New Building,* Museum of Modern Art, New York, May 10–September 30.
American Art Today, New York World's Fair.

1941 *Marsden Hartley, Stuart Davis,* Cincinnati Art Museum, October 24–November 24.
This Our City, Whitney Museum of American Art, New York, March 11–April 13.

The 52nd Annual Exhibition of American Paintings and Sculpture, Art Institute of Chicago, October 30–January 4, 1942. Also included in 1942, 1943, 1945–47, 1951, 1954, 1961, 1964.

1942 *Masters of Abstract Art,* Helena Rubinstein's New Art Center, New York, April 1–May 15.

1944 *Art in Progress, A Survey Prepared for the 15th Anniversary of the Museum of Modern Art,* Museum of Modern Art, New York, May 24–October 15.
Painting in the United States, 1944, Museum of Art, Carnegie Institute, Pittsburgh, October 12–December 10.

1945 *Three Contemporary Americans: Karl Zerbe, Stuart Davis, Ralston Crawford,* Arts Club of Chicago, February.
Four American Painters: Peter Blume, Stuart Davis, Marsden Hartley, Jacob Lawrence, Institute of Contemporary Art, Boston, March 2–April 1.
Paintings by Six Contemporary Americans, William Rockhill Nelson Gallery and Atkins Museum of Fine Arts, Kansas City, Missouri, April.

1946 *Pioneers of Modern Art in America,* Whitney Museum of American Art, New York, April 9–May 19.
Advancing American Art, traveling exhibition organized by U.S. Information Agency, Metropolitan Museum of Art, New York, October 4–27, and tour to Musée d'Art Moderne, Paris; Prague.
60 Americans since 1800, U.S. Department of State, exhibited at Grand Central Art Galleries, New York, November 19–December 5.

1947 *5 Prodigal Sons . . . Former Philadelphia Artists,* Coleman Art Gallery, Philadelphia.

1949 *Stuart Davis, Yasuo Kuniyoshi, Franklin Watkins: Thirty Paintings,* Santa Barbara Museum of Art, Santa Barbara, California, July 28–August 28, and tour to Fine Arts Museums of San Francisco; Art Museum, Portland, Oregon.

1950 *Contemporary American Painting,* College of Fine and Applied Arts, University of Illinois, Urbana, February 26–April 2. Also included in 1952 exhibition.

1951 *Abstract Painting and Sculpture in America,* Museum of Modern Art, New York, January 23–March 25.
1 Bienal de São Paulo, Museu de Arte Moderna, São Paulo, Brazil, October.
Amerikanische Malerei Werden und Gegenwart, Rathaus Schoneberg and Schloss Charlottenberg, Berlin.

40 American Painters, 1940–1950, University Gallery, University of Minnesota, Minneapolis.

1952 *The Edith and Milton Lowenthal Collection,* Whitney Museum of American Art, New York, October 1–November 1, and tour to Walker Art Center, Minneapolis.
Stuart Davis and Yasuo Kuniyoshi: Paintings Exhibited at the 1952 Venice Biennale, Downtown Gallery, New York, December 9–27.

1953 *Contemporary American Painting and Sculpture,* College of Fine and Applied Arts, University of Illinois. Also included in 1955, 1957, 1959, and 1961.
12 Modern American Painters and Sculptors, organized by the Museum of Modern Art, New York, and tour to Paris, Zurich, Düsseldorf, Stockholm, Helsinki, Oslo.

1955 *Modern Art in the United States,* organized by the Museum of Modern Art, New York, and tour to Paris, Zurich, Barcelona, Frankfurt, London, The Hague, Vienna, Belgrade.

1957 *An American Viewpoint: Realism in Twentieth-Century American Painting,* Cincinnati Art Museum.
Trends in Water Colors Today, Italy and U.S., Brooklyn Museum, New York.

1958 *Primera Bienal Interamericana de Pintura y Gravado,* Mexican National Institute of Fine Arts, Secretariat of Public Education, Mexico City.
Ten Modern Masters of American Art, paintings from the Joseph H. Hirshhorn Collection, circulated by the American Federation of Arts.

1959 *American Painting and Sculpture,* traveling exhibition organized by U.S. Information Agency, exhibition sent to Moscow; Whitney Museum of American Art, New York.
25 Anni di Pittura Americana 1933–1958, U.S. Information Agency, exhibition sent to Rome.
The 26th Biennial, Exhibition of Contemporary American Painting, Corcoran Gallery of Art, Washington, D.C.

1960 *Tobacco and Smoking in Art,* North Carolina Museum of Art, Raleigh.
Art across America, Munson-Williams-Proctor Institute, Utica, New York.

1962 *U.S. Government Art Projects—Some Distinguished Alumni,* Museum of Modern Art, New York.
Geometric Abstraction in America, Whitney Museum of American Art, New York.

1963 *Signs and Symbols, U.S.A.,* Downtown Gallery, New York.

 Dunn International Exhibition, Arts Council of Great Britain, Tate Gallery, London, and tour to Beaverbrook Art Gallery, Fredericton, New Brunswick.

 1913 Armory Show: 50th Anniversary Exhibition—1963, Munson-Williams-Proctor Institute, Utica, New York, February 13–March 31, and tour to 69th Regiment Armory, New York.

 The Decade of the Armory Show: New Directions in American Art, 1910–1920, Whitney Museum of American Art, New York, February 27–April 14, and tour to City Art Museum, St. Louis; Cleveland Museum of Art; Pennsylvania Academy of the Fine Arts; Art Institute of Chicago; Albright-Knox Art Gallery, Buffalo, New York.

 The New Tradition: Modern Americans before 1940, Corcoran Gallery of Art, Washington, D.C., April 22–June 2.

 American Modernism: The First Wave, Poses Institute of Fine Arts, Brandeis University, Waltham, Massachusetts, October 4–November 10.

1964 *200 Years of American Painting,* City Art Museum, St. Louis.

 Between the Fairs—25 Years of American Art 1939–1964, Whitney Museum of American Art, New York, June 24–September 23.

1966 *Art of the U.S.: 1670–1966,* Whitney Museum of American Art, New York, September 28–November 27.

1969 *New York Painting and Sculpture: 1940–1970,* Metropolitan Museum of Art, New York, October 18–February 1, 1970.

1973 *Pioneers of American Abstraction,* Andrew Crispo Gallery, New York, October 17–November 17.

1976 *American Master Drawings and Water Colors,* Whitney Museum of American Art, New York, November 23–January 23, 1977.

1977 *The Modern Spirit: American Painting 1908–35,* Arts Council of Great Britain, London.

1978 *William Carlos Williams and the American Scene, 1920–1940,* Whitney Museum of American Art, New York, December 12–February 4, 1979.

1981 *Modernist Art from the Edith and Milton Lowenthal Collection,* Brooklyn Museum, New York, March 21–May 10.

1982 *The Gloucester Years,* Grace Borgenicht Gallery, New York, February 6–March 4.

1983 *The Lane Collection, 20th Century Paintings in the American Tradition,* Museum of Fine Arts, Boston, April 13–August 7, and tour to San Francisco Museum of Modern Art; Amon Carter Museum, Fort Worth, Texas.

 Abstract Painting and Sculpture in America, 1927–1944, Museum of Art, Carnegie Institute, Pittsburgh, November 5–December 31, and tour to San Francisco Museum of Modern Art; Minneapolis Institute of Arts; Whitney Museum of American Art, New York.

1985 *Art for The Masses 1911–1917: A Radical Magazine and Its Graphics,* Grunwald Center for the Graphic Arts, University of California, Los Angeles, April 21–May 26, and tour to Whitney Museum of American Art at Philip Morris, New York; Boston University Art Gallery; Yale University Art Gallery, New Haven, Connecticut.

1986 *The Advent of Modernism: Post-Impressionism and North America, 1900–1918,* High Museum, Atlanta, Georgia, and tour to Center for the Fine Arts, Miami; Brooklyn Museum, New York; Glenbow Museum, Calgary, Alberta, Canada.

236. *Radio Tubes,* 1940
Gouache on paper, 22 x 14½ in.
Arizona State University Art
Collections, Tempe; Gift of
Oliver B. James

PUBLIC COLLECTIONS

Andover, Massachusetts, Phillips Academy, Addison Gallery of American Art

Athens, Georgia, University of Georgia, Georgia Museum of Art

Austin, Texas, University of Texas, Archer M. Huntington Art Gallery

Baltimore, Maryland, Baltimore Museum of Art

Bloomington, Indiana, Indiana University Art Museum

Boston, Massachusetts, Museum of Fine Arts

Brooklyn, New York, Brooklyn Museum

Buffalo, New York, Albright-Knox Art Gallery

Cambridge, Massachusetts, Harvard University, Fogg Art Museum

Charleston, West Virginia, Sunrise Museums

Chicago, Illinois, Art Institute of Chicago

Cincinnati, Ohio, Cincinnati Art Museum

Des Moines, Iowa, Drake University

Detroit, Michigan, Detroit Institute of Arts

Fort Worth, Texas, Amon Carter Museum

Hanover, New Hampshire, Dartmouth College, Hood Museum of Art

Hartford, Connecticut, Wadsworth Atheneum

Honolulu, Hawaii, Honolulu Academy of Arts

Houston, Texas, de Menil Foundation

Houston, Texas, Museum of Fine Arts

Iowa City, Iowa, University of Iowa, Museum of Art

Ithaca, New York, Cornell University, Herbert F. Johnson Museum of Art

Jerusalem, Israel, Israel Museum

Lincoln, Nebraska, University of

Nebraska, Sheldon Memorial Art Gallery

Los Angeles, California, Los Angeles County Museum of Art

Lynchburg, Virginia, Randolph-Macon Woman's College, Maier Museum of Art

Madison, Wisconsin, University of Wisconsin, Elvehjem Museum of Art

Milwaukee, Wisconsin, Milwaukee Art Museum

Minneapolis, Minnesota, Walker Art Center

Newark, New Jersey, Newark Museum

New Haven, Connecticut, Yale University Art Gallery

New York, New York, Metropolitan Museum of Art

New York, New York, Museum of Modern Art

New York, New York, Solomon R. Guggenheim Museum

New York, New York, Whitney Museum of American Art

Norfolk, Virginia, Chrysler Museum

Norman, Oklahoma, University of Oklahoma, Museum of Art

Philadelphia, Pennsylvania, Pennsylvania Academy of the Fine Arts

Philadelphia, Pennsylvania, Philadelphia Museum of Art

Pittsburgh, Pennsylvania, Carnegie Museum of Art

Portland, Maine, Portland Museum of Art

Poughkeepsie, New York, Vassar College Art Gallery

Purchase, New York, State University of New York, Neuberger Museum

Richmond, Virginia, Virginia Museum of Fine Arts

Rochester, New York, University of

Rochester, Memorial Art Gallery

St. Louis, Missouri, St. Louis Art Museum

St. Louis, Missouri, Washington University Gallery of Art

St. Paul, Minnesota, Minnesota Museum of Art

San Diego, California, San Diego Museum of Art

San Francisco, California, San Francisco Museum of Modern Art

Seattle, Washington, University of Washington, Thomas Burke Memorial Washington State Museum

State College, Pennsylvania, Pennsylvania State College

Syracuse, New York, Syracuse University, Joe and Emily Lowe Art Gallery

Tempe, Arizona, Arizona State University, University of Art Collections

Tucson, Arizona, University of Arizona Museum of Art

Urbana, Illinois, University of Illinois, Krannert Art Museum

Utica, New York, Munson-Williams-Proctor Institute Museum of Art

Waltham, Massachusetts, Brandeis University, Rose Art Museum

Washington, D.C., Hirshhorn Museum and Sculpture Garden, Smithsonian Institution

Washington, D.C., National Museum of American Art, Smithsonian Institution

Washington, D.C., Phillips Gallery

Wellesley, Massachusetts, Wellesley College Museum

West Palm Beach, Florida, Norton Gallery and School of Art

Wichita, Kansas, Wichita Art Museum

Winston-Salem, North Carolina, Reynolda House

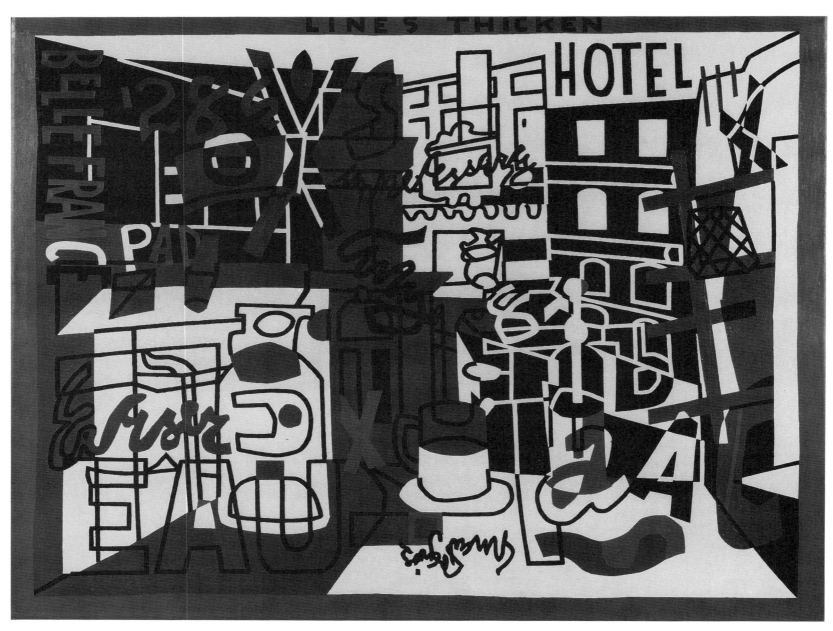

237. *The Paris Bit*, 1959
Oil on canvas, 46 x 60 in.
Whitney Museum of American Art,
New York; Gift of Friends of the
Whitney Museum of American Art

BIBLIOGRAPHY

Interviews and Statements

Davis, Stuart. "A Painter of City Streets: An Analysis of the Work of Glenn Coleman." *Shadowland* 8 (August 1923): 11, 75.

————. Letter to Henry McBride on French influence in Davis's paintings. *Creative Art* 6 (February 1930): supp. 34–35.

————. "Davis Translates His Art into Words." *Art Digest* 5 (April 15, 1931): 8.

————. "Self Interview." *Creative Art* 9 (September 1931): 208–11.

————. "From Our Friends—Stuart Davis." *Art Front* 1 (November 1934): 2.

————. Letter about Municipal Art Center. *New York Sun,* January 14, 1935, p. 22.

————. "Paintings by Salvador Dali, Julien Levy Gallery." *Art Front* 1 (January 1935): 7.

————. "The New York American Scene in Art." *Art Front* 1 (February 1935): 6. Reprinted in part and with comment in *Art Digest* 9 (March 1, 1935): 4, 21. Thomas Hart Benton replied in *Art Digest* 9 (March 15, 1935): 20–21, 25; reprinted in *Art Front* 1 (April 1935): 4, 8.

————. "Davis' Rejoinder to Thomas Benton." *Art Digest* 9 (April 1, 1935): 12–13, 26.

————. Introduction. *Abstract Painting in America,* exhibition catalog. New York: Whitney Museum of American Art, 1935, pp. 3–5. Reprinted in *Art of Today* 6 (April 1935): 9–10. Reprinted in part in Homer Saint-Gaudens, *The American Artist and His Times.* New York: Dodd and Mead, 1941, pp. 224–25.

————. "A Medium of Two Dimensions." *Art Front* 1 (May 1935): 6.

————. "American Artists and the 'American Scene.'" *New York World-Telegram,* May 4, 1935, p. 14.

————. "The Artist Today: The Standpoint of the Artists' Union." *American Magazine of Art* 28 (August 1935): 476–78, 506.

————. "Some Chance!" *Art Front* 1 (November 1935): 4, 7.

————. "The American Artists Congress." *Art Front* 2 (December 1935): 8.

————. "American Artists Congress. Thanks, All of You!" *Art Digest* 10 (March 15, 1936): 25–26.

————. Letter objecting to Edward Alden Jewell's criticism of Federal Art Project exhibition at the Museum of Modern Art. *New York Times,* September 27, 1936, sec. 10, p. 9.

————. "Why an Artists Congress?" Papers from First American Artists Congress. New York, 1936, pp. 3–6.

————. "The Artists Congress and American Art." Catalog for second annual exhibition of the American Artists Congress, New York, 1936.

————. "Show Is Model of Organization of Big Displays." *New York Post,* April 29, 1939, p. 4WF.

————. "Art at the Fair." *Nation* 149 (July 22, 1939): 112.

————. "Abstraction." *New York Times,* August 20, 1939, sec. 9, p. 7.

————. "Art and the Masses." *Art Digest* 14 (October 1, 1939): 13, 34.

————. Foreword to *Hananiah Harari,* exhibition catalog. New York: Mercury Galleries, 1939.

————. "Is There a Revolution in the Arts?" *Bulletin of America's Town Meeting of the Air* 5 (February 19, 1940): 11–14.

————. "Davis Explains His Resignation from Artists Congress." *New York Times,* April 14, 1940, sec. 9, p. 9.

————. "Davis Asks a Free Art." *New York Times,* July 7, 1940, sec. 9, p. 12. Further remarks, *New York Times,* August 18, 1940, sec. 9, p. 7.

————. "Stuart Davis." *Parnassus* 12 (December 1940): 6.

————. "The Abstract in Mural Art." *United Scenic Artists' Association Almanac* (1940–41): 20.

————. "Abstract Art in the American Scene." *Parnassus* 13 (March 1941): 100–103.

————. "The American Artist Now." *Now* 1 (August 1941): 7–11.

————. Response to "Bombshell" communication of Samuel Kootz. *New York Times,* October 12, 1941, sec. 9, p. 9.

————. Foreword to leaflet published by the *Pinacotheca.* New York: Pinacotheca, December 1941.

————. Letter to Edward Alden Jewell denying abstraction of painting *Arboretum by Flashbulb.* *New York Times,* September 27, 1942, sec. 8, p. 5.

————. "Art of the City." In *Masters of Abstract Art,* exhibition catalog. New York: Helena Rubenstein's New Art Center, 1942, pp. 12–13.

————. "The Cube Root." *Artnews* 12 (February 1, 1943): 22–23, 33–35.

————. "What about Modern Art and Democracy?" *Harper's Magazine* 188 (December 1943): 16–23.

————. "The 'Modern Trend' in Painting." *Think* 11 (January 1945): 19–20, 36.

————. *Personal Statement: Painting Prophecy 1950,* exhibition catalog. Washington, D.C.: David Porter Gallery, 1945.

————. *Stuart Davis.* New York: American Artists' Group Monographs, 1945. Davis's autobiography, reprinted in Diane Kelder, ed., *Stuart Davis:*

A Documentary Monograph, New York: Praeger, 1971.

———. "Contrasts: Paintings by Lucioni and Davis." *American Artist* 10 (April 1946): 34–35.

———. Letter to the editor. *Life* 22 (March 31, 1947): 9, 10.

———. Statement in brochure for George Wetling exhibition. New York: Norlyst Gallery, 1947.

———. Symposium on *Guernica,* unpublished. New York: Museum of Modern Art, November 25, 1947, pp. 58–63.

———. "Arshile Gorky: A Personal Recollection." *Magazine of Art* 44 (February 1951): 56–58.

———. Statement. *Look* 15 (June 30, 1951): 68–69.

———. "What Abstract Art Means to Me." *Museum of Modern Art Bulletin* 18 (Spring 1951): 14–15.

———. *40 American Painters, 1940–1950,* exhibition catalog. Minneapolis: University Gallery, University of Minnesota, 1951, pp. 18–19.

———. *Contemporary American Painting,* exhibition catalog. Urbana: University of Illinois, 1952, pp. 183–84.

———. "Symposium: The Creative Process." *Art Digest* 28 (January 15, 1954): 16, 34.

———. "Place of Painting in Contemporary Culture." *Artnews* 56 (June 1957): 29–30.

———. "Handmaiden of Misery." *Saturday Review* 40 (December 28, 1957): 16–17.

———. "Is Today's Artist with or against the Past?" *Artnews* 57 (Summer 1958): 43.

———. "Artists on Art and Reality, on Their Work and on Values." *Daedalus* 89 (1960): 118–20.

———. "Memo on Mondrian." *Arts Magazine Yearbook* 4 (1961): 66–68.

Devree, Howard. "Why They Paint the Way They Do." *New York Times Magazine,* February 17, 1946, pp. 20–21.

Feinstein, Sam. "Stuart Davis: Always Jazz Music." *Art Digest* 28 (March 1,

1954): 14–15, 24.

Homer, William I. "Stuart Davis. 1894–1964: Last Interview." *Artnews* 63 (September 1964): 43, 56.

Kelder, Diane, ed. *Stuart Davis: A Documentary Monograph.* New York: Praeger, 1971. Contains samples of Davis's unpublished papers as well as most of his published work, including the 1945 autobiography.

Klein, Jerome. "Stuart Davis Criticizes Critic of Abstract Art." *New York Post,* February 26, 1938, p. 24.

Lochheim, Aline B. "Six Abstractionists Defend Their Art." *New York Times,* January 21, 1951, sec. 6, pp. 16–17.

Sweeney, James Johnson. *Stuart Davis,* exhibition catalog. New York: Museum of Modern Art, 1945. Introduction contains statements by Davis.

Wight, Frederick S. "Stuart Davis." *Art Digest* 27 (May 15, 1953): 13, 23.

Wolf, Ben. "The Digest Interviews: Stuart Davis." *Art Digest* 20 (December 15, 1945): 21. Correction, *Art Digest* 20 (January 1, 1946): 23.

Documentary Material

Stuart Davis Papers, Harvard University Art Museums (Fogg Art Museum), Cambridge, Massachusetts. Gift of Mrs. Stuart Davis. Included are approximately 15,000 pages (some dated) of notes on art theory, preparatory notes for published statements and speeches, and some sketches and diagrams. The material is on fifteen reels of microfilm, with no frame numbers; there is an index by John R. Lane.

Stuart Davis Scrapbook, Archives of American Art, Smithsonian Institution, Washington, D.C. A collection on microfilm of miscellaneous reviews, articles, and artist's writings.

E. C. Goossen is in possession of a number of taped conversations with Stuart Davis.

Monographs and Solo-Exhibition Catalogs

Agee, William C., and Karen Wilkin. *Stuart Davis: Black and White,* exhibition catalog. New York: Salander-O'Reilly Galleries, 1985.

Arnason, H. H. Essay in *Stuart Davis,* exhibition catalog. Minneapolis: Walker Art Center, 1957.

———. Essay in *Stuart Davis Memorial Exhibition,* exhibition catalog. Washington, D.C.: National Collection of Fine Arts, Smithsonian Institution, 1965.

Blesh, Rudi. *Stuart Davis.* New York: Grove Press, 1960.

Crillon Galleries. *Stuart Davis,* exhibition catalog. Philadelphia: Crillon Galleries, 1931.

Downtown Gallery. *Stuart Davis: Hotels and Cafés,* exhibition catalog. New York: Downtown Gallery, 1930.

———. *Stuart Davis,* exhibition catalog. New York: Downtown Gallery, 1931.

———. *American Scene: Recent Paintings, New York and Gloucester . . . Stuart Davis,* exhibition catalog. New York: Downtown Gallery, 1932.

———. *Stuart Davis: Recent Paintings, Oil and Watercolor,* exhibition catalog. New York: Downtown Gallery, 1934.

———. *Stuart Davis: Exhibition of Recent Paintings,* exhibition catalog. New York: Downtown Gallery, 1943.

———. *Retrospective Exhibition of Gouaches, Watercolors and Drawings, 1912 to 1941,* exhibition catalog. New York: Downtown Gallery, 1946.

———. *Stuart Davis: Exhibition of Recent Paintings,* exhibition catalog. New York: Downtown Gallery, 1954.

———. *Stuart Davis: Exhibition of Recent Paintings,* exhibition catalog. New York: Downtown Gallery, 1956.

Goossen, E. C. *Stuart Davis.* New York: George Braziller, 1959.

Kachur, Lewis. *Stuart Davis: The Formative Years (1910–1930),* exhibition catalog. Manitowoc, Wisc.: Rahr-West Museum, 1983.

Kelder, Diane, ed. *Stuart Davis: A Documentary Monograph.* New York: Praeger, 1971.

Lane, John R. *Stuart Davis: Art and Art Theory,* exhibition catalog. New York: Brooklyn Museum, 1978.

————. *Modernist Art from the Edith and Milton Lowenthal Collection.* New York: Brooklyn Museum, 1981.

Myers, Jane, ed. *Stuart Davis: Graphic Work and Related Paintings, with a Catalogue Raisonné of the Prints.* Fort Worth, Tex.: Amon Carter Museum, 1986.

Sims, Patterson. *Stuart Davis: A Concentration of Works from the Permanent Collection of the Whitney Museum of American Art.* New York: Whitney Museum of American Art, 1980.

Sweeney, James Johnson. *Stuart Davis,* exhibition catalog. New York: Museum of Modern Art, 1945.

Washburn Gallery. *Stuart Davis: Works from 1913–1919,* exhibition catalog. New York: Washburn Gallery, 1983.

Weber, Bruce. *Stuart Davis' New York.* West Palm Beach, Fla.: Norton Gallery and School of Art, 1985.

Whitney Studio Club. *Retrospective Exhibition of Paintings by Stuart Davis,* exhibition catalog. New York: Whitney Studio Club, 1926.

————. *Watercolors by Stuart Davis,* exhibition catalog. New York: Whitney Studio Club, 1929.

Periodicals, Books, and Group-Exhibition Catalogs

Ashton, Dore. *The New York School: A Cultural Reckoning.* New York: Viking Press, 1972.

————. "Forces in New York Painting 1950–1970." *Artscanada* 36 (December–January 1979–80): 23–25.

Baigell, Matthew. *The American Scene: American Painting of the 1930's.* New York: Praeger, 1974.

Barr, Alfred H., Jr. *What Is Modern Painting?* New York: Museum of Modern Art, 1943.

————. *Masters of Modern Art.* New York: Museum of Modern Art, 1954.

Baur, John I. H. *Revolution and Tradition in Modern American Art.* Cambridge, Mass.: Harvard University Press, 1954.

Berman, Greta. "Abstractions for Public Spaces 1935–1943." *Arts Magazine* 56 (June 1982): 81–86.

Blesh, Rudi. *Modern Art, U.S.A.* New York: Alfred A. Knopf, 1956.

Bourdon, David. "Stuart Davis: Mural." *Arts Magazine* (February 1976): 60–61.

Bowdoin, W. G. "Modern Work of Stuart Davis at Village Show." *New York Evening World,* December 13, 1917.

Brooklyn Museum. *The Edith and Milton Lowenthal Collection.* Brooklyn: Brooklyn Museum, 1952.

Brown, Milton W. *The Modern Spirit: American Painting 1908–35.* London: Arts Council of Great Britain, 1977.

Cahill, Holger. "In Retrospect 1945–1910." *Artnews* 44 (October 15, 1945): 24–25, 32.

Checklist of the Prints of Stuart Davis. New York: Associated American Artists, 1976.

Coates, Robert M. "Davis, Hartley, and the River Seine." *New Yorker* 18 (February 13, 1943): 58.

————. "Retrospective of Paintings: Modern Museum." *New Yorker* 21 (October 27, 1945): 52.

————. "Exhibition at Downtown Gallery." *New Yorker* 30 (March 20, 1954): 81–82.

————. "The Art Galleries: MacIver, Davis and Corot." *New Yorker* 32 (November 17, 1956): 229–32.

————. "Art Galleries: Exhibitions at the Whitney." *New Yorker* 33 (October 19, 1957): 123.

"Critics Laud Young Artist." *Newark Morning Ledger,* June 1, 1918, p. 3.

Cummings, Paul. *American Drawings: The Twentieth Century.* New York: Viking Press, 1976.

de Kooning, Elaine. "Stuart Davis: True to Life." *Artnews* 56 (April 1957): 40–42, 54–55.

du Bois, Guy Pène. "Stuart Davis." *New York American,* October 31, 1910, p. 11.

————. "Stuart Davis." *Arts Weekly* 1 (March 26, 1932): 48.

Eldredge, Charles C., Julie Schimmel, and William H. Truettner. *Art in New Mexico, 1900–1945.* Washington, D.C.: Smithsonian Institution and

New York: Abbeville Press, 1986.

"From Men's Room to MoMA." *Artnews* 74 (Summer 1975): 150.

Geldzahler, Henry. *New York Painting: 1940–1970,* exhibition catalog. New York: Metropolitan Museum of Art, 1969.

Genauer, Emily. *Best of Art.* Garden City, N.Y.: Doubleday, 1948.

Gerdts, William H., and Russell Burke. *American Still-Life Painting.* New York: Praeger, 1971.

Goodrich, Lloyd. "In the Galleries." *The Arts* 16 (February 1930): 432. Review of exhibition at Downtown Gallery.

————. "Rebirth of a National Collection." *Art in America* 53 (June 1965): 82–89.

Gorky, Arshile. "Stuart Davis." *Creative Art* 9 (September 1931): 212–17.

Greenberg, Clement. "Stuart Davis: Selected Paintings at the Downtown Gallery." *Nation* 156 (February 20, 1943): 284.

————. Review of Davis exhibition at Museum of Modern Art. *Nation* 161 (November 17, 1945): 533–34.

Hamilton, George H. *Artnews* 58 (October 1959): 43, 56–57.

Henry, Gerrit. "Stuart Davis." *Artnews* 70 (April 1971): 10. Review of exhibition at Rubin Gallery.

————. "Stuart Davis: Murals." *Artnews* 75 (April 1976): 119–20. Review of exhibition at Zabriskie Gallery.

Hoopes, Donelson F. *American Watercolor Painting.* New York: Watson-Guptill, 1977.

Hunter, Sam. *American Art of the Twentieth Century.* New York: Harry N. Abrams, 1972.

Janis, Sidney. *Abstract and Surrealistic Art in America.* New York: Reynal and Hitchcock, 1944.

"The Jazzy Formalism of Stuart Davis." *Artnews* 53 (March 1954): 19, 59.

Jewell, Edward A. "Abstraction and Music: Newly Installed WPA Murals at Station WNYC Raise Anew Some Old Questions." *New York Times,* August 6, 1939, sec. 9, p. 7.

Kachur, Lewis. "America's Argenteuil: Art-

ists at Gloucester." *Arts Magazine* 56 (March 1982): 138–39.

————. "Stuart Davis and Bob Brown: The Masses to the Paris Bit." *Arts Magazine* 57 (October 1982): 70–73.

Kelder, Diane. "Stuart Davis: Pragmatist of American Modernism." *Art Journal* 39 (Fall 1979): 29–36.

Kramer, Hilton. "Month in Review." *Arts Magazine* 31 (November 1956): 52–55.

————. "Critic of American Painting: The First Six Volumes of the Great American Artists Series." *Arts Magazine* 34 (October 1959): 29. Review of E. C. Goossen's book.

Lane, John R. "Stuart Davis and the Issue of Content in New York School Painting." *Arts Magazine* 52 (February 1978): 154–57.

————, and Susan C. Larsen. *Abstract Painting and Sculpture in America, 1927–1944.* Pittsburgh: Museum of Art, Carnegie Institute; New York: Harry N. Abrams, 1983.

"La Peinture aux Etats-Unis." *Art d'Aujourd'hui* 2 (June 1951): 22–23.

Lardner, R. "Rhythm." *Artnews* 46 (November 1947): 107–10, 144.

Lawrence, Ellen. *Graham, Gorky, Smith and Davis in the Thirties.* Providence, R.I.: Bell Gallery, Brown University, 1977.

Levin, Gail. *American Color Abstraction.* New York: Whitney Museum of American Art and George Braziller, 1978.

McGonagle, William A. *The Thirties Decade: American Artists and Their European Contemporaries,* exhibition catalog. Omaha, Neb.: Joslyn Art Museum, 1971.

McKinzie, Richard D. *The New Deal for Artists.* Princeton, N.J.: Princeton University Press, 1973.

Markowitz, Gerald E., and Marlene Park. *New Deal for Art.* Hamilton, N.Y.: Gallery Association of New York State, 1977.

Marrin, Peter, Judith Zilczer, and William C. Agee. *The Advent of Modernism, Post-Impressionism and North American Art, 1900–1918.* Atlanta, Ga.: High Museum of Art, 1986.

Monroe, Gerald M. "The Artists' Union of New York." Ed.D. dissertation, New York University, 1971.

————. "Art Front." *Archives of American Art Journal* 13 (1973): 13–19.

Munro, Eleanor C. "Stuart Davis." *Artnews* 59 (Summer 1960): 14.

Myers, Bernard S., ed. *Encyclopedia of Painting.* New York: Crown, 1955.

New York City WPA Art. New York: NYC WPA Artists, 1977.

Novak, Barbara. *American Painting of the Nineteenth Century.* New York: Praeger, 1969.

O'Connor, Francis V., ed. *The New Deal Art Projects: An Anthology of Memoirs.* Washington, D.C.: Smithsonian Institution Press, 1972.

————, ed. *Art for the Millions: Essays from the 1930's by Artists and Administrators of the WPA Federal Art Project.* Greenwich, Conn.: New York Graphic Society, 1973.

O'Connor, John, Jr. "Stuart Davis: *Arboretum by Flashbulb,* wins Third Honorable Mention in Carnegie Show." *Carnegie Magazine* 18 (October 1944): 149–50.

O'Doherty, Brian. "Stuart Davis." *Famous Artists Magazine* 13 (Autumn 1964): 12–13.

————. *American Masters: The Voice and the Myth.* New York: Random House, 1973.

"Paintings from the 1952 Venice Biennale Being Shown by Downtown Gallery." *Art Digest* 27 (December 15, 1952): 16.

Paris–New York. Paris: Centre National d'Art et de Culture Georges Pompidou, 1977.

Paul, Elliot. "Stuart Davis, American Painter." *transition* 14 (1928): 146–48.

Reinhardt, Ad. Review of Davis exhibition at Museum of Modern Art. *New Masses,* November 27, 1945.

Richardson, E. P. *Painting in America.* New York: Thomas Y. Crowell, 1956.

Ritchie, Andrew Carnduff. *XXVI Biennale di Venezia.* Venice: Alfieri, 1952.

Rose, Barbara. *American Art since 1900.* New York: Praeger, 1968.

Sandler, Irving. *The Triumph of American Painting: A History of Abstract Expressionism.* New York: Praeger, 1970.

Sargeant, Winthrop. "Why Artists Are Going Abstract: The Case of Stuart Davis." *Life* 20 (February 17, 1945): 78–81, 83.

Seckler, Dorothy Gees. "Stuart Davis Paints a Picture." *Artnews* 52 (June 1953): 30–33, 73–74.

————. *Provincetown Painters, 1890's–1970's.* Syracuse, N.Y.: Everson Museum of Art, 1977.

Shuster, Alvin. "Stamps for Art's Sake." *New York Times Magazine,* September 20, 1964, p. 30.

Smith, Roberta. "Stuart Davis, Picture Builder." *Art in America* (September–October 1976). Review of exhibition at the Associated American Artists Gallery, in a special edition devoted to art of the 1930s.

Soby, James T. "Stuart Davis." *Saturday Review* 40 (November 9, 1957): 32–33.

Stebbins, Theodore E., Jr. *American Master Drawings and Watercolors.* New York: Harper and Row and Whitney Museum of American Art, 1976.

————, and Carol Troyen. *The Lane Collection. 20th-Century Paintings in the American Tradition,* exhibition catalog. Boston: Museum of Fine Arts, 1983.

Suro, Dario. "Homenaje a Stuart Davis 1894–1964." *Ahora!* 3 (August 10, 1964): 31–32.

————. "Stuart Davis 1894–1964." *Americas* 17 (January 1965): 30–31.

Sylvester, David. "Expressionism, German and American." *Arts Magazine* 31 (November 1956): 52–55.

Tashjian, Dickran. *Skyscraper Primitives: Dada and the American Avant-Garde, 1910–1925.* Middletown, Conn.: Wesleyan University Press, 1975.

————. *William Carlos Williams and the American Scene 1920–1940.* New York: Whitney Museum of American Art, 1978.

Teilman, Herdis B. "*Composition Concrete,* 1957, by Stuart Davis." *Carnegie Magazine* 54 (May 1980): 4–9.

Tillim, Sidney. "Exhibition at Downtown Gallery." *Arts Magazine* 34 (June 1960): 48–49.

Urdang, Beth. *Stuart Davis: Murals— An Exhibition of Related Studies,* exhibition catalog. New York: Zabriskie Gallery, 1976.

————. "Stuart Davis—Associated American Artists—Complete Graphic Work." *Arts Magazine* (November 1976): 6.

"Very Free Association; Critics Battle over Davis' 'Little Still-Life' at the Virginia Museum of Fine Arts." *Art Digest* 26 (March 15, 1952): 5.

"Virginia Museum Picks Its Winners in 1950 Biennial." *Art Digest* 24 (May 15, 1950): 17.

von Eckhardt, Wolf. "Turn Off the Sound." *American Institute of Architects Journal* 37 (March 1962): 118.

Waldman, Diane. *Twentieth-Century American Drawing: Three Avant-Garde Generations.* New York: Solomon R. Guggenheim Museum, 1976.

Wight, Frederick S. *Milestones of American Painting in Our Century.* New York: Chanticleer Press, 1946.

Wilmerding, John. *Portrait of a Place.* Gloucester, Mass.: Gloucester 350th Anniversary Celebration, 1973.

————, ed. *Genius of American Painting.* New York: William Morrow, 1973.

————. *American Art.* Harmondsworth, England: Penguin, 1976.

"Winner of Seventh Biennial Exhibition at the Virginia Museum." *Artnews* 49 (June 1950): 9.

INDEX

Page numbers in italics refer to illustrations.